GAUGUIN'S PARADISE LOST

GAUGUIN'S PARADISE LOST

WAYNE ANDERSEN

with the assistance of Barbara Klein

SECKER & WARBURG
LONDON

First published in England 1972 by
Martin Secker & Warburg Limited
14 Carlisle Street, London W1V 6NN

Copyright © 1971 by Wayne Andersen
SBN: 436 01725 3

Reproduced and printed in Great Britain by
Redwood Press Limited, Trowbridge & London

For Maja

You wish to know who I am; my works are not enough for you. Even at this moment, as I write, I am revealing only what I want to reveal. What if you often do see me quite naked? That is no problem; it is the inner man you want to see . . . and besides, I do not always see myself very clearly.

—PAUL GAUGUIN, *Avant et Après*

ACKNOWLEDGMENTS

I should like to thank the following for permission to quote: The City Art Museum of St. Louis for excerpts from Gauguin's unpublished manuscript *L'esprit moderne et le catholicisme*, and the New York Graphic Society and Dr. V. W. van Gogh for extracts from *The Complete Letters of Vincent van Gogh*. I should also like to acknowledge my debt to three Gauguin biographers, Bengt Danielsson, Henri Perruchot, and John Rewald, for countless facts and primary source material. I recommend their books to any reader who would like to know more of the facts that underlie my personal analysis of Gauguin's art. I should also express my appreciation to the senior staff psychiatrists of the Tufts New England Medical Center for inviting me to present portions of the manuscript at their colloquies; comments by Paul Myerson, M.D., Arthur McMahon, M.D., and Kenneth Robson, M.D., were especially helpful. I am very grateful to my friend Leonard Friedman, M.D., for reading those sections of the manuscript in which, venturing into the thicket of psychoanalysis, I needed a professional guide. Professor Mark Roskill kindly read my manuscript at proof stage and made several corrections of facts that would have caused me considerable embarrassment. To Claire Tyler I express many thanks for unstinting work gathering photographs and other supporting material. Finally I should acknowledge the supporting role that many of my students played in this production—at Massa-

Acknowledgments

chusetts Institute of Technology, where I reside in the department of architecture, and at other universities which I have visited: Harvard for the summer of 1966, Columbia for the summer of 1967, and Yale for the spring term of 1969. Although many participants in these seminars resisted my unorthodoxy, others hitched up and made the going a lot easier than if I had pulled all alone.

<div align="right">W.A.</div>

CONTENTS

Contents

GAUGUIN'S PARADISE LOST

Halo and Snake

*Philosophy is dull if it does not touch my instinct. Sweet to dream of,
with the vision that adorns it, it is not a science . . . or at most science
in the germ. Multiple like everything else in nature, ceaselessly evolving,
it is not a deduction from things, as certain solemn personages would
have us believe, but rather a weapon, which we alone, even as savages,
fabricate ourselves. It dares not manifest itself as a reality, but as an
image even as a picture is—admirable if the picture is a masterpiece.*

—Paul Gauguin, *Avant et Après*

LEGEND ASCRIBES the flowering of genius in Paul Gauguin
neither to industry nor to heredity but to mutation—an internal act
of God which transformed a solid Parisian stockbroker overnight into an
anguished artist-in-exile. That a myth of this school (which explains im-
probabilities by the imposition of magical metamorphoses: thus, coach
into pumpkin, water into blood, frog into prince, and order is restored to
the world) should be applied to Gauguin is less the license accorded to
poets than the vengeance of the popular press. Few men have worked
harder at creating an image than Gauguin did. His consummate self-
invention in Tahiti was the final stage of a long process of self-evolution,
in the course of which Gauguin came to a recognition of his powers. As
his consciousness of his potential grew, he began to court his image,

wooing it with ardor and occasional flamboyance until at last his life was given over to his image. He searched for a Paradise which would succor his dreamed self, but in the end his green oasis consumed the dream, leaving him, like Adam, bereft of his Eden and forced to bear the consequences of his original self.

Gauguin, the self-styled savage, found in the life and mythology of primitive societies a great natural fount of mystery to inspirit his art. In both Brittany and Tahiti he was moved by the drama of a life cycle simple in its course and free of the refinements of civilization. He saw that this life cycle existed beyond itself on another level, governed and motivated by unseen forces: an underworld of spirits exercising its will upon the instinctual life of the native. The primitive existence, free of artifice and excess, recognized only that which was essential to it. Gauguin perceived that the internal worlds of intuition, of sixth sense and second sight, resounded with tremendous force upon the realities of daily life in Brittany and Tahiti and were, in fact, the substance of that life.

In his lionization of the primitive, Gauguin was a man of his time; the romantic sensibility had long ago taken the savage to its heart. In one sense the romantic longed to return to a never-never land of naturalness and simplicity in which one might grow pure and wild, instincts unbridled but gravitating toward the good. But the darker drama of romantic primitivism was not concerned with healthy abandonment; rather it played itself out in pursuit of a musky exoticism, a sort of underbelly of civilization in which private fantasies and perversions might be enacted in the open under the guise of savagery. Flaubert, in *Novembre*, arrays before the reader a whole series of Oriental delights: ". . . glimpses of tigers seizing their prey, savages in canoes of which the prows are decorated with bloodstained scalps, poisoned arrows which bring an agonizing death, cannibal women . . ." (While in the Marquesas Islands, Gauguin held a brief, beatific discussion with an elderly cannibal about the taste of human flesh.)

For most romantics primitivism was a vehicle of fancy whose primary utility was to lend structure to a myth; for Gauguin it was the structure of a huge reality. Gauguin's art in the context of the symbolist movement was based upon the divining of reality's essentials and rendering them in such a way as to make them participate in the mystery of the eternal. The apperception of mystery was to him a spiritual faculty that must be developed in order to strengthen one's resistance to the flirtations

of sentiment and vanity. In his work he made a constant effort to veil his symbols so that they might remain, like neo-Platonic mysteries, obscure to all but those initiated to understand them. In his own mind the body of the uninitiated encompassed the civilized world at large, which failed to appreciate him or his art and condemned him to a life of exile and suffering; thus his quest for mystery was also his emblem of alienation. In March 1898 he wrote to his friend Daniel de Monfried, "Sometimes I hear people say, 'That arm is too long,' etc. Yes and no. No particularly, provided that as you elongate you accordingly sort out verisimilitude in order to reach for mystery, which is never a bad thing. Of course the whole work must reflect the same style, the same will. If Bouguereau made an arm too long, ah, yes, that would not do, since his vision, his artistic will stops at this stupid precision which binds us to material reality."

Gauguin believed that if one chose to live out the simplicities of the primitive life, one would be attuned to the eternal verities in which reside the eternal mysteries: the artist's sense of self, his instincts, his dreams and perceptions, his interpretive faculty, would become part of the fabric of nature, sharing in the immutability of the life cycle. The charisma that emanates from a creative being may be nourished by a style of life. Charles Morice, a poet friend of Gauguin's, specifies the fundamental virtues of the artist as "liberty, order, and solitude, from which there immediately results a feeling of unlimited power; immediately the soul acquires certainty about its own eternity in this exceptional solitude and knows that there is no death and no birth, and that veritable life is to be one of the conscious centers of the infinite vibration." [1] *

But the rhapsodizing of a philosopher-poet must be accepted for what it is worth; his championship of solitary soul-power averts the brute energy of strong public personalities. Ultimately the "centers of the infinite vibration" must be traced back to the innovators of the movement who exercise a godlike function in their creation of new worlds. Gauguin "created" a style of painting in the sense that he gave it its life force; and the vitality of his art was matched by the potency of his personality, by the loudness of his actions.

Gauguin's abandonment of his bourgeois existence added credence to his legend. Although the leave-taking was long in coming, the contrast between the world left and the world adopted was sufficiently extreme to

* Numbered reference notes begin on page 355.

make the act seem absolute, a giant step performed by a superman. The drama inherent in Gauguin's act, its finality and its black-white definition, was never duplicated in the lives of the other members of the artist's group; extended soul crises and conscientious vacillating make neither good legends nor profound artists. Gauguin's talented young colleague Émile Bernard, falling in love with a girl named Charlotte Brisse, was faced with the choice of supporting her or remaining free to pursue his painting. The debate vaulted back and forth for months while Bernard alternately bewailed his pervading bourgeois streak and pined for the exotic life, and Charlotte threatened to kill herself or die of grief. At last, worn by the struggle, Bernard left the decision to Charlotte, who graciously decided against ruining his career. Despite his invectives against it, Bernard continued to suffer from an overabundance of civilization.

Soon after Gauguin left his wife he wrote her a declamation which might have been a pledge: "You must remember that two natures dwell within me: the Indian and the sensitive man. The sensitive being has disappeared, allowing the Indian to go resolutely straight ahead." The sensitive man did not disappear but became transmuted into the passive Christ-figure who suffered at the hands of an unenlightened society; yet to the end of his life Gauguin clung to the inviolate image of the savage, which was at once his chosen metaphor for himself and the most fertile of his images. Barely a month before he died he wrote to de Monfried, defending his identity: "You were mistaken that day in saying that I was wrong to call myself a savage. I am a savage, and civilized people feel it, for there is nothing in my work which astonishes, perplexes, if it is not this 'savage-in-spite-of-myself.' That's why my work is inimitable. The work of a man is the explanation of the man."

Around 1878 Gauguin made a portrait of himself wearing a cap (figure 1). The picture intimates very little beyond its painted surface: a young man, rather stolid, with a clear gaze and a serious expression; the jauntily angled cap and the small goatee seem almost out of place, raffish accompaniments which mock the gravity of the subject. A curious left-right schism evident in many of Gauguin's portraits appears here; the right side of the face (reversed mirror image—at left in the painting) is weak and undefined, shrouded in shadows which give it a vague cast.[2] The left side is stronger, more heavily characterized; illuminated as if by a naked light, the features take on a sinister aspect—the eye is darkly outlined and stares almost belligerently, the mouth turns downward

sharply. This portrait is interesting for the same reason that Gauguin's brief career as a stockbroker is interesting: as a curiosity, and as a pole of comparison.

Gauguin's first known portrait of himself in the role of artist was made in 1885 (figure 2). It appears to be a mirror portrait, in the impressionist style which he still followed. The young man sits before an easel, staring ahead with a preoccupied gaze; the somber colors—the dark cloth of the coat, the blue backdrop behind his head, the brown rafters—lend a strange air of respectability. It would seem that painting is a serious business, and because of this weight of definition the portrait is stronger and more profound than the earlier rendering. However, the strength does not reside in Gauguin's self-interpretation but in the juxtaposition of man with task; the subject gains authority because he is in the act of working.

In 1896, after his final flight to his Tahitian paradise, Gauguin made another portrait of himself as an artist (figure 3). A comparison of the two characterizations is dramatic. Gauguin's legend had grown to grand proportions in the years between the rendering of the two portraits. As the chief proponent of synthetism he had become a figure in the intellectual life of the time. He had grown into his own image, and had presented himself in his old stamping grounds—where only a few years before he had sold stocks for a brokerage firm—as if he were an annotated Indian, calculating his effect and delighting in it. Armand Seguin wrote, "In his astrakhan cap and enormous dark blue cloak held together by delicate metal clasps, he appeared to Parisians like a gorgeous and gigantic Magyar." [3]

The portrait was made from a photograph (figure 4), which perhaps exonerates Gauguin from his physical self as a mirror would not have done, leaving him free to evoke his image. Although the pose is simple, almost elemental, the presence latent in the picture is so intense that one is made to feel the charismatic force of this man who is an artist and whose whole identity is caught up in art—not, as in the earlier portrait, an image of a man who happens to be painting. The figure, in its fur cap and blue cloak, holding a palette, is set against a scarlet backdrop; red tones seem to shadow the artist's face, lending a diabolical air to his heavy-lidded, measuring gaze. Brush strokes form arclike lines on either side of his head as if a halo were being etched from the fiery redness. Energy takes form as an intensity of concentration, expressed in

stylized frozen stillness rather than in motion. The spirit of the figure has been emancipated from its inner self and rendered tangible. The figure itself is rootlike, sculpturesque, while the motion which surrounds it is articulated in connotative lines, like an extension of meaning, a further definition of energy.

More typically, Gauguin surrounded his principal subject with a mute assortment of tangibilities, still-life objects which at first glance appear mundane and readily knowable. "In a way I work like the Bible," Gauguin wrote, "in which the doctrine announces itself in a symbolic form, presenting a double aspect, a form which first materializes the pure idea in order to make it better understandable . . . this is the literal, superficial, figurative, mysterious meaning of a parable; and then the second aspect which gives the spirit of the former sense. This is the sense that is not figurative any more, but the formal, explicit one of the parable."

In a letter to a painter friend, Émile Schuffenecker, Gauguin described a self-portait he had made for van Gogh at the latter's request and inscribed "les Misérables" (figure 5). Gauguin's image is to the left, placed before a background of large nosegays; in the upper right corner is an inset portrait of Émile Bernard with schematized palette. "I believe it is one of my best efforts," Gauguin wrote, "absolutely incomprehensible (upon my word) so abstract it is. First the head of a brigand, a Jean Valjean, personifying a disreputable impressionist painter likewise burdened forever with a chain for the world. The drawing is altogether peculiar, being complete abstraction. The eyes, the mouth, the nose, are like the flowers of a Persian carpet, thus personifying the symbolic side. The color is color remote from nature; imagine a confused collection of pottery all twisted by the furnace! All the reds and violets streaked by flames, like a furnace burning fiercely, radiating from the eyes, the seat of the painter's mental struggles. The whole on a chrome background sprinkled with childish nosegays. Chamber of a pure young girl. The impressionist is such a one, not yet sullied by the filthy kiss of the Académie des Beaux-Arts."

Seen on another level, beyond surface appearance and signification, the picture takes on an ominous cast. The strange right-left duality is especially evident here, the left side of the face (reversed mirror image) being almost a parody of evil suspicion, with its watchful shrouded eye and hooked nose, while the right side expresses great weariness and

vagueness, a contained sadness. In this context the flower backdrop is open to dual interpretation: as in Baudelaire's *Flowers of Evil* the nose-gays might imply death-in-sensuality, an evanescence which is unholy in the sense that it presupposes the doom and destruction of momentary pleasure even as the pleasure is being enacted—thus implying the fore-knowledge and savoring of sin; following Gauguin's explanation, the flowers would embody the evanescence of the state of innocence and purity, corrupted by the foulness of the Establishment world—a corruption which is essentially a form of rape.

For Gauguin the Savage-Christ duality was not a juxtaposition of opposites. Savagery was sublime, almost hallowed; the Christ-figure was the offspring of the maltreatment of the savage; thus Christ in his state of suffering represented a by-product of civilization, a residue of alienation and pain. The savage was the source not only of creative energy but of active, feeling pain, which brought about a state of endurance further extended in the Christ-figure, who summarized a state of resignation. In *Agony in the Garden* (figure 6) Gauguin as Christ is bent by his sorrow; his head droops, his hands fall listlessly, as if grief has overtaken him and he must give in to it. Behind him is a dead tree whose branch twists strangely back so that it falls horizontally across another branch, forming a cross. In the background Judas points out the victim to a soldier, while, over-all, an unseen force causes trees and grasses to bend to its will as if beneath a great wind. The total mood is one of capitulation to suffering. On the back of a calling card he gave to Aurier, Gauguin wrote, "Christ—special suffering of betrayal, which applies to Jesus today and tomorrow."

In 1889 Gauguin made a self-portrait in which he placed himself before images of the two sides of his nature (figure 7). At his left, behind him, is his canvas *The Yellow Christ;* at the right a self-portrait ceramic in the form of a tobacco pot which vaguely delineates the grotesque face of a savage with his thumb in his half-open mouth. Gauguin's face is turned in three-quarter view toward the right, aligned with the face on the pot; his eyes look out from the canvas, yet he seems aware of the gentle Christ behind his back: "Christ—special suffering of betrayal" coupled with the infant-savage—"the Jesus of today and tomorrow."

Gauguin's desire to return to the purities of the natural life was never to be realized. He was a savage in his art and in his intuitions, but his mentality, his formed character, remained that of an exiled European.

He was capable of acting in the manner of the people he most despised: he went to Tahiti with syphilis, in the classic manner of the European missionary-conqueror who seeks to reform and only contaminates. Unconsciously he continued to revert to the romantic concept of savagery, which glorified as "natural" what modern society perceived as sin. The ritualistic scavenging of the unconscious, the cultivation of dreams and memories, left little space for open, unadulterated emotions and perceptions. Gauguin's ego would never support the thought that the soul's refuse might be less than sacred; his consciousness of his genius led him to cherish all products of his psyche as if they might one day prove fruitful for his art. "My artistic center is in my brain and nowhere else, and I am strong because I make what is in me."

"You will always find nourishment in the primitive arts," he wrote to his daughter; "in the civilized arts I doubt that you will." He felt that he carried modern art's destiny in his own hands: "I created this new movement in painting, and many of the young people who have profited are not devoid of talent, but once more it is I who have shaped them. And nothing in them comes from themselves but through me." His province over his product was total; not satisfied with being an innovator, he demanded the homage due to a Creator-God.

He was concerned always with the "nourishment" of his art, with the renewal of the perceiving faculties. He felt that his own art, upon which devolved the fate of the modern movement, must continue to grow, to receive new stimuli which would allow it to advance in its exploratory journey into the primitive world. In his more personal contemplation of Tahiti he was boyishly eager and naïve; the islands loomed before him like a promised land, where he might escape at last the cancerous civilization which was inhibiting the development of his art. He believed that he would escape civilization by declaring his independence from it: "Free at last, without any financial worries, and I shall be able to love, sing, and die."

Like any former bourgeois who has strayed grandly from the path, he wrote, "I have been good sometimes; I do not congratulate myself because of it. I have often been evil; I do not repent it." Yet he was highly sensitive to the gradations of good and evil, and highly moralistic in a basic Biblical sense. After years of living away from his wife and with other women, he was still moved to write her in great seriousness that "the only crime is adultery." He chafed beneath the bonds of imposed

morality, which were to him another form of the unnatural restrictive-
ness of civilization. When he took up with a mistress he looked for the
qualities of openness and simplicity which he attributed to "good"
women; in this, he was following the romantic notion that a character
which has not been inhibited by civilization's taboos will produce only for
the good. Annah, his mulatto mistress during his return visit to France,
was one of his most exotic possessions; while in Brittany, as they were
walking with a party of friends at the port of Concarneau, a group of
urchins jeered and threw stones at the strange entourage, which included
Annah's monkey. In chastising the children, Gauguin's group drew the
wrath of some local fishermen; a battle ensued, in the course of which
Gauguin received a leg injury which never healed. For his gallantry
Annah rewarded him by returning to Paris and pillaging his apartment,
making off with everything except his paintings.

In 1889 Gauguin painted a diabolical self-portrait in which he por-
trayed himself as a Miltonic fallen saint (figure 8). Although he com-
monly associated the concept of the savage with satanism, this rendering
is far more revealing in its symbolic implications. Satan in Milton's *Para-
dise Lost*, after revolting against God in an attempt to control the heav-
enly spheres, has been ejected from heaven forever; in hell he refuses to
despair but marshals the forces of evil in preparation for an assault upon
the Garden of Eden. As Gauguin portrays him, he is surrounded by the
tools of his trade: in his hand is a small snake, held debonairly between
two fingers, which appears, even though separate, to be an offshoot of a
strange curved growth of stalks culminating in square schematic lilies;
above the vine Gauguin's head gazes, with its malevolent expression, as
if to contemplate the snake; a halo circles above the head, and above that
a single leaf which meets the boundary of the canvas; at the right a
branch also extends from the canvas-top, dangling apples, one green,
one red—ripening objects of temptation. The total effect is of an ordered
arrogance. The parts are represented as elements, with no logical narra-
tive setting to join them. Gauguin created a coat of arms of the lower
depths, peopled by insignia of the realm. He appears as its ruler, a magi-
cian-God, crowned by his halo and proffering his scepter-like snake; the
apples represent the instruments of his power and, by implication, the
continued glory of his reign.

At certain levels the Miltonic sense merges with that of Baudelaire.
In *Paradise Lost* Satan takes the form of the serpent, and in his dominion

over the snake Gauguin reigns over the evil in himself. The snake, sharing its supple and spineless nature with the arching lilies, may imply the presence of evil, which is latent even in uncorrupted nature; this concept, embodying foreknowledge of potential corruption, is romantic in its basic origin, and was championed by Baudelaire in *The Flowers of Evil*. (It has been noted that the upper hand, which holds the snake, is paler in color, as though evil were choking the life out of it—but Gauguin's moralism was not of the variety which threatened sickness and death as punishment for sin; he was much too concerned with the naturalness of sin and would have found the whole concept restrictive: if an act delighted him, or beguiled his imagination, he accepted it as fruitful, that is, life-giving and nourishing to his art. Of an illegitimate son he said, "He is pretty—as are all things born of adultery," and proceeded to laud the virtues of love-children, who are amiable, cost little, and cannot legally inherit.)

Gauguin was a savage and a sinner primarily in relation to the life he abandoned, which remained his classic metaphor, his handy vehicle of comparison with his new life; he was never able to abandon it completely. Yet, freed from immediate ties and at last able to possess without responsibility, Gauguin retained an almost mystic fear of the ravages of the life cycle. Like Baudelaire he believed in the inevitability of corruption, in which all natural processes become tainted with intimations of doom. In this syndrome, to make love is to germinate the beginnings of death; to marry is to sell oneself into bondage, to give birth is to suffer the wages of sin. In *Be in Love, You Will Be Happy* Gauguin, portrayed in the upper right corner as an infant monster, is at once the source and the culmination of original sin (figure 84). Just as Gauguin is a figure of instinct, the bound woman is a figure of receptivity as well as submission; the life cycle has been enacted upon her, as if she were made of earth or clay, for her function is to be shaped. Behind her head a carnivorous shape, biting down, seems about to devour her, to satisfy its instinctual need upon her flesh. In the grouping at the bottom right, four flowers grow on a bush; three are upright but the fourth bows low as if dead or broken, resting its head on the woman's knee. Beside them, a girl holds her hands to her face in an attitude of grief and fear: as a classic Baudelairean figure of foredoom, she seems to be contemplating her fate, which was also the woman's fate. She appears to be astride the fox, thus supporting the illusion of abduction, of innocence overtaken and overpowered by lust.

The *Portrait with Halo and Snake* is a drama of temptation; *Be in Love, You Will Be Happy* is a drama of submission and brute force, of capitulation to instinct. Gauguin believed that the instinctual life, Eden-like, embodied within it both paradise and hell, ultimate nourishment and ultimate death. He seemed to regard the genre of temptation as jaded and worldly, less instinct than art. (Eve, in biting the apple, was committing not an act so much as a mannered gesture, when she succumbed to worldly blandishments.)

Exotic Antecedents

GAUGUIN'S ANTECEDENTS were sufficiently exotic to jus-
tify the man he became. His maternal grandmother, Flora Tristan,
was a fiery revolutionary, a woman of single-minded passion and inten-
sity (figure 9). The illegitimate daughter of a poor Frenchwoman and
an aristocratic Spanish colonialist from Peru, she was nurtured on tales
of the grandeur of her origins and the splendor of her Peruvian heritage.
The poverty of the life she shared with her mother accentuated the gap
between what was and what might have been. At seventeen she married a
respectable young lithographer, André Chazal, and was thus "elevated"
to the bourgeoisie; in rapid succession she made him miserable, bore him
one child, and decamped while pregnant with a second. In pursuit of the
elusive fortune which awaited her in her mother's tales, she journeyed to
Peru, where she petitioned her uncle for a portion of her inheritance; he
graciously harbored her but refused to accede to her demands. Upon re-
turning to France she wrote a bitter book about her experiences, which
she titled dramatically *Pilgrimages of a Pariah.*

The years had been more unkind to her husband Chazal, who had
steadily degenerated since Flora had abandoned him; he kidnaped his
daughter Aline, whom he had never seen before, and in a state of semi-
madness attempted to rape her. Flora applied for and won a separa-
tion, spurring Chazel, at a peak of impotent fury, to fire a bullet into her

chest. While the demented man began a sentence of twenty years' imprisonment, Flora found herself a public figure of some notoriety. In the backlash of lurid publicity evoked by the trial her book became a best-seller, and she soon followed it with three others. Gradually she came to visualize herself as a classic victim of society, a pariah, and she threw herself into the role with characteristic intensity. A visit to the London slums made her conscious of the tribulations of the working classes and reinforced her image of herself as an angel of the downtrodden, a missionary of social change. About this time, as if on cue, she underwent an experience which entrenched forever the role she had chosen to play. While visiting Bedlam she was shown a French lunatic who approached her with great fervor, announcing himself as a messenger of God "come to banish all servitude, to enfranchise woman from the slavery imposed on her by man, the poor from the rich, and the soul from the servitude of sin." Never one to be cynical about the visions of others, Flora listened with equanimity as the madman described her as one of the elect, chosen to convey God's message to man.

"'My sister,' he said to me, 'I am going to give you the sign of redemption because I believe you to be worthy of it!' The unfortunate man had a dozen little straw crosses, surrounded with black crepe and a red band, over his heart. Above was written: mourning and blood. He took one and gave it to me saying, 'Take this cross, place it on your breast and go out into the world to proclaim *the new law.*' He knelt on one knee, took my hand and pressed it hard enough to break it, saying, 'My sister, dry your tears, soon the *reign of God* will replace the reign of the devil . . .' I besought him to let go of my hand; he willingly obeyed and prostrated himself on the ground, kissing the hem of my dress and repeating in a voice choked with tears and sobs, 'Oh, woman is the image of the Virgin on earth! And men fail to recognize it! They humiliate her and drag her in the mud!' I made my escape. I too was in tears." [1]

In making the madman's obsession her own, Flora used it to her own purposes. She continued to write sociological tracts and to take part in militant activities, finally conceiving the idea that workers should unite and form a class unto themselves. In April 1844 she set off on a long tour through France, seeking to propagate her philosophies. Operating at a near-hysterical pitch of nerves and energy, she literally burned herself out. In November of that year she died, a heroine to the workers of France and a martyr to her own consuming vision of herself. Her obses-

sional bent was to reappear with eerie genetic accuracy in another form in her grandson Paul Gauguin.

Aline Chazal Gauguin, the link between the two passionate figures of the mother Flora and the son Paul, remains a woman of mystery (figure 10). By all accounts she was quiet and gentle—"as sweet and good as her mother was imperious and hot tempered," George Sand wrote to a friend. "The child looks like an angel; her sorrow, her mourning, her beautiful eyes, and her modest and affectionate manner have touched my heart." [2] Yet Aline endured a harrowing childhood as the pawn of a dominating but careless mother and a maddened, incest-ridden father. Having spent the first part of her life in great insecurity, plagued by two haunting totems, she is not likely to have metamorphosed overnight into a placid domesticated spouse. Her marriage to the journalist Clovis Gauguin was arranged by friends of Flora's, George Sand among them, as a gesture of kindness and convenience to the abandoned girl. If Aline found peace in the union, it was only a temporary respite; in 1849, three years after they were married, Clovis died suddenly aboard a ship bound for Peru. Gauguin's republican sympathies had forced them to leave France when Louis Napoleon Bonaparte came to power; they had hoped to petition support from Aline's elusive Peruvian connections. Now Aline was forced to continue the journey alone with their two small children, Marie and one-year-old Paul.

It is interesting that his father's abrupt death should have been countered for the infant Paul by his introduction to the garish and luxurious atmosphere of Peru. Moved by Aline's desperate situation, the uncle whom Flora had maligned in her first novel gave welcome and shelter to the daughter of his old enemy. Paul's first years of awareness were spent in an aristocratic household, in a world rich with color and voluptuous in its material abundance. A variety of racial types, black, Chinese, and Indian, mingled freely. With his father's death it seemed that the European influence, the world of a well-brought-up French boy of the bourgeoisie, disappeared from his life—eclipsed if not erased. Peru's aura was peculiarly feminine at this time; its prosperity had clouded it in lushness, in an almost tropical air of profligate warmth which suggested that all forms of riches might be acquired as desired. In this fecund environment Aline seemed to come to herself; released at last from economic harassments, Paul's mother radiated her natural charm and became almost powerful in its light. "How gracious and pretty my

mother was when she wore Lima dress!" Gauguin was later to write.

Gauguin always retained the image of his mother in an exotic setting, later he would paint her as Eve in the paradisal garden. He was able to conceptualize her as an independent being whose appeal he could appreciate objectively, whose virtues made him proud. One has the feeling that he showed off his mother as some mothers show off their sons— as a product of undeniable quality, connected by the cleverness of fate to himself. By existing as she was, she made his own character more logical. Perhaps he never knew her completely; her very remoteness, the mask of her mildness, made her a perfect foil for his imagination. Her living presence never interfered with his image of her; even her attempts at discipline seemed only to enhance her gentleness. Gauguin recalled his punishment for playing adult games with a girl cousin: "a few smacks from a little hand as supple as india rubber." In a sense, Aline's remoteness of spirit permitted her son's aloofness to flourish. It was not lack of love which characterized their relationship but lack of intimacy: a model relationship rather than an animal one. In Gauguin's memory Aline would be enshrined, madonna-like, in her Peruvian costume, a hooded coat which covered the head in Biblical fashion and revealed only one eye—"so kind, so imperious, so pure and so caressing!" as it looked out upon her son.

Aline returned to France with her children in 1855 at the request of her dying father-in-law. In another polar reversal, Paul's golden tropical world dissolved into the gray and pallid environment of Orléans, where mundane concerns were the substance of life and pleasure was only incidental. Speaking mostly Spanish and inclined to wildness, he was now forced to go to school with shopkeepers' sons and submit to the regimentation of mass discipline and regular lessons. His economic circumstances had also changed; no longer would he lead the life of a little rich boy, protected from hurt by the power and affluence of his family. His mother's promised legacies from her father-in-law and her Peruvian great-uncle had failed to materialize, and she was forced to take up her old trade of dressmaking. Deep in worries again, she lost the gaiety which she had worn so briefly and intensely in the tropics. It is striking that Paul's recorded memories of his mother are concentrated almost exclusively on the Peruvian period of their lives; it is as if his conception of Aline was cemented during that era and remained inviolate in his mind for all time. Perhaps the reality of her anxieties, like the reality of his

present life, was an affront to him, an impetus to take refuge in dreams.

Paul was a consistently poor student. To his schoolmates he reacted with a characteristic mixture of haughtiness and insecurity, judging them because he could not join them. He was already established in his singularity and certain of his intelligence; since he barely studied, his masters were unaware of his gifts, or, as he thought, too stupid to perceive them. Had he been more inclined to compromise his nature, he might have formed attachments in this simple mechanical world—he might perhaps never have left it. But his precocious egotism, his overripe sense of self, never permitted him to deviate from his own road, to make allowances for those whose characters were weaker and less defined. "I grew accustomed there to being self-contained, continually watching the behavior of my masters, making my own joys, and also my own griefs, with all the responsibility that entails. . . . As for the rest, I believe it's there that from an early age I learned to hate hypocrisy, false virtues, informing on others (*sempre tres*), and to distrust everything that was contrary to my instincts, my heart, and my reason." In his school life, and now even at home, he visualized himself as an island surrounded on all sides by fools.

The family moved from Orléans to Paris in 1859. Aline's health was failing and her business declined. As Paul grew into late adolescence the question of his future became crucial. His mother did not know what would become of the sullen boy if she were to die. In her own youth her soft charm had moved influential people to help her, but Paul seemed to work purposefully at repelling anyone who showed interest on his behalf; his responses to social overtures alternated between icy indifference and overt rudeness. In her will Aline made special note of the fact that her dear son Paul would be obliged to make his career by himself, for he had made himself so little liked by all her friends that he would find himself totally abandoned.[3] Yet she left to him all her ornamental and aesthetic possessions, as if in acknowledgment of the currents in him which outran those of his prosaic sister: she left him all of her pictures, portraits, books; her watch, chain, and amulets, as well as her grandfather's signet ring.[4] In another sympathetic gesture she designated Gustave Arosa as her children's guardian; a wealthy stockbroker, Arosa was also a liberal and farseeing patron of the arts with a large collection of Peruvian and Oriental artifacts.

When he reached seventeen Paul's formal education came to an

end. He had no ambition beyond a generalized inclination for flight, which he had exercised at least twice as he grew up—once in Peru when he ran off and hid in a grocer's shop, and again in Orléans when at age nine he became enamored of an engraving of a traveler tramping a road with his possessions slung over his shoulder on a stick, and set out on his own journey, his handkerchief full of sand. "I have always had a whim for such flights." Now at last he could fly unimpeded. Placating his mother with visions of an officership, he became an apprentice on a cargo ship as the first step in joining the merchant marine. On his first voyage to Rio de Janeiro he was initiated into sex, first at port in a sailors' brothel, then in Rio at the home of an older woman, an opera singer and courtesan. "The ground was no doubt propitious, for I became very licentious." His second trip lasted a year and took him around the world; the ship stopped at several islands along the way, and he was beguiled by nostalgic echoes of tropical allure. Upon reaching India Gauguin was informed that his mother had died during the summer.[5]

He was to spend a total of five years at sea, becoming at once more solitary and more worldly (figure 11). A sailor's life had been no solace to him; the tantalizing stops at different ports had implanted more longings than they had quieted, and he was left with a sense of continued purposelessness. For all the time and the traveling, he remained undefined and unskilled, his intelligence still a passive force working inward. His singularity had too long taken form as an unfocused intuition, and he was no longer an adolescent for whom intuition was sufficient. He himself had lost sight of what was inside him.

As arranged, he went to stay with Gustave Arosa, who provided a congenial setting for him. Gauguin had begun to sketch while at sea, and now, infected by Arosa's passionate attitude toward painting, he was moved to pursue the hobby. His guardian had found him a post as a stockbroker's agent, and his daytime hours were spent in cafés around the Paris stock exchange, soliciting orders from speculators. After so many years of languishing, his intelligence vaulted to meet the demands of his new position. Up to now his insatiable dreaming had overshadowed the hard practical side of his nature. Now the steadiness of his position seemed to evoke the bourgeois in him: he worked hard, received commendations, and led a life of prudence and regularity. As always, he seemed able to function only in the clutch of extremes—an indulgence in one mode would likely beget an equally rigorous reaction from its oppo-

site. His character remained constant, but his style of life underwent great reversals.

In 1872 Gauguin met a young Danish girl, Mette Sophie Gad, who was acting as chaperon to the daughter of a rich Copenhagen manufacturer. Perhaps he was attracted by her foreignness, which was not so much exotic as textural—she was simply and unaffectedly different from French girls in her manner of presenting herself. Her Scandinavian directness implied disdain for the coy contrivances of young Parisiennes; her very lack of artifice could be interpreted as honesty. Gauguin's serious nature responded to Mette's frankness but also to her formidableness; in person and in character she exuded a solidity which banished doubt, as lesser beings might banish an unruly child from a room. Efficiently she saw through a situation to its solution, and efficiently she acted on her perceptions. Her intelligence took the form of an excess of competence; whatever her circumstances she would always make do. She had a great deal of vitality but almost no passion; yet her youth and her native health and spirit might have insinuated the presence of passion to Gauguin. Having had an unfortunate experience with a naval officer a few years before, she may have been reluctant to allow Gauguin to sample her favors. She regarded herself as a person of quality born to a position of decency, and no doubt she demanded that Gauguin "respect" her as she respected herself. Far from resenting this stance, Gauguin seemed to react positively to it; the bourgeois in him demanded a clear distinction between women to be used for pleasure and women fit to marry. Indeed, he had a great need to regard his wife as upright and pure; Mette's strong character, her very rigidity, seemed to give him confidence in her. Perhaps he saw her as a port to which he might moor himself, at last to find a settled peace; like his mother she would be a pole of security whose presence would calm the turbulence of his thoughts. In a letter to her employer, who had congratulated him on becoming engaged, Gauguin spoke only of her moral qualities: "I am certain that Miss Mette will find many admirers in France, the individuality of her character as well as the loyalty of her sentiments attracting the esteem of everyone, so I consider myself very happy with her choice."

Mette was in turn very happy to have captured Gauguin. Coming from a family of modest means, she had been forced to work as a governess to support herself. The insecurity of her financial position made her open to offers which might ordinarily be considered beneath her station,

but Gauguin's antecedents, as well as his assets, were eminently acceptable to a girl of her class and situation. His success at his job, his sound business sense, boded well for a prosperous future. Mette's weakness was seeing only what she wished to see; her mind traveled a straight line from perception to conclusion, rendering her incapable of understanding a deviant result. She entered into marriage with the idea that she would be able to live out her life in gracious matronhood; in the limits of her vision, Gauguin became an accessory to the fact. Trained from childhood to judge people by externals, to estimate the quality of the goods before purchasing, she probably had no concept of the intricacies of Gauguin's character before marrying him; to seek to know the inner man would have been a matter of unnecessary fuss to her. Yet she was far more shallow than she was cold-blooded; she fully intended to fulfill her part of the bargain by making him an excellent wife. Had he continued to be satisfied with their way of life, he would have found no fault with her.

They were married in 1873 and set up housekeeping in a comfortable Paris flat (figure 12). Gauguin's fortunes continued to rise, and their life together, though insular, was secure. As before, Gauguin had little taste for society; his only friend at the exchange was a clerk and part-time artist named Émile Schuffenecker, with whom he carried on dialogues about painting. All of Gauguin's leisure hours continued to be tied up with this hobby, which no one thought to call an obsession; stockbrokers, it was implied, were not belabored by obsessions. Testing himself, he sent a somber landscape to the Salon of 1876; to his surprise it was accepted. He experimented continually, with an intensity unbecoming to a Sunday painter, seeming at times consumed by his labor and by the questions it evoked. In an effort to broaden his knowledge Gauguin began to associate with other artists; he became the unofficial pupil of the impressionist Camille Pissarro, a dedicated innovationist who lived precariously by his painting alone.

Meanwhile Gauguin's daily life of job and family seemed to travel along by rote. Babies arrived at close intervals, to Mette's chagrin; having established her beachhead, she wished to maintain it in style, and her only consolation for her frequent pregnancies was that Gauguin's means continued to increase. She thought him talented as a painter but marveled at his fervent dedication—yet another idiosyncrasy in this odd man, who found satisfaction in such perverse pursuits. The artist's son Emil remembers his mother's wrath "when on occasions he would use her

best linen tablecloth for canvas or her finest petticoat for paint rags." [6] Gauguin often used Mette and the children as models; in 1877 he made a marble bust of his wife in academic style which elucidated her strong, stolid qualities (figure 13). She is presented very much in the tradition of the Roman matron, with heroic profile and masculinized features.

As the years progressed Gauguin spent more and more time in the company of the radical painters. Always strongly opinionated, he began to develop a philosophy of art which followed the route of the most daring thought of the day. He amassed a sizable collection of impressionist art and by 1882 had acquired works by Manet, Renoir, Cézanne, Pissarro, Sisley, Guillaumin, Jongkind, and Daumier. Through Pissarro he met Cézanne and painted for a while in his company; his admiration for the master emerged, as usual, in terms of mockery: "Has M. Cézanne found the exact formula for a work accepted by everybody? Should he find the recipe for the compression of the exaggerated expression of all his sensations in a single and unique procedure, then please try to make him talk in his sleep by administering one of those mysterious homeopathic drugs, and come to Paris as soon as possible to let us know about it." Having accurately appraised Gauguin's intensity, as well as the curious ruthlessness with which he pursued his goals, Cézanne chose to be offended by the jest; he implied that this upstart was perfectly capable of using foul means to discover "his little sensation." [7] Gauguin aroused distrust and dislike even in those who shared his passions; other artists seemed to sense a hardness in him which clashed with their own vulnerabilities. He was rough where convention and propriety dictated that he might be soft, and few who knew him would have called him a truly sensitive man. Even in his own genre he played the role of iconoclast, unable to apprentice himself to anyone or to subordinate his will in the process of learning.

Gauguin's renegade quality hastened the dissolution of his home life. Mette had no passion for art, but she was sufficiently broad-minded to have an understanding of it, and it was not her husband's choice of profession which finally alienated her. Rather, she could not bear the kind of painter he chose to be; he was no gentleman artist like her brother-in-law Fritz Thaulow, or even the poor journeyman Schuffenecker, who retained a semblance of gentility while placating his muse. Gauguin was a ruffian in his art who was fast losing a sense of balance in regard to real life. Mette's sense of propriety was offended by his complete indifference

to ingratiating himself with the world through compromise. In the early days of their marriage he had burst in upon a gathering of her lady friends wearing only a nightshirt and bade the ladies a cold good evening as he completed his errand; now as then his conduct was unreasonable, but even more frightening to her was his increasing inaccessibility. The verities which continued to support her existence no longer touched his life at all.

Gauguin's ultimate decision to abdicate from business and focus on painting was the inevitable end of a long, wracking process. Mette was a full partner in the decision, and her capitulation to his will honored his intensity even as she lamented it. "His determination was reached after due consultation with my mother," writes Emil Gauguin. "She agreed . . . not because she had faith in his genius but because she respected his passion for art. It was brave of her. It meant that she was to assume the burden of maintaining and educating the children. '*Sale bourgeoise*,' my father called her, but all his life he respected her profoundly." [8] This statement reflects a son's romanticism of the past. It is doubtful that at the outset of Gauguin's venture Mette was prepared to take on the support of the family. Her attitude was that calamity had visited the family and that they must now seek to hold it together in the face of oncoming disaster. Upon her marriage she had had no reason to distrust Gauguin's practical sense or his financial acumen, and now she could only give herself over to his pipe dreams and hope for the best. He had decreed that the family vacate their Paris lodgings and follow him to Rouen, where the wealthy population would surely subscribe to his art. Their departure from Paris in November 1883 marked the tenth year of their marriage. Mette was pregnant with their fifth child.

Rouen brought Gauguin face to face with the rude realities of his act. Far from being the triumphant scene of a new beginning, it provided a backdrop for an enactment of the bitterness which had been building through the past year. Psychologically, the move could not have come at a worse moment for Mette; to be torn from the home which she called "the little hotel" at a time when the birth of her child was imminent must have seemed terribly cruel to her. To be forced to live in reduced circumstances, to abnegate the status she had so proudly achieved in her marriage, would have been hard at any time for a woman of her character. Now the resilient strength which she had demonstrated in the months of argument and decision congealed to anger. Gauguin was not infallible;

the people of Rouen had little interest in patronizing impressionist art, and the problem facing her family was no longer one of life style but of survival. Mette soon convinced her husband that the only course was to go to her childhood home in Copenhagen, where they might at least live decently until they were once again solvent.

Mette's family was studiously respectable and eminently practical. In their eyes Mette returned home bearing the burden of her husband's disgrace. Gauguin was that most vile of beings, an economic failure—and beyond that, a little insane, for his poverty had come upon him not through lack of ability but by choice. They treated him as a criminal because, in the writs of the bourgeoisie, he had committed the ultimate crime in failing to provide for his dependents. Gauguin reacted with a mixture of pain and bitterness for, despite his loathing of his wife's relatives, he felt deep guilt at destroying his family's prospects for his own purposes. Before coming to Denmark he had become the representative of a firm which manufactured canvas cloth; a series of letters dealing with the frustrations of the floundering business reveal the continuing presence of his mercantile streak. He retained the hope that he might preserve his old stability along with his artistic freedom. "Regarding business," he wrote to Schuffenecker, "I am always as at the beginning; I will not see the result, if there is one, for six months. In the meantime I am without a sou, up to my neck in squalor—that's why I console myself in dreaming. Little by little we will manage to pull through; my wife and I give lessons in French; you will laugh, me, lessons in French!"

"We shall extricate ourselves . . ."—Gauguin's wryness takes on the hollow ring of graveyard humor. His business venture, his French lessons, were part of the façade of a life which was, in substance, already dead; all that remained was to acknowledge the fact and allow the pretense to flag. The body of his letter to Schuffenecker is devoted to the explication of his philosophy of painting: "The straight line reaches to infinity, the curve limits creation, without reckoning the fatality in numbers. . . . Colors, although less numerous than lines, are still more telling by virtue of their potent influence on the eye . . . why should not lines and colors reveal also the more or less grand character of the artist? . . . why does not all your Academy, which knows all the methods used by the old masters, paint masterpieces? Because it's impossible to create a nature, an intelligence, a heart. . . . A strong emotion can be translated immediately: dream on it and seek its simplest form." These

are not the ramblings of a dilettante; the evolution of Gauguin's paintings in coming years would bear out the validity of his early verbalizations. In essence, he was already solidifying into the artist he would become.

Poor lodgings, a nagging wife, and a hostile family made Gauguin's tenure in Copenhagen a time of darkness. But beyond and more acute than these immediate difficulties was his alienation from the stimulating environment of an art center. Copenhagen was a mercantile city, a haven for level-headed and right-minded souls whose aim in life was to establish bastions of security and prosperity. The predominating sensibility was attuned to comfort rather than beauty, to the polishing of established norms rather than to the creation of new forms. Gauguin was almost totally cut off from the currents of radicalism and innovation which were rooted in Paris; he maintained a link with that world through his correspondence with Schuffenecker, whose anecdotes of new movements and new talents must have been tantalizing to the isolated painter. In Cophenhagen he had no hope of attaining financial or aesthetic success; an exhibition of his works in May 1885 had been a total failure and closed after five days. Almost paranoiacally he wrote to Schuffenecker of intrigues against him, of favorable reviews suppressed by his academic enemies, of frame-makers who refused to make frames for him for fear of boycott. "Human stupidity is almost as strong as the vanity of mortals!" In fact, a week was the normal length of time for art exhibitions in Copenhagen. Gauguin's response was characteristic; his habit was to impose his own extreme faith in himself upon even the most unpromising situation and then, having met the inevitable defeat, rage against the world for falling short of his visions.

Gauguin left for Paris in the early summer of 1885, taking with him his young son Clovis. His parting from Mette was bitter, and the dregs of bitterness continue to appear in the letters they exchanged throughout the next months. As usual his resources took the form of visions which failed to materialize; privation was his constant companion from the moment he departed from Copenhagen. His old master, the sculptor Bouillot, had no work for him. He charged Mette with the task of marketing his works in Denmark, a function which she readily undertook; she kept the profits of all sales, forcing Gauguin to instruct a friend to give her canvases only on payment of an advance. He again agreed to sell choice items from his impressionist collection, but "the important thing is to push mine," as he wrote his wife. He attempted to re-establish

himself in some subsidiary position on the stock exchange but ended by insulting another businessman and being challenged to a duel; his rival, he was careful to note, "backed out, not wanting to fight an Ishmael like me." When Clovis fell sick with smallpox Gauguin was forced to take a position as a billposter in order to buy proper food and medicines. He flaunted the fact before Mette, ravishing her "Danish self-esteem" once again.

His day-to-day existence in Paris forced him to face depths of physical privation which he had not yet known. Under the strain of circumstances he adopted the mentality of the renegade who despises society yet demands that it support him. His letters to his wife brim with self-pity; he saw himself as a martyr to his self-imposed destiny and perversely chided her for living in comfort while he suffered his meager existence. Do not worry about Clovis, he advised her; the boy was doing quite well on a few pieces of bread a day. And why would she not send them bedding and warm clothes? Obviously she was growing both slothful and malevolent in her soft life. In one letter he renounced his family forever and forgave his wife her sins, implying that her character was only as wretched as the rest of mankind's; in the following letter he acknowledged that, although "love at a distance doesn't cost much," they would be compelled to see each other again in time. He remarked upon a passage in her letter which had referred to suicide and love, but in these expressions he divined no depths of passion; rather, he accused Mette of being, by her own admission, "only a mother and not a wife," and warned her that she must expect him to seek a more complete relationship elsewhere. "You mustn't be surprised if one day, when my position has improved, I find a woman who will be something more to me than a mother." But in the same letter he cautioned her that the only crime is adultery. All through the letter, even in the most contrived and wounding passages, Gauguin's pain is obvious; he felt rejected by his wife, who would not accept him as he had chosen to be, who regarded him as "devoid of all attraction," and in defiance he would seek more than ever to live the image of the man she despised. Like Flora Tristan he had assiduously courted banishment, and once evicted he would play the part of the pariah for all it was worth.

III

Immunization

GAUGUIN'S ENTRANCE into the impressionist arena came after the real action was over. The major battles had been fought and won, and the critics who had egged on the revolutionary combatants from the sideline were now fidgeting out of boredom. The energy of impressionism had been expended in its innovation; as a movement it had created a viable alternative to academic painting and to the heavily laden work of Courbet with its weighty content and dark colors. In eulogizing individual vision and submission to nature it had made the idiosyncratic respectable, had championed the eye's monogram upon subject matter. Yet what came to be known as impressionist subject matter was impeccably placid; the thrust of imposed personality, the power of the conception, reached canvas in diluted form, and by the early 1880s intuitive discoveries had come to be conceptually applied. The charisma of impressionism lay in its faith in intuition; if impressionism was renegade, it was also infectious, with the result that many academic painters had adopted the impressionist brush-stroke and coloring techniques. The very commercialism of the style, its lighthearted subject matter which linked too easily to academic frivolity, and its dearth of contrasts and figure-ground (formal credulity) brought criticism down upon it. A great weight of sensation was expended in the act of seeing, so that the *working out* of conceptual substance had come to be regarded as a man-

nerism, a forced gesture which perverted the spontaneity of original vision. As a result impressionism appeared to lack the solidity of traditional art. Cézanne retired unto himself in 1878 and took again to the museums, and Monet, Pissarro, and Renoir suffered crises as impressionism's lack of substance in both form and content became increasingly apparent, as the long process of intuitive discovery faded out in the light of conceptual imagery and technique. The radicals experienced reversion to a general classicism which was in no way a regression but rather an attempt to fortify the new edifice with enduring materials. Gauguin in 1886, experimenting in order to find his own way, was caught in the flux of mass transition.

Upon returning to Paris Gauguin had begun to re-establish his ties with the neo-impressionists. In May of 1886 he participated in the last exhibition of the Company of Painters, Sculptors, and Engravers (the impressionists) at the Avenue Lafitte, contributing nineteen works, including landscapes from Rouen, Copenhagen, and Normandy, some still lifes, and one sculpture. His work attracted the attention of the critic Felix Fénéon, who, in an article on impressionism, rallied his observations around the polar figures of Degas, Gauguin, and Seurat, whose departures from impressionism were the most marked. Fénéon was impressed by Gauguin's diversity of media and uniqueness of style; he was the first to make note of Gauguin's iconography, which was new in content and insinuating in its mystery. Paradoxically, Gauguin's reaction to this spate of acceptance was to retreat in fear of having his efforts subsumed under a group success—particularly when the loudest acclaim was going to Seurat, whose pointillist style had ensnared even the powerful Pissarro.

Gauguin's frequent fallouts with his peers at this time are symptomatic of his struggle to establish his own style and dictum, to emerge from the melee as a unique artist. He had come to know Seurat well and was one of the first to recognize the import of his work, but unlike Pissarro he refused to acknowledge Seurat as the messiah of the new art. It was difficult for him to deal with his contemporaries on an equal basis— much less do reverence to a younger and more amiable innovator. Typically, a minor incident of personal misunderstanding gave him a chance to disavow the entire neo-impressionist group. The painter Signac had offered him the use of his studio during his absence; Seurat, in ignorance

of this promise, took it upon himself to close the studio. Gauguin's sensitivities flared, and he generalized his anger upon the neo-impressionist group, including the sympathetic Fénéon. In another reversal he aligned himself once again with Degas, whom he alternately denounced and championed.

Gauguin's ego forswore all tendencies to disciplehood; even in his early days of painting he refused to identify with other artists, according those who might have stood as his masters a measure of admiration but never veneration. His motivation was always to solidify the products of his painterly instinct; if he was imitative, it was because his instincts were not yet sufficiently refined. He adhered to styles only as long as they freed him from conventional bonds. His journey through the avant-garde art of the day was ruthless in its course but direct in its destination; he passed from impressionism through neo-impressionism on the way to his own formula for painting, and when the seeds of the school were planted, he would go off to brood on his creation by himself.

The same instinct for self-promulgation caused him to be contemptuous of technique, and as soon as an innovatory process became mechanical he ceased to abide by it. It was technique, or surface style, that held the other members of the neo-impressionist group together, especially those marshaled around Seurat. Though he experienced influences intensely—Pissarro and impressionism in general, Cézanne and Degas—he always ended by disowning the source of his learning. Having taken the giant step of abandoning job and family, he would now abandon anyone who inhibited his progress, any technique which threatened to develop into a stricture.

In fact he consistently rejected any influence or opportunity that might weaken his pledge to suffer martyrdom at the end of an heroic struggle. It was essential to his life process that the battle be sustained with the enemy always in sight—as if his line of vision-ambition would not waver as long as the fact of fight remained constant. He harbored a generalized hostility which fueled his pride, and, in the manner of a perpetual-motion scheme, his pride fed on hostility. He spoke often of the need to harden himself in preparation for the battles into which his art would lead him. The concept of the artist as a martyr persecuted by society was absolutely essential to his character; while admitting that poverty impedes one's intellectual development, he could proudly claim

that suffering "sharpens one's genius." In 1886 he wrote to Mette, "I have become hardened and I no longer have anything but disgust for what has happened in the past."

Aside from being of biographical interest, these qualities of character were essential to the formation of his style. Had he been able to contend with authority, he would have fitted more easily into one or another of the molds that shaped the ongoing art of the eighties. Instead he identified with renegade heroes such as Jean Jacques Rousseau, whom he quoted in his journal in defense of his own cultivated obstinance: "When a man says to me, 'You must,' I rebel. When nature (my nature) says the same thing to me, I compromise; I am defeated." Such statements betoken Gauguin's Son of God phase—immortal giant in a human shell, endowed with fantastic capacities with which his poor earthly self could not grapple.

As his style became more defined, so did his self-image grow—and with it, as a logical evolution, his use of symbolism. The creator marveling at the malleability of clay can hardly resist imposing his own form upon it. Gauguin's concept of his divinity, of his power as an artist and as a man apart from other men, resided in his capacity to capitalize on his dreams. As time went on, the earth made less and less of a claim on him: his ties to job and family fell away, and he came to accept his fantasies as his true substance. The imposition of self upon subject was, in Gauguin's case, a manifestation of a personal mythology—the world re-created in his own image.

Gauguin's true break with impressionism came in 1880, when he exhibited, with the impressionists, an imposing canvas that fell outside the circle of impressionism and came dangerously close to academic painting in its intimations of anecdotal symbolism. The painting was of a naked (rather than nude) woman seated on an unmade bed, sewing (figure 14). It had been enthusiastically reviewed by the critic Huysmans, who recognized in Gauguin's portrayal a true representation of a woman of "our day" whose skin was "reddened by blood, under which nerves tremble," who was not posed for the art gallery, who was neither lascivious nor simpering.[1] The painting was composed of homely elements: the model was Mette's maidservant Suzanne; the mandolin is one Gauguin bought for his daughter; the setting is a room in the Gauguin apartment. No special meaning can be attached to the elements of the composition, but one might ask why Gauguin posed the naked woman on

an unmade bed, her face and the front of her body in shadow, her back turned to the prominently displayed mandolin.

Gauguin's stage-managing of this subject departs from the impressionistic styles of the seventies; he implies, in the manner of contemporary academic painting, particular meanings that underlie appearances. The act of sewing carries a heavy weight of conceptual meaning, for sewing was considered an archetypal and primary occupation for a virtuous woman. Gauguin's mother sewed dresses to provide for her son after his father died and her income waned. Customarily a woman took in sewing when she was widowed or abandoned, for it was one of the few honorable ways in which a woman could earn money. Art with the needle is peculiarly feminine in that it carries a connotation of both vulnerability and self-protectiveness. It appears throughout the life cycle at ritual moments of woman's life. Sewing keeps the virgin occupied and, in keeping her hands from her body, preserves the innocence of her actions; it is proper for girls to sew in preparation for marriage. For the young girl between life stages, neither child nor woman, whose daily existence is played out in anticipation of transition, sewing whiles away the time as the mind runs free. The motion of sewing—the rhythmic in-and-out of the needle, the ever-present danger of pricking fingers and drawing blood —provides an apt undercurrent to her thoughts. Because it so conveniently allegorizes the marriage act, while retaining all appearances of virtue and respectability, sewing becomes a woman's principal form of sublimation.

Musical instruments similarly hold instinct in abeyance. Gauguin's mandolin motif (a popular element in academic painting) appears again in a still-life study for a painted fan done in Copenhagen in 1885: a young girl, her hair down, grasps the neck of a mandolin, extending it toward a vase of peonies; a seascape of beach, water, and cloud-filled sky composes the backdrop. Gauguin's first use of a mandolin and cut flowers in a vase occurred in a still life of 1883; again, in 1885, he made a still life of a ceramic vase filled with flowers, beneath which a mandolin reposes on its back (figure 15). The mandolin not only echoes the form of the young girl but also defines her state of idyllic innocence. Playing an instrument, like drawing and sewing, is an activity which occupies the mind and body in a socially acceptable way. In a more general interpretation, the mandolin as a vehicle of music evokes instinct as opposed to intellect. Music, in its characteristic attribute, induces a state of reverie, a

spatiality of feeling which soothes beasts as well as arouses them, which dissipates anxieties even as it evokes potent visions. Gauguin's mandolin is less an instrument of pleasure than an intimation of pleasure.

These evidences of symbolic thinking, which emerged above ground between 1880 and 1886, were the first shoots of the dense growth to come. Isolated and random in their prematurity, they barely saw the light before they were repressed. There was no place for them yet in Gauguin's artistic outlook; he had not developed the skill to deal with his deepest emotions as material for his art, nor did the mundane circumstances of his life at that time lend themselves to translation. Only at moments when the trauma of his environment met the shocked hardening of his perceptions was he able to turn from the impressionist's passive outlook on nature to imagery which involved some transference of his passions. At such times he was not able to sustain a discreet aesthetic distance: the neutrality of the impressionists, the solidity of Cézanne, the restraints of an intellectual process such as neo-impressionism—all fell before the armed cavalry of his fuming instincts.

It was in Denmark, where his familial conflict was most intense and where the stolid Danes looked upon his avocation of painting as the grossest eccentricity, that Gauguin first struck his symbolist vein in a painting as a whole. In this atmosphere he painted a still life of a Danish interior in which onions and dead moorhens are strewn about the table in the foreground, while shadowy and mordant silhouettes of Mette's family loom in the back, formidable in their very facelessness (figure 16). Behind them, an open curtain gives evidence of outside light, but the interior remains dark and dead. Like the artifacts of dead nature on the table, the inhabitants of the house are spiritually dead—and death-dealing in their very lack of life.[2] Gauguin, who felt victimized by them, was now intuitively attuned to a symbolic vocabulary which would express the bitter parallel. Perhaps he saw himself in the image of dead birds placed at random on the table; in his rejection of the orderly processes of society he may have identified randomness with man's true nature as expressed in instinctual drives. The structured world of his in-laws, like the ordered ghostlike group in the background, would have primed the contrast in his mind. The painting functions as a kind of *memento mori* to his black tenure in Copenhagen, with the central motif of the table serving double function as an altar upon which the offerings of dead wildlife are displayed.

One of Gauguin's earliest creations of a frankly symbolic nature was made, fittingly enough, while he was living through the abyss of Copenhagen. This was a jewel box he carved as a double-edged present for his wife, employing the theme of Death and Vanitas (figure 17). Cruelly motivated, perhaps answering her own cruelties, he based the general design on a Bronze Age Danish warrior coffin containing a mummy (figure 19).[3] The outside of the box is decorated with copies of Degas's dancers and of Oriental theatrical masks; carved on the inside is a strange figure of an ambiguously sexed youth arranged in essentially the same position as the mummy in the coffin (figure 18). Set between the flower-like hinges are netsuke figures, Japanese theater masks carved in wood. On the top of the box a mysterious drama is enacted: two dancing girls in tutus emerge from a curtain; one looks over her shoulder at a matronly figure who holds up her hand in a stop-gesture; a stage flat separates her from the head of an old man who peers around it, bulbous-nosed, walrus-mustached, as if to catch a glimpse of the dancing girls (he is the old man who appears often in Degas's paintings of ballet rehearsals); behind him sits the figure of an older woman with breasts rendered as rounded protuberances as if in mockery of babies' heads at the maternal bosom; behind her, scattered casually before another ornate stage flat, are a number of round pumpkin-like objects which appear to be schematized heads. The woman's ritualistic pose and grotesque face, together with the disembodied heads around her, recall the Hindu deity Kali, whose attributes are weapons, jewelry, and severed male heads often worn as a necklace. Kali is usually depicted with the corpse of her husband-son-lover, whom she has killed, stretched out full length on his back at her feet as she holds a necklace over his head. In Gauguin's interpretation the dead male (husband-son-lover) is placed on the bottom of the box; his death underlies vanity.

Kali, though an interesting speculation, may not have been lurking in Gauguin's mind at this time. Themes that link death and vanity have long traditions in Western art, dating back to the late Middle Ages. Persistently popular among academic painters of the nineteenth century, and also strongly resurgent in *art nouveau*, such themes seem to be fundamental elements of the male psyche. Objects of female vanity are lures, and to be lured is to risk capture and death. Gauguin created the jewel box as a vessel of vanity, both in its function as a container of decorative items and in its motifs, which center around the theme of theatrical life.

In this context the jewel box becomes a coffin, suggesting that female vanity is the cause of man's ultimate death. Like Pandora's box, the age-old symbol of female genitalia, Gauguin's vanity coffin contains the worldly evils.

In creating this morbid gift for his wife Gauguin was no doubt acting out his bitterness toward her and toward women in general. Yet the motifs juxtaposed on the jewel box are oddly ambiguous, as if his condemnation of female vanity was also a warning of the dangers of licentiousness. The woman with upraised hand is blocking the young girls from woman's fate—in the form of the lusting, leering old man and the matronly figure with gross breasts. But Gauguin's sympathy for the dancing girls was tainted with contempt. In an age when theatrical life was not respectable, when actresses were considered amoral, the theme of the young ballerina being liberally "entertained" by a wealthy old man was a common one. The dancing girls were nicknamed "rats," and paintings of them attacking rich old men, by Rops, Forain, and other artists, were among the more popular of sub-art themes. Years later Gauguin verbalized his, and perhaps also Degas's, feelings about the ballet "rats": "And to go out at night, to relax from a day at the Opéra. There, Degas said to himself, all is false—the lights, the scenery, the buns of the dancers, their corsets, their smiles. The only truth is the performance— the carcass, the skeleton. . . . Degas' dancers are not women. They are machines in motion . . . arranged like a woman's hat on the rue de la Paix, with the same pretty artificiality. The scenery is not landscape; it is decor."

In opposing the young girls with the leering old man and the death image of the old woman, Gauguin evoked an idea that was to become the essential theme in the whole of his symbolic imagery: the wages of sin is aging and death. The ultimate fate of the young girl who succumbs is to lose her birthright of beauty and hasten her degeneration. Embodying the drama of the cut flower and the dead birds on the "altar," the bloom and beauty of youth is shadowed by the specter of death.

A few years later, in a revealing letter to Madeleine Bernard, Émile's sister, whom he coveted but dared approach only as a brother, Gaugin urged the girl to "crush all vanity . . . and above all, the vanity of money." This remark takes on special significance in the context of the rest of the letter—a paean to the virtues of sexlessness: "If . . . you want to *be someone* . . . you must consider yourself, like Androgyne,

without sex; by that I mean to say that the soul, the heart, in fact all that is divine, must not be a slave to matter, that is, to the body. But crush *vanity*, which is the hallmark of mediocrity, and above all the vanity of money."

Gauguin's abrupt elevation of the vanity of money to the highest level of sin neatly surfaces the strong association in his mind between sex and money. His constant anxiety over finances, his peripatetic plots to institute a steady income, were perhaps expressive of more deeply felt doubts about his manhood. Sexual worries had come to be confused with monetary concerns. His own failure as a husband and father was always in the forefront of his mind; in the eyes of his wife and her relatives he had failed to fulfill the male role of protector and provider. He once wrote to his wife that, ideally, the woman should be the head of the family, bearing all responsibilities for its maintenance. Although he consistently chided her for materialism, he felt keenly the diminishment of his image within his family circle. In his letters he often returned to the theme that one day his children would have cause to be proud of him, that in his adopted role of artist he would yet prove potent: "All are of my opinion, that art is my business, my capital, the future of my children, the honor of the name I have given them—all things which will be useful to them one day. When they have to make their way in the world, a famous father may prove a valuable asset."

Gauguin grew into symbolism as the elements of his psychological make-up crystallized under economic pressures and became conscious. Receiving no support from the outside world, he reinforced his ego by denying any needs other than freedom. He forced himself to wage battle on all fronts. Lacking strong allies, he rejected alliances; he composed a medley of war cries that could drown out all sighs of defeat. In order to sustain the courage that was essential to abandoning a comfortable existence, a respected profession, and a family—courage that counteracts guilt— Gauguin set about to harden his character; hence he called forth and cultivated the primal energy which generates in times of crisis—and christened it Savagery, as if it were both a natural resource and an acquired attribute, to be turned on at will. His preoccupation with suicide, expressed as early as 1884 in a letter to Pissarro, was more of a safety valve than a threat: if all went wrong, Gauguin kept handy his right to die by his own will. Suicide was his undeniable right and one which could be expressed as sexual power: not only to determine the conduct of

one's life, but whether it should be lived at all. If death is the ultimate state of impotence, then the decision to revoke life is the ultimate antidote to impotence—the power resides in the exercising of choice. Gauguin, in his flaunting of extremities, was immunizing himself against the virus of life by injecting himself with the virus of death.

IV

Terrestrial Imperatives

G AU GU I N W E N T to Brittany in the spring of 1886 in search of both spiritual refreshment and economic relief. The grayness of his life in Paris had begun to affect his art, and he craved a form of aesthetic renewal—a need which was to recur within him spontaneously throughout his lifetime as a painter. No matter what psychological or existential travail afflicted him, he retained this stubborn sense of instinctive artistic health; rather than allow his art to lie fallow, he would create the circumstances for rebirth. In this way he cut off all propensities to create a cliché, to settle upon a style and turn jaded in its clutches. Already the idea of a return to primitivism had taken root in him. He hoped that Brittany would present a panorama of new forms, a new terrain vitalized by strange customs and populated by unfamiliar myths.

Even so, money was the motivating force behind his sojourn; it was as if the reality of the move could only be accomplished under pressure from that sharp spur. The painter Jobbé-Duval, Gauguin's landlord that winter in Paris, had stayed at the pension of Marie-Jeanne Gloanec in Pont-Aven; he told Gauguin of the cheap living conditions there, and of Madame Gloanec herself, who was sympathetic to artists and might give him credit. As warm weather approached Gauguin was primed to leave Paris and his morose winter memories behind. His first session as an independent artist and a free man had been tainted with illness and physical

hardship. Anxiety over money remained a constant refrain in letters to his wife and friends; he eulogized his destitution as he begged their aid —and spared no gall in castigating those who failed to respond. Another recurrent fantasy, his eventual reunion with his family, who had stayed behind in Copenhagen, was always spoken of in conjunction with financial success. They had made it obvious, he implied, that they would accept him on no other terms.

In spite of his privation and fallouts with his Parisian peers, Gauguin persisted in paying court to success, as if it were waiting and ready to capitulate to his embrace at last. The sale of a canvas to the engraver Felix Braquemond for two hundred and fifty francs was regarded as a permanent change of luck. Poverty had only sharpened his desire to regain the economic poise which he felt the world had taken from him; the financial canniness which had made him a prosperous stockbroker was with him still. He was willing to pay the price for his freedom by contriving money schemes, at varying levels of logic and practicability, which would support his painting.

Braquemond also helped brighten Gauguin's financial prospects by introducing him to the ceramist Chaplet, who promised a collaboration. The expectation of earning money from the sale of ceramics renewed Gauguin's spirit; and it seemed a benevolent omen that Chaplet was interested in the technique and styles of Norman and Breton pottery. With Braquemond's money in his pocket Gauguin set off, leaving Clovis stranded in a boarding school, for a summer's stay in Brittany. He had the intention of designing motifs for pottery to be fired in Chaplet's kilns upon his return. The specter of success loomed full-fleshed before him.

Brittany was a ready polarity-of-place, a quick and neat contrast to Paris and Copenhagen. It was tailored to fit his belief that the inhabitants of an unsophisticated society were closer to their original nature; openhearted and generous, they would feel no qualms about helping an itinerant painter in lean times.

Pont-Aven at the time of Gauguin's stay was a small port community of farmers, millers, and fishermen near the mouth of the Aven river about twelve miles from the sea (figures 20–22). Since the eighteenth century its picturesque setting had attracted writers and painters. American artists popularized it in the mid-nineteenth century; during the era of impressionism, when outdoor painting was in vogue, it also attracted great numbers of artists from England, Holland, and Scandinavia. Espe-

cially during the summer the area took on the character of an artists' colony, inhabited by a broad range of mediocre talents and loafers with artistic pretensions, and discouraging (as it would Gauguin) artists of more viable conviction.

On the whole, Brittany appealed to those of romantic bent. Flaubert and DuCamp toured there in the 1850s; in anticipation of the trip they devoted a winter's reading to the local customs, and on their return wrote alternate chapters of a book on this land of dolmens, menhirs, and calvaries. André Gide and Guy de Maupassant visited Brittany in the 1880s. Serious excavations, begun in the seventies near Carnac, not far from Pont-Aven, uncovered relics of Gallic occupancy, including a temple of Venus containing small statuettes of Venus, Minerva, and the Goddess of Maternity, Venus Genetrix. Such echoes of classical antiquity, residing in the neighborhood of the dolmens, added to the mystery of Breton lore and to the enigma of Breton identity. (The language spoken there was as foreign to the French as it was to the English visitor—so that Brittany had no implied or inherited identity beyond its own borders.)

Through the eyes of English travelers one sees the inhabitants of Brittany as relics of an ancient and mysterious age. In 1877 one traveler attempted to rationalize the enigma. "There is so large an element of poetry in the aspect of Western Brittany, and also in the hearts of its people, that it often becomes difficult not to be carried away into the borderland that lies beyond stern fact—a borderland which, if one spoke Breton fluently, one might find to be after all no creation of the fancy. Something mystic and utterly unlike the commonplace of their outward existence seems to gleam out of the long black eyes of these dark silent dwellers on the wild west coast." [1]

Following the pattern of all others who have written about Brittany, the writer focuses on Breton women. He writes of "the clumsy looking, large-featured, coarse faces" that stare from under the faded hoods of the women. Of one native he reports that "she was dressed like the rest of the villagers, and had the same awkwardness, half-savage ways. . . . It was strange not to find a trace of the adroit deftness of the French women in these large-eyed, sad-faced, clumsy village Bretonnes; coquetry and grace seemed equally unknown to them; certainly, as a Frenchman once said, '*Il n'y a pas l'ombre de séduction chez ces femmes.*'" [2]

The country itself seemed timeless and primordial, with the land as

yet half-cultivated and divided into small properties. The fields were lit-
tered with ancient Druidical stones, or dolmens, to which strange powers
accrued. One near Pont-Aven was known as *"La Pierre aux maris
trompés,"* or the stone by which husbands tested the faithfulness of their
wives. These boulders once functioned as sites for serpent worship and
for rituals involving sacrifice; even in Gauguin's day a prominent trait of
the Breton character was a casual yet premeditated cruelty to animals, as
expressed in the crude slaughtering and marketing of beasts. As if to
match the roughness of the countryside, the cruelties of life were overt
and frankly displayed. The Breton scarecrow is a dead, decaying crow
wired by one leg to a forked stick planted in the field. At festivals and
religious ceremonies it was not uncommon to see all manner of deformi-
ties of age and illness paraded unhidden and unashamed. Wrestling was
the national sport, and every *Pardon* and harvest festival was highlighted
by rough displays of brute strength.

Many stories and traditions were collected around the menhirs and
dolmens. The legends persisted into the nineteenth century—Gauguin
is sure to have heard them—and continue to circulate in some areas
today. Primitive aphrodisiac rites were connected with certain menhirs to
which time-honored supernatural powers were ascribed: young girls
massaged their naked bodies against a rock before selecting a husband
from among the eligible young men congregated nearby; a sterile wife
had intercourse with her husband at the foot of a menhir beneath a full
moon; pregnant women rubbed themselves against a certain menhir to
ease labor. The menhirs existed side by side with calvaries, monuments
of medieval Christianity imposed on the daily life of the peasants as re-
minders of Christ's suffering. Nowhere in Europe could one find more
numerous and varied reminders of death—calvaries, ossuaries, *ex votos*
—that, in their abundance, as one nineteenth-century visitor remarked,
"had turned the landscape of Brittany into one vast charnel house." [3]

The peasants of Pont-Aven had adapted themselves to life in a tour-
ist colony. Arrayed in their native costumes, they would hire themselves
out as models for a small fee: ". . . both men and women . . . are
glad to sit for a franc for the greater part of the day." [4] In the general
course of their lives, however, they existed on a primitive level, living
perhaps a shade better than the average Breton in a mud-coated or stuc-
coed stone-walled hovel shared with cows and pigs. Their daily life was
infused with legends of gnomes and witches, with strange rites in which

pagan customs and beliefs mingled with Catholicism to form an exotic alchemy of tradition. The very isolation of the country reinforced and preserved this lingering medievalism, often expressed in extreme distrust of outsiders and in the proud provincialism of the native population. "Nowhere in France are there finer peasantry," claims the English traveler,[5] but nobility of aspect did little to cover the crudities of character which appalled many foreign visitors. It was usual for women to do the heavy work on the farm while the men looked on and gave orders or, as chronicled by an earlier traveler, "lived literally like pigs, lying upon the ground and eating chestnuts boiled in milk." [6] The women were incarnations of Gauguin's fantasy of feminine strength; they ran the homes along with the farms, looking after the family finances and undertaking the most strenuous tasks with inbred assurance: "Women pass busily up and down, carrying heavy loads, some with the white lappets of their caps thrown backward, treading heavily like beasts of burden." [7]

The Pont-Aven women were more gay than their rural sisters, for they partook of the festive summer-colony spirit, but they were as husky and robust as men. Reflecting on a woman who worked at Pont-Aven's Lion d'Or, a traveler in 1879 writes, "She hovered about us like a fairy, attending to our needs in the most delicate way; to outward seeming a ministering angel with pure white wings, but in truth, a drudge, a methodical housewife, massive and hard to the touch. She did the work of three Parisian garçons, walked upstairs unaided with portmanteaus which it would require two men to lift, anywhere out of Brittany. . . ." [8]

Of the three hotels in Pont-Aven the least pretentious was the Pension Gloanec, described by a contemporary traveler as "the true Bohemian home at Pont-Aven." [9] For a minimal monthly payment the guest was entitled to two solid meals a day, a clean, comfortable bedroom, and the ministrations of the motherly Madame Gloanec. In exchange for kindnesses artists had decorated the walls of the inn with samplings of their works, a grace which Gauguin would also offer. At the end of the day the guests would gather about a large table in the room and discuss art late into the evening. Reportedly the indoor discussions were terminated at midnight, when the landlady would order the inmates from the dining room so that she and the maids might set up their cots and retire.

Nearby was the Villa Julia, which housed the more academically oriented artists. Like Madame Gloanec, Mademoiselle Julia cared for her guests with maternal devotion, affording them extensive credit when they

couldn't pay, listening to their boastful arguments and, in private, to their plaintive tales of frustration and ill fortune. Her legend grew, so that she became famous among artists in Paris, London, even in America. Charming stories were told about her, ranging from chronicles of her softhearted tears for floundering neophytes to her roughhouse discipline of rowdy drunks—she was known to have carried a full-grown man outdoors and dumped him into the mud.

Gauguin stood out among the dozens of painters at Pont-Aven, but not as one who had cast off the lineaments of a civilized man. In comparison with his compatriots he appeared almost bourgeois, a pinnacle of painterly gentility, an older man regarding with jaundiced eye the costumes and escapades of the new generation, whose nighttime pranks included painting the village's white chickens, geese, and ducks in impressionist colors. The daughter of the English painter Mortimer Menpes, who spent three years in Brittany, described the artists of Pont-Aven as universally strange and rough and weird: "More like wild beasts they looked than human beings." [10] The artists sported long and unkempt hair and beards, wore old paint-stained suits of corduroy, battered wide-brimmed hats, loose flannel shirts, and coarse wooden shoes stuffed with straw. They were as eccentric in their doctrines as in their dress; Menpes himself (whom Gauguin was to meet three years later) found in Pont-Aven a nest of fledgling artists, each hawking his own wares and trying to edge his nestmate up, over, and out. Cults proliferated, and the conflict generated far outshone all effort expended in the service of art. One group, called the stripists (these would qualify as impressionists), painted in stripes with vivid color, as nearly prismatic as possible; there were also the dottists (pointillists in Seurat's wake, no doubt), who painted in a series of dots, and the spottists, a sect of the dottists, whose differentiation from the mother group was too subtle for Menpes to understand. He discovered men who held the theory that in order to create a masterpiece one must ruin one's digestion—no physically healthy person, these zealots declared, could hope to do fine work. Many of them fostered an addiction to absinthe and painted only when drunk; one painter, who specialized in pure saints in blue dresses, bathed his face in ether to bring on the essential spiritual state. Finally there were the primitives, whose distinctive mark was a New Zealand Maori walking stick, carried to give them inspiration. "So powerful was the influence of these sticks," Menpes's daughter wrote, "that even the head of a Breton peasant as-

sumed the rugged aspect of the primitive carvings in their paintings." [11]

These colorful accounts of the painters working in Pont-Aven point up Gauguin's singularity in the artistic milieu. The most complete description of Gauguin at this time is given by the Scottish painter A. S. Hartrick: "Tall, dark-haired and swarthy of skin, heavy of eyelid, and with handsome features, all combined with a powerful figure, Gauguin was indeed a fine figure of a man. . . . He dressed like a Breton fisherman in a blue jersey and wore a beret jauntily at the side of his head. His general appearance, walk and all, was rather that of a Biscayan skipper of a coastal schooner; nothing could be further from madness or decadence. Almost dour, though he could unbend and be quite charming when he liked." [12]

At the Pension Gloanec Gauguin's art created an immediate stir. He noted in a letter that the American painters staying at the inn were particularly receptive to his painting. In a short time he came to be known as a leader and an innovator, although at this stage of his career he tended to regard the attentions of young potential disciples as a drain on his time and energy. But his ego, which had taken a beating during the demeaning months in Paris, was in sore need of bolstering. Shortly after arriving he could write to his wife: "People respect me as the best painter in Pont-Aven; it's true that this doesn't make me a penny richer, but perhaps it foretells the future. At any rate it gives me a respectable reputation, and everyone here (Americans, English, Swedes, French) quarrels for my advice, which I am silly to give because people make use of us without due recognition."

Gauguin's claim was no empty boast. Hartrick records a supporting incident: "When Gauguin arrived, a Dutch painter called V———, who had been awarded a medal at the Salon and seemed particularly pleased with himself as he flaunted about the streets of Pont-Aven in a green velvet Rembrandt-like beret, had a pupil called P———. And one morning when Gauguin was returning to luncheon, V———, who was holding forth to a group in the doorway of the inn, tried to raise a laugh at the 'Impressionist's' expense. He asked him why on earth he daubed his canvases with such crude colors. Gauguin contented himself with an angry glance and walked past V——— without replying. A fortnight later P——— abandoned V——— and became Gauguin's pupil, and then the Dutchman kept asking P——— for information, since he also wanted to benefit from the precious lessons." [13]

Gauguin's successes resounded in Paris, where they reached the ears of his mentor-foe Pissarro, who passed on his own translation of the news: "I have heard that at the seaside this summer Gauguin pontificated and was followed by a train of young men who listened to the master, the austere heretic."

Among the train of disciples at Pont-Aven that summer was the aspiring young painter Émile Bernard, a former student, along with Toulouse-Lautrec and Vincent van Gogh, of the academic painter Cormon. Still in his teens, Bernard could already wear the renegade's badge of honor, for Cormon had dismissed him on the charge that he had been seduced by impressionism. Bernard came to Gauguin through Émile Schuffenecker, whom he had met while on a walking tour of Brittany. Schuffenecker, who was painting at Concarneau in sanctuary from his virago wife, knew that Gauguin was in nearby Pont-Aven but had refused to join him, partly because he preferred a more urban environment but also in self-protection—he was painting in the pointillist technique that Gauguin abhorred, and he knew enough to keep out of reach of Gauguin's biting tongue and lacerating eye. Schuffenecker nevertheless advised Bernard to look up Gauguin, and to help ease the introduction he gave Bernard his card with a note of recommendation.

Bernard arrived in Pont-Aven in mid-August. Gauguin received him coldly, probably because Bernard openly admired Seurat and was painting in the pointillist style. Although the neophyte was to describe this first meeting as "a bad reception," and Gauguin as "stubborn" and "mocking," he was nevertheless impressed by the older artist. Shortly after the meeting he wrote to his parents that he had found Gauguin a very talented man who drew and painted well.[14]

Brittany was at best a summertime Eden, a deciduous paradise. The artists in residence were flushed from the countryside by the first blast of winter; like migrant birds they flocked back to Paris—their winter nesting, breeding, and hunting ground—to their wives and children, academies, cafés, coteries. Paris in the winter was also the marketplace for art. As if brought in from summer pasture, the artist's products would go to the official Salon—the stockyard of the art world—or to the circle of private galleries where themes from Brittany would be weighed against those from Provence, Normandy, the Juras—or those of Egypt, Sicily, Greece, or North Africa, painted in Paris by artists who basked in an imaginary Mediterranean sun.

Gauguin returned to Paris reluctantly, only in mid-November when it seemed he could no longer survive financially. While in Brittany he had sold nothing of his own production of paintings and pottery. Now in Paris, even those few who were intrigued by Gauguin's work were not prepared to back their curiosity with hard cash. Gauguin was reduced to selling a picture by the proto-impressionist Jongkind for a sum sufficient to meet minimal needs and the arrears on Clovis's board. Reunion with his family was out of the question as, economically and physically, the Parisian winter renewed the agonies of the previous siege. The business arrangement with Chaplet had aborted; Gauguin could find no steady employment, though there is some evidence that he taught briefly at the Académie Vitti in Montparnasse.

The familiar mirage of a place in the sun shone through the harsh realities of the season; Gauguin's obsession to activate his dream took hold of him once again. With a painter friend from Pont-Aven, Charles Laval, he formulated plans to go to Panama, where he hoped to partake of the twin advantages of a tropical climate and his brother-in-law's business connections. In April 1887 he announced his plan to his wife: "By a vessel sailing on the tenth of next month I embark for America. I cannot go on any longer living this wearisome and enervating life, and I want to put all to the test in order to have a clear conscience."

The voyage was impulsively undertaken and ill-planned. Gauguin and Laval stopped in Martinique, which Gauguin immediately spotted as a congenial tropical paradise, and went on to Panama, where both were miserable. His brother-in-law's reception was cold, and no place was found for the artists in his business, which involved the importation and sale of workmen's tools and supplies. In order to earn money to get back to Martinique, Laval undertook portrait painting. Commissions were plentiful, according to Gauguin, but professional pride prevented him from becoming commercial; he preferred manual labor on the Panama Canal. There was no way to settle down and make the best of his misfortune: the canal operation had destroyed the landscape while disrupting the native way of life. Gauguin reported on the alarming mortality rate of the canal laborers, perhaps partly to impress Mette with the courage he had summoned to overcome his financial plight while simultaneously protecting his stature as a serious artist.

The pair were finally able to return to Martinique, where they were beset by new misfortunes. Laval caught yellow fever and attempted sui-

cide in the throes of delirium, and Gauguin suffered from malaria and dysentery, describing himself as having reached a state so low that he expected to die every night. Unable to work, he was barely able to pay his doctor's bills, and his only potential source of income was his pottery, which at this point had begun to sell in Paris.

With no news from his wife for months, he was filled with anxiety about her and the children, for even at this stage of his alienation Gauguin retained fantasies of reunion with his family. "I hope to see you here one day with the children," he wrote Mette; "don't be alarmed, there are schools in Martinique and Europeans are treasured like white black-birds." Later on, in the aftermath of sickness, he wrote to her that "we can expect nothing good when the family is broken up." Half jokingly he warned Mette of the "Potiphar's wives" who attempted to seduce him, recalling one who squeezed a fruit on her breast and then gave it to him in hope of bewitching him. But he intended to remain faithful: "Now that I am warned I will not fall and you can sleep soundly, assured of my virtue."

His assurance of virtue may not have been based entirely on consid-erations of marital honor: the black women of Martinique may have ap-pealed to him more as models than as love objects. His attraction to women of exotic cultures was in keeping with his fantasized taste for the primordial; rarely in his life did he allow his fantasy to reach logical extremes, preferring to consort with mulattoes and Europeanized half-castes rather than pure-blooded blacks. The first woman he lived with in Tahiti was a half-caste prostitute who dressed in ball gowns and hats trimmed with artificial flowers.

His verbal descriptions of the Potiphar's wives, no doubt embel-lished for Mette's watchful eye, did not jibe with his painted rendi-tions of Martiniquan womanhood. On the whole they are not sympa-thetic portrayals. Gauguin's blunt honesty prevented an idealization of the reality he encountered, and he painted no visual propaganda to sup-port his claim that inhabitants of tropical lands are spiritually beautiful because unburdened by sin. In fact a degree of contemptuous humor marks two zincographs of 1889 that Gauguin based on Martiniquan themes (figures 24 and 25). In one the mannered contours of two native women are reiterated in the contours of a she-goat suckling her kid. The other contrasts a row of women with loads on their heads with others lazily seated on the ground, feeding their faces with one hand while mas-

saging a bare foot with the other—just as locusts rub their appendages together to make a sound. Gauguin's title *The Grasshoppers and the Ants* is borrowed from La Fontaine's fable, which opposes those who are idle with those who scurry about gathering food for lean times. The theme seems out of key with Gauguin's preconception of Martinique as a paradise where food is always within arm's reach. The imagery is a recollection of his visit, but it harks back with a tone of validity.

La Fontaine's fable played an inadvertent part in the acclimatization of newly arrived slaves, who, before being given to their owners, were taught rudimentary French (or patois Creole) as part of a course of instruction in "civilized" behavior. The French grammar was often capsulized in moralizing tales, primed to infiltrate the savage mentality with European virtues in a painless and insinuating manner; "The Grasshoppers and the Ants" was a favorite selection, for it advertised the virtues of hard labor. Gauguin was probably made aware of this practice through a book by a French traveler, *Souvenirs de la Martinique et du Mexique*, in which La Fontaine's fable is mentioned as an instructional, moralizing tool for elevating the savage to "the first level of civilization." He quotes it in both French and *le patois creole*:

La Cigale et la Fourmi

Une cigale il y avait,	*Y on cigale ye te tini*
Qui toujours chantait.	*Qui toujou te ka chante;*
Il y avait une fourmi	*Y te tini yon frommi*
A côté d'elle qui restait.	*Cote li te ka rete.*
. . . etc.	. . . etc.[15]

In his afterimages of Martinique Gauguin may have fused his direct observation with material from travelogues. Books on life in the French colonies were popular in the 1880s. Those concerning Martinique dwell on the exotic colors in the jungle landscape, the finely shaped Creole carrier-girls, and the dangerously enigmatic coolie half-breed women. Gauguin's on-the-spot paintings represent country life as lived by either the half-breed Creole or the pure Negro, rather than the white Creole or the coolie; the ceramics and wood carvings he was to make on returning to Paris touch on different aspects of Martiniquan life and lore.

Charles Chassé, an early commentator on Gauguin and his circle at Pont-Aven, cites Marie Henry's recollection that, among several wood

reliefs carved by Gauguin at Le Pouldu, one represented Martiniquan Negro women and was patterned after the foreground figures in the zincograph *The Grasshoppers and the Ants* (figure 28).[16] Added to the composition are certain images that extend the fable into a mystery: at the left a childlike figure ornamented with flowers, at the right a woman's head in profile set abruptly in the background in the manner of an apparition—a Martiniquan zombie.

In choosing between the "grasshoppers" and the "ants" Gauguin—not surprisingly—aligned his interest with the exhausted women. He might well have elaborated a certain decorativeness in his current style by devoting his attention to the carrier-woman, the lightly built, incredibly graceful *porteuse*, whose economy of motion, expressed in a lithe swift gait, allowed her to walk up to fifty miles a day under a head-load of as much as one hundred and fifty pounds (figure 27). The carriage of these Creole girls would seem to invite a style of sinuous contours undulating in response to sustained motion, but Gauguin preferred static poses which, in Martinique, became synonymous with spent women, and also with his own state of exhaustion. (When in Tahiti Gauguin applied La Fontaine's fable quite literally to himself, he cast his lot with the grasshoppers while chiding the ants for not sharing their hoard.)

It eventually became essential for Gauguin to leave Martinique, where the climate sapped his strength and retarded recovery from persistent illness. In his extremity Gauguin wrote to Schuffenecker, begging him to find a way to forage enough money for the passage back to France: "Sell forty of the pictures at fifty francs each, everything I possess at any price. . . . I must get out of here, otherwise I shall die like a dog." In the end he signed up as a deckhand to the master of a sailing ship and arrived in France in November 1887. The faithful Schuffenecker offered him a room in his own house, overlooking for the moment the considerable debts Gauguin owed him. Gauguin's decision to return home had been bolstered by the possibility of a real partnership with Chaplet, to be financed by an enthusiastic patron, but unfortunately by the time he got back Chaplet had leased his business and was in the process of establishing new ovens elsewhere; moreover, both Chaplet and his lessee were busy preparing a major exhibition and had no time for Gauguin. Gauguin's chances of emerging from debt and becoming independent again were diminished.

He did, however, have some valid reason to be hopeful about the

impact of his art. During his stay in Martinique the art dealer Théo van Gogh, Vincent's brother, had become interested in Gauguin's works. In January Théo organized a small exhibition of Gauguin's works at Boussod and Valadon's, in company with works by Pissarro and Guillaumin. Gauguin's contributions included pictures and ceramics from Martinique, which engendered some favorable comment in art circles. Bernard wrote of the "high poetry" of Gauguin's Martiniquan Negresses. In *La Revue indépendante* Fénéon commented in favorable tone on the ceramics: "stoneware, spurned by all, funereal and hard, he loves it; haggard faces, with broad brows, with smallest eyes half-closed, with flattened nose—two vases; a third: head of a royal ancient, some Atahualpa whom one robs of his possessions, his mouth torn into an abyss; two others of an abnormal and cloddish geometry." [17] Although evocative of Gauguin's Martiniquan impressions, the pottery had been made in Paris and finally fired in Chaplet's kiln through the latter's generosity. The paintings, however, had been brought from Martinique—about a dozen, according to Gauguin, who singled out four of them as displaying figures far superior to those from his Pont-Aven period.

Through good fortune and bad, Gauguin's courage remained a match for his despair. The slightest encouragement was received as payment from an indebted god—predestined but long overdue. While bemoaning his present plight in a letter to Mette, Gauguin added, "Although it may be difficult, it is not impossible that one day I will be in the position that I deserve."

Deciduous Paradise

G A U G U I N'S S Y M B O L I S M had remained nebulous during his first period at Pont-Aven in 1886; the principal themes had not yet achieved focus but hovered like dreamscapes over everything he did. His work at that time, almost antidramatic in tone, falls into the broad category of romantic naturalism. The naturalist's mild pastoral mode was more suited to his kind of symbolic intuition than the contrived theatrics of the realist tradition, which hunted down essentials and epitomes, pinned them to precise moments in time, and ruthlessly rendered them in the most literal of symbols. In the hands of a realist Eve's legend would be told in turning points; we would see her by the tree, with the snake, reaching for the apple; or at the moment of expulsion, in active anguish. Gauguin's dream-Eve, to the contrary, lived out her first incarnation in a state of simple waiting; her attitude is pastoral, uninvolved; the setting of the wait is open nature. The biding Eve is an esoteric object to be viewed from a distance; she has not declared herself, and so she eludes definition.

The passage of time as compressed in a charismatic moment is a tenet of the realistic school. The problem which confronts the realist is how to make the moment tell. Most frequently—because most readily grasped—a solution is achieved by the use of polarities, by the studied confrontation of the old with the new, the strong with the weak. In this

spirit Courbet paints a boat in a storm, submitting helplessly to the power of sky and sea—thus contrasting not only the fragility of the boat with the might of a more potent force, but also the weakness of manmade objects and enterprises with the unwilled whims of nature. A subject matter based on strong contrasts is romantic in a theatrical rather than a pictorial sense; to point his moral the artist will use his armory of dramatic devices so that the audience will be lulled into accepting his focus, reading his meaning. He will set the stage with eye-catching specifics which command the viewer's attention; he will fit the incident of highest action into the most precise moment in time. The rendered moment thus becomes eternal not in its duration but in the force of its reverberations. The artist has *contrived* to capture it, has canceled its happenstance so that its peculiarity is spotlighted and rendered significant. The empathy of the artist goes out to the subject matter and is echoed in the viewer's response which is, in turn, echoed in time—the repeated striking of a single nerve.

Temporal concepts are equally basic to the romantic naturalism practiced by Gauguin, but the moment bears much less weight. In selecting his subject matter Gauguin consistently chose themes that were both universal and diffused in time. The climactic moment did not concern him; he was drawn to the ongoing process of time, the orderly and even procession of events which take shape in time but are not defined by it. In his treatment of the figure in the landscape he held to the impressionistic method of diffracting the object in a field so that it is undifferentiated from the space around it—a deliberate blurring of visual boundaries which permits the viewer to digest the experience whole, as if space and time were moving before his eyes. The naturalist landscape is generalized and undefined, the objects within it caught *in passing*. This very vagueness renders the elements eternal: they cannot be located in time; neither can they be stopped. Ongoing, they extend eternally.

Each school of eternity has its appropriate residence. The naturalist Hereafter is a standard heaven, stretched horizontally across the skies—an experience in duration. Idyllic scenes abound, in which men and women work on and on at simple tasks, effortlessly, without strain, as if the task were a form of mind-wandering extended to the muscles. The glory of it all lies in the continuation.

The realist Hereafter is vertical—an experience not in duration but in depth, leading to the lower regions. The subject matter deals with

intensities of experience in an attempt to maintain a pitch of constant awareness—the inmates of hell, burned and tormented without relief, are forcibly bound to the highest level of awareness, their every moment etched in flames and reiterated on their flesh. The realistic artist lays his empathy on the line and courts the viewer's sympathetic response; thus his themes often deal with violence and suffering, in varying degrees of subtlety. Manet paints *The Execution of Maximilian* at the very moment of execution, so that we see the guns smoke and the head of the victim rear back with the shock of the bullets. The moment registers and reverberates with equal force in Millet's *Man with a Hoe*, in which the stance and expression of the worker pausing to rest from his labors give a spiraling sense of the plight of all such men. The moment of pause is weighted with the physical and emotional residue of labor. The frozen figure becomes aggressive by virtue of the intensity of concentration placed upon it, as if it were a visual monologue exercising the timbre of its muteness.

The naturalist eternity found its most hospitable haven in themes of the Golden Age. Ancient Greece in the eyes of a nineteenth-century romantic languished across time like Lady Eden, unthreatened by the Fall. The primary quality of this most romantic of pastures was its balance. Activity took the form of a ballet of stylized gestures, each incumbent being assigned his fated task, his ritualized share in life. The population was composed of graces of both sexes and varied ages—but sex and age were treated as functions rather than as states of being. A woman lived out her woman's role into eternity; an aged man disseminated wisdom for all time. Sensuality was a concomitant of the flesh and existed as a natural fact, impersonal and without voluptuousness, as free of the levels of passion as it was of the shadow of mortality. Sex was fixed, without interplay, and so became androgynous; age was fixed, and so became immortal. In Puvis de Chavannes's renderings of Golden Age themes, muscular women work alongside the men, as if Adam's rib had emancipated itself without declaring its independence. Periods of labor were balanced by periods of rest. The motivation to labor was not the maintenance of existence—for fruit grew from the trees for the picking—but rather the continuance of the orderly pattern of life.

Gauguin's idealized naturalism may have received its primary inspiration from Puvis de Chavannes, but it took a very different direction. Puvis's work was founded upon a displacement in time. He took the Golden Age as gospel, rendering it in the purity of its basic themes,

unadulterated by the influence of succeeding eras. He was content to build his world of fantasy on canvas, to remove from it all evidences of the present day, of localized time and place; it was a dream refuge made of dreams. Mythology and the literature of antiquity provided his subject matter. Gauguin required a more substantial Eden, one which would offer a live texture to quiet his cravings. Puvis's wrestling boys, testing their strength before a circle of garlanded girls in some classical time, became Gauguin's paired Bretons wrestling beside a stream (figures 29 and 30).

In order to sustain his illusion of Eden, Gauguin sought geographical displacement in Brittany—an environment in which he turned out to have no real involvement. Still, he could feel free to play his theme off it, could reconceive it as he wished it to be. Removed from it, he could not only impose structure upon it but could see it *as* structure: a society in microcosm composed of essentials and absolutes, sorted and examined by his selective eye. Essentials once achieved, Gauguin could then elaborate upon them, give form to his fantasies of exoticism. Similar motivations had driven Corot to Italy, Delacroix to Algeria—each beguiled by *specters* of tangibility, fleshed ghost towns which implored his habitation. The primal nature of the quest took form in the urge to defile virgin territory with one's fantasies, to perform Pygmalion's mission on a body of mute material which yielded its potentialities to the touch. The artist's vision would operate within the chosen landscape like the worm within the apple, ingesting native substance until it became his own, its pure form adhering to his fantasy.

Brittany proved eminently hospitable to Gauguin's wiles. Puvis's landscapes were peopled by props, but Gauguin sought flesh-and-blood subjects. The feminine population of Brittany was both earthy and un-differentiated, the women possessing a shared character which took form in a sort of animal nature, the result of centuries of ritualized response to an established role. Thus Gauguin was able to present his concept of woman's life with consistency, uninhibited by the sheer variety of types encountered in Paris. A postscript to his motivations may have been the knowledge that his intimate subject matter would be judged not by po-tential subjects—for the unsophisticated Bretons did not identify with the art they inspired—but by his fellow artists, who would be more likely to accept it on a basis of aesthetic merit than to challenge its content.

Puvis's pristine classical theme may have given Gauguin a meta-

phor, but it could prove no model for a fleshly paradise: to add substance to his Eden Gauguin turned to the tradition of rustic naturalism practiced by Pissarro and perhaps epitomized in the work of Millet. Here also the ideal was man's harmony with the earth, but in Millet's perspective life was a great deal more than a game of musical tasks. His laborers were akin to the earth, if not *of* it; in allegorizing the relationship of man to labor he painted a moral about the toll that *earthly* existence takes of man. His sowers and gleaners, frozen in ritual poses, expound a transcendent symbolism which takes them beyond their bodies, beyond their tasks, into a union with the very earth that drains them. If they are creatures which live upon the earth they are also deities which see that it keeps rolling and renewing.

Gauguin imposes an anonymity upon his figures, looses them at random within large landscapes. He makes use of symbolic equivalents rather than transcendents: his goosegirls and shepherdesses comprise a species which inhabits the earth—as animals (figures 31 and 33). Millet's subjects labor in the manner of beasts, but Gauguin's are indistinguishable from the beasts. The burdened Breton female elicited no sympathy from Gauguin, who chose with delight and some leering to render her at her natural task. The moral outrage which motivated Millet's and Courbet's social awareness is replaced, in Gauguin, with a tone of sly insinuation which mocks the comportment of Eve herself. The woman might as well be a cow or a goose; visually or philosophically, it's all the same.

If Gauguin's goosegirls were stamped with cynicism, it is also true that they did not bear that stigma alone. Even the high-minded Millet was not above the drawing of equations between girls and geese, as in *Bather with Geese*, in which a goose extending its neck to drink from a stream parallels the young bather who extends her leg to test the temperature of the water (figure 32). Pissarro, with whom Gauguin had stayed at Osny in 1883, had painted countless *Gardeuses d'oies*—and Gauguin borrowed liberally from his poses.

The popularity of this theme, which seems in essence insipid, attests to the ulterior preoccupations of that era of Victorian sensibility which revered women as paragons of abstract virtue and despised them for their earthly weaknesses; elevated beyond her capacities, a woman must fall straight from heaven—into the bowels of the earth. Among themselves, men talked of witless, wanton creatures—"silly geese"—

chattering and quacking and preening their feathers until, caught, clipped, stuffed with child, they waddled out their days beneath a weight of domestic tasks. The goose covered a maiden's symbolic strata: *"une oie blanche"* (a white goose) was a euphemism for an innocent young girl, while an unaccompanied "goose" marked a prostitute. In an 1889 magazine article on an animal show at the Palais d'Industrie the accompanying illustration depicted a fashionably dressed lady standing before a double-decker cage containing, in the upper level, a turkey, and in the lower, geese (figure 34). The caption reads, *"Qui se ressemble s'assemble"* [1] (Birds of a feather flock together).

For all its ruinous connotations, the maligned goose roamed the idyllic reaches of the Barbizon landscape in leagues. If its status had not improved, its stamping grounds had at least been expanded; it came to serve as a token character, a sort of mascot to the Golden Age realm, which separated the age of innocence from the post-Fall state of forced labor. It would man its humble station by the one true Fall, useful in its homely solidity, which helped to keep the rendered pasture intact while the thematic cosmos quaked. Pierre Dupont, whose poems reflect the Barbizon concept of woman and the age of labor, defined a popular nineteenth-century concept of woman's domestic role in "La Mère Jeanne":

> I am Mother Jeanne
> and I love all my nurslings,
> my pig, my bull, my donkey,
> cows, chickens, girls, boys,
> turkeys, and I love their songs
> since, being a young peasant,
> I have loved the voice of my finches. [2]

Mère Jeanne is Mother Earth, who sustains those who feed upon her. Her body is diminished even as her dependents are strengthened; she loves those who nourish off her, loves the evolution of her death. In a strange twist to the principle of survival of the fittest, she is the dying species who gives her body willingly so that her flock may thrive.

The Golden Age, as interpreted in Barbizon landscapes, is the twilight zone between temptation and the Fall, between idyllic innocence and forced labor. More purgatory than heaven, it is like a vast waiting room whose inhabitants bide time, or a scale which balances time on one

end and task on the other, and seeks above all to maintain equilibrium. The labor itself is menial and repetitive, its main function being to occupy the laborer, to keep him involved in a simple ongoing process, a state of busy biding. The classic Golden Age task for women was the tending of animals—a duty which allowed the girl to play or relax while she worked, in an extension of a child's amnesty from labor, while at the same time prefiguring her woman's function of tending children. She placated the gods by doing her share to keep the earth moving, but suffered none of the sweats and strains of physical labor. At this point in her life she neither tills the fields nor births the child but performs tasks which intimate and anticipate the serious labor to come. Her Golden Age lies between the realms of girlhood and womanhood, and her golden state is one of *transition*: she sews to prepare for marriage, but also to wean her thoughts from the more dangerous duties which come with marriage; she tends cows, wielding her stick to keep them in line, as she will one day discipline her children. The propriety of domestic responsibility is thus both mocked and maintained, while the burden which accompanies responsibility is put off.

These girls-on-the-brink are the Barbizon equivalent of Eves-before-the-Fall, just as the Golden Age is a variety of Eden, devoted to idyllic labor and underscored by the languor of waiting. The Biblical Eden was more truly a virgin territory than these Golden acres; Eden was deflowered in a single act, a single gesture—the snake rears its ugly head, Eve bites the apple, is summarily doomed—but the Golden Age courts doom with masturbatory rites, masques which simulate the Event while suspending the actors in a state of unreality. The spinners and shepherdesses attempt to carry on for an eternity that feat which Eve renounced in a fatal moment: the placating of God. Yet, in their common identity as paradises, the two realms share a congenital innocence and a conceptual likeness. The Golden Age girls, as natural extensions of the earth, follow the pattern set by Eve in her evolution from Adam's rib as an extension of Adam. Polarities have not yet come into play, nor is one sex alienated from the other. Woman follows her natural pre-Fall function in an era when reproduction is a function of the future: to tend; to maintain earthly existence. God made Eve from Adam's rib, a curved bone which presaged the rounded female form; it is the least important bone in the body, its only function being to provide a supportive structure for the flesh.

Before the Fall Eve had no claim to a separate existence; as Adam's appendage she was obliged to work for the propagation of Adam, and for his continuance. In the same spirit she was obliged to care for the terrain of Eden itself, to keep her house running smooth and inviolate, to maintain the divinely instigated status quo. Adam's relation to the land was simpler and more whole; he was its keeper, his mission being to protect it as an established state, a finished product, a created object. He was himself an object created by God in the image of God—as much God's creature as his creation. Adam's responsibility was to reflect credit upon God, to afford him glory through his being; but Eve was only a subsidiary creation, made from a part of a man, and a spare part at that, and her natural fealty was to earthly things. Eve was formed of bone, a living substance which outlasts flesh itself; she must be bent to the will of God and, in the grip of that will, either stand firm or break.

The theme of woman bending to a higher will, be it God's or man's, appears frequently in Gauguin's pastoral painting. In deference to God the taskmaster she bends to labor, her penance etched in the curve of her back—her insignia the bowed flower that accompanies the fallen woman in *Be in Love, You Will Be Happy* (figure 84). A stoneware vase of the Pont-Aven period portrays a Breton woman bent almost double while beside her a goose holds its head high (figure 35)—in Gauguin's idiom, a sly insinuation of labor after the Fall.

In her bowed position the woman is prostrate before God but in touch with the earth; her exhaustion is the natural result of her earthly contact; she has spent herself in its service. In the classic Michelangelesque portrayal, dawn, or the virgin day, rises slowly from the ground to the heavens, while night, the used woman, collapses from the higher realms to the earth. Gauguin's heroines sit planted firmly on the ground, exposed in open nature, ready and waiting to give Fate the time of day. For a stoneware jardinière completed that winter Gauguin chose to combine motifs from two previous works to afford a two-sided allegory of Eve before the Fall (figure 37). One side is a coy pastoral piece featuring a young girl in full Breton regalia seated on the ground, her back to the viewer and her head turned to face him—the pose a direct copy of a Pissarro shepherdess; beside her, and echoing her pose to the point of parody, is a goat with its neck arched back; separated from this pair by a small fence is the proverbial goose. The theme is stated more frankly on the opposite side, which duplicates the figure of a nude young girl seated

on the ground beneath a tree brushing her hair, first seen in the wood relief *La Toilette*—a gentle but direct evocation of the maiden who, in the innocence of vanity, courts the dooming delights of maturity (figure 36).

Just as Eve was planted in the earth and bound to it in sin, so the roots of the Tree of Knowledge were planted in earth. Exposed in open nature, the trunk of the tree bent like the spine of Eve before the will of the wind—and bent further beneath the burden of fatal knowledge which weighed upon it, invading and investing its fruit. The tree had been *endowed* with knowledge, its branches burdened with fatal fruits, as Eve had been endowed with instincts and would be burdened by childbearing, rearing, and the cares of motherhood. About the rigid trunk wound the supple snake, spineless and adaptable, undulating to fit the situation, obviating, or getting around, the compulsion to bend; for the serpent was "more subtil than any beast of the field which the Lord God had made," and he was the worm in the apple of God's eye.

During his third sojourn in Brittany three years later, Gauguin would paint another tree in another garden, Gethsemane, its branches twisted back as if by a ruthless and aggressive wind; before the tree Christ weeps like a woman, clutching a white handkerchief in his hands (figure 6). In a drawing of the same scene the branches twist in such a way as to form a cross.

The force that bends the branch and bows the spine is obviously a masculine force, wreaking domination upon the passive feminine nature. It is an active force to which the female must respond with a mute offering of self, not to be molded or formed by it, but to define her existent state against it—the snake which rubs against a rock to shed its skin. The ritual polarity of the sexes would prescribe that as a man *does*, so he *is*—whereas as a woman *is*, so she *is*—and her doing is an offspring of her existing.

In imposing domination the male uses his will as a tool, a utilitarian object, not of himself, but to be wielded by himself, a blunt instrument which reflects the power of the being who brandished it; thus, the gamut of male weaponry, from the primordial phallus to the sheriff's holstered and slickly-drawn gun to the lightning which snaps from the fingers of God. The female, bending beneath wind, whip, will, responds only with her nature, is carried along in the currents set in motion by the man's

active gesture. Her reaction, because natural, is rhythmic, and her cycle echoes the cycle of the earth. After the Fall the earth is a female province, changing seasons, making waves, floating from birth to growth to death. The woman's body reflects most accurately the impersonal will of the life cycle, producing its monthly ransom to appease the Forces and to buy her right to continue.

The rhythm of woman's life was portrayed by Gauguin in a light and charming rendition of four Breton girls at a garden wall (figure 38). The visual pattern of the conversation aestheticizes the reality which lies beyond the wall in its enactment of a ritual of display and seduction, a channeled eroticism which embodies the courting process. The girls commune with each other in a protective circle from which men are excluded; they form a fraternity of femininity, knowing instinctively the truths of woman's life which they have not yet lived. Later Gauguin would develop the motif of grouped fallen women into an ominous archetype: infernal gossips disseminating a plague of bitter knowledge, used by life until, like *memento-mori* of their former selves, they lower their death's-heads over the beds of young virgins, who might see therein a reflection of their future fate. At Pont-Aven however, Gauguin's use of the motif remained as coy as the maidens themselves, masquerading behind the lushness of the setting, offering a hint in place of a revelation. He next assembled the four young Bretonnes on the unlikely pasture of a fan—ordinarily a luxury item better suited to less rustic themes. This paradoxical placement becomes more plausible when the fan is recognized as a vehicle of flirtation, a common accoutrement of "nice" girls of that era. In response to the pleas of her suitor, the girl would wave her fan in a series of rhythmic gestures which often contradicted the proprieties she mouthed. Thus, while the girl begged her lover to cease his advances for the sake of modesty, her fan was sending signals to him to go ahead; restricted by convention, she allowed the rhythm to carry her.

The stances of the active male and the passive female as they dissemble their way to the inevitable consummation are part of the standard vocabulary of the pastoral genre. Gauguin's most innocuous and innocent themes—wrestling boys, girls picking flowers—are used by other artists with greater daring and a certain symbolic dash—if not yet sophistication, at least dexterity. Degas selected a theme of young Spartan boys

engaged in feats of strength observed by a group of girls who tease provocatively, as if to drive the boys on to further feats (figure 39).

Gauguin executed a brave symbolic gesture in 1888 when he conceived a canvas of Jacob wrestling with an angel (figure 40). The theme has Golden Age markings and is peopled by the same rustic white-coiffed peasants who inhabited his earlier pastoral works; but now, as if to push himself to greater symbolic momentum, Gauguin screens the theme through Genesis, giving it the force of a single narrative event. The elements of the painting are as simple and ambiguous-by-omission as Biblical prose itself. In the foreground a group of Breton women in pious postures are assembled to watch the antics of Jacob and the angel, who, separated from the women by the trunk of a tree which divides the canvas, wrestle vigorously. The popular reading of this painting casts the women as parishioners awed by the curé's words into a trance in which the subjects of the sermon appear before them in a vision. In reality Gauguin used the theme as a vehicle to point up his active male-passive female polarity. The tree trunk, like its counterpart in Eden, divides and alienates the passive praying women from the active male faction of Jacob and the angel. The polarity heightens the dramatic effect, both visually and intellectually. The white hats of the women, with starched wings falling downward over the shoulders, seem to oppose the arched erect wings of the angel in another aspect of the passive-active allegory. In the same way, the prancing cow moving before the unseeing eyes of the praying group finds its equivalent in the Jacob-angel formation, which seems less like two separate figures engaged in a mutual activity than like one four-footed beast contorted in a ritual posture.

The cow originated in Piero di Cosimo's *Forest Fire*, wherein it also prances behind a tree, which divides the burning forest from the farmland (figure 41).[3] A shepherd drives his flock out of the forest in an Eden-like expulsion from the garden, now being consumed by the fiery wrath of unseen forces. As a consequence of the fire, however, the domestic and the wild animals are united in a common cause, in a universal exodus from the flames; and in the heat of the quest they transcend their polarities. In the same spirit, the praying women are united with Jacob in a common spiritual quest which overcomes their separate natures; together, in opposing modes, they battle with the forces of God. The red background of *Jacob and the Angel* takes its hue from the flame-shot sky

in Piero's painting. The cow, wandering mindlessly over the burning terrain, epitomizes that domestic stupidity which was Gauguin's favorite scapegoat; caught in the midst of divine conflagration, the cow does not know enough to be afraid of the fire and has no thought to stay away from the flame.

Volcanics

I n O c t o b e r 1888 in Pont-Aven, Gauguin was ill with a re-
currence of dysentery, aggravated by continuing anxieties over
money. So severe were his straits that he often could not afford paints and
canvas. Gauguin's plight bestirred Vincent van Gogh's sensitivities—
why should an artist of Gauguin's stature have to live in the constant
shadow of economic disaster?—as well as his plans. For a long time Vin-
cent harbored the idea of forming an Atelier of the South, which he envi-
sioned as a Golden-Age gathering of artists who would offer each other
support and succor, criticism tempered by the spirit of communion. His
vision was fed by the emotional hungers which assailed him in his state
of isolation at Arles. He invited Gauguin to share the yellow house which
he was already decorating. As he saw it, they would not only make a life
together but establish a precedent for a community: "Let us screw up our
courage for the success of our enterprise," he wrote, "and go on thinking
that you are in the right place here, for I verily believe that all this will
last a long time." [1]

Gauguin eventually accepted Vincent's proposal, but for pragmatic
rather than spiritual reasons. He had no great desire to migrate to Arles,
or even to commune with Vincent in person, for he continued to find the
Breton atmosphere intriguing, and his intercourse with Bernard and

other painters stimulating. However, he could not ignore Théo van Gogh's generous offer to pay for his trip and expenses in Arles in exchange for paintings. He would at last be paid to produce art, and he could look forward to a long period of relative ease. It had been arranged that he would stay a year.

Always in control of any situation, Gauguin had refused to commit himself to Vincent's proposition for months. He never clearly refused to come; rather, he indicated his approval of the plan but pleaded illness and poverty and acute depression in the face of Vincent's urgent pleas. The knowledge that he had a place to go was like money in the bank to him, and like a cautious investor he would deposit just the amount that would keep the account operative, being careful to keep himself free and clear until the propitious moment. Meanwhile, Vincent was left to the ravages of his own overactive conscience: he hesitated to frame his hopes in the form of an ultimatum for fear of offending Gauguin and adding to his burdens, yet he was unable to quiet his suspicions that Gauguin was using him and Théo for his own purposes. At one point he confided to Théo that he felt instinctively that Gauguin was a schemer "who, seeing himself at the bottom of the social ladder, wants to regain a position by means which will certainly be honest, but at the same time, very politic." Even at this stage van Gogh sensed that Gauguin was a man of the world, at the mercy of his talent but not above marketing it. He recognized that Gauguin was a family man and even conjectured about a possible family reunion if his friend's financial situation improved. And he continued to speak of Gauguin's talent in awed terms, never allowing his personal doubts to cloud his admiration.

Ceaseless tension took its toll of Vincent even before Gauguin's arrival. In mid-October he wrote to Théo that he felt on the edge of madness, "and if it were not that I have almost a double nature, that of a monk and that of a painter . . . I should have been reduced, and that long ago, completely and utterly, to the aforesaid condition." He went on to explain that his insanity did not take the form of persecution delusions but rather "the contemplation of eternity and eternal life." Indeed, his monklike nature was not totally self-imposed; he had little success with women, and the Arlésiennes in particular proved difficult, refusing even to model for him. "I feel that even so late in the day I could be a very different painter if I were capable of getting my own way with the

models, but I also feel the possibility of going to seed and of seeing the day of one's capacity for artistic creation pass, just as a man loses his virility in the course of his life."

Vincent saw Gauguin as the future master of the atelier. In his intense humility he honored his friend's age and skill, not with the passive awe of the apprentice but with a strange mixture of bravado and respect for the strength of Gauguin's art and opinions. In anticipation of the older man's arrival he expressed to Théo his "great desire to show him something new and not to undergo his influence (for he will certainly have an influence on me, I hope) before I can show him my own undoubted originality." His attitude parallels the timidity evoked in one medicine man upon first meeting another whose magic may possibly be greater than one's own. One has the feeling that Vincent felt possessed by his talent, that the intimate links between his painting and his emotional life put him at the mercy of another blessed with greater sureness and control. "I find my artistic ideas extremely vulgar compared with yours," he had written to Gauguin. "I have always the gross appetite of a beast."

Van Gogh's intense sense of self was countered by an equally vigorous need to be actively known and supported. He needed to feel the presence of companions, to know and be known by them intimately. For this reason he entered into friendships with the fervor and commitment one would bring to a mystic communion; in the ecstasy of communication he hoped to emancipate himself. He was willing to acknowledge Gauguin's masterhood, but in the face of it he was argumentative rather than subservient. He was able to generate electricity by means of friction with another surface—left to himself, the electricity took him over, became unmanageable, turned into the beginnings of madness. Ironically, the intensity of his need to communicate rendered him unreachable. He was able to transmit only the waves of his own violent unrest.

For Gauguin friendship was a utilitarian matter: a good friend supported one materially and made no demands. His friends, as his mediators with the world, enabled him to stand alone. The degree of closeness required by Vincent could only be an intrusion to Gauguin. Perhaps the weight of cast-off bonds still lay heavily upon him. All intimations of dependence were distasteful to him; he would not stand as the provider in any situation, no matter how far removed from home and family. His dominance from now on would take the form of truculence—an insistence upon his own viewpoint and an unwillingness to be diverted from

his path. He would be the father of a movement but not its wet nurse. He would germinate, he would innovate, but the infant would learn finally to get along without him. It was not up to him to save Vincent, but only to coexist with him.

When Gauguin finally arrived in Arles on October 23, 1888, he was shown to the guest room which Vincent had carefully prepared for him—a room more elegant than others in the house and dubbed by van Gogh "the lady's boudoir." Vincent seemed taken by Gauguin's personality, as well as by his rapid success with the Arlésiennes. His creeping suspicions were waylaid, replaced by an openhearted appreciation of his friend's charisma: "I know well that Gauguin had made sea voyages, but I did not know that he was a regular mariner. He has passed through all the difficulties and has been a real able seaman and a true sailor. This gives me an awful respect for him and a still more absolute confidence in his personality."

Vincent continued to have confidence in his friend, but as the weeks progressed his respect became tainted with less savory emotions. He saw Gauguin as an aggressively sexual figure who was also a master of his art, and this double-barreled potency activated his deep fears about his own manhood. Although rugged in appearance and inclination, van Gogh had very little control over his emotional spectrum. He was like a puppet dangling from a cosmic string. Only in his art could he impose order upon his outpourings—and he lived out his artist's role in the trappings of a monk. His letters repeatedly allude to the necessity for continence in an artist, to the enforced channeling of sexual energy into pictures. Later he would write to Bernard a veritable paean to the virtues of painterly chastity: ". . . eat a lot, do your military exercises well, don't fuck too much; when you do this your painting will be all the more spermatic. . . . If we want to be really potent males in our work, we must resign ourselves to not fuck much and for the rest be monks or soldiers, according to the needs of temperament." He admired the Dutch painters for their virility and health, and he eulogized Rubens and Courbet, whose "health permitted them to drink, eat, fuck. . . ." In his mind a man who could both paint and make love was a creature of godlike dimensions, almost too formidable to be met without fear.

Of a handsome young soldier who posed for him, van Gogh wrote that "he has as many Arlésiennes as he wants, but then he cannot paint them, and if he were a painter he would not get them." To watch Gau-

guin, his acknowledged master in art, make conquests with little effort and, perhaps, some characteristic flaunting, must have been a constant source of pain to him. Gauguin had also flirted with abstinence, as in his admonition to Madeleine Bernard to "be Androgyne." Yet he seemed to tailor his advice to fit women only; in a letter to Schuffenecker from Arles he wrote, "You can ask Pissarro if I am not talented. No constipation and regular fucking, with independent work, and a man can pull through." His use of the term "Androgyne" suggests a cancellation of sex rather than a renunciation of it; to declare oneself sexless is to enter another state of being, and in so doing to exercise the ultimate in masculine control by rendering the sexual state irrelevant. Van Gogh's mannered turning from sex was considerably more martyred; sex remained central, as the seed from which the renunciation sprouted. As a monk he was always conscious of his abstinence; as a soldier he was militantly aware of his needs and fearful of the inadequacy of his weapons.

Gauguin's and van Gogh's life together, at first almost dull in its regularity and dedication, became increasingly volatile. Discussion fired into argument, and into criticism which bordered on personal attack. "Vincent and I agree very little indeed in general, and especially in painting," Gauguin wrote Bernard. "He admires Daudet, Daubigny, Ziem and the great Rousseau, all of these people whom I can't stand. On the other hand, he detests Ingres, Raphael, Degas, all of those people whom I admire; I answer, 'Corporal, you're right' for the sake of peace. He likes my paintings very much, but while I am making them he always thinks that I am wrong here, that I am wrong there. He is romantic and I am rather inclined toward a primitive state. When it comes to color he is interested in the accidents of the pigment, as in the case of Monticelli, and I detest this messing about in the medium."

In opposing Vincent's romanticism to his own primitivism Gauguin was being unwittingly perceptive. In life as well as in art their temperaments came together only to produce friction. "Our discussions are terribly electric," Vincent wrote his brother; "sometimes we come out of it with tired heads, like an electric battery after discharge." There was something unwholesome in their interaction, as if the sparks generated produced no light but only a feverish heat which threatened to consume them. Vincent remained a convulsive dreamer; already the force of his dreams promised to precipitate him into a visionary state. His strength

lay in the intensity of his perceptions; yet he was driven to exorcizing them in frenzies. His art, as the manifestation of his visions, controlled him. The disparity between his needs and his attainments was vast, not because his attainments were small but because his needs were dream-needs, conceived to excite rather than to presage fulfillment.

Gauguin, the primitivist, held to the essentials of life. As a man of the world he was careful to keep accounts, to chart his needs in economic terms (Vincent would later write of "the marvelous way he can apportion expenses from day to day") even if, in the throes of half-demented desperation late in his life, his residual trader's canniness would lead him to falsify figures. Vincent's own financial excursions, as recorded in his letters, were mostly diaries of indebtedness to his brother Théo, who was supporting him; toward the end of his life his account of expenses became almost pathetic in its detail, as if, in making this concession to worldly realities, he was staking a claim to sanity. Gauguin's utilitarian conception of friendship precluded any feelings of guilt; he felt simply that as a man of talent he deserved the support of his friends, and he judged them according to their usefulness. In his self-centeredness he was insulated from the world in a way that van Gogh was not. His inner drives were no less strong—Vincent would one day suggest that he was a fellow candidate for the madhouse—but he was able to act upon his environment, to use himself as a weapon and thereby maintain his latent power. He did not spend himself on behalf of others.

Much later, in his journal, Gauguin told the following incident: "I did the cooking, on a gas stove, while Vincent laid in the provisions, not going very far from the house. Once, however, Vincent wanted to make a soup. How he mixed it I don't know; as he mixed his colors in his pictures, I dare say. At any rate, we couldn't eat it. And my Vincent burst out laughing and exclaimed: *'Tarascon! la casquette au père Daudet!'* On the wall he wrote in chalk:

Je suis Saint Esprit
Je suis sain d'esprit."

As the weeks passed, Vincent's behavior (according to Gauguin) became more and more erratic. Moments of extreme rambunctiousness would alternate with periods of dour silence, and on several occasions Gauguin awakened to find van Gogh standing over his bed, staring down

upon him. On December 23 Vincent wrote Théo an abrupt and constrained note which belied the image of serenity and vibrant debate that he had transmitted in earlier letters:

"I think myself that Gauguin was a little out of sorts with the good town of Arles, the little yellow house where we work, and especially with me.

"As a matter of fact, there are bound to be grave difficulties to overcome here too, for him as well as for me.

"But these difficulties are more within ourselves than outside.

"Altogether I think that either he will definitely go, or else definitely stay.

"I told him to think it over and make his calculations all over again before doing anything.

"Gauguin is very powerful, strongly creative, but just because of that he must have peace.

"Will he find it anywhere if he does not find it here?

"I am waiting for him to make a decision with absolute serenity." [8]

That evening at a café Vincent flung a glass of absinthe at his friend's head. Taking him in his arms, Gauguin brought him home and put him to bed. "When he awoke, he said to me very calmly, 'My dear Gauguin, I have a vague memory that I offended you last evening.'" Gauguin answered, "I forgive you gladly and with all my heart, but yesterday's scene might occur again, and if I were struck I might lose control of myself and give you a choking. So permit me to write your brother and tell him that I am coming back."

After dinner, at the close of another nightmarish day, Gauguin had left the house for a walk by himself when he heard a rush of footsteps behind him. As he turned he saw Vincent rush toward him with an open razor in his hand. "My look at that moment must have had great power in it, for he stopped and, lowering his head, set off running toward home." Choosing not to follow him, Gauguin took a room at a hotel and remained there until morning. When he entered the square he found himself in the midst of an excited crowd and heard the story of his companion's activities of the preceding night. Vincent had returned to the house and cut off the lower portion of his ear. After stanching the flow of blood with towels and pulling a beret over his head, he walked to the local

brothel where he presented a girl named Rachel (*nom-de-guerre* Gaby), formerly his special woman, with an envelope containing his severed ear, carefully washed. "Take this in remembrance of me," he is reported to have said. He then went back home and to sleep.

Returning to the house, Gauguin was confronted by the chief of police, who informed him that Vincent was dead and intimated that he was a prime suspect in the murder. Upstairs, Gauguin ascertained that his friend still lived and instructed the police official to "awaken this man with great care, and if he asks for me to tell him I have left for Paris; the sight of me might prove fatal to him." Gauguin's next act was to summon Théo to Arles by telegram.

Gauguin was never able to forgive himself completely for having left Vincent at that crucial moment in the square. But in his journal he typically covered his doubts with bombastic pronouncements: "Was I negligent on this occasion? Should I have disarmed him and tried to calm him? I have often questioned my conscience about this, but I have never found anything to reproach myself with. Let him who will fling the stone at me."

Gauguin's entire narration of the incident has the harried and defensive tone of trial testimony: "It so happens that several men who have been a good deal in my company and in the habit of discussing things with me have gone mad. . . . This was true of the two van Gogh brothers, and certain malicious persons and others have childishly attributed this madness to me." Much of the narrative is devoted to declamations of Vincent's affection and respect for him, of his substantial role in the formation of van Gogh's style. Even at this stage, with Vincent dead and himself in exile with only his memories to bear witness, he felt impelled to take refuge behind the walls of vanity. Yet he was as strongly moved by Vincent as he was capable of being moved by anyone, and found in him "a rich and fertile soil"—for his own teachings. For all the time they spent together, it is doubtful that he knew Vincent objectively, or in any context which did not relate directly to himself. A telling paragraph in his journal makes a sad epitaph to the limitations of their community of two—a failure of compassion as well as of temperament: "When I arrived in Arles, Vincent was trying to find himself, while I, who was a good deal older, was a mature man. But I owe something to Vincent, and that is, in the consciousness of having been useful to him,

the confirmation of my own original ideas about painting. And also, at difficult moments, the remembrance that one finds others unhappier than oneself."

Gauguin was much in Vincent's thoughts in the weeks spent recovering from his attack. As soon as he was released from confinement he wrote to Gauguin reiterating their friendship: "I often thought of you in the hospital, even at the height of fever and comparative weakness." His letters to Théo were filled with anxious queries about Gauguin's whereabouts and state of mind: "Have I scared him? In short, why doesn't he give me any sign of life?"

Anxious concern gradually changed to bitterness as Vincent took account of his friend's actions. He was deeply angered at Gauguin's ignominious departure and at his summoning of Théo to Arles. "Suppose," he wrote, "that I was as wild as anything, then why wasn't our illustrious partner more collected?" And later, "How can Gauguin pretend that he was afraid of upsetting me by his presence, when he can hardly deny that he knew I kept asking for him continually, and that he was told over and over again that I insisted on seeing him at once. . . . Just to tell him that we should keep it between him and me, without upsetting you. He would not listen."

Even more painful to Vincent was the realization that his dream of a utopian community was not to be, that it had died in its germination, not yet born. In the extremity of his feeling, and in reaction to the pressures which Gauguin brought to bear against him, he began to project some of his most entrenched inadequacies upon his partner: "I think the mistake in old Gauguin's calculations was that he is rather too much in the habit of ignoring the inevitable expenses of house rent, charwoman, and a lot of worldly things of the kind." Yet in a later letter he praised Gauguin's ability to apportion daily expenses, observing with his curious keenness of perception that "while I am often absent-minded, preoccupied with aiming at *the goal*, he has far more money sense for each separate day than I have. But his weakness is that by a sudden freak or animal impulse he upsets everything he has arranged." In his journal Gauguin would write of the chronic disorder in which Vincent functioned, and of his own solution of a cash-box system in which small amounts of money were set aside for each of the day's activities. In the aftermath of his failed dream Vincent saw Gauguin as humanly fallible

in worldly tasks, and resented, in retrospect, Gauguin's imposition of order upon his compulsive and intimate chaos.

The dream, though dead, continued to persist. In Vincent's mind Gauguin still bore the weight of his visionary role and could no longer stand simply as man, friend, or fellow artist but as an errant partner, a betrayer of Théo's trust and his own. "Now do you stay at your post once you have taken it, or do you desert it?" He had meant so well for his friend, but Gauguin had never adopted the proposition as his own, preferring to fix his imaginative grasp on his own projects. "There is nothing to prevent our seeing him as the little Bonaparte tiger of impressionism as far as . . . his vanishing, say, from Arles would be comparable or analogous to the return from Egypt of the aforesaid Little Corporal, who also presented himself in Paris afterward and who always left armies in the lurch." Gauguin as the master artist had lent his paintings and his presence to the yellow house, but in his own life scheme it had always been a stopgap measure, a period of economic recovery which would set him up strongly for his proposed Atelier of the Tropics, which he hoped to found in Martinique or somewhere in the South Seas. Most grievous to Vincent was Gauguin's refusal to take Arles seriously; he had surely expressed to Vincent in more direct and violent terms the sentiments he conveyed to Émile Bernard: "I am at Arles quite out of my element, so petty and shabby do I find the scenery and the people." It is evident from statements in Vincent's letters that, in the ensuing financial disagreements, Gauguin had managed to imply to Théo that he had been misused and exploited in the clutches of this van Gogh enterprise. Vincent answered these charges in a letter to his brother, first with a cry and then with heavy cynicism:

"Must he not, or at least should he not, begin to see that we were not exploiting him, but on the contrary were anxious to secure him a living, the possibility of work . . . and . . . of decency?

"If that does not attain the heights of the grandiose prospectuses for the association of artists which he proposed, and you know how he clings to it, if it does not attain the heights of his other castles in the air—then why not consider him as not responsible for the trouble and waste which his blindness may have caused both you and me.

". . . He has had experience in what he calls 'banking in Paris' and

thinks himself clever at it. Perhaps you and I are not curious at all in this respect.

". . . If Gauguin stayed in Paris for a while to examine himself thoroughly, or have himself examined by a specialist, I don't honestly know what the result might be.

"On various occasions I have seen him do things which you and I would not let ourselves do, because we have consciences that feel differently about things. I have heard one or two things said of him, but having seen him at very, very close quarters, I think that he is carried away by his imagination, perhaps by pride, but . . . practically irresponsible.

"This conclusion does not imply that I advise you to pay very much attention to what he says on any occasion. But I see that you have acted with higher ideals in the matter of settling his bill, and so I think that we need not fear that he will involve us in the errors of the 'Bank of Paris.' "

Even while he castigated Gauguin, Vincent continued to maintain a certain awe of him, of what he stood for in the world. He might advise Gauguin to attend to his own madness, but inwardly he recognized the different qualities of their afflictions: Gauguin's madness was a blunt instrument which bent the world to its shape, while he, Vincent, was at the mercy of a feverish and self-consuming fire. He was not made like Gauguin, and so he continued, as if in obedience to the natural order of things, to be humble in Gauguin's presence and to understand his excesses: "He is physically stronger than we are, so his passions must be much stronger than ours. Then he is a father, he has a wife and children in Denmark, and at the same time he wants to go to the other end of the earth to Martinique. It is frightful, all the welter of incompatible desires and needs which this must cause him."

In the end Vincent's cynicism seemed to evaporate, and with it, his awe. He retained a ghostlike and persistent sense of kinship which in its very ephemerality cemented the union for all time. The banalities of their daily life together, and even the series of eruptions which presaged the final tragedy, seemed insignificant in comparison. Gauguin, this strong man with a family who had told him stories of going to sea, was as mad as himself, and as lost, and as absolutely tied to his art, and as ultimately bereft of rest. They were mutually afflicted.

Volcanics

"I have just said to Gauguin about this picture that when he and I were talking about the fishermen of Iceland and of their mournful isolation, exposed to all dangers, alone on the sad sea—I have just said to Gauguin that following these intimate talks of ours the idea came to me to paint a picture in such a way that sailors, who are at once children and martyrs, seeing it in the cabin of their Icelandic fishing boat, would feel the old sense of being rocked come over them and remember their own lullabys."

VII

Day and Night

I N D E C E M B E R 1888, the last month of his partnership with
Gauguin, Vincent made two studies, one of Gauguin's chair and
another of his own. His chair, the picture of which he called *The Day*
(figure 42), is of plain wood with a straw seat, straight-backed and with-
out armrests. Its character is homely and sturdy, a country chair fit for
hard use. On its seat lie an unlit pipe and a bit of tobacco on a pouch. It
stands on a floor of plain reddish tiles, and behind it, against the wall, is a
bin full of onions with "Vincent" inscribed on its front. By contrast, van
Gogh's rendering of Gauguin's chair (figure 43) is ornate and almost
theatrically decorative in its effect: of reddish wood, its high curved back
tapers into graceful curved limbs; the seat is plush and rounded, covered
with green rush or straw; on the seat a burning candle in a holder
stands before two closed books. An exotic carpet of muted reds and
greens provides contrast with the deep green wall; in the upper left
corner a lamp casts a yellow glow. Vincent called this study *Effect of
Night*.

The chairs can best be understood as *memento mori* for a dying
union. Vincent wrote to the symbolist writer Albert Aurier in February
1890, giving some details about the crucial timing of the studies: "A few
days before we separated, when my illness forced me to enter a hospital, I
tried to paint 'his empty place.' This is a study of his armchair in dark

brown-red wood, the seat of greenish rush, and in the place of the absent a lighted candle and modern novels." The chair became in Vincent's mind a summation of concepts which represented an equivalent for his friend, a sort of residue of the partnership. Gauguin, soon to be gone in fact, had left a sense of himself which resided now in Vincent, who translated it into his own imagery.

In his evocation of his soon-to-be absent friend, Vincent resurrected his ingrown concept of Gauguin as a wily magician, pulling live fantasies from his mind and imposing them upon the solidity of the canvas. He felt that Gauguin's imaginative grasp was stronger than his own, that Gauguin was subtle and elusive in his approach to subject matter, whereas he, Vincent, could not transcend the mundane. As if to reiterate this image of himself, and oppose it once again to his vision of the essential Gauguin, he presented his chair and the objects surrounding it in the most earthbound forms, so straightforward and simple as to mock any attempts to extend them beyond themselves. In their very homeliness one senses the tyranny of humility which Vincent exercised upon his person and upon the objects which fell within his radius. Each form stops dead within its own boundaries. The red brick floor, the straw seat, the pipe, the onions—each achieves its identity in its relationship to Vincent's person, in its mute function as an extension of his vibrating center of consciousness. He is saying not "These objects sum up what I am" but rather "I, Vincent, use these objects and they suffice for my needs."

He saw Gauguin as capable of transforming the minutiae of everyday life into forms which fit an inner vision—a conceptual approach to art rather than a pragmatic one. In this respect Vincent regarded himself as Gauguin's student. In his own work he had attempted to transform reality even before he met Gauguin, but he had never consciously organized his perceptions into a coherent and telling vision. Although better read than Gauguin, and more aptly characterized as "literary," in his painting he was vulnerable to an immediacy of perception, an instinctual grasping of a scene or an object so that it emerged on canvas still in the clutches of his stark and unrefined vision. Under Gauguin's tutelage, and by his example, he hoped to learn to explore the slower-spinning processes of his imagination and to add a new level of profundity to his work. In a sense he had already gone beyond expressionism into a more mystic and perilous realm; now he would begin to extend a measure of intellectual control over the stampedings of his instinct. He wrote to Théo,

"Gauguin gives me courage to imagine, and things from imagination certainly take on a more mysterious character."

In rendering Gauguin's chair Vincent honored the conceptual nature of his friend's painting. The chair itself is feminine and decorative, removed, in its curving lines and soft rounded seat, from all intimations of functionalism; like certain women, and perhaps like the whole concept of the "lady's boudoir" in which it was placed, it is a luxury item, notable for its beauty rather than its solidity. It is set upon an Oriental carpet of red and green, but the floral pattern is etched in such a way that the flowers appear to be floating on some liquid or living medium, water or waving grass; the chair is afloat on a garden-like foundation which supports its ephemerality rather than its bulk. The two books and lit candle which rest in place of Gauguin testify to the fecundity of his ideas; the books are products of the intellect and contain organized lore of the imagination; the lit candle illuminates and makes clear dark areas of the mind. Taken as an entity, the two books and the candle form a neat parallel to a male sexual organ which is both fertile in its seminal endowment and potent in its execution of the creative act. The dark green background intensifies Vincent's *Effect of Night* and reiterates the idea of a boudoir interior, a place and a time to dream and fantasize, to allow the phantom thoughts of the unconscious to rise unrepressed to the surface of the mind. The glowing night-light in the corner is another testament to the constancy of awareness which, in Gauguin's dark and inward nature, keeps the thinker awake and ideatively functioning in the hours when others sleep; in a broad sense it epitomizes the thinking process itself, as today, in comic-strip illustrations, a light bulb might be drawn above the head of the bearer of a "bright idea."

Vincent's experiments in drawing strictly from imagination did not prevail after Gauguin's departure. For his own purposes he remained most comfortable when drawing from life, and indeed he seemed to consider total immersion in the imagination a frightening prospect; perhaps he feared that the depths of his own introspection would seal his divorcement from reality. While hospitalized he wrote to Émile Bernard, "When Gauguin was in Arles, as you know, once or twice I let myself go to an abstraction, in the *Berceuse* and in *A Woman Reading Novels*, black in a yellow library; and then the abstraction appeared to me a charming path. But this is enchanted land, my dear fellow, and soon one finds oneself up against a wall."

A comparison of the self-portraits which the two artists exchanged just before coming to live together reveals the separate currents of their approach to symbolism. Gauguin's painting is pure self-invention. He casts himself in the role of a literary figure, the outlaw Jean Valjean (figure 5), and in rendering his image takes delight in distorting nature until it capitulates to his own artfulness—"I believe it is one of my best efforts: absolutely incomprehensible (upon my word) so abstract is it." In his description to Schuffenecker he is careful to itemize each choice contrivance; the features of the face "like the flowers of a Persian carpet," the color "remote from nature," the "childish nosegays" dotting the wall which transform the room into the "chamber of a pure young girl." Jean Valjean, whose mask Gauguin has donned, has in turn been endowed with the deeper identity of that pure-hearted renegade, the impressionist painter. Gauguin's cynical glance, emanating from the flower-like eyes, seems to dare the viewer to join the conspiracy, to attempt to penetrate the mystery. Gauguin is the Knower, and his gaze, directed outward so frankly, is an overt challenge to the viewer's curiosity.

The portrait which Vincent prepared for exchange was no less symbolic than Gauguin's but of an entirely different genre of symbolism (figure 44). He wrote about it at length in a letter to Théo: "Here at last I have the opportunity of comparing my painting with that of the copains. My portrait, which I am sending to Gauguin in exchange, holds its own, I am sure of that. I have written to Gauguin, in reply to his letter, that if I too were permitted to enlarge my personality in a portrait, while seeking to render in my portrait not only myself but in general an Impressionist, I had conceived this portrait as that of a bonze [Buddhist monk], simple worshiper of the eternal Buddha. And when I put the conception of Gauguin and my own side by side, mine is as grave but less despairing."

Vincent's portrait is as stark as Gauguin's was ornamented. His head, ash-colored and almost skeletally outlined, rears against a greenish background. In keeping with his identification as a Buddhist monk, the head is close-shaven, the eyes slanted and set in bony Mongol ridges, the skin yellowish beneath its translucent paleness. A small brooch at the neck, and the bright purple binding which outlines the vest and coat collar, do not soften the rigidity and fierceness of the head but provide an illumination by contrast, as a wisp of drapery serves to enhance and point up nakedness.

On the surface, the premise of Vincent's portrait is similar to Gauguin's: each seeks to subsume his identity in a larger mythic characterization, which would make him not only a member of a group but an epitome within it. Gauguin achieves his epitome by donning a mask and setting a scene; he constructs the externals of the outlaw's world and, like an invader at a costume ball, installs himself as the foreign element which will change the chemistry of the scene. For all its proclaimed mystery his approach is brash and open and frankly contrived, because we are always aware that he is the stage manager searching for ploys, that he is submitting his conception to a process which will create the desired effect.

Vincent wears no mask. His own face does not peer from behind the façade of a Buddhist monk, but rather he has attempted to incorporate the essence of monkhood into his own person, as if he were himself, Vincent, born in another form and character. There is a unity to his conception which has no place in the context of Gauguin's symbolism; he establishes the fact that banishes the accessories. Gauguin created a puzzle in fragmented parts which has no one solution: the flower-features, the flamelike unnatural color, the nosegays on the wall, are each small puzzles in themselves, personal anagrams which spell out the artist's coded impressions of what it was like to be an impressionist in a hostile era. When Gauguin speaks of "all the reds and violets streaked by flames, like a furnace burning fiercely," we cannot logically conclude that these signify "the seat of the painter's mental struggles"; we must match our intuition to his annotation.

Vincent also included an annotation of sorts in a letter to Gauguin. The parallel description forms an interesting contrast: "I have a self-portrait all ash-colored. The ash color comes from mixing veronese with orange mineral on a pale veronese background, and dun-colored clothes. But in exaggerating my personality I sought rather the character of a simple adorer of the eternal Buddha. It has given me a lot of trouble, but I shall have to do it all over again if I want to succeed in expressing the idea. I must get myself still further cured of the conventional brutishness of our so-called civilization, in order to have a better model for a better picture."

Compare Vincent's simple breakdown of color with Gauguin's description of his tones, carefully proclaimed to be "remote from nature;

imagine a confused collection of pottery all twisted by the furnace!"
Vincent used no exotic imagery when discussing his creation of image;
his conception was as germinal as if it had been nurtured in a womb, and
the emergent image remained a simple organism, whole and self-con-
tained. Vincent's approach was based on the divining and rendering of
essences. In using the homely and familiar material of his own essential
nature, he fretted about the limitations of his art—the picture could only
improve if he were to become a better monk and a better man!

Spiritual and theoretical differences were manifested not only in the
aura of a work but in its execution. In his *Still Life on a Drawing Board*
Vincent tips the large board toward the viewer so that the objects upon it
are arrayed before the eye in the manner of a display case. A candle,
onions, a pipe and tobacco, a book on health, a letter from his brother—all
contributed to the texture of Vincent's daily life, which, in a primitive
sense, overlay his art in the person of the drawing board. He is asking the
viewer to look upon the anatomy of his life and to accept it as mute evi-
dence of his substance. He presents the objects but does not moralize
about them or draw conclusions. They are personal items of comfort
which relate to his physical self.

In Gauguin's still-life portrait of his painter friend Meyer de Haan
(figure 80) a table also tilts to display its contents, but the angle at
which it leans toward the viewer is exaggerated and unnatural. In con-
trast to van Gogh's bright, informal spread of objects, the items on Gau-
guin's table are few and offered not as a grouping but as separate spots of
interest, each bearing the weight of its own significance. A plate of ap-
ples looms in the foreground; behind it two books are placed with titles
facing toward the viewer and clearly visible beneath the artificial light of
a gas lamp. Meyer de Haan's diabolic visage peers outward; from be-
neath his devil's cap a crop of hair sprouts like a horn, his eyes slant in an
inhuman stare, and a pawlike hand is pressed to his mouth. Gauguin has
imposed a perspective upon the viewer that makes us see through de
Haan's eyes even while looking at him. Immediately we are led to wonder
why these particular books—Carlyle's *Sartor Resartus* and Milton's *Par-
adise Lost*—were selected as the objects of that penetrating gaze. What
does de Haan—or Gauguin—see in the books? And why were apples,
whose symbolic connotations are so deep-seated and obvious, chosen for
display above all other fruits? De Haan's demonic contemplation casts a

sinister air over the objects, which is reinforced by their particulariza-
tion. They ask to be accepted on an interpretive level as well as a visual
one.

The portrait which Gauguin made of van Gogh at his easel is in-
vested with symbolic intimations (figure 45). In his journal Gauguin
recalls Vincent's response to the portrayal as "It is certainly I, but it's I
gone mad." Vincent records his own reaction in a letter to Théo of Sep-
tember 10, 1889: "It is me extremely fatigued and charged with electric-
ity, as I was then." The painting must be considered as a prevision of the
shattering events of the next few days, which culminated in Vincent's
confinement. Gauguin chose to portray Vincent painting his favorite sub-
ject, sunflowers. Set upon Vincent's wicker chair, the flowers create a
great mass in the foreground; they turn away from the artist with almost
a striving motion and, like the books in the portrait of Meyer de Haan,
seem to arch toward the viewer, offering themselves to external contem-
plation. Gauguin echoed Vincent's eyes in the eye of the sunflower, as if
the flower were a manifestation of Vincent's inner life. Gauguin chooses
to repress Vincent's act of painting, preferring to render only the profile
of the easel and, in the artist's hand, a thin, fragile brush. This dictato-
rial diminishment is reminiscent of Gauguin's painting of Émile Schuffe-
necker and his family, in which the artist is portrayed standing stoop-
shouldered and humbled beside his easel with his hands clasped, while in
the foreground his wife and children hunch together in a rejecting mass.
Although he considered van Gogh a strong painter and an apt pupil, yet
perhaps he perceived that Vincent was at the mercy of his art, that his
medium controlled him, and that the subject, as embodied in the sunflow-
ers, ultimately eluded and rejected him; no matter how Vincent worked,
he could not capture the subject to his satisfaction. (Interestingly, the
motif of sunflowers was repeated in a mordant context in Roland-Holst's
illustration for the catalogue of the memorial exhibition held after Vin-
cent's death in 1892; here the flowers are wilted and the roots exposed, as
if to emphasize the destructive quality of van Gogh's genius.) In the
background, completing this castration-by-omission, Gauguin included
one of his own landscapes, spread out nearly the width of the canvas.

Gauguin imposed his symbolism even upon strict genre scenes. He
and van Gogh both painted physically similar views of the women of
Arles, but the tone and impact of each work is entirely different. In his
Women of Arles (figure 46) Gauguin depicted a file of women in black

Provençal costumes. "It is strange," he wrote to Bernard, "Vincent feels the influence of Daumier here; I on the contrary see a mixture of colorful Puvis and Japanese art. The women have elegant hairdos; Grecian beauty. Their shawls, forming folds like the primitives, are, I say, like Greek friezes. . . . Well, it must be seen. In any event, there is here a source of a beautiful 'modern style.' " In their dark garb, gray-faced, with shawls clutched close to the mouth in a grief-checking gesture, the women make a strangely funereal procession; the purposeful overlay of mourning eliminates any tincture of genre randomness from the scene. The elements stand out severe and isolated, rendered in flat stretches of color which, despite their vividness, are almost anti-sensual; the very clarity of each form has an astringent quality which defies the eye's tendency to blend, to skim, to unify the parts of the painting into a whole vision. In the background a small white island with a black mass at its center floats upon a body of water; before it on the grass, two stark perpendicular forms, probably hay-frames with drying hay, arched upward, and in front of them, as if to lock the women into the picture and the viewer out, a bright red picket fence. Gauguin has again resorted to the use of the great foreground mass, this time in the form of a bush which blocks the passage of the marching women and obscures the lower half of their bodies; on the surface of the bush, just barely visible, Gauguin has etched the features of a face, which are faintly reminiscent of earlier evocations of Meyer de Haan's features.

Vincent was strongly impressed by this painting and carried it in his mind as a model when he made his parallel version *Souvenir of the Garden at Etten* (figure 47). In following Gauguin's advice to work from memory, he attempted to construct the subject matter from recollections of his family garden in Holland, superimposing recalled figures and costumes upon it. Two women proceed down a winding path while behind, a group of bushes separate them from a woman bent over to pick flowers. Gauguin's characterization of himself as a primitive in opposition to van Gogh's romanticism is demonstrated clearly when Vincent's painting is set beside his own. Vincent's version is united, thematically and formalistically, by a like texture which is in itself the dominant visual factor of the painting. All separate elements converge in a confusion of form, color, and brush stroke so that each part is subservient to the over-all pattern and becomes significant only in its expression of that pattern. Thus the painting makes a concerted assault on the senses, present-

ing the essence of the scene and demanding only that the viewer drink it in, that he receive this conjured remembrance siphoned through the artist's eye. Only the sense impressions are clear, and they are founded on confusion and diffusion. The curving forms make of the painting a whole.

In another case of shared subject matter, both Gauguin and van Gogh made simultaneous paintings of a vineyard in Arles. Vincent wrote to Théo, "On Sunday if you had been with us, you would have seen a red vineyard, altogether red as wine. In the distance it turned to yellow, then above that a green sky with a sun; the earth after the rain looked violet, glittering here and there where the setting sun mirrored yellow on it." In this setting Vincent placed several women in different postures picking grapes, while horse-drawn carts wait to carry off the fruit of their labors. The genre is once again expressive without being anecdotal. Vincent's innate sympathy for the workers shines through, but it emerges as a pervasive aura rather than encased in overt symbols.

The Red Vineyard (figure 48) became one of van Gogh's favorite paintings, and Gauguin seemed to feel a similar affection for his own version, *Vintage at Arles* (figure 49). He described it at length in a note to Émile Bernard: "Purple vines forming triangles on the upper part, which is chrome yellow. At the left, a Breton woman of Le Pouldu in black with a gray apron. Two bending Breton women in light blue-green dresses with black bodices. In the foreground, pink soil and a poor woman with orange hair, white blouse, and green skirt mixed with white. The whole thing done with bold outlines, enclosing tones that are almost uniform, laid on coarse sackcloth very thickly with a knife. It's a view of a vineyard that I saw at Arles. I have put in some Breton women; so much the worse for exactitude. It's my best canvas of the year, and as soon as it's dry I'll send it to Paris."

Gauguin's purposeful imposition of Breton women upon an Arlesian landscape suggests his growing discontent with Arles as a creative environment. He claimed to find both the women and the landscape "cheap and pretty," even though he had once referred to the "Greek beauty" of the Arlésiennes. It was not so much the natural resources of Arles that he found lacking, but rather historical depth; there was none of that calcification of custom and legend which gave such a timeless and distinct flavor to the Breton landscape. In Brittany he sensed the presence of mystery, and the whispers and insinuations and secret rites gave flesh to his own formulating iconography. In comparison, Arles

seemed banal and shallow, and when he searched his memory for symbols he returned naturally to the more fertile soil of Brittany.

Gauguin based the background of his vineyard painting on van Gogh's version, but he carried the theme far beyond the limitations of genre. The maiden sitting in the foreground, her fists supporting her face in a petulant attitude, provides an immediate contrast with the dark, faceless older women. One is aware of an abrasive contrast of attitudes, which exposes an intentional and contrived use of symbolism. The girl's childlike pose, her subtle and devilish smile, imply not only a resistance to the labor of the older women but also an unspecified temptation which preoccupies her. She will become Gauguin's prototype of Eve before the Fall.

The same beguiling intimations appear in a contemporaneous painting in which a woman leans against a haystack, her dress pulled down and draped about her hips (figure 50). The initial impression is that the subject has sought relief from the heat of the day, but the meaning goes much deeper. The large shapes in the foreground are the hindquarters of pigs, whose placement recalls the looming face-in-the-bush in Gauguin's *Women of Arles*. In the upper right corner, another more obvious pig shape appears, with the tail aligned with the woman's head. Gauguin has repressed the heads of the pigs and emphasized the hindquarters; similarly, the face of the woman is not visible, and only her back is exposed. Cast by the artist among swine, she will become Gauguin's prototype for the fallen Eve.

The canvases completed in Arles testify to Gauguin's increasing development of a personal myth. His grasp of "mysterious" subject matter had grown to the point where he now had a concrete imaginative vehicle to work with, a superstructure of legend which would support and enhance his stylistic innovation. His session with the intense Vincent had perhaps forced him into new confrontations with himself; certainly Vincent's challenges in the course of their overwrought debates must have opened him to higher levels of introspection and self-definition. In the vineyard painting, and to a lesser degree in his *Woman against the Hay*, Gauguin seemed to be reaching toward an allegory of womanhood, a parable about the course of woman's life for which he could not yet formulate a moral. Brittany, with its functionalist attitude toward women as laboring beasts, had given him a metaphor, but the sense behind his intuition remained mysterious even to him.

VIII

At the Black Rocks

A M O N G G A U G U I N's entries in the Café Volpini exhibition of 1889 was a pastel painting of a Breton Eve in a posture of anguish, seated crouched against a tree, hands pressed against her ears to shut out the urgings of the serpent which writhes menacingly behind the trunk (figure 56). The mood is one of hysteria and imminent disaster, with the main figure-in-conflict set almost allegorically against the source of confusion and doom—in this case, the tree, whose branches twist downward to threaten Eve, as if weighted with the evil of the snake which provides the force. Because Eve's situation and her fate were strongly reminiscent of his own, it is fitting that Gauguin submitted an Eve theme in this particular show. She too had been driven into exile by forces which had deceived and rejected her, and in her role as a victim she embodied his most extreme feelings about the status of an artist in European society. Gauguin's emotions on the subject of rejection ranged over a wide spectrum, from romanticism of the renegade hero, the Jean Valjean who winked lewdly at the proprieties of the straight world, to paranoid posturings of cosmic alienation which would rival the anguish of an Eve—at his weakest, Gauguin fell victim to the classic depressive delusion that he too was a victim of God's plot.

Paris in 1889 was in a great state of excitement over the upcoming World's Fair which was to open in the spring beneath the newly com-

pleted Eiffel Tower. The art world was to be represented in a Centennial Exhibition, in which the critic Roger Marx had managed, over considerable resistance, to include several works by such controversial painters as Manet, Monet, Pissaro, and Cézanne. In a world in which even these Old Guard radicals had to be smuggled through the back door, it was of course unthinkable that the current crop of innovationists, the Gauguins, Bernards, van Goghs, be represented. Gauguin reacted to the exclusion with his usual mixture of surly contempt and retributive energy, at once thumbing his nose at the quality of the exhibition and contriving plans to somehow be a part of it. His friend Schuffenecker provided a feasible solution to the problem by requisitioning wall space in a café next door to the official art section; the owner, Volpini, had been easily persuaded that choice examples of new art would better serve his decorative purposes than the 250,000 francs worth of mirrors he had originally ordered.

As soon as he heard the news from Schuffenecker, Gauguin set himself up as a one-man admissions committee, screening potential candidates, honing the exclusivity of the group. "But do remember that this is not an exhibition for the *others*," he wrote to Schuffenecker. "Consequently, let's arrange to have a small group of friends, and from that point of view I desire to be *represented* by as many works as possible. Please see to it that everything is done to my best advantage, according to the space available. . . . I refuse to exhibit with the *others*, Pissarro, Seurat, etc. It's our group! I intended to show only a few works, but Laval tells me that this is my turn and that I would be wrong to work for the others." [1]

Gauguin set up a provisional, list, allotting ten canvases each to himself, Guillaumin (who later refused to show with them), Schuffenecker, and Bernard, while the other artists in the group were to be more modestly represented; van Gogh was vouchsafed only six canvases because Gauguin did not consider him a touchstone of the new movement; ultimately his brother Théo discouraged him from entering at all. As Gauguin later explained to Théo, he regarded himself and Bernard as innovators of the new art and the others only as "substitutes," or followers, however competent, of his formulas. Exile was a sweet and fertile state for Gauguin, no matter how he railed against it; his alienation allowed him to enjoy the fruits of absolutist reign over a small but select dominion, to hand down dictates as he pleased, and even to select his subjects. Sweeter still was his status as a revolutionary, an archmember of a

persecuted minority. If his methods were dictatorial, who could condemn him for it, who could study his sufferings and deny him the right to hack out his place in the sun?

The painting of the anguished Eve bore a caption in pidgin French, the dialect spoken by Negroes in the French colonies: *"Pas ecoutez li li menteur"* (Do not listen to the liar). The critic Jules Antoine was provoked to ask in a review on what basis Gauguin supposed that Eve spoke Negro; Gauguin responded to this latest critical aberration in a letter to Émile Bernard: "What lunacy this article is!—it seems that Eve did not speak Negro, but good God! What language did she speak, she and the serpent?"

Gauguin's caption related not only to Eve's origins but to her nature as well. A reference in the journals of the Goncourt brothers reveals that pidgin French was commonly used among prostitutes; if Gauguin's Eve were to share this identity, she would have to be considered a Woman Tempted, and not merely a passive member of the forces-that-be. Eve's temptation by the snake recalls a Gauguin still life in which a young girl gazes with slanted eyes over the edge of a table laden with a rich display of fruit; she is a child-woman tempted by evil (figure 53). In following the Miltonic concept of the Fall Gauguin used fruit as a symbolic device which would propel Eve through sin to death. Just as Eve resides in the seducer, and desire resides in Eve, so the basic substance of sin, mute and passive in its beauty, is incarnated in the fruit. In Milton's *Paradise Lost* the apples of the Tree of Knowledge act as aphrodisiacs on Adam and Eve, driving them to a frenzy of lust which precedes the onslaught of shame. Having eaten of the fruit, Eve has incorporated sin into herself, has given form to her inchoate desires.

The snake and the fruit join forces to tempt another young girl in a vase Gauguin made in the winter of 1887–1888; the girl rears back in obvious fear, alarmed by the double assault on her senses (figure 52). Her attitude, like that of Eve or of her mythological parallel Persephone, is an ambiguous tension between attraction and withdrawal: her body is drawn inward with her knee up and away from the fruit, in an anticipation of the pose of the anguished Eve; her left hand reaches toward the fruit even while her right hand holds it back in a gesture of restraint.

As the vessel of desire Gauguin's Eve becomes potentially destructive, so that, even in a state of virginity, she must support the stigma of

sin. Innocence and guilt live as coexistent qualities in her, nurturing rather than negating each other. Eve's innocence is made more poignant by the imminent probability of its desecration. Gauguin seemed to savor not only the pre-nostalgia of inevitable loss but also the titillating qualities of despoiled youth. In the course of his life he often chose young prostitutes as mistresses, including the fifteen-year-old mulatto, Annah, whom he lived with for a time in Paris. His Tahitian "wife" Tehura was only thirteen when she came to stay with him, and she constituted, by his own account, his most successful female relationship. In 1895, in between his sojourns in Tahiti, he stayed at the Paris home of William Molard, whose thirteen-year-old stepdaughter Judith became the object of his attentions. Judith's memoirs recall a scene: "I went quickly up to Gauguin. He slipped his arm round my waist and, laying his hand like a shell round my budding breast, repeated in his gruff voice, which was barely audible: 'This is mine, all this.' Everything was his, indeed: my affection, my as yet unaroused sensuality, my whole soul. I stood up on tiptoe and raised my lips toward his cheek, but met his lips. I offered him my whole soul, as I offered him my lips, and all he had to do was take it." [2] As Judith sadly narrates, Gauguin did not follow through on his preliminary enticements; he considered her, despite her precocities, a well-brought-up girl, the daughter of a friend. He preferred to play the serpent to Eves already tumbled—however fresh the Fall.

Gauguin's sympathy for Eve was tempered by a certain male remoteness as well as a residue of puritanical morality; implicit in his conception of the anguished Eve of the Café Volpini is a condemnation of Eve's conduct after the Fall. His translation of Eve's anguish finds its origin in the nerves rather than the heart; she emerges as a hysterical woman, withdrawn, guilt-ridden, her head clasped in her hands as if caught within the latitudes of her grief. In *At the Black Rocks*, a woodcut which appeared on the cover of the catalogue of the Café Volpini show, Gauguin presented a similarly dark portrait of Eve: in the same crouching posture, she leans against a large black rock, while behind her another woman abandons herself to the waves (figure 58). The title refers to certain rocks on the beach at Le Pouldu which are coated with a flat-leafed sea weed that, at low tide and when dried by the sun, transmutes into a glossy, tarlike black coating. The seated woman holds her hands over her ears to close out the words of the snake, while the woman in the waves holds a fist to her mouth—hearing no evil, speaking no evil.

The black rock echoes the form of the tree in the painting of the anguished Eve—no doubt a bid for less obvious symbolism, carrying the same intimations of doom but declining to transcribe the message in literal terms. The beach is the setting for the Fall—the border between the earth and the waters, the primordial division between substance and the undifferentiated matrix of precreation.

The prototype for the pose of the anguished Eve is the girl in the foreground of *Vintage at Arles* (figure 49); her posture, with arms closely gathered and propping the head, and knees drawn up, is the first intimation of the pose and attitude of the Café Volpini Eve. Her features are repeated again in the girl in *Still Life with Fruits* (figure 53): the same slanted eyes, the brooding, almost sly, devilish expression, the hands supporting the face in withdrawn thoughtfulness, indicating a conflict between desire and fear. In *Vintage at Arles* the girl seems to be dreaming of freedom from the bovine domestic servility symbolized by the two grape pickers in the background and by the maternal figure at the left. The pinned-up aprons of the three women, forming pouches to contain the harvest, suggest pregnancy and thereby contrast the innocence of the girl with the labor of women after the Fall. The woman at the left is a deity of sorts, a maternal presence. The painting loosely follows the tradition of the Virgin in the walled natural garden, secluded from scenes of agricultural labor which are enacted outside the walls. Still a virgin, and therefore in her natural, or wild, state, the girl allows her hair to flow loose and uncovered, unlike the bound hair of the laboring, domesticated women. In this way she flouts decency by ignoring the proscription of the Church to cover the hair, which was rigorously adhered to by the Breton women. (Once when Gauguin coaxed a peasant woman to pose for him without her shift, she agreed only on condition that she be allowed to keep on her bonnet.)

The composition of *Vintage at Arles*, with its foreground rendering of a state of temptation contrasted with the settled, socially accepted norm of work and maternity in the background, casts the peasants as both harvesters and harvested. At the same time as they harvest the crop, the sustenance of human life, they are being harvested by mortality, cultivated while they are useful and then abandoned to the wages of time. The young girl in the foreground has a temporary amnesty; although she has turned her back on the grape pickers, she will herself be caught up in the harvest. Behind her at the left, the older woman in dark garb

with hooded head stands watch. She proffers her apron as if opening her belly to receive seed, to add to her harvest and increase her offering. Her pouch, like the belly of a pregnant woman, holds the fruit of the harvest; she seems to signify the presence of the Grim Reaper who will harvest the girl's youth. (In certain paintings of Gauguin's Tahitian period she will reappear as the Spirit of the Dead.) In establishing the polarity of the Fall in this manner, Gauguin goes beyond academic paintings of related themes, which only hint at the Fall by showing young girls resting, or musing idly, during their day of work, as if in transition between idyllic innocence and forced labor (figure 51).

Gauguin's Eve, in all her complexities of brooding desire and anguished withdrawal, has no precedent in the history of art. She is Gauguin's invention, but her pose was adapted from a specific source. On view in the Musée d'Éthnologie de Trocadero in the 1880s, and no doubt prominent in the displays of the World's Fair, was a Peruvian mummy, its legs and arms drawn inward and bound, its feet crossed, its head tilted and couched in the hands to approximate a fetal position, which was the customary burial position in Peru (figure 57).[3] The posture of Gauguin's Eve duplicates in eerie detail the posture of the mummy. Mere coincidence is ruled out by a comparison of the mummy to a figure in a woodcut that Gauguin made in 1897, *Be in Love, You Will Be Happy* (figure 83), which, in allegorizing the course of woman's life, included an image of the mummy as the symbol of old age and death: the hairless skull, the hollow eyes, the tilt of the head, the expression of the gaping mouth, and the crossed feet correspond exactly to those of the mummy.

This modeling of Eve in the form of the withered mummy counts as Gauguin's most mysterious iconographical coup. Genesis does not cast Eve before the Fall in a state of anguish, as Gauguin does. The posture and expression of the woman conveys grief, guilt, and despair, an extreme extension of the ambivalence between attraction to and fear of danger that is characteristic of figures in traditional loss-of-virginity motifs. It is a natural indrawn attitude assumed in indecision or resignation. The figure, in its fetal burial position, symbolizes the fusion of birth and death, which can be interpreted as a cycle of birth-sin-death, or of birth-death-rebirth. If it is assumed that the loss of virginity leads to death, then the moment of sin—in Christian terms, the Fall—marks the turning point in man's life, the beginning of inevitable and ultimate decline.

Gauguin's selection of the Peruvian mummy as a sympathetic vehicle for his imagery was not purely an arbitary and personal vision. A favorite contemporary romantic theme dealt with the inevitability of death in love, with the early death of fair women whose loveliness flowered briefly and intensely only to be cut down at its height; Baudelaire was the chief lyricist of the cult of tainted pleasure, which extolled the sensualities of doomed love and flesh marked for decay. Undoubtedly Gauguin was familiar with contemporary examples in literature telling of the ideal courtesan, epitomized in Marie Duplessis, who became the heroine of Alexandre Dumas's influential novel *La Dame aux camélias*. Consumptive, and expected to die young, Marie was noted for her pale skin; in tune with the romantic motif of sensuality intensified by the shadow of mortality, her illness increased her erotic impact. Marie always carried white camellias, probably as equivalents to the white lilies of the Virgin (after whom she had named herself) but also suggestive of white funeral flowers.

Gauguin's Eve is a romantic heroine of the same genre; her anguish takes the form of foreknowledge of her own capitulation to temptation and accompanying doom. She harbors within the confines of her flesh not only the newly realized potentialities of her sex but also the skeleton which embodies the diminishment of flesh, the shrinking of desire, and the slow withering which is the consequence of fleshly pleasures. Because of the intervening influence of the mummy, Eve's attitude has evolved from a sly expression of desire, as epitomized in *Vintage at Arles*, to one of anguished guilt in anticipation of death.

In *At the Black Rocks* Gauguin demonstrated the contrast between the two figures symbolically by portraying the unadulterated Eve in a frontal position and the fallen Eve from a back view as if she were hiding her shame and guilt. The two figures are a double aspect of one woman, whose attitudes sum up archetypal stopping-places along the road to doom. Gauguin's sympathetic portrayal casts Eve as the wanderer in a Pariah's Progress, courting death rather than truth, maturing to the stage of Contemplative Anguish before proceeding along a fixed route to the moment of Abandonment, at which point she throws herself with a cry into overwhelming waters. Yet the posture of the Woman in the Waves is so constrained, so taut with fear and instinctive recoil, that "Abandonment" would seem a misnomer. With one hand stifling a scream, and the other flung before the waves in an extension of the ges-

ture of negation, Eve has been abandoned by God; only in a limited sense, in natural innocence and human shortsightedness, would she abandon herself to a doom of oceanic proportions. The form of her fate is obviously the work of a master's hand.

The precedent for the pose of the Woman in the Waves, as well as an intimation of the punishment which awaited her, is found in *Woman against the Hay* (figure 50). Painted in 1888, the same year as the vineyard painting, it continues the saga of the girl who has been harvested. We see the back view of a woman, nude from the waist up, who has thrown herself against the side of a haystack, one arm spread out to clutch the straw, the other arm bent up and doubled back, her face pressed against her forearm—each element an antecedent to the pose of the Woman in the Waves. The initial impression is not of a nude woman but of a woman whose clothing has been dropped down; the blouse of the Breton-style apron lies loosely across the hips in homely fashion, suggesting in its very casualness that the undressing of the woman has greater significance than that of the classically draped nude.

Reiterating this theme are two watercolors (figures 54 and 55) related to *Vintage at Arles* and *Woman against the Hay*, both done around the same time. In the former a young girl, hands propping her face in the classic Eve-before-the-Fall pose, contemplates what appears to be a haystack, behind which a black rock is visible; in the latter, a woman viewed from the back holds before her a drapery which corresponds in texture to the haystack of the final version.

Hay itself is a complex medium, because it embodies two characters and two functions: although it takes form as the harvested dead grain, it also contains the seeds that regenerate its life. It is often equated metaphorically with water, for fields of grain moved by the wind resemble the undulating sea; it shares water's symbolic function as a mediatrix between life and death.

The evolution of the *Woman against the Hay* into the archetypal figure of the Woman in the Waves is an allegory for Gauguin's journey from genre subject matter to frank symbolism. His use of homely motifs —a peasant woman and hay—was reflected in the title he is said to have given the painting: *In the Heat of the Day*. Each element of the painting was out in the open, belying in its very simplicity the potentialities for more complex meaning; the commonness of the material obscured the strangeness of the dropped clothing, made it seem incidental. Not until

later, when Gauguin had achieved the courage of his concoctions, did the woman emerge as an ungeneralized and archetypal female figure, an incarnation of all women, in the grip of a cosmic and essential force which is its own metaphor—for water is a fundamental substance, like earth and air, amenable to metaphor but never to metamorphosis; thus grain can be likened to water, but water is reminiscent only of itself and must be the basis of comparison at the root of the metaphor. As the *Woman against the Hay* drops her blouse in the heat of the sun, so the Woman in the Waves goes naked in the light of the moon—a shift from a utilitarian to a religious act. In a similar transition, the girl in *Vintage at Arles*, with a group of women behind her, becomes Eve in anguish with the serpent behind her. Activities which previously were implied to have animalistic qualities emerge ultimately in frank animal form.

Gauguin's association of pigs with women may not have been totally Biblical in its orgins; in Brittany pigs were treated as pets and as objects of fashion, led on leashes by well-dressed ladies on promenades. In Gauguin's elaborate design for a plate, titled *The Follies of Love*, a pig is suspended from what appears to be a ribbon or scarf tied into a bow, reminiscent of a pig's curled tail; in the center of each loop is a slanted eye which betrays desire, and from the pig's belly a strange plant grows downward (figure 59). The rear end, with its curved tail, is set against the dark head of a young girl who seems to whisper to the hooded head of an older woman—another expression of what would become a classic motif of paired gossiping women. The forefeet of the pig are planted in a small outlined area enclosing a peacock atop a thorned flower. Legend holds that a flower grows thorns after it has been plucked; the peacock is both critic and commentary, a mockingbird chastising the vanity of Persephone, Eve, and all women who are plucked in a time of innocence and afterwards, in bitter knowledge, grow thorns. Bitter knowledge is, after all, what the old hooded woman imparts to the young girl.

The equation of women with pigs is not wholly Gauguin's predilection as a theme in art. It appears often in such scatalogical illustrations as those of Gauguin's contemporary Félicien Rops, and the Salon exhibitions regularly displayed scenes of equal lewdness, though couched in pastoral insinuations. One such depicted a girl musing dully surrounded by domesticated pigs eating from a bowl at her feet; one can readily conjecture that the girl, pausing from her lowly duties, is indulging in

swinish daydreams (figure 60). Émile Bernard also equated women with pigs, but he strove, as Gauguin did, for a total physical parallel rather than a sly hint of mutuality; in his vision women not only harbored piglike qualities but were interchangeable with pigs: in a zincograph of 1889 one peasant woman feeds potatoes to two pigs while another is bent down on all fours, aligned with the animals, her hindquarters paralleling that of a pig with swollen teats, the side-wings of her bonnet resembling the pig's ears (figure 61). Another work by Bernard features a peasant girl confronting a pig as if on common ground; this painting is analogous to one by Gauguin in which a young Breton girl exposes her breasts to a cow in a gesture of fellowship.

Gauguin saw the pig as a creature of instinctive—even enviable—stupidity. "I should like to be a pig; man alone can be ridiculous," he wrote in his journals. He implied that stupidity was more becoming in a pig than a man, more acceptable as a natural state than an achieved one. In equating women with pigs he was judging them as victims of a natural stupidity which brought them to a human downfall and made them candidates for a higher judgment; like the Miltonic God, he was foisting a moral judgment upon a natural instinct. His condemnation fell heaviest upon the heads of European women who submitted to their desires; he perceived them as guileful and cunning, all the more piggish for cloaking their instincts in the transparent garments of civilization, for ritualizing sex and love in the name of economic security: "When Madame is present (she is an honest woman because she is married) everyone is on his best behavior. When the party is over and they all go home, our honest Madame, who has yawned the whole evening, stops yawning and says to her husband, 'Let's have some nice piggy talk before we do it.' And the husband says, 'Let's not do anything but talk. I have eaten too much this evening.'" These women also aroused animalism in the eye of the beholder, who measured the value of flesh with a mercantile rather than a sensual vigor: "This very distinguished gentleman would tap his wife on the shoulder as much as to say to us, 'There's a fine piece of meat for you!' In fact, she was meat, nothing but meat. . . . And his little human pig's eye would add, 'This meat is mine, mine alone.'"

In Tahiti, Gauguin would revel in the natural and uninhibited love play of island women, who saw no virtue in chastity and so were noble in their "vice." The Tahitians were frank about the flesh and its needs; their sexuality was not denatured by laws or rules or pretensions to higher

meaning. Gauguin had once written that "in the pig all is good"—good because the polarity of evil did not exist. In indulging their instincts the Tahitians, like the pig, were being true to their nature; their activities, however animalistic, originated in innocence and retained purity.

The link between the Woman in the Waves and the woman with pigs leaning against a haystack goes deeper than a mere translation of substance into like substance. As the pig is a creature of instinct, unable to differentiate between good and evil, so water, as an essential substance, is undifferentiated, embodying in its unified nature, its formidable wholeness, several paradoxical functions. When she enters the waters Eve is submitting to a life force which will carry her along in its currents, for better or worse, for good or evil; she is yielding to a process which will give her form, but will also, ultimately, *conclude* her. The nemesis of Eve's sin, as enacted in her matriculation to the life cycle, and to hard labor, is the definition of her mortality.

IX

Calvary of the Maiden

W OOD AND STONE sculptures of the crucified Christ, ominous scarecrows, haunted the fields and crossroads of Brittany; in village churchyards the dark theme was elaborated with scenes of the Passion and the Pietà. Prohibitive in intent, functioning as a form of preventive medicine, they were designed to remind the laborer of the pain and decay which followed upon sinful indulgence, and to infuse in him a renewed guilt for the death of Christ.

The calvaries proved particularly potent images for Gauguin and other artists. So prismatic was the symbolism attached to them that the artist could virtually make of them what he would. They were intended to intrude upon the everyday life of the people, to confront them in the midst of daily tasks, to bring the doctrine of original sin and its consequences to a unique level of personalization.

In the *Yellow Christ* of 1889 (figure 63), a crucifixion set in the fields of Brittany, a group of Breton women kneel in a curve about the cross in attitudes derived from the assembly of passive women in *Jacob Wrestling with the Angel*. Their lowered eyes and clasped hands give them a penitential air; as representatives of the fallen Eve and inheritors of the stigma of original sin, they have been responsible for the suffering and death of Christ; they bear a measure of the guilt for his sacrifice. In this context the field setting becomes meaningful, for after the Fall man-

kind was condemned to labor in the fields. The vista of fields and pathways which forms the backdrop suggests that the burden which Christ bore beneath the cross is paralleled in the loads of the laborer, who traverses these same fields and pathways similarly weighted.

Gauguin fashioned his *Yellow Christ* after a polychrome wooden crucifix, which still hangs in the chapel of Trémalo near Pont-Aven, suspended from the timbered architecture of the nave arcade (figure 62). The flesh color of the model has a pale yellow cast, which is intensified in the painting. Gauguin in his rendering kept sufficiently close to the general conformation of the crucifix to evidence a careful scrutiny of the model; but he altered some significant details: in the carving Christ's eyes and mouth are open; in Gauguin's painting the mouth is closed, one eye is closed, and the lids of the other are slightly parted with the eye cast upon the viewer (a similar eye occurs in the sunflower in Gauguin's portrait of van Gogh at his easel.)

The Trémalo chapel model is the literal Christ: scourged, crowned with thorns, nailed to the cross, his side pierced; the expression on his face, contrived to elicit resolutions of guilt-salving conduct, is directed to the congregation. By contrast Gauguin's Christ gives himself over to suffering, is passively resigned to an ordained death; more noticeably than in the model, the feet are awkwardly crossed, emphatically immobile. The cross seems a fitting appendage to Christ's nature, an organic extension of his limpness, his paralysis in the face of fate. His body is weak and unmasculine, his expression passive beyond the point of resignation, as if death had already settled on him. The yellow pallor of his body is reminiscent of the yellow sunflowers in Gauguin's portrait of Vincent—the color functioning as a shroud which encloses the presence of death.

In his *Green Calvary* (based on a Romanesque calvary encrusted with green lichen at Nizon near Pont-Aven) the three Marys support Christ's lifeless body, which hangs with one arm dangling down, the other fallen against the hip (figures 64–65). The oldest Mary supports the head, the Virgin Mother the heart, and Mary Magdalene the waist and limbs. In Gauguin's version Mary Magdalene leans away from the other Marys as if the stigma of her sin were still with her, making her a pariah in the company of good women. The figure of a Breton woman appears at the foot of the calvary, her body beneath the body of Christ and echoing the curve of his figure. She grasps a handle which fades into

the border of the picture; the pose of her arm suggests that it might attach to a cradle. In his alignment of the woman with the dead Christ Gauguin intimates that she shares the crucifixion and that her own death, as he will later illustrate, is incarnated in the burdens of womanhood with its labors of childbirth and its submission to the will of man. A black sheep stares up at her from beneath the figure of the Magdalene, forming the third member of an implied triumvirate, an unholy threesome. In the background, life and labor go on in the fields: a woman walks along a path, a man hoists a rake, cows graze, a boat sails on the sea beyond. The setting is the beach at Le Pouldu.

On a calling card—*Paul Gauguin, artiste peintre*—found among the papers of Aurier, Gauguin jotted some notes on his *Green Calvary:*

<div style="text-align:center">

Calvary
cold stone
of the soil—Breton idea
of the sculptor who explains
religion through his Breton
soul with Breton costumes—
Breton local color
</div>

passive sheep
and on the right

<div style="text-align:center">

All in a Breton landscape
i.e., Breton poetry
point of departure (color
brings the circle into heavenly
harmony)
etc . . . sad to do
In opposition (the human shape)
poverty, etc.
</div>

The inscription might also be interpreted as an epitaph for the artist himself. Gauguin's identification with Christ, the suffering Christ, the Christ of the Cross, was beginning to affect his art, rendering his religious themes as private stages of the Cross and setting him up for an alliance with Eve.

Émile Bernard also exploited the Breton calvaries, but his interest was more utilitarian than Gauguin's; unable to commit his soul, he was content to intellectualize loosely on the theme, labeling it as "proper," that is, proper subject matter for the artist who perceived in Breton soci-

ety "a living Middle Age propitious to the blossoming of symbolism." The calvaries appealed to Bernard because their religious nature intensified their usefulness as popular imagery; symbolism, he felt, involved a simplification of language, and religious feelings were among the first that were translated. In Bernard's view the very nature of symbolism was religious.[1]

Using as a model the Christ figure in a Breton calvary (figure 69), Bernard universalized his imagery so that it might appear both timeless and contemporary (figure 70). The painting encompasses two distinct scenes within the same landscape, so that the viewer is presented with a dramatic progression, or a ritualized sequence of emotion. At left the three Marys kneel in attitudes of grief over the prostrate body of Christ laid out before them on a white cloth. The figures are elongated and stylized, almost decorative in the submission of flesh to form; similarly, the postures of grief are not in themselves presentations of sorrow but aesthetic ends which exist as patterns, just as figures on a tapestry contribute to the decorative whole. The three Marys are portrayed again at right, the Madonna supported between the other two in the aftermath of mourning; standing together with halos and arms linked, their united figures form a triptych—three aspects of one attitude. On the ground, between the Christ figure and the standing Marys, lie a skull and crossbones, relics of Adam who has suffered the spiritual death of eviction from Paradise. No attempt has been made to identify the Breton landscape; Bernard preferred to ritualize his background scene by concentrating on simple elements that would not compete with his figures: a hill, trees, rocks, a few dark clouds ribboned across the night sky.

This type of image was lurking in Bernard's mind when he painted his sister Madeleine in the Bois d'Amour, a picturesque wood near Pont-Aven much frequented by artists (figure 68). He said he had posed her in the elongated attitude of a *gisant*, that is, of an effigy on a tomb. Bernard's reference was more precise than he let on, however; surely the effigy he had in mind was a sculpture of the reclining Virgin Mary on the cathedral at Chartres, which corresponds to Madeleine's pose, and to her character, in surprising detail (figure 67). Bernard adopted the general pose, and specifically the position of the maiden's right arm bent at both elbow and wrist to couch the head. In both examples the eyes are wide open and have pronounced pupils. Madeleine's face is rendered in the linear mode of Gothic sculpture; as in the stone effigy, the brow lines

continue into the bridge of the nose, and the lips are sharply defined.

Bernard's affiliation of the image of his sister with the tomb effigy is a measure of his association of Madeleine with the archetypal "virgin in a meadow," Persephone or Europa, whose innocent flirtation with nature resulted in allegorical death. Bernard made one glaring deviation from the pose of the model: the effigy figure has her left hand over her genital area, in the manner of Venus *pudicita*, a gesture that focuses on the woman's virtue at the same moment that it draws the viewer's attention to the tabooed place. To hide it the woman must touch it, couch it in her hand as a precious possession, thus enhancing its value in the eye of the beholder (an effective ambiguity which has made Venus the goddess of both chastity and prostitution). Bernard was moved to repress the gesture lest he suffer a degree of incestuous guilt; he shifted the left hand to Madeleine's waist, safely midway between breasts and genitalia.

Gauguin was sufficiently taken with Bernard's painting to describe it in detail to van Gogh when they were together in Arles.[2] A year later, disturbed by Bernard's forced medievalism, van Gogh wrote Bernard a blunt criticism which held up the painting of Madeleine as the positive pole of comparison. He chastised Bernard for the affected manner of his *Adoration of the Magi*, a photograph of which Bernard had sent him at the hospital at St. Remy, but softened the castigation with soothing comments on a picture by Bernard that Gauguin had told him about: "Last year you did a picture which I imagine to be somewhat as follows: on the grass, which fills the foreground, lies stretched full length the figure of a girl in a blue or white dress; behind her the edge of a wood of beech trees, the ground covered with red leaves which have fallen, the tree trunks grey-green giving the effect of vertical stripes. . . . I said to myself what a simple subject, and how well he achieves elegance with nothing." [3]

To the letter van Gogh added a sketch which is either striking proof of his ability to retain images (Gauguin's description of Bernard's painting was a year old) or evidence that Gauguin supported the verbal description with a sketch of his own which van Gogh held in memory (figure 66). Whatever the case, one detail of Madeleine's pose is altered in van Gogh's sketch: Madeleine's left hand is placed over her pubis; van Gogh (perhaps Gauguin too) restored this hand to the position it has in the model at Chartres.

This incident attests to Gauguin's interest in Bernard's painting of

Madeleine, which may have influenced Gauguin's composition of *The Loss of Virginity* (figure 73), in which the girl's pose is similar to Madeleine's. The influence would not have been the pose, however, as Gauguin's choice of pose is in line with academic tradition, but rather the subject; Gauguin was infatuated with Madeleine, who consoled him in his solitude at Le Pouldu. The girl, then seventeen years old, was possessed, as her brother described her, of the true soul of a saint. Gauguin thought wildly of abducting her, but Madeleine's father intervened. His wistful vision enshrined Madeleine as an idealized virgin—a Child of Mary, a sister virgin—despite the fact that in his thoughts he had threatened her virginity.

In *The Loss of Virginity* the elements of the setting are neatly specific: the girl is lying in the harvest stubble; near her feet is a pool of blue water, and below it a single bundle of grain; a dark hedge isolates her from a background of harvested fields, grassy dunes, and the distant sea. A group of peasants, led by children, are crossing the fields, coming from the seaside road toward the chapel that lies behind the painter's vantage point.[4]

Although the girl's eyes are open, she seems to be frozen in a death-like state. Her feet are crossed one over the other, as were the nailed feet of the crucified Christ. Her head lies back, and she gazes unseeing at the sky. The pose is reminiscent of the crucified Christ in Bernard's calvary, who also lay supine staring upward, his arm stretched straight along his side. The location of Adam's skull is the same as that of the bundle of grain in Gauguin's painting. Also, like Madeleine, she lies in open nature, but Bernard's woodsy springtime setting has been rejected in favor of a stark autumnal landscape whose prime vegetation is the harvested grain.

Gauguin's fusion of the Christ image with virginity was perhaps derived from the legends attached to the Breton calvaries themselves. Many of them were inscribed with apologies to the crucified Christ; certain inscriptions admonished young girls to guard their chastity, costuming the moral in vivid tales of sin and punishment calculated to draw a young girl's interest. A popular story of this genre narrated the crime and hard fate of one Catherine the Lost, who was beguiled by the devil in the form of her lover and condemned to a terrible death.

The relationship of the crucifixion to the loss of maidenhood is twofold: on one hand, the death of Christ finds its *raison d'être* in the fall of woman—it is, in a sense, a direct result of the Fall; on the other hand,

the crucifixion forms a parallel to the loss of virginity, for the virtuous maiden is made to suffer at the hands of cruel and sinful men. The latter theme appeared frequently in romantic literature of Gauguin's time and, as a pervasive literary motif, was known as the Calvary of the Maiden; it underwent many variations, but its one constant decreed that the maiden's virtue always be punished by death. Stories of the persecuted maiden were popular during the Middle Ages and were revived in eighteenth-century France and England, carrying through into the writings of Baudelaire, Flaubert, Poe, Gautier, and Zola, which Gauguin knew.[5] In this tradition the piety of the persecuted maiden heightened the erotic effect of her demise at the hands of demonic, sadistic lovers; the taint of sacrilege illuminated and lyricized the process of her destruction. The white lily, the traditional attribute of the Virgin Mary and the virgin saints—who were often martyrs—is also associated with the loss of virginity in modern scenes of seduction, for it is a symbol of both purity and death. The sacrilegious character of seduction seems to manifest itself in the male's wish to experience the original seduction of Eve in her virginal reincarnation. In Gauguin's painting the profanity is heightened by a subtle allusion to the seducer as a priest: the paw of the fox on the girl's chest recalls the priest's hand placed on the chest of the dead in the absence of a cross. (Among the exploits of the wily Reynard the Fox, the most popular in medieval French imagery casts Reynard in the role of a priest, delivering a soulful sermon to a flock of geese. When Reynard's touching words cause the passive geese to close their eyes in piety, he slyly makes off with the tenderest of his congregation. Depictions of this scene occur in Breton church sculpture (figure 76) and in tales of Reynard the Fox which were handed down from generation to generation.) [6]

The girl's deathlike state is reiterated in the unconventional setting and in her peculiar pose. Instead of lying in a traditional grassy spring-time meadow, as would be expected, she is stretched out on her back in the stubble of the harvested grain. She is in fact equated with the single bundle of grain at her feet, which also has fallen in a parallel direction to her body, the heads at the left and the stalks at right, all bound by a swatch of grain corresponding to the fox's forefoot across her chest.

In the agricultural society of Brittany the grain took on a spiritual as well as a practical significance. An old country tradition required a straw cross to be hung over the wooden one at harvest time as if to imply that the grain, in being harvested, was undergoing a sort of crucifixion

and that it would redeem itself by sprouting anew in the spring (figure 74). In examples of Breton popular imagery, admonitions to young girls are accompanied by images of the crucified Christ with an offering of harvested grain (figure 77). Certain sections of the Breton countryside retain the custom of placing a bundle of grain before the altar in the manner of a sacrificial offering, perhaps to persuade the gods to look favorably upon the next year's crop. In certain Breton churches an autumnal service is offered in a setting that includes a bundle of grain before the altar and a row of smaller bundles in the background; over each of the latter a fox's tail is draped (figure 75). The configuration recalls an ancient Thracian tradition which holds that a weak man may gain strength and virility by draping a fox over his shoulder; the tradition was generally sustained throughout Europe. The fox is universally imbued with sexual prowess, and the physical similarity of the fox's tail to a ripe ear of grain helps to explain the ritualistic association of the two. In Brittany, when the ripe grain is waving in the wind, it is said that "the fox is in the grain" and children are warned to stay out of the fields.

The most strongly established stories and customs about the fox are those associated with the harvest, are essentially the same throughout France. Most of the beliefs about the fox at harvest time are connected with the last sheaf. In many areas of France the fox is believed to hide in the last bundle of grain, fleeing before the reapers, always clever enough to hide behind successive bundles until only one is left standing, behind which he must remain.[7] This folk belief may account for the presence of the single or the last bundle of grain in *The Loss of Virginity*, overlooked by the harvesters, from which the fox might have emerged. The idea is suggested formally in the sketch for the painting, in which the fox visually blends into the background field of grain by means of the hatching, which continues in texture from the body of the fox into the grain (figure 71). Related harvest traditions involving the fox are those in which the last sheaf itself is called the fox. When the reapers are cutting the last grain, they leave a handful standing and throw their sickles at it; the man who hits it is called the Fox, and two girls deck his hat with flowers—a custom that recalls the tradition of decorating the Roman fertility god Priapus with flowers. In the evening a dance is held, at which the Fox is allowed the first dance with all of the unmarried girls and is expected to take certain liberties in keeping with the character of his totem. Even the harvest supper is called the Fox, and

the expression "We have eaten the Fox" means that the harvesters have partaken of the supper. The harvest supper thus has a sacramental character: the grain spirit is believed to be embodied in an animal, which is slain in the last sheaf, and whose flesh and blood are eaten symbolically by the harvesters. This too relates the Calvary of the Grain to the Calvary of Christ. The general concept underlying these customs, then, is that at the end of the harvest, in the autumn, the old deity must die, to be reborn in the spring—a common symbolic pattern of most vegetation myths, which finds its most classic expression in the story of Persephone.

As an agent of cosmic renewal Christ is associated with both the calvary of the maiden and the calvary of the grain. The Agony in the Garden parallels the state of the maiden in open nature—at the mercy of unscrupulous men and, ultimately, punished for being virtuous rather than as a due result of sin. Yet, through the imposition of sin upon her, the maiden becomes fecund and produces new life, as Christ, in dying, established the promise of eternal life. Thus, the maiden achieves sanctity and fulfillment by grace of her rape, as Christ achieved divinity by grace of his crucifixion. In the same way the sacrifice of the grain is essential to the renewal of the crop. Christ's benevolence, intrinsic in the bequest of his death, was to subsume the evil of original sin within a greater good—the promise of eternal life. In this context the rape, the sacrifice, the crucifixion become part of a divine plan which has at its base the maintenance and extension of the life force. The Breton legend of Catherine the Lost, associated with the Calvary of Christ, operates for the social good; in admonishing young girls to preserve their chastity, it regulates the normal issue of procreation.

The maiden courts rape as Christ courted death—but her motivation has little to do with previsions of salvation. In *The Loss of Virginity* it is the girl who plucks the flower; thus she unwittingly brings about her own seduction by placing herself in an open unprotected area, and then compounds her crime of naïveté by casually plucking flowers, a direct yet deadly submission to desire. She is victimized not only by her innocence but by the vanity implicit in her cravings.

The iris that the girl holds is Gauguin's substitute for the traditional lily, the symbolical equivalent for both virginity and death. Gauguin may have chosen the iris because it is much more common in France, especially in Brittany, than the lily and therefore more geographically appropriate to the rustic setting in the painting. The iris is a spring

flower and a misfit in the autumn scene, emphasizing the sequence from spring to autumn, or from birth to death, in the cycle of life.

Gauguin may also have adopted the iris as a means of avoiding the traditional symbol, which was weakened by contemporary academic painters, whose stock imagery would include a whey-faced girl reaching to pick a lily as her lover poises to seduce her—a pallid modernization of the Persephone myth. Gauguin once stated that he would never use a lily to signify virginity, as did Puvis de Chavannes, because the symbolic translation would be too obvious; he was referring to Puvis's allegorical painting *Hope* in which a pure young girl, seated on a rock in a meadow, holds a small plant (figure 72). Gauguin owned a photograph of the painting and had interpreted it so that it fit his own symbolism, disavowing not only Puvis's style but also his intentions; his statement seems to be masking his intention through denial. Ironically, it was Gauguin himself who used a plucked flower to symbolize the loss of virginity, rather than Puvis, whose painting he misread. The young girl in Puvis's painting is not holding a flower but a small plant or tree, and the background is not a meadow of flowers but a field covered with crosses marking graves. Puvis's theme of hope partakes of the traditional regenerative image of new growth on old wood; the crosses in the background act as a foil, contrasting death with the hopeful potentiality of the little girl holding the plant. Gauguin's questionable interpretation reveals his own preoccupations and attitudes: he saw in the girl another lost maiden of vanquished virginity, and in the crosses a foreshadow of her ensuing death —an interpretation which would fit precisely his own symbolization.

The plucked flower is linked with death and, ultimately, with the revival of the grain in the Greek myth of Persephone, daughter of the earth goddess Demeter. The youthful Persephone was gathering narcissus in a field one day when Pluto, Lord of the Dead, erupted from the bowels of the earth and proceeded to carry her down to Hades to be his bride and queen. In grief and anger at her child's fate, Demeter decreed that the seeds would not grow out, nor the corn sprout, until her pirated daughter be restored to her. Fearful of the consequences of Demeter's act, Zeus ordered Pluto to restore the maiden to her mother—which he did, but not before feeding her a pomegranate seed to ensure that she would return to him. Zeus proscribed that from that time onward Persephone must spend two-thirds of the year in the upper world with her

mother and one-third with her husband in the nether world; upon her ascension to the higher realm the earth would bloom with life and vegetation, which would wither into a wintry death with her descent.

Persephone epitomizes the motif of the innocent maiden alone in nature, open to the whim and will of dark forces. Significantly, the flower which led to her downfall, to her capitulation to the forces of hell, was none other than a narcissus—Greek symbol of vanity. She had dared to leave her companions and expose her beauty to the elements, and in her vanity she was vulnerable to evil. Pluto himself betrayed vanity in his abduction of the flower-like Persephone, for he who desires a flower must destroy it in order to possess it. In stealing her away for his pleasure, Pluto removed the maiden from light and life, thereby possessing her only in a state of diminution. The original Narcissus, who pined and died for love of his own beauty reflected in a pool of water, was probably escorted to his death by just such a chaperon as Pluto—in the person of a water spirit who also emerged from the bowels of the earth to drag the boy's soul (as incarnated in his reflection) underwater, leaving him a soulless shell.

The bittersweet story of Persephone was popularized in the late 1880s by the appearance of Édouard Schuré's *Les grands initiés*, which gave equal attention to Christ, Buddha, and Persephone. Schuré was already known for his *La vie mystique* and *Les grandes légendes de France*, which drew upon Breton folklore; preceded by such notables, the publication of *Les grands initiés* in 1889 probably had immediate impact. Only indirect evidence connects it with Gauguin's painting; the critical passages are those that link Persephone with Christ. Schuré writes that the story of Persephone, which likened life to an expiation, or a trial, was an astonishing revelation for each soul, a divine drama of man—"in other words, the drama of the fall and of the redemption in its hellenic form." [8]

Gauguin's concept of virginity holds that the maiden is more vain than innocent, that in harboring sinful thoughts she has already aligned herself on the side of the damned. In this rigid view, the contemplation of vice is evidence of lurking contagion which exists already in potential if not in exercised fact. Like Narcissus, the lustful virgin who dreams of exploiting her charms has put her soul in jeopardy. Even in capitulating to a stronger will, she is guilty of willful submission; she embraces her

own weakness in the person of her lover. The caresses and ravages of her seducer are her due reward—penance meted out to fit the measure of the aberration. Thus in *The Loss of Virginity* the girl embraces her seducer, the fox; she has accepted him as her lover.

The fox is, in the classic tradition of masked mystery men, someone else in disguise. It departs from its life model in the reversed slant of its eyes; the eyes of a true fox slant downward from the bridge of the nose, whereas the slanted eyes conceived by Gauguin associate his fox with a stereotyped Oriental physiognomy—and, more crucially, with the devil, who is often portrayed with Oriental eyes. By 1890 the Oriental eye had become a cliché in French art. Bernard and van Gogh both used it—van Gogh in the self-portrait-as-Buddhist which he gave to Gauguin, whose avid interest in the Orient may have spurred the conception.

In a letter to Émile Bernard, Gauguin described the fox in *Be in Love, You Will Be Happy* (figure 84) as the "Indian symbol of perversity." The Oriental concept of the fox as seductive and lascivious is carried through in *The Loss of Virginity*, but blended with two Western traditions: the fox as both priest and devil, and the fox as a symbol of fertility, a spirit of the grain.

Gauguin's conjunction of the slanted Oriental eye with diabolism was not new to his art. He had used it as far back as 1888, at Arles, when he gave slanted eyes and a sly, perverse expression to the young girl seated in a vineyard, dreaming of forbidden pleasures (figure 49). He repeated this evocative physiognomy in the painting of another young girl looking with desire at a sumptuous display of fruit laid out on the table—the random display echoing the girl's own unbridled instincts (figure 53). And in the symbolically rich painting of Meyer de Haan, the devil-fox, replete with red hair, pawlike hands, and slanted eyes, stares down at the books tossed upon the table as if they were to be devoured (figure 80). Complementing these objects of lust, bathed in the eerie light of a lamp, a plate of apples mediates between the viewer and the books.

Milton's place on the table of temptation is fixed, but why Carlyle? Gauguin could not read much English and only a few parts of Carlyle's book had been translated. Yet *Sartor Resartus* had found a place among the essential props of the French romantics, who were also attuned to Baudelaire's lyrical Miltonic Lucifer.[9] The hero of *Sartor Resartus* was,

like Baudelaire's Lucifer, an angelic-demonic personality, split down the middle. As others have noted, Gauguin in his angelic-demonic *Self-Portrait with Halo and Snake* (figure 8) entrusted his own personality to Baudelaire's scheme.[10] Carlyle's Herr Teufelsdröckl (devil's dung), whose life and opinions constitute the book, had, in his creator's words, "the look truly of an angel, though whether of a white or black one might be dubious."[11] Much of the content is couched in symbols, and an important section deals with clothing which shrouds the body's shame. The moral skepticism which permeates Carlyle's writing was in keeping with Gauguin's own predilection to jockey both the cynical and the spiritual positions on the Fall.

De Haan's foxy attitude evokes an image of moral degradation, but his pose has also aroused comparisons with the contemplative pose of the creative artist as fixed in tradition by Dürer's *Melancholia* and Rodin's *Thinker*—the latter exhibited in 1889 at the Galerie Georges Petit; the *Thinker* originally surmounted Rodin's *Gates of Hell*.[12] Closer to the core is a comparison to the Martiniquan devil, who, as described in Martiniquan lore, looks from a distance like a squatting man, but on closer approach is seen to have red hair and the feet of an ape. The fox-devil de Haan appears in a later painting, *Barbaric Tales*, in a dwarfish, hunched pose behind two girls; his exposed foot, with long toes and nails, is primate rather than canine (figure 81). Gauguin might have fused the Martiniquan image with a Breton belief that the devil, who appears as a gentleman, can only be recognized by his one deformed foot.

De Haan's own physiognomy contributed to Gauguin's fabrication of this composite creature. He was a hunchbacked dwarf, just over five feet tall, with red hair and beard and odd pointed features. A contemporary wrote of de Haan's eyes that "they bespoke the wiliness of their host"[13]—a fitting trait for a foxlike devil whose hobby was religious philosophy, both orthodox and occult. His attribute was an enormous twenty-pound Bible, which he carted about as if to counterbalance the weight of his hump. Bolstered by a red fez, fluent Hebrew, and a thick Dutch accent that enhanced his image of mystic and scholar, he bested Gauguin in philosophy. He also outdid him in an amorous affair with their inkeeper at Le Pouldu, Marie Henry, who was tall and robust, an object of compensation for de Haan's diminutive and sickly physique; out of his customary generosity, which was at this time sustaining Gau-

guin financially, de Haan vouchsafed to Gauguin Marie Henry's maid. Gauguin's ensuing spates of jealousy broke this odd, symbiotic friendship. When de Haan retreated to Paris he left Marie pregnant and Gauguin to fend for himself. No doubt this affair contributed to Gauguin's interpretations of de Haan's physiognomy.

De Haan's self-portraits show that his self-conception was not alien to Gauguin's interpretation; he emphasizes his penetrating eyes, his tight mouth suggestive of a mastery of speech, his large hand with long, articulated fingers like the feet of an ape (figure 79). Gauguin's elaboration of de Haan's physiognomy was presaged by pre-Darwinian speculations on the animal-in-man, such as the early-nineteenth-century drawings by Le Brun equating human types with animal species; the features of his foxmen mirror the soul of a fox (figure 78). French romantic writers from Baudelaire on calculated the color and definition of eyes and the color of hair to reflect externally the subject's inner character. In the painting *Nirvana* (figure 82), in which de Haan presides over the Fall of Eve, Gauguin gives his anti-hero contracted pupils—evidence of night sight native to the devil himself and to his emissaries the cat and the fox; faint traces of a devil's cap appear on de Haan's head. In a sculpted image which Gauguin made of de Haan the eyes glow green with cruelty and vice[14]—as they also appear in *Barbaric Tales*—and the head is surmounted by a copulating rooster, whose foul image appeared also in Gauguin's painting of Eve picking the forbidden fruit. De Haan poring by night light over the texts of Milton and Carlyle is an evocation of the devil who presides over the fall of the maiden. His compatriot the fox gazes with voracity—out of red eyes with dot pupils—upon the fallen girl in *The Loss of Virginity*.

Milton's version of the forfeit of Eden was a direct inspiration to Gauguin in the evolution of his own Eve saga. All of the Salon paintings that touched on the virginity theme treated it in the traditional lighthearted, idyllic way, as if the loss of innocence blithely made room for pleasure. Academic depictions of the fall of Eve were coy and low-keyed; often an early-adolescent girl innocently eyeing an apple made a starlet's debut as the Earth Mother. Rarely does one find examples that emphasize the bitter consequences of an abduction or a fall. Gauguin preferred to follow Milton in treating the dark side of the prototypical myths; his symbolization derives less from the story of Europa, who, after a brief fright, accepts readily her abduction by a god, than from the legend of

Persephone's abduction by Pluto, in which the loss of virginity is strongly associated with death.

The elements of Milton's story are almost identical with those of the Greek myths. After a troubling dream the preceding night, the virginal Eve wanders away at dawn from Adam's protection, just as Europa and Persephone wander away from their companions. The setting is a bountiful meadow of flowers and fruits, and it even includes a pool of water, an equivalent of Eve's purity, which reflects her image as she gazes into it, Narcissus-like, to admire herself. In the vulnerability of her vanity, Eve is easily tempted by Satan in the form of a serpent; he is the seducer disguised as an animal, as was Zeus, and he is also a counterpart to Pluto, likewise a ruler of the underworld, who emerges from the interior of the earth in the tradition of the serpent-devil dwelling in the infernal waters. As Persephone picks the narcissus, the flower of vanity, so Eve picks the apple, motivated by the vanity of emulating God, seeking knowledge forbidden to man; as Eve eats the apple, so Persephone eats the pomegranate which guarantees her return to the realm of death. The two legends, so alike in their particulars, share a common conclusion: each heroine suffers a seduction which brings death into the world; in the Greek myth it comes in the form of the death of nature and the crops during the winter of Persephone's term in Hades; and in the Christian context, in the form of man's mortality following his expulsion from the Garden of Eden.

Both Eve and Persephone are instruments, and in a sense victims, of the higher powers. Persephone was caught in a power struggle between the gods, and Zeus, in his Solomonic wisdom, saw fit to resolve the conflict by dividing her in half, by passing her back and forth between those who loved and coveted her. She was truly a living sacrifice, a pawn whose virtues must be marketed and whose happiness martyred to the pursuit of cosmic balance. As a consequence of Pluto's abduction and Demeter's vengeance she was doomed to return periodically to the realm of death—a maiden crucified not once and for all but, in true Grecian style, again and again for as long as the world turns.

Eve too was a crucified maiden, used by God to cleave good from evil. Like Persephone, she existed before the Fall in a state of innocence and easy grace, unrealized and undefined. As a virgin she was flesh waiting to be formed—or waiting for a creator to shape her. Both vulnerable and malleable in the hands of a creative manipulator, she is used as a

defining device, whose function it is to elucidate polarities. Thus Persephone was the mute tool by which the underworld was separated from the upper, barrenness from fecundity, the world of the dead from the world of the living. Eve in the first stage of her being lived in a unified world—was herself, in her evolution from Adam's rib, an extension of his own body, a part of himself. United with Adam in bonds of common humanity, the only other member of his species, she combined with him to complete him. Never having known desire, she was not armed to deal with frustration; never having known sin, she had not developed moral equipment. God's forbiddance of the Tree of Knowledge was the first imposed morality in Eden; laying down this single archetypal law, God set Eve up for her Fall as neatly as if He had felled her with a bolt of remedial lightening.

The wrath of God also forsook Christ, allowing him to be crucified for what he was intended to do, and the betrayal reverberates in Christ's words from the Cross: "My God, my God, why hast thou forsaken me?"

In the *Agony in the Garden* of 1889 (figure 6) Gauguin chose to render Christ in his own image, in its most docile evocation; his Christ is the quintessential "gentle man," almost female in his passivity and thoroughly humbled by Judas's betrayal. He stares at the ground beneath lowered lids; his hands droop listlessly, clutching a white handkerchief, a weeping cloth which looks ahead to the white cloth which Eve will later hold over her shame. The most dominant feature of this Christ is his attitude of submission; like Eve or the vulnerable maiden, he waits in the garden for his fate to come upon him, and like Eve or the maiden, he will be sullied by a viper, in the person of Judas, who is posed in the background like a stalking faun. He has chosen not to act, and Judas only fulfills a function in bringing him to the requisite martyrdom, as the snake brought down Eve, as the fox brought down the maiden. Christ was made to bear the result of mankind's sin in much the same way that women must take the consequences of the original sin of Eve; it is in the nature of womankind to be weighted with men's guilt. Once again, a tree separates the passive Christ from the activities of Judas and the soldiers; the tree branch nearest Christ follows the contour of his body and then abruptly turns away, as if in a parody of his own turning away from action. The trees in the background incline forward, also aligning with his body, in submission to the direction of a powerful wind. Gauguin had

chosen to envisage himself at the mercy of the forces of evil, but the duality of his nature did not permit him to take refuge in one role; that same year Émile Bernard completed an *Agony in the Garden*, and in Bernard's representation of Judas, Gauguin saw a likeness of himself; for this offense Bernard was only lightly admonished.

Calvary of Eve

THE ANGUISHED Eve lived out her virginity, her first incarnation, as a tragic heroine caught in the clutches of a single overwhelming circumstance: her vulnerability; her accessibility to guilt. The breadth of her existence was bordered by the immense orb of her Fall from innocence to guilt. In the wood relief *Be in Love, You Will Be Happy* (figure 84) Gauguin for the first time relieved Eve of her burden of singularity by subsuming her in the cycle of post-Fall life with its diffused daily pains. The threatened Eve is joined by future extensions of herself—wife, mother, crone—and her anguish loses its elemental purity, becomes servility, exhaustion, malice: *diluted* in complexity.

A large figure of a woman of exotic origins, a Martiniquan or Negress type, predominates in the center section of the relief; her body is heavy, maternal, and she clutches her right wrist with her left hand in a fused gesture of submission and resistance. Above her, in the right corner, is a large effigy of Gauguin himself, in the self-described role of an "infant monster," sucking his thumb; a disembodied hand, which reaches downward to clutch the woman's, belongs to this figure.

The relief is divided into three sections by a wishbone-shaped construction which extends from the top downward, then wings off with one arm in each direction; thus the matronly figure in the large central sec-

tion is separated from the grasping hand on the upper left by a barrier, and from the infant monster on the upper right.

The figures crowded in interstices relate to the awakening of the dead in scenes of the Last Judgment, as in the tympanums of Rouen and of Amiens, where, with awakened limbs and bewildered minds, the arisen react to the call of trumpets and uncertain fate. More directly comparable to Gauguin's hellish implication is Michelangelo's *Last Judgment*, in which Minos, god of the underworld, entwined by a snake and with animal ears, is placed in the lower right corner, in the same location as the fox in Gauguin's relief. Under the gloating eyes of Minos, Charon unloads his barque of lost souls. Sympathetic to this nautical motif, Gauguin has patterned certain of the interstitial figures after the figures of the damned in Delacroix's *Barque of Dante* (figure 85): the old woman who has gnawed through the barrier relates to the figure of a man gnawing the gunwale of Dante's barque; the head which emerges from behind the barrier just beneath the word *heureuse* has its model in the figure behind Virgil, who clings to the side of the boat. In a later work, a woodcut which Gauguin also gave the title *Be in Love, You Will Be Happy* (figure 83), in which the mummified Eve appears as a polarity in the life cycle, Gauguin surmounted and amplified the cycle with female images, one modeled on a female figure in Delacroix's *Wreck of Don Juan* (figure 86). His imagery of hell was infused with the fate of those claimed by the sea—further evidence that the woman who casts herself into the waves shares the fate of the damned.[1]

The suffering of the doomed who have been cast into hell for their sins held particular magnetism for Gauguin. He related his own trials as an exiled artist to the furies of hell, as if, in being possessed of art and seeking to keep his pure artist's soul from the flames, he was nevertheless doomed to suffer in the upper world the fate of the damned. He wrote to Émile Bernard in 1889, describing a pot cast in his own image, which he had sent to Bernard's sister Madeleine: "You have known for a long time and, I wrote it in the *Moderniste*, I look for the character in each material. But the character of the ceramic in stoneware is the feeling of the high firing, and that figure burnt to death in that inferno, expresses, I believe, the character rather strongly. Such an artist glimpsed by Dante during his visits to the inferno.

"Poor devil driven in upon himself, in order to bear the suffering.

Such as it may be, the most beautiful girl in the world can only give what she has."

Be in Love, You Will Be Happy is an ironic message, as acidic as a veiled threat, to all girls who have given what they have—and been damned for it. In his description of the relief Gauguin puts the title in the mouth of the infant monster who bears his visage—a creature of instinct who reaches to grasp his prey. In another attempt at irony Gauguin's hand comes down from the margin in the manner of the hand of God in medieval art, drawing souls upward to heaven. Yet the woman resists salvation. She wears a wedding ring, a symbol of bondage, and has already committed the original sin; if, according to Biblical interpretation, her salvation lies in childbirth, then the very act which cleanses her soul would break her body and bind her to earth. Gauguin has a dual role as the lustful lover and the infant monster who sucks his thumb as he sucks the life energy from his mother.

The maternal woman shares the center panel with the figure of an anguished Eve who sits, hands to face, astride a fox. Appropriately, the two female figures are linked by an orchestration of flowers which seems to sprout fresh and full-blossomed from the body of Eve, then grows downward beside the body of the fox until at last, in final descent, one wilted flower, its petals drooping and stem bent, falls in subjection upon the knee of the maternal woman—a minute allegory of the cycle which ends in the Fall. Although Gauguin clutches at the older woman, his heavy-lidded gaze falls upon Eve, who waits to be devoured by his brutal life force; the figure whispering in his ear is perhaps an evocation of Virgil himself, an intimation of conscience who brings proof of the power of intelligence to monitor instinct.

The fox is an evocation of the devil, placed on the right side of the relief, in the traditional devil's seat in Last Judgment scenes—to the left of Christ; in Michelangelo's *Last Judgment* Minos, king of the underworld, a snake wrapped round his body, reigns in the same lower right location. The fox has a two-sided function: he is at once the *vehicle* of sin, bearing evil within him in the depths of his nature, and the *attribute* of sin, bearing evil upon him in the person of the girl. The weight of her sin is upon him as he carries her off to hell—even as Pluto carried Persephone.

The figures which surround Eve carry connotations of temptation rather than death, of potential doom rather than enacted doom: the large

figure of instinct nagged by moderating reason; the fox with its timeworn characteristic of plotting to trap the prey before taking it. The maternal woman is attended by agents of death which reiterate her fully achieved doom; she has come the full cycle. Directly above her, sharing space with the infant monster's clutching hand, is the arm of a drowning swimmer from Delacroix's *Barque of Dante* whose mouth gnaws convulsively at the barrier, as Delacroix's swimmer sought to devour the boat; having eaten through the barrier, he will then be free to sink his teeth into the woman, not for delectation, as Gauguin might wish to devour Eve, but for sheer carnivorous nourishment, as a vulture might demolish dead flesh, as shipwrecked men, maddened by hunger, take to consuming one another.

An animal attribute of the maternal woman, at the upper left, is a Martiniquan marsh rat, symbol of death in that country. Even in the West rats in holes are traditionally associated with the devil and death; they emerge during times of natural disaster, floods, and sieges of plague, carrying contagion wherever they go and contaminating whatever they touch. A nautical tradition holds that when rats leave a ship before it sinks, their defection forecasts death.

A second animal attribute appears on the snoutlike form at top center, beneath the segment of the title which reads "happiness"; it is a little dog, a domestic animal, wearing a collar around its neck as its human counterpart wears a wedding ring—another small construction of Gauguin's bitter wit.

The figure which carries the heaviest weight of connotation is also one of the most obscure; functioning as a sort of allegorical monogram, it is placed in center stage, lost between the enormities of the infant monster and the maternal woman. A small, bowing female figure, it is based on Degas's *Exhausted Ballerina*, and on a surface level it carries through Gauguin's running theme of futile vanity. But in a large sense it epitomizes the exhaustion and dejection of the other figures, each of whom has come to hard use: the broken body of the maternal woman, the sucked thumb of the infant monster, the sapped strength of the swimmer, the cannibals devouring wood in place of flesh, the ringed finger, the collared dog, the wilted flower—each figure has come full cycle, has lived out its own diminishment and death. Even the aggressors are exhausted in their evil: the features of the infant monster are slack, embodying instinct robbed of vitality, going blindly through the motions of lust, with eyes

drawn shut. The *cycle* devours the vitality, sapping the spirit from lust through repetition—a ceaseless and helpless round. In the anonymity of death the devoured merge with the devouring, good with evil, feeding on each other until polarities are swallowed up and all merge in common doom: even the sinful fox must bear the weight of the sins of Eve. As exhaustion is the last answer to vanity, so death is the final answer to love. Plainly, love leads not to happiness but to perdition, damnation, and annihilation.

Be in Love, You Will Be Happy was exhibited in *Les XX* exhibition in Brussels in 1891. The peculiar quality of the work moved critics to high rage, and, as if personally attacked, they castigated the presence of vice where no vice had been intended. One reviewer called the work "an erotico-macabre temperament of a genius of lewdness, of a dilettante of infamy who is haunted by vice." [2] Another, reaching more operatic heights of disgust, spoke of "the deformed sculpture of a sadistic faun, whose kisses are slobbery and disgusting, whose forked tongue sensuously licks a beard impregnated with slime." [3] Gauguin had dared to impose his personal vision on the romantic conventions of the day, to expose the underside of love without coyness. His symbolism, however mysterious, was free of evasion, and the critics could not forgive him his refusal to wink lewdly in the presence of the viewer. In criticizing him they were forced to resort to personal attack, expressing their revulsion in thick and tactile terms as if Gauguin's works had lingered like a bad taste on their sensibilities.

Gauguin made a companion piece to *Be in Love, You Will Be Happy* entitled *Be Mysterious* (figure 88). The central figure is a nude woman, hand to mouth, who appears to be throwing herself into the waves; a flower, floating disembodied to her left and mounted by a peacock, may have been tossed away in the force of her plunge. In the lower left a female head with exotic physiognomy appears like an apparition, following the sweep of the waves; it unites with a hand raised in a stop gesture. Another exotic head, its features sufficiently defined to identify it as Martiniquan, looms in the upper right corner, in the place of the moon, its hair curving like a crescent, with the body of the face completing the sphere; the outer edge of the circle is formed by a continuation of the wave pattern, culminating in what may be a stylized snake's head. Taken separately, the motifs would indicate a theme of abandonment to instinct; the woman hurls herself into the waves as if she cannot

help herself, one hand stifling a scream, the other thrown back, with fingers spread as if to ward off what is to come. The warning hand does not stop her; rather it seems to form an epitaph to her doom. The woman-in-the-moon functions as an objective deity; she overlooks the scene of temptation from the vantage of the upper right, casting a mediating influence, a suggestion of the eternality of the pattern, which takes its place in an Oriental round of eternal life. It is not known what depth of Oceanic legend was imbibed by Gauguin before departing for Tahiti, but his interpretation of lunar deities of the South Seas, as described in *Noa Noa*, may reflect a pre-Tahitian prejudice: "The counsel of the moon who is feminine might be the dangerous advice of blind pity and sentimental weakness. The moon and women, expressions in the Maori conception for matter, need not know that death alone guards the secrets of life. . . ."

The double aspect of the moon in *Be Mysterious* is a small puzzle within a larger one. True to its title—and to the philosophy of its creator —it abounds in intimation but defies ultimate solution. The critic Albert Aurier wrote in 1891 that this work "celebrated the pure joys of esotericism, the troubling caresses of the enigma, the fantastic shadows of the forest of problems." [4]

The figure of the Woman in the Waves was reiterated in a painting also exhibited at the Café Volpini, and subtitled *Undine* (figure 87). Although Gauguin may not have provided the title, it proves fitting, for sirens and undines represent the dual nature of women. Until the mid-nineteenth century in France, Germany, and England, the siren prevailed over the undine in art; as the water nymph of academic painting she was seductive yet playful. Cabanel's *Pearl and the Wave*, which captured the first prize in the great Paris World's Fair of 1855, typifies the academic use of this motif in its coy association of the caressing wave with the surrendering woman.

Gauguin's Woman in the Waves is to be associated with the undine, rather than the siren, species of water spirit. The fishlike nature of sirens refers to the relationship between the waters (and the moon) and woman; in the undines it is the feminine, or perilous, character of the water which is symbolized. Undines are naturally wicked, embodying the treacherousness of rivers, lakes, and torrents. According to legend an undine could acquire a soul by marrying a mortal and giving birth to his child. As the heroine of a German fairy tale available in numerous French translations, Undine was a changeling in a fisherman's hut when

) 117 (

Sir Huldbrand fell in love with her and married her. He soon abandoned her for a mortal woman, and Undine was brought back to the sea by her own sisters; she returned to Huldbrand on the day of his wedding to give him a fatal kiss. Undine appears in numerous guises in later nineteenth-century art and literature. She was the first representational figure in High Art Nouveau: Gustav Klimt depicted many water nymphs, whose hair combined with climbing plants to conceal their nudity. Young girls embodying the Undine image, with passionate, longing eyes, half-closed lips, and long, undulating hair, are typical *femme fatale* subjects for late-nineteenth-century art.

In Gauguin's time, in France, water was symbolically a perilous medium. Storm-tossed boats and shipwrecks had been favored subjects in the romantic imagery of the first half of the century. Géricault and Delacroix worked the awesome rage of the sea, in contrast to the academic painters whose imagery subsisted on allegorical descriptions of the sea as a seductive, sensuous female body. The sea, like a woman's body, was eulogized as both the originator of life and the deadly seductress, thus neatly summarizing the polarities of female nature, creation and destruction. Gauguin's Woman in the Waves inverts the concept of Undine, for in taking on the role of the fallen Eve she casts herself willfully if fearfully into the depths of the sea (figure 58).

Gauguin compounded his own symbolical formula for the wave, fusing the life-force of the man with the perilous abyss of the woman, which receives man to conceive life and then lures him again to its depths where he eventually dies. With each entry man dies a little as he emits his life-force, and with each birth woman dies a little as she gives life to a new generation.

Immersion in water is also a form of regeneration, of cleansing oneself of the original sin, as in baptism. Water can "symbolize the universal congress of potentialities, the *fons et origo*, which precedes all form and all creation. Immersion in water signifies a return to a pre-formal state, with a sense of death and annihilation on the one hand, but of rebirth and regeneration on the other, since immersion intensifies the life-force." [5] In this way Western and Eastern philosophies merge, as they merged in the image of the fallen Eve casting herself into the waves. Buddhist doctrine conceived Nirvana as the ultimate emancipation of the transmigrating soul, the attainment of a beatific freedom from worldly passions and evils by means of annihilation of desire, or by absorption into the divine.[6]

According to Buddha, life is suffering and sorrow (a belief to which Gauguin clearly subscribed); suffering and transmigration result from desire (thus the anguish of Gauguin's tempted Eve); the only escape from desire is through its systematic annihilation (thus Gauguin's Eve casts herself into the waves). One of Buddha's formulas for eclipsing desire, along the Eightfold Path, was to renounce sexual pleasure.

The nature of water in its relation to the life cycle is inherently paradoxical in its capacity to engender and destroy: "The cosmic waters are the immaculate source and the inevitable grave. Through a power of self-transformation, the energy of the abyss puts forth, or assumes, individualized forms endowed with temporary life and limited ego-consciousness. For a time it nourishes and sustains these with a vivifying sap. Then it dissolves again without mercy or distinction, back into the anonymous energy out of which they all arose." [7]

Around 1888 Gauguin was inspired to illustrate an episode from Poe's *Descent into the Maelstrom* in which an innocent youth, like the youth in the vanity coffin, is drawn by the deadly whirlpool into the depths of the sea. Later, in his book *Noa Noa*, Gauguin would write of the sea as God's medium of destruction and the grave of the past: ". . . the deep waters, which had once engulfed the sinful race of the living for having touched the tree of knowledge."

Gauguin may have been influenced by Oriental metaphors of the sea as the masculine pole of life, of Yin-Yang, the life formula that divides the perenniality of the female substance from the vitality and forcefulness of the dominating male element, which, because it is energy rather than matter, must rise, expend itself, and fall, like the phallus or the wave. The wave at its climax beats against the female shores, receptive thighs, and is expended in foam; its life energy is absorbed into the unfathomable depths. A distinction can be made between the wave of death, an active force which overtakes and carries off the body in its current, and the passive waters into which the body is received and dissolved in preparation for rebirth as a new form. Thus the anguished Eve echoes the Peruvian mummy's fetal pose, encompassing in her being both death and rebirth. The sullied Eve who steps into the water emerges as the Virgin Mary, washed of sin after having borne new matter—a child untouched by sin, living in a state of innocence.

The child is, of course, born unknowing, unable to distinguish between good and evil. Presumably, as it grows it will be weaned from its

state of innocence by a tempter and thus be forced out to take its place in the life cycle. In Gauguin's work, as well as by historical appointment, the concept of the animal seducer is firmly entrenched. If one accepts the concept of the Tempter as a Knower then the animal must be recognized as the bearer of instinctive knowledge. An animal's level of knowledge remains consistent from birth to death, for the beast acts only upon its instincts, making no choices which will affect the course of its life and therefore suffering no decline. Animals have constant knowledge, so for them, as well as for the unknowing, there is amnesty from the life cycle. Milton's serpent adopted the tongue of man, a refinement of intellect rather than of instinct, in order to deceive Eve, and Eve, beguiled by this display of "human" knowledge, was dealt a deathblow with the weapons of her own kind. Gauguin's statement that "in the pig all is good" gains validity in this Miltonic light; in his bestial state man is virtuous, and only when he applies the fig leaf of civilization to his proud nakedness does he become "ridiculous." Inevitably, the fig leaf mocks and memorializes the nakedness it was meant to hide.

In Hindu mythology the symbol for water is the serpent, called Ananta or "Endless," which supports in its coils the Lord of Maya, or life energy.[8] The serpent is an invincible life-force set in a mortal sphere; it has the power to rejuvenate itself by shedding its skin. The merging of serpent and water images is compelling because it allegorizes a union of the invincible, self-rejuvenating life cycle with the most instinctive form of knowing—specifically, the tendencies and attitudes of the deeper unconscious, of which water is a ubiquitous symbol. The abyss is universally associated with knowledge: in French *un puits de science* means a man of profound learning. The Eves who abandon themselves to water are giving in to instincts which they cannot control; they are, in giving birth, regressing to the amorphous condition of their beginnings, when knowledge was total, undifferentiated as good or evil. The serpent as tempter is a manifestation of Eve's own underground nature, which fertilizes the waters as it bestows life. It is fitting that serpents should attend the goddess Hera, also known as Mother Earth, whose Tahitian counterpart, Hina, was later to figure in Gauguin's themes. The serpent represents the bondage of nature, which keeps the captive Eve both earthbound and deathbound.

Unlike the serpent-tempter whose wiles resided in Eve's own nature, the fox-tempter seems to represent a more impersonal knowing, a

shallower form of desire. Gauguin's first form of Eve tempted is foxlike: the girl in *Still Life with Fruits* (figure 53) simply lusts after the fruit, for desire is immature in her, free of more serious consequences. Her foxlike eyes, and the foxlike presence of Meyer de Haan lusting after knowledge, represent the primary stage of desire, pure instinct, which is dangerous because it has not yet been afflicted with conscience. In the Middle Ages the fox was often depicted as being hanged by flocks of geese, his potential victims; the geese, as representatives of civilization (a synonym for human intelligence and all its concomitants), have arrested and are about to stifle predatory instinct, which would otherwise overcome them. This metaphorical attitude was sustained in the nineteenth-century tales of Reynard the Fox. In Hindu art the goddess Kali is sometimes represented as carrying a noose in order to capture wild animals and bind the enemy; the noose, according to doctrine, stands for knowledge, "the master-force of the intellect, which seizes and fixes with a firm hold on its objects." [9] Civilization's founts of wishful and willful thinking, its moralizing and reasoning power, seek to keep down the ravages of instinct.

The foxlike image of Meyer de Haan in *Nirvana* (figure 82) features slanted eyes set beastlike in high cheekbones which taper down to a pointed beard; the ears are slanted and tapered. De Haan is placed in the foreground, with the heads of two women directly behind him, the anguished Eve on his right and the Woman in the Waves on his left; he holds before him a plant that twists downward in a serpentine shape. Gauguin habitually places the figure endowed with phallic power between the two Eves, as he placed the rock between them in *At the Black Rocks* (figure 58).

Gauguin's choice of the title *Nirvana* for this work, which follows the familiar theme of loss of innocence leading to death, implies that the scene is essentially one of rebirth. This allusion is supported in his use of the Peruvian mummy pose, a fetal position, for his Eve before the Fall, and in his recourse to water symbolism, with its universal connotations of death and rebirth, in the motif of the Woman in the Waves. The fox-devil is a masculine figure of base nature; it represents desire itself, predatory, demanding, undifferentiated as good or evil, with no thought to the consequences. It is the male instinct which stalks the quarry, enjoys it to the point of satiety, and then departs to hunt for another victim. The fox does not abandon himself to his senses; rather, he indulges them

coldly, in an almost vampire-like relationship to the object of pleasure, using it and leaving it to die.

The theme of rebirth is intimately connected to the concept of fatal knowledge. The need to know, and to increase knowledge, is yet another cosmic inevitability which has been divinely induced; it follows in the tradition of the betrayal and crucifixion of Christ, the rape of Persephone, the sin of Eve. To seek knowledge is to court an absolute, to explore alternatives in search of an essence—and to risk losing sight of the essence altogether in the complexities of the search. The gift of life is foisted upon man as God foisted Eden upon Adam and Eve, leaving them to wallow in their unannotated paradise, daring them to question his bequest. Tradition decrees that one must never look a gift horse in the mouth, but it sometimes ignores the threat at the root of the homily: if one questions, one risks the withdrawal of the gift; thus the only safe attitude is passive acceptance of a given situation, studied aversion from the source of things. Generations of fishwives, former Eves all, bitter wisdom now tempering their withering teats, shake the crone's nest, raise the stop-finger to warn and chide: "If you're afraid of the fire, stay away from the flame," or more appropriately, "Don't go near the water." The gist of their wisdom is to stay away from sources and avoid essences, to maintain the *pattern of existence* without bringing existence to the *polar point of life versus death.*

Knowledge is fatal because it leads to the ultimate question of the roots of self and the origins of life; in the vernacular of crones and prelates, knowledge is translatable as original sin. Ironically, it is necessary to re-enact the sin in order to be reborn. This, then, is the knowledge which the experienced would prefer to withhold from the innocent for as long as possible. Born in a void, in a state of undifferentiated innocence, we use sin as a fulcrum to propel us back into the void—the blankness and finality of death—and over our dispossessed bodies the ritual is intoned: ashes to ashes, dust to dust. We seek to die in a state of grace, to be absolved of our sins before we re-enter the void. The priest seals our absolution with holy water, bringing the passage of this essential substance to its inevitable end in the life cycle—a journey which began with the waters in the womb and at the baptismal font, and which takes its eternal form in the blood of Christ as transformed in the sacraments.

Gauguin's great testimonial painting of 1898, completed just before his attempt at suicide and meant to stand as a summation of his life's

work, was titled *Where Do We Come From? What Are We? Where Are We Going?* (figure 120). The painting features a representation of each stage of the life cycle, but even here overtones of fatal knowledge invade the Eden-like exposition: at the feet of an old crone, a reincarnation of the Peruvian mummy, sits a white bird with a lizard in its claws, representing, in Gauguin's interpretation, "the futility of vain words." Perhaps he referred to the hopelessness of seeking answers to such questions, or to the ruthlessness of the cycle, which at once consumes and subsumes all attempts to annotate it. Of the three questions, only the first is truly basic; the other two are its offspring and can only be answered in the light of its tutelage. In discovering his origin a man also confronts his identity, his essential trappings, his birthright of worldly equipment— thus, to know who he is and what he is made of, he must know where he came from. The fatal knowledge may emancipate him for a time, but it will ultimately doom him; no matter what good omens are presaged in the past, the ultimate fate is the void—the first and last stop in the circular syndrome.

For all his mockery of "vain words" Gauguin was intensely preoccupied with his own origins. As his symbolism grew in sophistication, his quest also grew franker; he sought to evoke an image of his past so that he might support and nurture—and perhaps justify—his constructed image of himself. His burden of guilt at leaving his family was great, and to offset it he had only his own convictions of his destiny. To don the mask of a Jean Valjean, to comport himself as an artist in renegade's clothing, was not sufficient cover. It was necessary for him to build a dream environment to house his image and to harbor his inclinations. He had cried "savage" so often, mocking his wife with this convenient antithesis to all she believed, buoying his compatriots with tales of lush Edens which would succor them as corrupt Europe could not. If some thought his inclinations aberrational, then he could only plead natural causes and put the blame on his Peruvian blood, which, to hear him tell it, pulsed with primitivism undiminished by time, distance, or years of French upbringing.

Gauguin's construction of his Eden took form in an 1890 portrait of an exotic Eve poised to pick a blossom from a small flower tree (figure 89). Although a serpent is coiled around the tree, the mood of the painting is serene, almost sublime; the lush vegetation lends a paradisal aura, intimating that Gauguin was already anticipating his next year's trip to

Tahiti. Employing a device which he would use repeatedly all through his stay in the South Seas, Gauguin derived the main figure from a photograph of an ancient monument; in this case the body of Eve is based upon the figure of Buddha in a frieze of the Javanese temple of Barabudur (figure 90).[10] It is fitting that Gauguin, in the role of self-styled savage, should portray the exotic figure of the Earth Mother in a primitive tropical setting, but a further detail makes it clear that Gauguin was thinking not only of mankind's origins but of his own: the head of Eve was copied from a photograph of his mother (figure 91).[11] In portraying his mother as Eve, Gauguin was stating that Peru was where he came from, that therefore, in his present existence, he was a savage, that a tropical paradise was his destination: the syndrome re-enacted in his own terms. His migration to Tahiti, where he would be self-sufficient and free of money worries, able to "love, sing, and die" in rapt progression, at peace with the cycle at last, was a journey backward to the era of his Peruvian childhood, the womb of his first conscious years. As he himself stated, his art was the hobbyhorse of his youth.

The drive to begin again was powerful in Gauguin. It afflicted him at all levels of existence, the pragmatic as well as the fantastic. Before leaving for Tahiti he would give ardent expression to his recurrent wish to make a fresh start in his marriage: "Goodbye, dear Mette and dear children; love me well. When I return, we will begin a new marriage. What I send you today, therefore, is a betrothal kiss. Your Paul." While talking with Charles Morice he broke down in tears and spoke of the "terrible sacrifice" he had made in abandoning his family to pursue his vocation.[12] Yet he was also capable of taunting his wife with visions of a complete new start in the new world, as in this letter of February 1890: "May the day come—and perhaps soon—when I can flee to the woods on a South Sea island, and live there in ecstasy, in peace and for art. With a new family, far from this European struggle for money"

He wished to be a child again as he had wished to be a pig—because children cannot be ridiculous. As a child he had been accepted for what he was; now, in his middle age and still bearing the same instincts, he felt impelled to return to his natural habitat, which was not only hospitable to his needs but also logical for his nature. If he were to return to his family he would be forced to abandon his true being, but in returning to his mother and her world he would meet his being head-on. Thus, in a

curious way, his thoughts of going back to his family in Denmark were more fantastic than his dreams of a tropical Eden.

In setting his mother up as the resident Eve in his Eden, Gauguin was only reinstating her to her proper place—no doubt she had resided there in his memory through all the years of his growing up. While still young he had seen her removed from a golden world into an epoch of grayness which ended only with her death. His fortunes had echoed her own until, in an effort to recover what he had lost, he had chosen to go to sea in the hope of achieving his own entrenched myth once again. Ironically, she had died while he was at sea, and he had received the news long after the event, upon reaching port. Perhaps it seemed to him that he had lost his other parent to the waters—a bizarre memento of the father he had barely known, who had died aboard ship and whose body was abandoned en route. His further journey was bound to take on the nature of a quest—to find himself, and also to redeem his mother's image in his mind. He had seen her descend from the "veritable spoiled child" of her Peruvian family to a careworn dressmaker whose worries and responsibilities hastened her early death. Years after, with the image of the anguished Eve already growing in his mind, Gauguin's first sight of the Peruvian mummy at the Musée d'Éthnologie must have triggered a psychic explosion. (In his journal, while recalling his childhood, he described a rich cousin as a "perfect mummy" and went on to add that "the mummies of Peru are famous.") In the fetal pose of the withered figure he may have seen an allegory of his own mother's downfall and death— and of her ultimate redemption. No doubt it was of great urgency to him that she, as the epitome of all Eve images, be redeemed, that her image be cleansed and renewed, so that it might remain sacred in his memory.

The nature of the envisioned salvation is revealed in the naming of his only daughter, his favorite child, after his mother. At his last meeting with his family in 1890 she alone responded to him with spontaneity and warmth. He recalled her response in a letter three years later: "Mademoiselle is off to the ball. Can you dance well? I hope the answer is a graceful YES, and that the young gentlemen talk to you a lot about your father. It is a way of indirect courtship. Do you remember three years ago when you said you would be my wife? I sometimes smile at the recollection of your simplicity."

He felt for this child, whom he saw so rarely, an empathetic affec-

tion; of all his children she seemed to him most like himself. In Tahiti he put together a small book of a confessional nature; in dedicating it to his daughter he expressed himself with unusual fervor: "The ruminations are reflections of myself. She, too, is a savage; she will understand me. . . . But will my thoughts be of use to her? I know that she loves and respects her father. . . . At any rate, Aline, thank God, has a head and a heart sufficiently uplifted not to be scared and corrupted by the demoniacal brain nature has given me." [13]

Tragically, Aline was to die in 1897, at the age of nineteen, of pneumonia contracted after coming out of a ball. Mette had informed him of the fact in a curt letter, the last he was ever to receive from her. His reply is full of his pain, which "sank deeper every day that passed," propelling him into a profound depression: "I have just lost my daughter. I no longer love God. Like my mother, she was called Aline. We all live in our own way. Some love exalts even into the sepulcher. Others—I do not know. And her tomb is over there with flowers—it is only an illusion. Her tomb is here near me; my tears are her flowers; they are living things."

The love which "exalts even into the sepulcher" Gauguin had felt for only two beings, his mother and his daughter. In each he saw the imprint of his own savagery, which, by its very presence, was a validation of his nature. In a sense, death and distance facilitated whatever degree of love he was capable of; the rhetoric of the heart is truly exotic in a man who can barely force the fatal syllables past his lips: "To say I love you would break all my teeth." Yet he loved the two Alines because he saw his image reflected in the images he held of them; in the limitations of his vision, enclosed by ego on all sides, he loved them as he loved himself. For this reason it was crucial for him to uplift the image of his mother; the purity of his own image as an artist was at stake, the validity of his renegade self. His mother must be deified lest the knowledge of his origins prove deadly to his own self-esteem.

Did he see his mother reincarnated in his daughter? Such a literal translation is suspect, but the form of rebirth which it implies is central to Gauguin's conception of Eve's salvation. He held to the classic Puritan belief that childbirth, or the creation of a sinless being, is the only reparation for the original sin of Eve; however, he made no moral judgment upon Eve for her sin, nor did he conceive of the act of childbirth as righteous punishment. He sympathized with Eve far too deeply to con-

demn her. In his vision, childbirth was a repayment for sufferings rather than a reparation for sin. The suffering artist in him, the effeminate Christ passive in the grips of pain, was only another aspect of the crucified maiden whom he chronicled so carefully at each stage of her calvary. After hearing of his daughter's death he wrote in anguish to William Molard, "Bad luck has dogged me since childhood. Never any luck, never any joy. Always adversity. And so I cry: *God, if you exist, I charge you with unjustice and malice.* You know, on hearing of my poor Aline's death I could not believe in anything any more and laughed in defiance. What is the use of virtue, work, courage, and intelligence?" In common with Eve, he had given in to his instincts, acted according to the nature given him—and in return for this he had been made the dupe and victim of God's plot.

It would seem that, for artists and women alike, suffering at the hands of a vain and callous God is inevitable. Salvation comes in the form of an option: to use one's creative powers and thus to challenge God at his own task. In producing a work of art—or a work of flesh—one begins to emancipate oneself from the iron hand of the primal creator. The strength of the new creation lies not only in its sinlessness (synonymous with its present invulnerability to divine justice) but in its potential for perfection. The newborn child has not yet been marked by the cycle; similarly, Gauguin, unwilling to give up his creator's might, never allowed his art to fall into a pattern or to be subsumed by any movement which might stifle its development. Although constantly bemoaning his worldly plight, he was obsessed with the struggle to stay free of fate—a struggle which, he was careful to note, "springs from pride and not from vanity."

Toward the end of his journal, in a section devoted to stances of suffering, he seems to slip almost involuntarily into a partnership with Eve. They meet on Calvary hill, each bearing a cross-weight of grievances: "Laughing, you climb your Calvary; your legs stagger under the weight of the cross; reaching the top, you grit your teeth—and then, smiling again, you avenge yourself. Spend yourself again! Woman, what have we in common?—The children!!! They are my disciples, those of the second Renaissance."

⚹ XI ⚹

Logistics

WHEN GAUGUIN at last sailed for Tahiti on March 31, 1891, he would carry with him a shotgun, a French horn, two mandolins, and a guitar. With the shotgun he hoped to hunt the wild beasts of the Tahitian jungle, thus to supplement the lush fruit which hung from the trees for all to pluck and eat. The musical armory, less deadly but equally devastating to paradisal peace, would enable him to fulfill his desire to sing and love for all the rest of his days. Practical even in his madness, he had taken care to provide himself with the necessities of tropical life.

This incredible stroke of naïveté, as ingenuous as it is comic, attests not only to the force of Gauguin's dream-delusions but also to the influence of his adoptive coterie, the symbolists, who bolstered his fantasy by contriving an ethical basis to support it, who laid the groundwork for his great symbolic gesture. Like indulgent parents they ushered him off to the New World with an honorary celebration and a blessing in the form of a favorable review.

Gauguin's unofficial alliance with the symbolists is a case of personal development coinciding neatly with the evolution of a trend in time. For years Gauguin had pursued his own course, grappling, as far back as 1885, with "the translation of thought into a medium other than literature," with the rendering of the "simplest form" of the dream.[1] He never

had to evade naturalism, or to pass through a naturalistic stage and then reject it; always, his imaginative faculty grew commensurate with his technical proficiency. In his life as an artist he was self-liberating, propelled toward change by the force of his own instincts rather than by the pull of a group or a particular master. Even the early portrait of a nude woman sewing becomes, in the grossness of the subject's reality, a symbolic object, whose nerves and blood are isolated and offered for perusal along with the mandolin and the cloth-and-needle.

His contact with Émile Bernard, who had followed the more standard route of rebellion, caused him to solidify into the "public painter" who caught the imagination of the symbolists-to-be. Bernard was a young man of talent in search of a focus; he had left the academy for impressionism, in the wake of Toulouse-Lautrec and Louis Anquetin, but the limitations of the movement did not suit his particular intelligence. As a painter he was more purely mental than Gauguin, more attuned to the formulation of processes and to the studied hatching of ideas. He was most powerful on a conceptual level; as a figure in history he emerges as a writer in painter's clothing, annotating his every move with a precision which is almost Darwinian—in contrast to Gauguin's annotations and descriptions, which repaint the picture in verbal brush strokes, never analyzing the image but presenting it in a state of translated immediacy, in the manner of an announcer giving a blow-by-blow description of a prize fight.

By the time he became intimate with Gauguin in the summer of 1888 at Pont-Aven, Bernard had already evolved a new style, called cloisonnism, from a study of medieval stained glass and Japanese prints, which involved the use of heavy outlines to surround and define forms. Gauguin had been traveling a similar route in his own work, and he was as receptive to Bernard's "little sensation" as he had been to Cézanne's. They worked together as compatriots, but, as proved ultimately unfortunate for Bernard, the roles of master and pupil were firmly fixed by the fates of personality and circumstance. Bernard was twenty years Gauguin's junior and by nature indecisive and vulnerable; in his correspondence with Vincent van Gogh, he confessed to feeling afraid in the presence of the older man, timorous about working before him. The precocity of Bernard's intellect did little to buffer him from the stings of criticism, and Gauguin, while receptive to Bernard's work—and to his adulation— was a notorious dispenser of dictatorial advice. The ruthlessness of his

nature, which had prevented him from being anyone's true pupil, must have devoured Bernard's concepts whole, so that they were transformed in a natural and unself-conscious way into the matter of his own work. What Cézanne knew by instinct in 1881, when he accused Gauguin of coveting his "little sensation," Bernard would be forced to learn through painful experience.

At the inn at Pont-Aven Gauguin and his friends occupied a pariah's table. A young painter named Paul Sérusier, seated with the academicians, was attracted by the spirited dialogue of the errant group. Not until the end of the summer could he summon the courage to penetrate the group's insularity and seek out the apparent leader, Paul Gauguin. His interview with this renegade so electrified him that he returned to the Académie Julian as a disciple, intending to disseminate Gauguin's teachings among the students. He carried with him a cigar-box cover on which he had hastily painted a landscape in pure colors, following Gauguin's instructions; this he brandished before his fellows in the manner of a friar marketing a mini-grail, a touchstone, a sacred relic which would prove the existence of the new art. By way of explanation he repeated the master's words: "How do you see that tree? Is it green? Then put down green, the most beautiful green on your palette;—and this shadow, is it especially blue? Do not fear to paint it as blue as possible." [2]

In the force of his enthusiasm Sérusier soon mobilized a core group of his fellow students to stand the radical line. As often happens in the primary stages of such groups, they began by generalizing their radicalism, negating all movements which had preceded impressionism and lionizing each trailblazing trend which came after. They called themselves the *Nabis*, from the Hebrew word meaning "prophet," which encompassed not only their worldly task of theorizing about the future of art but also their predilection for mysticism and the occult; they were pleased to regard themselves as divine intuitors, senses pressed to the keyhole of the cosmic mysteries. Maurice Denis, Sérusier's fellow theorist, describes the group's fledgling explorations: "Thanks to Paul Sérusier the milieu was far more cultivated than that of most academies. We spoke regularly of Péladan, Wagner, the concerts of Lamoureux, and of Decadent literature, with which we were hardly acquainted. A student of Ledrain introduced us to Semitic literature, and Sérusier held forth on the doctrines of Plotinus and of the Alexandrian school to the young

Maurice Denis, who was preparing for the examination in philosophy for a *Baccalauréat de Lettres*." [3]

Meanwhile, Gauguin was building the glass house wherein his public image might reside, wary host to stones and stares. At Pont-Aven he had been known and honored as the best painter, the master, and his work had grown in power and definition as if in response to congenial surroundings. There he had painted *Yellow Christ*, the *Breton Calvary*, and *Jacob Wrestling with the Angel*—each work conceived supravisually, the form born from the idea. The exhibition at the Café Volpini had served as a showcase for Gauguin's masterhood; he had selected his fellow exhibitors from among his Pont-Aven satellites so that their work, grouped around his, might enhance his own accomplishment. The *fact* of a movement, which had appeared like a spontaneous eruption in the wake of his personal experimentation, appeared to give him pleasure. He related to it not as a participant but as an originator who, having casually sowed the seed, observes with detached pride the bastard child who thrives on air.

The young painters who had formed Gauguin's circle were a sort of postwar generation of the arts: born too late to do battle, they had inherited a vacuum of infinite possibilities; the freedom to experiment had been won, but motivation and direction appeared to have departed with the mobilized armies; one could seek stimulation in what had gone before, or share a generalized sympathetic reaction to upheavals in the other arts. The impressionist movement had hit with the impact of an underground coup; revolutionary in its potential, it struck with the banality of home truths; the simplicity of its premise was stifling as well as liberating. The new generation of painters were faced with a *fait accompli:* they had observed the overthrow of academic naturalism only to see it replaced with a new naturalism which was profound in its implications but equally limiting in its possibilities for growth. Maurice Denis, a member of that generation, has written of Gauguin's liberating charisma, which captained and activated the further evolution of the revolt: "Perhaps it was not he who invented Synthetism; Émile Bernard is very affirmative on that controversial question. But Gauguin was after all the master whose paradoxes were listened to and repeated, and one admired his talent, his flippancy, his action, his physical strength, his sarcasm, his inexhaustible imagination, his resistance to alcohol, his romanticism of

behavior. The reason of this superiority consisted in furnishing us with one or two very simple and obviously true ideas at a moment when we were totally lacking instruction. In this way he brought it about when practically all of us were preoccupied by beauty in its classical meaning, something he had never sought. He wanted above all to convey the character and to express the 'innermost meaning' even of ugliness. He was still an impressionist, but he pretended to be reading the book 'wherein the eternal laws of the beautiful are written.' He was ferociously individualistic and at the same time clung to the most collective and the most anonymous popular traditions. We drew a law, an instruction, and a method from his contradiction. But the impressionistic ideal was far from being absolute at that faraway date. One could live on the attainment of a Renoir or a Degas. Gauguin transmitted it to us, loaded already with that which he himself had borrowed from the classical tradition and from Cézanne. He brought us the art of Cézanne not as the work of a genial independent and of an irregular of the Manet school, but as what it is, namely, the result of a long effort, the necessary consequence of a great crisis." [4]

In October 1889 Gauguin left Pont-Aven, which had grown even more commercialized and touristy, for the more secluded town of Le Pouldu. At the inn of Marie Henry he was surrounded by his disciples, Laval, Sérusier, Charles Filiger, Meyer de Haan; in a spirit of exuberance and exclusivity they took it upon themselves to decorate the main room of the inn. De Haan shared with Gauguin the small allowance he received monthly from his family in Amsterdam. The prime disciple, Bernard, had been unable to join the group because of the hostility of his businessman father, who hoped to forcibly wean the young man from Gauguin's influence. Yet he continued to serve an important function in Gauguin's life through the medium of correspondence; it was to him that Gauguin confided his recurring tropical daydreams, and it was he who helped feed the fantasy with his own fervent approbation. With his fatal talent for applying his intelligence to the documentation of dreams, Bernard supplied the very site of the tropical atelier; Tahiti was his suggestion, not Gauguin's.

Time and again, privation had brought the tropics to the forefront of Gauguin's thoughts. The adulation of friends was not sufficient to blot out his continuing commercial failure, which was linked in his mind with the fate of his family. Earlier he had written to his wife that "art is my

business, my capital, the future of my children, the honor of the name I have given them—all things which will be useful to them one day." He had not seen his children for five years, and the hope to see them *as he wished to be seen by them*—powerful, successful, and solvent—grew daily more obscure. The barrenness of Le Pouldu, its landscape etched in stern lines by incessant winds, had underscored his despair. He countered a dejected letter from Émile Bernard with an aseptic dose of his own hard lot: "As for me, of all my efforts this year, there remains nothing but the howlings from Paris which come here to discourage me, to such a point that I no longer dare to paint, and I merely walk my old body in the dry and cold wind of the north on the shores of Le Pouldu! Mechanically I do some studies (if one can call brush strokes in accord with the eye, studies). But the soul of me is not there and stares sadly at the gaping pit in front of it. The pit in which I see the desolate family without paternal support, and not one heart in which to empty my anguish. Since last January I sold 925 francs worth; at 42 years of age, to live on that, buy colors, etc., it's enough to discourage the strongest soul. Not so much the privations now, as that future difficulties appear to be so high, when we are so low. In view of this impossibility to live, even meanly, I do not know what to decide upon. I am going to make efforts to obtain some kind of a post in Tonkin; there I might be able to work in peace, as I wish."

In vain he petitioned the colonial department for a post, noting sadly that "usually the only people they send to the colonies are persons who have misbehaved, embezzled, etc." It must have seemed ironic to him that his profession, considered reprobate in almost all other circles, should be judged respectable at a time when its raffishness might have done him some good. He went so far as to make a trip to Paris to plead his cause in person, but his appearance, in cloak, painted clogs, and Breton fisherman's jersey, served only to reinforce his rejection. Still caught up with the idea, Gauguin paid a visit to Odilon Redon, whose wife had visited Madagascar several times. She convinced him that it would be the proper place for his atelier, for conditions were such that one could live almost without money.

Before his return to Le Pouldu Gauguin set about to marshal members for the envisioned atelier. Armed with the same scrupulous self-interest which had motivated his selection of exhibitors at the Café Volpini show, he contacted his soul mate Bernard, the moneyed de Haan, the

blundering but doggedly dependable Schuffenecker, and Vincent van Gogh, still confined in an asylum, who would assure the support of the art dealer Théo. Bernard replied immediately and rhapsodically: "How glorious to get far, far away and escape from all cares! To abandon this loathsome European life; these dolts, misers and fat swindlers, all this pestilential scum. As for my fiancée (yes, I am in love, and why not?) she will come after. If she really loves me, she is sure to; yes, ah Yes; how grand to drink freedom to the full, to admire the sea, imbibe the void. . . . Thank you for giving me such great comfort; now I am so full of confidence." [5]

Gauguin wrote back, mordantly suggesting that one who was serious about savagery would direct his affections to a native woman rather than an imported wife. Meanwhile, Bernard had encountered a travel book by Pierre Loti which described in glowing phrases the Eden-like existence to be enjoyed on the South Sea island of Tahiti.[6] At first Gauguin was unmoved, cautioning the impetuous Bernard to beware the embellishments of Loti's prose. He clung to the idea of Madagascar, feeling that it was nearer than Tahiti and that it offered access to more distinct racial types. It is difficult to determine the precise reasons for his change of mind, but perhaps an official handbook on Tahitian life, obtained for him by Bernard, helped to persuade him of the greater virtues of the South Seas. In fact this handbook, put out by the staid colonial department on the occasion of the Universal Exposition of 1889, merely echoed Loti's sentiments in more restrained prose. Praising the inhabitants of Tahiti as "a magnificent race with beautiful figures and temperaments to match," the authors then paraphrased the words of a French settler who had spent half his life in Tahiti: "A Tahitian woman is usually a perfect model for a sculptor. Her features can occasionally be a little too Malayan, but with her large, dark eyes, so wonderfully fine and clear, her almost excessively full lips, and her marvelously white and regular teeth, she looks so sweet and innocently voluptuous that it is impossible not to share in the general admiration which she arouses. Her long, jet black hair is made up into two plaits or is left hanging loose over her shoulders as suits her fancy. Her features are open and composed, with never a hint of worry or concern." After another passage devoted to the ease of living —"the Tahitians have only to lift their hands in order to harvest the breadfruit and wild bananas which form their staple food"—the writer, who had actually visited Tahiti, glides to a lyrical finish: "While men

and women on the opposite side of the globe toil to earn their living, contend with cold and hunger, and suffer constant privation, the lucky inhabitants of the remote South Sea paradise of Tahiti know life only at its brightest. For them, to live is to sing and love." [7]

To sing and love. At the end of July 1890 Gauguin expressed to Bernard his last recorded doubts about migrating to Tahiti. In August his letters referred to "the Company P. G. and Co." and requested Bernard to inquire about details of the voyage. That same month Gauguin heard of the death of Vincent van Gogh, who had shot himself in the stomach in anticipation of another attack of madness. "He died," Gauguin wrote, "in the knowledge of not having been abandoned by his brother and of having been understood by a few artists. . . ." But he did not grieve at the loss of his fellow voyager, which he claimed to have foreseen: "To die at this moment is a piece of good fortune for him, it marks the end of his sufferings; if he awakens in another life, he will reap the reward of his good conduct in this world (according to the teaching of Buddha). . . ."

Would Gauguin also reap the reward of his good conduct in the new world? He appeared to exist in a state of suspended animation, removed from all matters not directly concerned with the coming journey. He loped along the shores of Le Pouldu, neither working nor worrying, taking his sweet seventh-day rest. Emancipation was in sight, and for the time being he need only relish the thought of it. He wrote to Bernard, "I don't know who has told you that I am in the habit of strolling on the beach with my disciples. The only disciples I know of are de Haan, who is working outdoors, and Filiger, who is working in the house. I myself walk about like a savage, with long hair, and do nothing. I have not even brought colors or palette. I have cut some arrows and amuse myself on the sands by shooting them just like Buffalo Bill. Behold your self-styled Jesus Christ."

The imminent reality of Paradise evoked the Creator-God in Gauguin. Although he would not at this time regard his tenure in Tahiti as eternal, he wished to build the foundations of a life there, to create a working world. By September his correspondence with Bernard spoke of Tahiti as the looming fact in both their existences. From his outpost in Le Pouldu he badgered Bernard to make arrangements for the passage—"have no fear, *we will go*." Tahiti's physical alienation from Europe bolstered his sense of self-sufficiency: "Hang Pissarro, but when we

are in Tahiti, I shall defy Pissarro and his associates." A heaven-hell polarity seemed to cast a delusory shadow over his mood-in-waiting; the collective anguishes of his European existence, in which he had burned and writhed for so many years, would all be dissipated upon his exodus to the promised land. He spoke of working for six months "to build a comfortable and solid house, to sow and plant what we need for our support"—as if, in this lush land where the sun always shone and where fruit hung from the trees for the taking, he wished to make the desert bloom with the labors of resurrected artists.

The brightness of the dream was enhanced by the gloom of his last weeks at Le Pouldu. A Dr. Charlopin, who had promised to subsidize him in return for a share in his works, failed to send him money. By October Meyer de Haan was the only other resident at the inn, and he would soon leave for Paris. Then out of the blue, a telegram arrived from Théo van Gogh which announced that money for the passage to the tropics was forthcoming. Gauguin interpreted this manna as being a sort of bequest by which Théo hoped to propagate his brother's memory; the atelier which had lived so long and vividly in Vincent's imagination would achieve reality through this benefaction to his friends. But the forces of fate never seemed to work in Gauguin's favor, and once again he would have cause to chastise the perversity of God. Théo van Gogh had dispatched the telegram in an attack of madness. He lay in a state of apathy, and his art gallery was quick to dissociate itself from his rash action. Gauguin left Le Pouldu for Paris in the aftermath of this debacle, his natural state of alienation enveloping him like a second skin.

Already, his fellow voyagers were having second thoughts about actually embarking on the idyll. Meyer de Haan had made no headway with his hostile relatives. Schuffenecker, whose hospitality Gauguin was abusing once again, was too concerned with his family's security to leave his job as drawing master. It appeared that Gauguin himself would have difficulty financing the journey. The practical future was still a myth, but in his present life Gauguin found some consolation. Sérusier's impassioned publicizing had sowed the seeds, and Gauguin, returning from his outpost, had only to reap the fruits of his growing fame.

He took to dining at a restaurant frequented by members of the symbolist literary group. There he met Jean Moréas, a poet and theorist of the movement, and re-established his ties with the avant-garde critics Albert Aurier and Julien Leclerq. They were ready for him. He was

invited to attend their café meetings, where he became acquainted with the pillars of the movement: the ill and aging Paul Verlaine, who, although grandly in decline, was hailed as a symbolist pioneer; Stéphane Mallarmé, already beginning to achieve fame as a poet; and Charles Morice, a handsome and personable literary critic and poet who served as the voice box of the movement, lecturing, orating, and in general disseminating eloquence. At thirty Morice had assumed the post of potential boy wonder, and he was eagerly awaiting, along with his compatriots, the emergence of that work of genius which would establish once and for all the glory of the symbolist philosophy. In the meantime Morice's most practical function as a man of the future was his ability to assess and appreciate greatness in others; he had been the first to recognize Verlaine's genius, and now he sensed a like power in Gauguin.

Keeping his eye on the star, Morice played Boswell to Gauguin's Johnson, recording his observations for posterity. His writer's eye gives his perceptions a peculiar immediacy, as when he describes the impact of Gauguin's physiognomy: "A broad face, a narrow brow, a nose neither curved nor hooked but as if broken, a thin-lipped mouth without inflection; heavy eyebrows sluggishly lifting over slightly protruding eyeballs with bluish pupils rotating in their orbits to glance left or right, while his head and body made almost no effort to follow them." [8] This tallies with his characterization of Gauguin as aristocratically aloof, proud in his role of seer but limited in the scope of his vision by the stiffness of his neck; the eyes would not deign to glance outward, except to confirm what already resided within. In a letter to Schuffenecker, who had chided him for his superior attitude, he wrote, "Whatever I do to compose my features, my face always gives the impression that I am condescending, and therefore I can't help it. But no matter! There's nothing to be gained by trying to ingratiate oneself with idiots—and I have reason for despising a large proportion of humanity."

Gauguin's inner eye, the monogram of his image and the justification for his pride, qualified him for the post of symbolist painter-in-residence. The symbolists looked for archsymbols in each of the arts, as if to prove to themselves and to the world that they existed. Mallarmé was their poet and Wagner their musician; Redon had been drafted to stand as their painter but had withdrawn on plea of introversion. Gauguin, in his personal and professional attributes, was tailor-made for the role. He was voluble and loved to expound about the nature of art. Trav-

eling his own path, he had virtually created ideist art, and had been formulating its doctrines, in letters and discussions, for several years. As the critic Aurier noted in an article written in February 1891, ideist art is symbolic in that it expresses the idea by equivalent forms.[9] Way back in 1885, in his trailblazing letter to Schuffenecker, Gauguin was painting according to this principle: "A strong emotion can be translated immediately; dream on it and seek its simplest form." Aurier was one of the first to place Gauguin in historical perspective in relation to the movement: "Since it is becoming evident that we witness in literature today the death agony of naturalism, since we see an idealistic, even mystic reaction preparing itself, we must wonder whether the plastic arts do not manifest some tendency toward a parallel evolution. *Jacob Wrestling with the Angel* . . . testifies sufficiently, I believe, that this tendency exists, and . . . the painters engaged in this new style have every interest in ridding themselves of the absurd label of 'impressionist,' which implies a program directly contradictory to theirs. . . . Let us invent a new kind of 'ist' . . . for the newcomers, at the head of whom comes Gauguin: Synthetists, Ideists, Symbolists, as you like. . . . Paul Gauguin appears to me as the initiator of a new art, not in history, but at least in our times. . . . It is evident . . . that there exist in the history of art two great contradictory tendencies, one of which depends upon the blindness and the other upon the clairvoyance of this 'inner eye of man' of which Swedenborg speaks—the realistic and ideistic tendencies." [10]

Clairvoyance is a faculty which accrues to men, not movements, and Gauguin stood out among the symbolists as a seer. Because he owed no allegiance to doctrine—yet had chanced to encounter a doctrine which reiterated his own—he could claim the divine right of kings and the transcendental righteousness of gods. As he was, he *knew*. He was his own equivalent. If he catered to the movement, and courted its members, it was only because he hoped that it would aid him in his quest; powerful connections, like loyal friends, produce dividends. There was something grandly simple in his nature which eliminated all superfluities; in this he was eerily like his wife, Mette, and the friction produced by their two natures, so completely different in content but so similar in form, caused them to be perennially obnoxious to one another. Each was to the other a monster of selfishness, pigheaded and unenlightened. Isolated in fanatic utilitarianism, each pursued his own true path, choosing to believe that the other had lost his way.

Gauguin wore the symbolist movement like a tattoo which marked the surface but never penetrated the flesh. Its main function in his life was that it made him a public man and forced upon him that sophistication which turns self-awareness to glamour. As he was called upon to act the substance of the symbolists' myth, he learned to deploy his image, to throw his weight into the hands of willing receptors. Like a self-made man surrounded by college kids, he laughed at their endless theorizing, called them cymbalists, noisemakers—but accepted the clangor that was offered in his behalf.

Gauguin confided to Morice his dreams of the South Seas, as usual larding his narrative with lamentations about his financial state. He called upon Morice to assist him in his latest caper, which was to put up a body of his unsold pictures for auction at the Hôtel Drouot. In entering into the scheme Morice would serve as a public-relations man, making contacts and garnering support. To begin with, Morice drafted Stéphane Mallarmé, whose interest in Gauguin's cause was likely to create waves of interest and attention. He then made the rounds of newspaper offices, playing up the dramatic and sensational aspects of the proposed exodus, eulogizing Gauguin not only as the man of the hour but as a man ahead of his time. This energetic publicizing evoked several articles, including one by Albert Aurier in the symbolist mouthpiece *Mercure de France*, which castigated European society in general and the French art world in particular for refusing to support an artist of Gauguin's stature: "If you powers that be only knew how posterity will execrate you, ridicule, and spit on you the day mankind begins to appreciate what is beautiful! Wake up; show a little common sense; you have in your midst a decorator of genius. Walls, walls; give him walls!" Aurier referred to Gauguin as "essentially a decorator," as all ideist painters were; he means it in a complimentary sense, relating the term to a sense of style, an uninhibited but ordered imaginative faculty which had been liberated from naturalistic strictures. "In the limited confines of a canvas his compositions seem cramped. Sometimes they give the impression of being merely fragments of huge frescoes, on the point of bursting the frames which so narrowly enclose them." [11]

The most complete article, which may be seen as a symbolist send-off to a loyal son, was written by Octave Mirbeau, a popular free-lance writer not of the symbolist crowd but sympathetic to it.[12] In terms of impact and circulation, this lengthy accolade from a widely read critic

was like a gift from the world outside, and Gauguin may well have basked in its disinterested recognition. Mirbeau traced Gauguin's present preoccupation back to its roots in his history; in delineating, in romantic and stylized prose, the savagery of Gauguin's antecedents, and his spiritual progress from stockbroker to passionate artist, Mirbeau was perhaps the first to publicize the Gauguin legend—leading one to speculate that the originator of the legend was Gauguin himself. The making of the myth lies not so much in distorting the facts as in rallying them around a prefabricated core—construed with manic single-mindedness, they make obeisance to a single great truth before which the collected small truths wave and undulate. In Gauguin's case, the core was his consuming artistic commitment, his own true self, which external circumstances conspired to cripple. It was his blood which mocked the world's water, his princemanship which registered in the frog-eyed world as a deformity. Mirbeau did him the honor of accepting his polarities as gospel, of eulogizing his magico-logical transformation.

This conclusive article also stamped his identity as a symbolist, running down the sources of his mystery (while delicately emphasizing the "irony of suffering" which was Gauguin's true source of mystery). Mirbeau revealed the essential ingredients: "a disquieting and fragrant mixture of barbaric splendor, of Catholic liturgy, of Hindu dreams, of Gothic imagery, and of obscure and subtle symbolism." Gauguin himself achieved a complexity of identities in his art, was "a painter and poet . . . an apostle and demon." His image of himself as savage and gentle man, as tormentor and sufferer, as wielder and victim, was now displayed for ten thousand readers to note.

During the winter of 1890–1891 Gauguin had been staying at Schuffenecker's house in Paris, as always taking full advantage of the hospitality offered. The list of comforts may have come to include Madame Schuffenecker, a piquant but shallow and headstrong woman who was ill-matched to her conciliating mate. No one knows precisely what occurred—whether the affair was a figment of Schuffenecker's imagination or whether it actually took place. Sadly, for a personality like Schuffenecker's, the awful revelation would have made little difference; if ever a man was born to be cuckolded, it was he. In his relationship with Gauguin he was truly a passive Christ-figure, or, more accurately, a willing disciple prepared to die for the master because the master spoke true. He admired Gauguin's art without qualification, and he knew that his

own art would never equal it. Out of some martyred sense of decency—imagine this civilized quality extended to fanatic lengths—he underwent numerous humiliations and a great deal of trouble and expense to do what he could for a man who consistently demeaned him. In a portrait made while living with the family, Gauguin portrayed Schuffenecker as a weak, hunched creature groveling before his easel while, in a separate bloc, his wife and two daughters huddle together in mass rejection of him. Seeing his castration enacted before his eyes, Schuffenecker had no choice but to reject the man Gauguin, although he could not yet bring himself to reject the artist; even as he evicted Gauguin he offered to retain responsibility for his paintings. Ironically, he may have reacted to one of Gauguin's infrequent defeats. Gauguin later made a portrait bust of Madame Schuffenecker in which she is portrayed with a serpent twined around her head, leading to the speculation that she may have invited the advances of her house guest only to reject them.

Gauguin took a furnished room across from a cheap restaurant, next door to a school of painting, which allowed artists to pay for meals in pictures. He soon acquired a woman to share his new abode, a young seamstress named Juliette Huet who might have graduated from match girl to mistress with only the change in status to show for it; she remained waiflike, with the sort of harried and helpless untidiness, loose-endedness, which forebodes a maturity of drudgehood. In character she was loyal and virtuous, with a sort of tidiness to her virtue which she would never achieve in her person: a decency expressed in small details, a dusting in the corners of a modest house. She was a good woman, and Gauguin gladly harbored her and settled her on his knee, but, as the description by the Danish painter J. F. Willumsen shows, he had another sort of woman on his mind: "The studio was completely bare except for an iron bedstead which stood in the middle of the room, and on which Gauguin sat, with a woman on his knee, playing the guitar. The only work of art which I saw there was a small wooden figurine, just finished, on the mantelpiece. This represented an exotic-looking woman. Perhaps it personified one of the wish-dreams in Gauguin's mind. The leg was incomplete. Gauguin had called it *Lust*." [13]

Gauguin later moved to a room in the art school, where he began to give lessons. At the restaurant he renewed his acquaintance with Daniel de Monfried, who had also left his wife to pursue a career as a painter. Monfried was sea-struck, and he often took long cruises in his yacht; he

was especially susceptible to Gauguin's verbal voyaging, which struck at the heart of his own fantasies. He possessed many of Schuffenecker's virtues, his generosity and dependability, but he also shared a manly bond with Gauguin which raised their relationship beyond a purely utilitarian level. Of all the members of Gauguin's circle who revolved around and lent support to the master, Monfried alone would hold fast.

As the date for the Hôtel Drouot auction drew near, Gauguin's optimism quickened. Once again, liberation was in sight. Aglow with the vision of future triumphs, he wrote to his wife, offering to stop off in Copenhagen on his way to another show in Brussels. He wished to see his family before he left for Tahiti, and he applied for permission to visit with the same degree of obsequiousness which accompanied his application for a colonial post: "Don't be afraid I shall put you out. I will stay at a hotel for the few days I shall be in Copenhagen incognito. I realize that the burdens you are bearing are heavy, but there is always the future to look forward to, and I think that one day I shall be able to lift them all off your shoulders. The day will certainly come when the children will be able to appear anywhere and before anybody with their father's name for protection and honor. Do you imagine that the influential friends I have gained will refuse to start them in life? I doubt whether business life would have yielded as much."

The show took place on February 22, 1891. Scouting the visitors, Gauguin encountered Émile Bernard and his sister, joined in mutual indignation. The fair and saintlike Madeleine was moved to voice her wrath: "Monsieur Gauguin, you are a traitor. You have betrayed your obligations, and done my brother a great wrong, for he was the real initiator of the art you practice." [14]

The explosion had been building for a long time. Gauguin's public image, which had flowered at the hands of the symbolists since his return from Le Pouldu, was a constant affront to Bernard. In Brittany they had been equals, as pioneers in a new movement, although the master-pupil ambiance was sustained; Bernard had felt the radiance of Gauguin's fond eye upon him. Recognizing Gauguin's greatness, he had felt honored by the master's response to his ideas, had preened at the vision of himself in Gauguin's gaze. Fate had cast them together and they were the elite; but in Paris it soon became obvious that Gauguin was caught up in making his own fortune for his own purposes; his single-minded consciousness had left no space for Bernard. The dispossession came at a

bad moment for the younger man. For some time he had been in trouble with his art, which had become mannered and jaded in the grip of the theory which he had imposed upon it. "The more I want to do something very complete and very highly wrought, the more I get bogged down, the more I achieve nonassertiveness, emptiness, hollowness," he had written to Gauguin.[15] Now it became increasingly apparent that the sort of spontaneous regeneration which energized Gauguin's art was not native to Bernard; if he had a claim to fame, it would rest in his ability to innovate styles, not in his painting. To observe Gauguin's lionization by the symbolists, to sit by while he was touted as the innovator of synthetism—the irony overpowered Bernard. Had he not created the style and seen Gauguin flourish through his use of it?

Fittingly, Bernard confided his bitterness to Schuffenecker, who was nursing his own portion of gall against Gauguin. Although different in personality and creative power, the two men were similarly afflicted with a self-conscious sensitivity which made them perfect foils for Gauguin. In Bernard it took the form of a righteous idealism; in Schuffenecker, a righteous morality. There lived in each a capacity to take on the role of the sacrificial lamb who, as an expression of absolute faith, approaches the altar with eyes closed and throat exposed, hoping for a stroke of mercy from the Master. Schuffenecker, in particular, seemed to accept his fate as inevitable. In a farewell letter to Gauguin, which stood as an eviction notice, he wrote, "You are made for domination, whereas I am made for inferiority."[16] Bernard was not so resigned, and for that reason his subservience was perhaps more tragic; he suffered not from Gauguin's presence but from his absence, which forced him to take his stand as a man and a mature painter rather than a precocious pupil. Unable to achieve potency in his art, he transferred his passions to the human situation. Like Schuffenecker, he came to feel that everything had been taken from him, that his professional inadequacy was a direct slur upon his manhood. Gauguin's indifference was the insult which crowned injury and concluded in impotence.

It was true that Gauguin had done little in a material sense to help his friends. He was geared to acting as the worthy recipient of favors. It apparently never occurred to him to recommend his host Schuffenecker to the *Vingtiste* exhibit in Brussels—even though he wrote a letter on request for Filiger. He considered Schuffenecker's art so inferior as to be beyond the support required by the niceties of friendship; no doubt it

seemed logical to him, in view of his own talent, that Schuffenecker harbor and support him without question. In Gauguin's eyes Bernard had misled Schuffenecker. "Poor Schuffenecker, how he'd tied himself up with that brat! And naturally it is I who have caught it."

Bernard had reason to be injured at not being invited to participate in the sale at the Hôtel Drouot. Morice's article-scavenging had paid off, and the event was well attended; several eminent art critics and collectors made an appearance. Thirty pictures were sold, including *Jacob Wrestling with the Angel*, which went for the relatively substantial sum of nine hundred francs. In total Gauguin cleared nine thousand francs—a bounty sufficient to launch him on his journey.

It was becoming apparent that the journey would also be a one-man show. De Haan's family had severed his allowance, and he had departed from Brittany hastily, leaving behind a pregnant Marie Henry; after a spate of family quarrels in Paris, he was now in Amsterdam, nursing his consumption in the midst of familial antagonism. Schuffenecker, surrounded by an equally hostile family, had little inclination to undertake an adventure with the source of the hostility. Gauguin had succeeded in alienating his most profound disciple, Bernard, and would forge into the wilderness without this reluctant man Friday; he had made no attempt to placate Bernard, had in fact lost no time in calumnizing him for ungratefulness. Most poignantly, he had turned his own circle of influential friends against Bernard, with the result that an article by Aurier on pictorial symbolism, which Bernard had solicited, was published without a single mention of the movement's self-professed founder. Aurier explained the omission by stating that Bernard's work labored under many influences, that until it became "more specific and personal" it would not merit analysis.[17] Gleefully Gauguin predicted that Bernard would end up by painting like the academic painter Benjamin Constant—and sure enough, as if in a final gesture of rejection of the man who had rejected him, Bernard retreated into a stringent and antiseptic classicism which would occupy him for the rest of his days. In a long history of castrations-*de-grâce*, Bernard's must count as Gauguin's finest effort.

Gauguin arrived in Copenhagen on the morning of March 7, 1891, and was met at the station by Mette and his two oldest children, Emil, now sixteen, and Aline, fourteen. Mette was by this time partially graying, a stolid and square-faced Roman matron who had fulfilled the physical prophecy of his early bust of her. She had requested that he bring her

some corsets from Paris; her choice of gift suggests that she wished to armor herself against his advances lest, as her mother had cautioned her, heaven should bless their union once again. As it turned out, she had no need to gird herself against him, for he went tamely to a hotel according to their prearrangement. The gap of years which had separated him from his children was painfully embodied in the fact that they could no longer speak French; for all practical purposes they were budding members of the Danish bourgeoisie. The boys were wary in their response to him; for years they had absorbed the vilifications which Mette's family had heaped upon their father's head, and they had shared no countering experiences with him; the youngest boy, Pola, could have known his father only through the descriptions of others. The manhood of the family (or that portion of it which Mette could not muster) had no doubt passed to them. The only member of the family who responded to Gauguin's raffishness was his daughter Aline, who saw him through adolescent eyes as romantic and misunderstood. She suffered over Mette's bitterness against her father, and she once wrote him that when he returned, she, Aline, would be his wife. Years later, in Tahiti, he would remember her declaration. A photograph of father and daughter, taken during that visit, shows a striking resemblance; Gauguin's distinctive profile, the poise of his head, prefigures hers, and the likeness between the wild-haired man in his embroidered Breton shirt and the prim schoolgirl in white lace collar is strangely moving. Of all the children she was most emphatically his descendant.

No one knows what transpired between Gauguin and his wife during that visit, but it appears that they left each other in mutual amity. Released from the years' calcification of resentment, with his dream-journey imminent, Gauguin could afford to become almost ardent. After his return to Paris he wrote Mette a love letter, asking her to share the future which he now felt to be assured. Basking in premonitions of success, he seemed to feel that he had a right to make a claim to his family again: "In the absence of passion, we can—with white hair—enter an era of peace and spiritual happiness, surrounded by our children, flesh of our flesh. . . . Yesterday a banquet was given for me, at which forty-five people were present: painters, writers, under the chairmanship of Mallarmé. Verses, toasts, and the warmest homage for me. I assure you that three years from now I will have won a battle that will permit us— you and me—to live safe from difficulties. You will rest and I will work.

Perhaps one day you will understand what kind of a man you chose to be the father of your children. I am proud of my name, and I hope—I'm even certain of it—that you will not soil it, even if you were to meet a smart captain. If you go to Paris, I beg you to visit only decent, simple people, and not charlatans. . . . Goodbye dear Mette, dear children, love me well. And when I return, we will remarry. It is therefore a betrothal kiss that I send you today."

Meanwhile, in Paris, Morice had been capitalizing on Gauguin's new fame, attempting to procure for him an "official mission" which would open doors for him in Tahiti. When Gauguin returned from Copenhagen the two went to call upon his archetypal enemy, the director of the Académie des Beaux-Arts. From some reservoir of sympathy buried in his heart—or, more likely, with the relief of the justice who has at last managed to deport a troublesome criminal—the director took it upon himself to be receptive to Gauguin's request. He not only granted approval to the official mission but also promised that the French government would purchase a painting for three thousand francs upon Gauguin's return. On the way home Morice was jubilant about this unexpected triumph. It was obvious that Gauguin's luck was taking a glorious turn; yet the darling of the gods seemed strangely morose. Morice questioned him. "Gauguin was silent. I told him that the time of painful struggle was over for him, that he was finally going to be able to realize his work freely . . . Suddenly, having watched him, I was silent myself, stupefied by the desolate expression on his face. His naturally livid complexion had lightened to a sickly pale, his features were distorted, his fixed eye no longer seeing, and his gait shambling. Gently I took him by the arm. He gave a start and, pointing to the nearest café, said to me, 'Let's go in there.' When we had sat down in the darkest corner of the place—which was empty this early in the morning—Gauguin put his elbow on the table and, hiding his face in his hands, wept. I felt more fear than pity: that man, that man there, crying!

" 'I have never been so unhappy,' he finally murmured, raising his head a little.

" 'What! today, today when justice is beginning, when glory is coming! . . .'

" 'Listen to me. . . . I haven't known how to support my family or my vocation by myself. I chose to pursue my vocation, but I haven't even succeeded there. And today, when I have reason to hope, I feel

more frightfully than ever the horror of the sacrifice I made; which is irreparable.' And he spoke to me at length of his wife, his children, from whom he had separated himself so as to devote all his force, and all those years, to artistic creation. How he loved them! Suddenly he rose and said, 'Let me go! I need to be alone for a bit. I'll see you again in a few days' time.' And he added with a rueful smile: 'In time for you to forgive me for troubling you with my tears.' " [18]

If the account by the romantic Morice is accurate, then it appears that Gauguin was paying the price for his polarities. The underground fantasy which had sustained him was that he might have the best of both worlds; prosperity in Eden surrounded by his transplanted family. Now that the primary fantasy was about to be enacted, he was confronted with a revelation which years of separation from his family had failed to bring him. The vision of the savage, which he had conjured so recklessly before his wife, would indeed go straight ahead—but there would be no wife, no children, no home to provide a civilizing cushion for it. Perhaps Gauguin knew for the first time how absolutely he had chosen, how subservient he had been to the rigors of his dream. If his farewell letter to Mette is a crying of "wolf," or yet another demonstration of regressive sentiment, it is also most nakedly a cry in the wilderness.

The banquet given by the symbolists in honor of Gauguin was held at the Café Voltaire on March 23, 1891. The symbolic hero was going off to a symbolic destiny—and truly, the members of his mother group could have wished for no finer consummation of their hopes. Employing all their subsidiary talents, they outdid themselves in "verses, toasts, and heart praise." About forty people were present, among them Monfried, Aurier, Morice, Sérusier, Jean Moréas, and Odilon Redon. Stéphane Mallarmé, serving as host, delivered the welcoming speech: "Gentlemen, let's do first things first; let us drink a toast to the eventual return of Paul Gauguin, but not without admiring his superb dedication which, at the peak of his talent, drives him into exile, to seek new strength in a far-off country and in his own soul." [19]

Charles Morice recited a paean to the beauties of life in Tahiti, featuring such gems of anthropological data as "living statues from man's primeval age" who were "clad only in sunbeams" and nurtured on "sweet desire." It was decided during the banquet that the next play at the Théâtre d'Art, Morice's projected symbolist masterpiece *Chérubin*, would be given for the benefit of Gauguin and Verlaine.

Toasts and speeches were followed by a recitation from Mallarmé's recent translation of Edgar Allan Poe's *The Raven*. With the spirit of this strange bird perched on his shoulder, Gauguin rose to offer his awkward appreciation: "I like you all and am much moved. I can therefore speak neither at length nor very well. Some of us have already created well-known masterpieces. I give you a toast for them and works still to come."

For all practical purposes, Gauguin had been launched. It remained only to purchase the ticket and to patch up his affairs at home. He decided on a second-class passage which would approach Tahiti via New Caledonia. His life affairs did not solve so easily: Juliette had become pregnant, and he was forced to vouchsafe to her a portion of his precious funds—with which she purchased a sewing machine, as befitted her renewed status as a woman alone, as well as the spinning-out of time which loomed before her. Pre-journey expenses had cut into his funds, but he remained optimistic; his old pictures were in galleries waiting to be sold, and the symbolist benefit shimmered in his wake like a posthumous promise.

So it came to pass that on the afternoon of March 31, 1891, Gauguin took the train for the embarkation port of Marseilles. A gathering of friends accompanied him to the station and applauded while Gauguin, his shotgun, his French horn, his two mandolins, and his guitar set off for the New World. No doubt universal faith circulated among his compatriots that he was on his way to Eden. It is not recorded whether any of them offered up a prayer that, in achieving Eden, he would not find it wanting.

XII

Interlude

"Paul Gauguin" by Octave Mirbeau.
Published in *Écho de Paris*, February 16, 1891

I HAVE JUST learned that Paul Gauguin will leave for Tahiti. It is his intention to live there for several years alone, to build his cottage there, and to get a fresh perspective on all the things which have haunted him. I find it both strange and touching to see a man escape from civilization, voluntarily seeking oblivion and silence in order to gain greater insight and to better listen to his inner voices, which are being drowned out by the blare of our emotions and daily strife. Paul Gauguin is a very exceptional artist, very disturbing, one who seldom appears in public and therefore is but little known. I had often promised myself to speak of him. Alas! For no reason that I know, there no longer seems to be enough time to do anything. It may also be that I have recoiled from this difficult task for fear of not doing justice to a man whom I hold in the very highest esteem. I ask myself whether to interpret briefly and rapidly the substance of Gauguin's art, intricate and yet primitive, clear and yet obscure, crude and yet refined, is at all feasible and not beyond my powers. To explain such a man and such a work would require the meticulous and detailed care of a chronicler. Still, I believe that, by first demonstrating Gauguin's intellectual integrity and then summarizing in a few char-

acteristic details his strange and troubled life, his work can be revealed in a brighter light.

Paul Gauguin was the son of parents who were not very wealthy but who enjoyed a comfortable and secure existence. His father worked together with Thiers and Degouve-Denuncques on Armand Marrast's *le National.* He died at sea while on a trip to Peru which was, I believe, his way to exile. He is remembered for having had a forceful soul as well as a keen intelligence. His mother, born in Peru, was the daughter of Flora Tristan, that beautiful, vivacious, and energetic Flora Tristan who was authoress of many books on socialism and art and played an active role in the phalansterianist movement. I know one of her books, *Walks Through London,* in which can be found commendable and generous outbursts of compassion. As a result, Gauguin carried with him from the cradle the heritage of two virtuous influences that molded and permeated his genius: struggle and imagination. His childhood was filled with warmth and security. He grew up happily in these familial surroundings, steeped in the spiritual influence of an extraordinary man who was without doubt the greatest of the century, the only one since Jesus who truly embodied the divine spirit: Fourier.

At the age of sixteen Gauguin enlisted in the navy in order to interrupt his studies, which proved too expensive for his mother; their fortune had vanished with the death of his father. He traveled. He crossed unknown seas, walked under new suns, observed primitive peoples and abundant vegetation. He stopped thinking. He thought of nothing—so he believed—he thought of nothing but the arduous job to which he devoted the whole energy of a young, healthy, and strong man. However, in the silence of his night watches he began subconsciously to dream and to think of infinity; and sometimes, during rest periods, he sketched aimlessly as if "to kill time." Brief interludes, to boot, with but little indication of his state of mind—brief escapes into the bright and mysterious depths of his inner world which vanish instantly. But the great blow was yet to come; he had yet to experience the birth of his passion for art, which was to captivate him and smother him entirely, soul and flesh, to the point of suffering and torture. He was completely unaware of the gigantic impact, powerful and diverse, which by means of an imperceptible and latent process of perception was to invade, intensify, and subconsciously penetrate his soul so profoundly that later, after his return to normal life, he experienced an obsessive nostalgia for these suns, these

peoples, these lush islands, and the Pacific Ocean, where to his great surprise he would rediscover the familiar songs of his mother, like the cradle of his own people, which seems to have rocked him long ago.

Back in Paris, his service concluded, he found responsibilities: He must make a living and support his family. Mr. Gauguin enters the business world. To a casual observer it will not be the least bizarre circumstance of this incongruous existence that this supreme artist would go to the Stock Exchange to carry orders for the brokers. Far from smothering his budding dream, the Exchange stimulated it, molded it, and gave it direction. For thoughtful people and for those who know how to appreciate it, the Stock Exchange powerfully evokes the mystery of man. It represents an important and tragic symbol. The fear of a cursed dogma seems to hover above the feverish confusion, the noise of screaming frenzy, the convulsive gesticulations, and the startling specters. It would not surprise me in the least if this natural contrast, through a spirit of unavoidable rebellion, were responsible for Gauguin's passionate love of Jesus, a love that later was to inspire his most beautiful conceptions.

In the meantime, a new human being developed within him. This revelation appeared almost overnight. His background, his travels, his memories, and his present life, amalgamated and interwoven, created an explosion of his artistic talent, which seemed all the more violent because it was so slow and late in developing. He was seized and devoured by a great passion. He spent all his spare time painting. He painted with obsession. He became entirely preoccupied with art, haunted the Louvre, and sought out contemporary artists. His instinct directed him toward the metaphysical artists, the violators of conformity, and to the synthetists of form. He was enthralled by Puvis de Chavannes, Degas, Manet, Monet, Cézanne, and the Japanese artists, at that time known only by a few privileged people. This curious phenomenon was the result of his protected youth and to an even greater extent of a profession which poorly equipped him for expressing his dreams. Despite his intellectual ideals and his aesthetic predilections, his first attempts were representational. He tried to rid himself of this defect because he sensed that representationalism meant the suppression of art just as it is the negation of poetry and that the source of all emotion, beauty, and life was not to be found at the surface but in the depths of individuals and of objects, where the hook of the ragpicker cannot reach.

What should he do? How should he make up for lost time? Each

minute delayed his drive forward. The stock market required his full attention. It is impossible to pursue a dream and at the same time follow the fluctuations of the market, wonder at idealistic visions only to fall from the heavens back to the hell of having to liquidate a dozen reports. Gauguin hesitated no longer. He quit the Stock Exchange, which had provided for his physical needs, and devoted himself entirely to painting, despite the threat of poverty and of an insecure future. There followed years of merciless struggles, tremendous efforts, and disillusions intermingled with rapture. This difficult period in which the artist tried to find himself produced a series of landscapes which went on exhibit, I believe, at the Impressionists of rue Lafitte. Despite inevitable setbacks, an obviously vigorous talent asserted itself, the talent of a superior artist, joyful, almost wild, and yet charming and sensitive as it reflected the light and idealism which it imparts to his subjects. His canvases, although still too crowded with detail, began to reveal a very personal ornamental taste in their composition which he was to perfect in his later paintings, his exotic ceramics, and his delicate wood carvings.

Despite his appearance of outward sturdiness, Gauguin was by nature restless and infinitely tormented. Never satisfied with his creations, he continued to seek perfection. He felt that he had not given his all. Confused thoughts troubled his soul, vague yet powerful ambitions directed his mind toward more abstract paths, more compact forms of expression. His thoughts returned to the lands of light and mystery which he had visited long ago. There, he believed, lay hidden, asleep and untapped, the rudiments of the new art of his dreams. Moreover, he yearned for solitude, peace, and quiet. It is there that he would be able to listen to himself and to live a fuller life. He departed for Martinique, where he remained for two months, only to return home, ill with yellow fever, which nearly took his life and from which it took him months and months to recover. He brought back with him a series of brilliant and stark canvases, in which he had finally conquered his entire personality and which displayed a remarkable amount of progress, a tremendous step toward his ideals. No longer did his forms reveal themselves in their outer appearance; they demonstrated the state of mind of one who possesses a thorough understanding. In the lush underbrush, the huge blossoms, the hieroglyphic structures, and the magnificent sunsets lay hidden an almost religious mystery and the sacred abundance of Paradise. His

designs became broader and more flexible; he confined himself to the essential message, thought. Within the majesty of his contours, he was guided by his dream toward spiritual synthesis, toward an eloquent and profound expression. It was then that Gauguin proved to be his own master; his hand was his slave, obedient and faithful to his spirit. His sought-for masterpieces were going to be achieved.

Masterpieces curiously intellectual and passionate, still somewhat uneven but poignant and superb in their unevenness; painful as well, since in order to understand them and experience their impact one must have known the suffering and the irony of suffering which is the gate to mystery. At times they reached the height of a mystic act of faith, and at other times they grin and grimace in the fearful depths of doubt. At the same time his art exudes the bitter and strong aura of the venom of the flesh. It possessed a disquieting and fragrant mixture of barbaric splendor, of Catholic liturgy, of Hindu dreams, of Gothic imagery, and of obscure and subtle symbolism; it embodies stark realities and irrevocable escapes into poetry, in which Gauguin created a new art form, entirely personal: the art of a painter and poet, of an apostle and demon, art which fills us with anguish.

In a yellow countryside, an agonizing yellow, high on a Breton hill sadly jaundiced by autumn's end, under an open sky, stands a cross—a cross poorly carved, rotten, and disjointed, which spreads its awkward arms. Like a Papuan divinity, crudely carved out of a piece of wood by a local artist, Christ in torture, the compassionate and uncouth Christ is daubed yellow. At its feet kneel peasant women. Indifferent, their bodies slumped heavily on the ground, they have come as is their custom on a day of penance. But their eyes and lips are devoid of prayer. They have no thought or eye for the likeness of Him who died for their love. Others, happy to have completed their devotions, hurry to their farmyards, climbing over hedges and rushing under the red apple trees. The melancholy of this wooden Christ remains indescribable. His expression is one of overwhelming sadness. His emaciated body reflecting His old tortures, and He seems to say to Himself, looking down at this miserable human race which does not understand: "Was my martyrdom in vain?"

This is the masterpiece which marks the beginning of a series of symbolic canvases by Gauguin. Unfortunately I cannot dwell any longer on his art, which I would have loved to study in its various manifesta-

tions, such as his sculpture, his ceramics, and his paintings. I hope that this brief description will serve to unveil the very special spirit of this artist with his exalted visions and his noble aspirations.

It would seem that Gauguin, having achieved such depth of thought and such grandeur of style, would have arrived at serenity, peace of mind, and rest. But no: a dream never stands still in such an active intellect, it grows and develops as it takes on a more concrete shape. This is the cause of the recurrence of Gauguin's nostalgia for the lands where the seeds of his first dreams came to life. He wants to live again, alone, for several years among the things he left behind. Over here, he was spared few tortures and was overwhelmed by great worries. Also, he lost a dearly beloved and much admired friend, the tragic Vincent van Gogh, one of the most magnificent creative temperaments, one of the greatest artistic spirits in whom our hopes found expression. Further, life made too many rigid demands. The same need for silence, introspection, and complete solitude which had once driven him to Martinique urges him further on still, to Tahiti, where nature is in better tune with his dreams, where he hopes the Pacific Ocean will caress him gently, an old and trusted ancestral love rediscovered.

Our compassion will accompany Gauguin wherever he goes.

NOTE TO THE READER

In the following chapters much use has been made of Gauguin's writings, especially *Noa Noa*. In the face of scholarly debates over which version of this remarkable book is the "genuine" one—the one written solely by the artist—the versions have been accepted as one book, drafted by Gauguin, reworked by his collaborator Morice, and transcribed by the artist with an incorporation of Morice's ideas into the initial fantasy. *Noa Noa* is, after all, essentially a fantasy which combines fact and wish into a dream-tale; and as no one knows the content of discussions between Gauguin and Morice, it would be presumptuous to assume that Morice's contributions were just literary elaborations added to commercialize Gauguin's amateurish narrative.

Also, in the use of passages from Gauguin's journal *Avant et Après* and from *The Modern Spirit and Catholicism*, the artist's exaggerations, fictions, and plagiarisms are not always pointed out. The fact that Gauguin chose to exaggerate, invent, or borrow from other writers is sufficient to count the material as his own; it must function like the found-object in a modern art form. Assigning any lesser value to this material would weaken the reality of Gauguin's self-creation.

XIII

Pariah's Progress

I F G A U G U I N'S golden dreams had trumpeted Tahiti as a clas-
sic Paradise, then surely his first view of Papeete must have sounded
in him the full resonance of Eden's fall from grace. Perhaps any center of
commerce set upon the surface of a natural and self-sufficient landscape
becomes tainted by comparison, takes on the nature of a stain or an abra-
sion upon flesh, and is rued for its presence. Papeete made no pretensions
to grace; it resembled a ghost town of the Old West transplanted to a
tropical setting, with row upon row of general stores and saloons, low-
lying, some constructed of unplastered brick and others of unpainted
wood, topped by roofs of corrugated iron. The physical properties of the
natives themselves, which might have redeemed the uninspiring land-
scape, were shrouded beneath tentlike dresses and ankle-length loin-
cloths, in accordance with the standards of decency imposed by the
missionaries. At the time of Gauguin's visit, Calvinist, Catholic, and
Mormon missions had been established in Tahiti for decades; the Bible
was the only reading matter available in Tahitian at the time, and the
natives attended church faithfully every Sunday, understanding little of
the doctrine but responding enthusiastically to the stories and parables
which informed them that they were children of sin. The pagan gods
who had enlivened Tahitian religion and mythology for thousands of
years had departed from the scene, perhaps in disgust; nowadays no one

knew their names, and sadder still, the primitive forces which activated
them had also abdicated. Only in the deepest countryside did the dark
forces wield any power in Tahiti; in Papeete, the colonial officials, pom-
pous and overstuffed, held sway over the town's business in the same way
as the missionaries dictated the content of "savage" souls. The imposition
of unnatural materials polluted Papeete: iron roofs and cement walls cap-
tured the tropical heat and made it unbearable; venereal disease had
come like a plague from the European God, as if to remind the natives
that their centuries of unhampered sin had not gone unnoticed; imported
mores, which acknowledged the existence of sin but insisted that it be
labeled and quartered and treated as low life, succeeded in transmuting
free love into purchased pleasure.[1] Henry Adams, who had visited Tahiti
not long before Gauguin's arrival, had this to say of Papeete: "The town
is different from anything I ever saw in the long catalogue of towns I
have met, and has an expression of lost beatitude quite symbolic of Para-
dise, apart from its inhabitants." [2]

In the days before the missionaries came Tahiti had lived in the
European imagination as an ancient Greece of the South Seas, embody-
ing, in the words of the botanist Joseph Banks, "the Golden Age come
again." Banks, who accompanied Captain Cook on his expedition, wrote
that the Tahitian women were the most elegant in the world, their cloth-
ing as natural and beautiful as the drapery of a statue, "their bodies
. . . so beautiful that they might even defy the imitation of the chisel
of a Phidias or the pencil of an Apelles." [3] Louis de Bougainville, who
visited Tahiti in April 1768, compared the natives to Greek gods. A
naked young Tahitian girl on the deck of his ship appeared "as Venus
. . . herself to the Phrygian shepherd, having the celestial form of
that Goddess." [4] An English captain named Wallis, with an eye for the
baser necessities of life, rhapsodized about trees that grew bread and
palms that supplied milk.[5] In fact, Tahiti was an explorer's dream of the
Promised Land, which hovered just over the horizon for the duration of
Gauguin's journey, appearing, like a mirage, too good to be true.

One subtle result of expanded exploration was that the classical
metaphor of Tahiti as a living Golden Age soon gave way to a Christian
interpretation. Bougainville speaks of Elysium fields and then, practi-
cally in the next breath, remarks, "I thought I was transported into the
Garden of Eden . . . everywhere we found hospitality, ease, innocent
joy, and every appearance of happiness amongst them." [6] This blissful

and generalized description seems to obscure the differences between the Golden Acres and Eden—but the distinction, once made, once *committed*, is profound. Paradise is founded upon guilt. The innocuous behavior of the inhabitants of Elysium becomes suspect when transplanted to Eden: ". . . and every *appearance* of happiness amongst them"—as if bliss itself were a façade beneath which unwholesome curiosity and hidden desires seethed. Europeans came to Tahiti to confront Paradise and, once again, could not let it be. The Puritan's credo that rewards were the fruit of labor was mocked by the plenty of Tahiti, by the food and flesh available to all. What had they done to deserve it all? More crucially, why were they not judged harshly for their conscienceless way of life? The most romantic viewpoint held that Tahiti was proof against the necessity of Revelation: Hawkesworth, who visited there in the mid-eighteenth century, claimed that "these people have a knowledge of right and wrong from the mere dictates of natural conscience." [7] However, God-fearing Englishmen, observing the uninhibited antics of the Tahitians with gloom-shrouded eyes, saw visions of licentious dances, prostitution, infanticide, strange funerary customs. Rites which might have been characterized as ingenuously primitive in a Golden Age context became sinister when characterized as pagan; in the missionary's vision the Tahitians were heathens who knew not what they did, who flaunted their godlessness in an obnoxiously good-humored manner, as if the thought of falling from grace had never entered their heads. One senses that the churchmen might have been less likely to begrudge them their Paradise if they had been not quite so graceful, so carelessly and effortlessly lovely, in their state of Fall. John Courtenay, an officer at Tahiti in 1774, wrote an ode on the subject:

> Naked and smiling, every nymph we see,
> Like Eve unapron'd, ere she robbed the tree,
> Immodest words are spoke without offence,
> And want of decency shews innocence. [8]

Gauguin's first dwelling in Tahiti was at the rear of a Catholic church in Papeete, furnished with Victorian pieces rented from a colonial store. Photographs of his family decorated the walls. The character of his passage into savagery was that of a gentle man in the furthest extension of the term, a definition he would surely have writhed at: i.e., a gentleman.

His link with his family—and, in a perverse way, with their values —was still strong. Success had eluded him in Europe, and so he had spat at those who withheld it from him, but in the New World the urge to garner respect from the worthies who would fit Mette's definition of "right" people renewed itself. Soon after arriving he wrote to her of his initial conquests: "Thanks to the article in *Le Figaro* and to some letters of recommendation, I arrive in a country where I'm known. Very well received by the Governor and by the Secretary for the Interior, who is an honest family man, with his wife and two daughters. I had lunch with them, and they go to all extremes to make me happy."

In the same letter he speaks of being "bombarded" with requests for portraits. With a businessman's deference for convention, he had cut his hair, purchased a white tropical suit of the sort worn by proper colonials, and set out to impress Tahitian society. The glamour of his "official mission" carried him through his first weeks pleasantly and profitably; he was even admitted to the Cercle Militaire, an exclusive private club usually reserved to high-ranking officers and government officials. The spectacle of him sitting on the balcony, absinthe in hand, making conversation with the local blue-bloods, carries a certain charm which grows stronger with the years.

More was involved in his courting of society than the placating of Mette and the garnering of commissions. The white-garbed colonial officials at ease in a tropical setting may have evoked fantasy recollections of his years of Peruvian childhood. Then he had been part of an aristocratic household, had shared in the deference accorded to his uncle and been treated himself as an adored spoiled child. No doubt the legend had grown in anecdotes told by his mother and his godfather. After years of rejection by the bourgeoisie it must have been tonic to him to be treated as a member of the upper classes, a personage—and an artist, at that— of some importance.

"Tomorrow I am going to see all the Royal Family," he wrote Mette. "All of which is advertisement, however tiresome." With what casual dash he dropped this potent fact!—but, as fate would have it, he was never to have the pleasure of requesting the patronage of the king. Pomare V died on the very morning of Gauguin's appointment with him, the cause of death being acute alcoholism. The obese monarch was overdue to die, but the fact that he passed on to a soberer world on this particular morning seemed another strike in Gauguin's log of ill luck.

Adding insult to injury, the official funeral director requested Gauguin, as an approved artist, to take charge of the decorating of the throne room where Pomare's body was to lie in state. Unimpressed by the glamour of this commission, Gauguin refused.

Dreams of royal patronage die hard, but the romanticism which cloaked Gauguin's vision of Paradise died harder still. He chose to interpret the death of the king as the knell of the old civilization, which had maintained itself, pulsing and primitive, beneath the sordid veneer of colonial habitation. "With him disappeared the last vestiges of ancient customs and grandeur. With him died the Maori tradition. It was at an end. Civilization, alas, triumphed—soldiers, trade, officialdom." Pomare was an odd archetype to select, for he was kingly by title only and summarized in all his dissipated glory the full toll which European civilization had taken of what once had been a pure and powerful race.

The charm that Tahiti held for Gauguin was not entirely illusory. Even in Papeete there were sufficient opportunities to sing, dance, love, or merely languish to remind the visitor that the Golden Age, if hopelessly tarnished, was at least not eradicated. Public dances in the park, held once a week, offered a fine array of fleshly pleasures: food, vast quantities of drink, the music of a brass band, and leagues of willing vahines, who asked no more than an evening of good fun. The French National Day, July 14, gave an excuse for several weeks of uninterrupted celebration. In honor of this occasion the natives brought their ancient dances and chorales out of storage and displayed them with enthusiasm and ceremony. Gauguin must have been delighted to observe these remnants of his fantasy culture; it is known that he spent considerable time during the festivities sketching native types.

In spite of his financial difficulties, which were already beginning to move in on him, he seemed more spiritually whole during these first weeks in Tahiti—as if the landscape provided a cushion for his anxieties. In a letter to Mette, in which he tried to convey the essence of this change, he rose almost to poetry. He spoke of the "night silence" investing him: "I understand why these people can spend hours, days, sitting without saying a word, gazing melancholically at the sky. I apprehend all the things that are going to invade my being, and I feel amazingly peaceful at this moment." Then, thinking to whom the letter was addressed, he followed with a statement from a most gentlemanly savage: "It seems to me that the turmoil of life in Europe exists no longer; tomor-

row will be the same thing, and so on until the end. Because of that don't think I'm an egotist and that I shall abandon you. But let me live thus for a while. Those who reproach me don't realize all there is to an artist's nature; why should they wish to impose on us duties similar to theirs? We don't impose ours on them."

Gauguin's penetration into native life undercut his status as an establishment artist; it is obvious that his hours in the street soon began to outnumber his hours on the balcony of the Cercle Militaire. Those who had expressed a readiness to have their portraits painted failed to follow up. An English cabinetmaker, Thomas Bambridge, was his only client; he had commissioned a portrait of his eldest daughter but was so appalled by Gauguin's realistic rendering that he hastened to hide it in his toolshed (figure 92). This debacle is interesting less for its own sake than for the disintegration in the artist's character which it points up: in Martinique Gauguin had preferred to dig in malaria-infested canals rather than support himself as a portraitist; Laval was less than a man in his eyes for choosing to compromise his art instead of his health. It is perhaps too harsh to imply that the passage of time had eroded his spirit —yet, in some basic way, he was not the man that he had been. His Promised Land nonplused him; he had achieved it, and his desire to succeed within its boundaries was great. Further failure could only reflect back on him and his art—"This beastly painting! How often you have insulted it, not as talent but as breadwinner"; he wrote to Mette. He would rather pander than return to Europe in disgrace, his great experiment failed, his great dream exposed like a rabbit up a sleeve as another empty gesture. He was too much a showman for that.

Yet hardship was a habit with him, as much a part of his act as of his experience. When it came, which due to his free spending was soon enough, his letters to Mette began to take on the familiar pattern of bombastic self-justification and glorification, laced with quantities of guilt. The full syndrome can be traced in a long letter dated March 1892. He begins by discussing business matters, urging Mette to do her part, and to push recalcitrant friends into action. Then, his thoughts of economics turning in due course to thoughts of love, he prods nervously to discover whether she has only "sinned in thought" with a Danish captain whom she had admitted to having met; there is no condemnation in his suspicions, only a curious probing for penance, as if he hoped to locate the magnitude of his abandonment in the sins of her flesh. "I realize that a

woman who spends her years of youth away from her husband may have moments of desire, of the flesh and of the heart. What do you want from me? It is not my fault that I was born at a time so unfavorable to artists."

As he writes, her accusing image appears to stand before him like a muse. His period of self-prostration is followed by anger—not against her but against that cosmic stupidity which condemns artists to exile and artists' wives to thoughts of adultery. Let her take comfort in the fact that the magnitude of their suffering is well-matched to the magnitude of his genius: "For I am an artist and you are right, you're not crazy, I'm a great artist and I know it. It's because I am such that I've endured such sufferings. To have followed my path in any other circumstances would make me out as a bandit. Which I doubtless am for many people. But then, what does it matter?"

He achieves a strength which rises from the extremity of his situation. In the face of insurmountable opposition he has been forced to turn to the one person he can trust—himself—and once again he has proven his mettle. "You tell me that I am wrong to remain removed from the artistic center. No, I am right. I have long known what I am doing and why I do it. My artistic center is in my brain and not elsewhere, and I am strong because I'm never sidetracked by others, because I do what is in me." (Then follows a condemnation of Pissarro, who has made the mistake of following the crowd—"these petty chemical persons who pile up little dots"—rather than following Gauguin, who climbs in solitude the one true path. "I alone am logical. Consequently, I find very few who follow me for long.")

As he realizes, the struggle engenders anger, and anger generates strength to face more struggle. He believes fervently that time will justify him, but at the depths of his braggadocio lies the sediment of resignation. He works with no real expectation of rest. "I'm always starting over again," he writes, and this phrase might stand as both eulogy and epitaph. "'I believe I am doing my duty, and strong in this, I accept no advice and take no blame. The conditions in which I work are unfavorable; one must be a colossus to do what I am doing under these circumstances." He reminds Mette that, however hard her lot, she is, after all, "the wife of a somebody."

Next comes the recitation of hardships which have afflicted him since he left Europe. "Were it not *essential for my art* (I am pretty sure of this), I would leave at once." Apart from financial difficulties, he had

been afflicted with a mysterious disease which caused him to spit blood by the cupful. "It seems that great injury has been done to my heart, which is not at all surprising."

Indeed, this catalogue of routine disaster causes the reader to wonder that the heart is working at all. In the face of death Gauguin turns philosophical, views his demise in the context of his own acidic view of the world. Had he ever been so naïve as to expect justice? "Is not life always the opposite of what one believes and hopes for? What good is it to think passively about the future, it only makes us forget the present. Each day, I say to myself, here is another day gained. Have I done my duty? Good, then let us retire to rest; tomorrow I may be dead."

He comments on a painting—the early canvas of *Suzanne Sewing* —which Mette has just sold. The sale of this single canvas sets him off on a minor diatribe in defense of painting as a moral occupation and himself as a satisfactory provider: "What do husbands, and especially stockbrokers, do in general? On Sundays they go to the races, or the café, or spend it with whores, because men need a little distraction, otherwise their work goes badly, and besides, it's only human nature. As for myself, I worked, and that was my diversion. Add this all up over several years and see if I haven't saved money which has helped you." And then a paean to Claude Monet, who rose from humble beginnings to an income of one hundred thousand francs per year—Claude Monet, whose relatives, "instead of casting him off, supported him and praised him to the skies."

He ends with a game note that he is growing thin and gray, living like a native, has not had a headache for four months. And signs off: "Love to the children who are to kiss you for me. Your Paul who loves you."

The arid resources of Papeete could not support Gauguin's fantasy for long. Not three months after he had arrived in that city he was already prepared to leave it, to search for that essence of savagery which promised to regenerate him. "It was the Tahiti of former times which I loved. That of the present filled me with horror."

His entry into the jungle was delicate, tentative, even genteel. He borrowed a comfortable carriage and hired a female companion, a half-caste girl called Titi (perhaps in approbation of the most outstanding aspect of her character). For her debut in primitive society she had put

on her most elegantly ornamental dress, a reed hat garnished with ribbon, straw flowers, and orange-colored shells, and the omnipresent flower behind her ear. The journey ended about twenty-six miles from Papeete, in Mataiea on the south coast of Tahiti. Gauguin had come to know the native chief of the district, Tetuanui, who was eager to chaperone his guests about the beauteous landscape, which, in its physical properties, did justice to Gauguin's wildest dreams. Impulsively, beguiled by its charm but knowing nothing of its character, he decided to settle there. He rented a bamboo hut from a wealthy orange-picker who had vacated it for a grander dwelling next door. Mataiea had a population of 516, living in about fifty widely spaced houses. Gauguin had no near neighbors except his landlord to disturb his tranquillity. He was not, however, without human contact, for his hut was flanked by the Protestant church and school on one side and the Catholic church on the other; the combined hymn-singing and bell-ringing sandwiched him in an aura of sanctity.

Thus was the fact cruelly brought to bear upon Gauguin that Mataiea was one of the most civilized districts in Tahiti. The Catholic school was taught by French nuns, and the French Calvinist mission, in order to compete with the Catholics, had appointed a Frenchman to its pastorship instead of a converted native. Unfortunately for Gauguin, his friend Tetuanui was not the only authority to wield ruling power; the strong arm of the law was none other than a French gendarme who summarily threatened Gauguin with a summons if he continued to pervert public morals by bathing naked in a stream. As to the fabled availability of food and resources, this too proved true in fact but not in practicality; the agile natives were adept at hunting and fishing and gathering the wild bananas which grew in the mountains, but such feats were beyond Gauguin; he was forced to purchase his own provisions from the Chinese-run general store, and to pay exotic prices for imported tinned foods.

The affluence of native resources was almost an affront to Gauguin, whose agility proved inadequate to overtake his quarry; willing vahines proved to be as elusive a natural bounty as any. On deciding to remain in the country he had sent Titi back to Papeete, but now, vulnerable in his solitude, he requisitioned her once again. Unfortunately her gaudy presence reacted, like a plot of Papeete transplanted, in an adverse way upon his work. His paintings of this time reflect a certain stillness, an idealization of mood, which suggests that he had managed to sublimate the less

romantic aspects of life in Mataiea and to concentrate upon its beauty and relative strangeness; it was, for all its civilization, as close as he had come to the terrain of his dreams. Titi proved to be an element of discord on the serene horizon, but Gauguin's self-confessed reasons for sending her back were of a deeper order. As he implies in a passage in *Noa Noa*, he had apparently decided that half a savage was no savage at all: "Titi had a terrible reputation at Papeete, having brought, successively, numerous lovers to their graves. . . . The experiment furthermore didn't succeed, and in the boredom that I felt in the company of this woman accustomed to the luxury of officials, I could see what real progress I had already made in the Wilderness. At the end of several weeks, we separated forever. Once again alone."

Titi's mixed blood, and also her mixed persuasions (those of a native woman who had cultivated a taste for the bounties of "civilization"), which might have reeked of exoticism to the newly arrived Gauguin, now aroused in him an aesthetic distaste; in a country context, in the purity of an unadulterated landscape, Titi lacked grace. She was not an ideal; thus in Gauguin's eyes she was nowhere—a displaced person who reflected his own displacement. His country neighbors, whom he observed and later painted at their daily activities, now seemed to him full of grace, their spiritual superiority echoed in a structural nobility, a strength of outline—as if the course of their lives had not dissipated them. " 'Savages!' This word came involuntarily to my lips when I looked at these dark beings with their cannibal-like teeth. However, I already had begun to understand their genuine, strange grace. . . ."

Gauguin developed a desire to do a true portrait of one of these admirable creatures, a rendering which would concentrate the qualities he perceived as essential to the Maori character. At last he succeeded in luring to his hut one of his neighbors, a young woman "of true Tahitian race." Charmed by her "enigmatic" Maori smile, he attempted to sketch her, but as soon as she realized his intention she fled. An hour later she returned, of her own will, dressed in her best and ready to pose. In sketching her Gauguin sought to get to the bottom of her charm, to capture it:

"She was not very pretty, on the whole, according to European standards of aesthetics. But she was beautiful. All her features presented a Raphael-like harmony in the meeting of the curves, the mouth shaped by a sculptor speaking all the languages of speech, of the kiss, of joy and

of suffering. And I read in her the fear of the unknown, the melancholy of bitterness mixed with pleasure, and the gift of passivity which apparently gives in, and surmounts all, but remains dominant. I worked with haste and with passion, doubting the permanence of this willingness. I put into this portrait that which my heart permitted my eyes to see, and especially that which the eyes alone, perhaps, would not have seen, this intense flame of a contained force. Her noble forehead, with its elevated lines, recalled this phrase of Edgar Poe: 'There is no perfect beauty without a certain singularity in the proportions.' And the flower at her ear listened to her perfume."

"This intense flame of a contained force . . ." In this telling phrase Gauguin's rendering of Maori grace can be summed up (figure 93). The model is as still as a statue; her features might have been cut from stone, so massive and solid do they appear: high, planed forehead, broad nose, full-lipped, fully *realized* mouth, set in a facial structure which is as premeditated and defined as a carved frame; the head rooted upon heroic shoulders, squared body; the hands like blocks of wood indented with fingers. For all its stillness, as manifested in the supreme poise of its containment, the figure radiates great light. Its poise is the poise of a deity, in whom the essential characteristics and the cell-implanted longings of an entire race are consummated. Light strikes the forehead in the manner of a benediction—but a benediction given *out*, so that the viewer, like Gauguin, feels honored by the presence of the subject.

The degree of fervor stored in the portrait of the Tahitian girl becomes more obvious when compared with that of Suzanne Bambridge, the cabinetmaker's daughter (figure 92). This oversized Englishwoman was married to a Tahitian chief, and in her matronhood had taken on the Tahitian name of Tutana; she held a position at the court of Pomare V as a sort of official hostess, presiding over feasts and receptions and other weighty occasions. She chose to pose in a tentlike flowered Tahitian robe, and Gauguin rendered her unmercifully in all her gaudy detail. If Titi's half-caste glory was garish, then Suzanne's uncongenial mixture can only be termed ludicrous: the small features seem lost in a field of flesh; the pallid skin, punctuated by a red nose, is no match for the bright splash of flowered fabric which anchors the figure in a state of bonelessness, like a moored ship composed entirely of sail. The portrait, though accurate and even perceptive, makes of the subject a sad monument, massive without

grace, solid without dignity—and to top it off, a heaviness of expression, so that poor Suzanne Bambridge emerges with all the solemnity of a sphinx in drag.

Gauguin's mission at this time was to pinion the essential Tahitian character, to render it in a state of timelessness, frozen in repose. His country neighbors proved to be apt specimens, for a certain posed stillness of posture was natural to their character; it was not unusual for a native to assume a reposeful attitude and hold it for hours, in the manner of a professional model. Confronted with this array of living statuary, Gauguin soon began to formulate definite figure types, which he repeated again and again in different contexts until, as if reiteration had imposed upon them the secret lining of much-used objects, they assumed a definite symbolic function.

At first Gauguin dispersed his figure types in picturesque landscapes, in which they functioned as objects in a scheme, the mute populace of genre scenes of native life. In a typical painting of this order, *The Great Tree* (figure 94), several types are represented: the woman standing erect, seen in profile, pacing like a monitor; the pair of women beneath the tree, one turned toward the viewer, the other turned away and resting on one arm; the distinctly shaped leaf, centrally placed like a monogram, repeated in a portrait of a Tahitian woman, where it forms her sole accompaniment, her emblem. The seated figure which leans on one arm is seen again, in front view, in another portrait, accompanied by two black pigs; she reappears, with her seated companion, in yet another painting, *Who Will You Marry?* (figure 95), done the next year, retaining her front-view position but with more ominous implications: the other woman now peers over her shoulder at the viewer, her visage invested with a composed and knowing expression, as if she is the bearer of some secret knowledge. If a proper narrative form were imposed on the repeated motifs, then a work of 1892, *Where Are You Going?* (figure 121), might be said to be a concluding chapter: the standing figure in the early painting is reunited with the seated figures beneath the tree, but now she looms large in the foreground, bare-breasted, while the other figures, both turned to the front, seem to watch her intensely and furtively, one woman crouching behind the tree. The seated postures, come full circle, have lost the randomness and languor which they conveyed in the genre scene, and now the figures seem crouched, ready to spring, and

the strolling woman, lost in thought and staring straight ahead, appears curiously vulnerable, as if her nakedness, couched in self-preoccupation, will be offered up to feed the designs of the other two.

A similar array of figure types appears in *Tahitian Women Fishing* of 1891 (figure 96) in which a tree separates a seated melancholic figure from two bent women collecting fish in a stream; behind the tree appears another walking woman, seen in profile. The contrasting of figure types was a technical device that Gauguin often made use of: the seated figure with the walking; the brooding attitude with the working. Such juxtapositions took on a symbolic nature only when repeated. However, in such works as this, the philosophical polarities intrude upon the purely physical; the *Vineyard at Arles* painting comes to mind with its seated melancholic girl and its working women bent in labor. The woman against the tree recalls the woman crouched against the black rocks in Le Pouldu. One has the feeling that the major battles were fought in Brittany and now are being relived in Tahiti in anecdotal form, with only the setting changed. Like an omen for the future, however, the walking-woman-in-profile marches her somnabulistic route behind the tree.

The variety of postures, activities, settings, manifests the intensity of Gauguin's quest to understand, through his art, the character of Tahitian life. He never *imposed* an ideal upon his creations, but rather *derived* it from a siphoning of his perceptions; although he used poses from ancient art and Italian primitives, he continued to refer to his own sense impressions of the life around him. Unlike his Paris-bound colleague Puvis, he never fell back on stereotypes of Golden Age imagery; the essence of his visionary "essence" was sweat, not perfume. In the toughness and honesty of his renderings it is possible to calculate the depth of his journey—he had shed a lot of excess baggage since the day he walked off the ship.

He had also shed that most lively vestige of a dead civilization, the half-caste Titi. And now he was feeling forlorn in the silence, restless and unable to work well. As a rejuvenating measure he decided to travel around the island to a more primitive area. He borrowed a riding horse from the French gendarme at Taravao and set off to explore the east coast, a wild section little known to Europeans. At Fa'aone the weary traveler was hailed by a native—"Halloa! Man who makes human beings!"—and responded gratefully to a dinner invitation. In the hut an

attractive Maori woman of middle years asked him where he was going. "I do no know what idea passed through my mind and perhaps, without knowing it, I expressed the real purpose of my journey. 'To look for a wife' I responded. 'There are many beautiful women in Itia.'

" 'Do you want one?'

" 'Yes.'

" 'If you like I will give you one. She is my daughter.' "

The woman returned a short while later leading a young girl of about thirteen. Gauguin could not have been more awed and enchanted in the presence of the moon goddess Hina herself: "Through the dress of transparent rose-colored muslin, one could see the golden skin of her shoulders and arms. Two swelling buds rose on the breasts. In her lovely face I did not recognize the model which I had hitherto seen everywhere dominant on the island, and her hair was also exceptional, thick like a bush and slightly crispy. In the sunlight it was all an orgy in chrome."

The progression of the courtship devolved with an almost dream-like sparseness and simplicity. The complex mechanizations inherent in European marriage customs were totally absent here; it was give-and-take in the most primitive connotation of the phrase.

"I greeted her; she sat down beside me; I asked her some questions:

" 'Aren't you afraid of me?'

" 'Aita (no).'

" 'Do you wish to live in my hut for always?'

" 'Eha (yes).'

" 'You have never been ill?'

" 'Aita!'

"That was all."

Gauguin was at once intrigued and shaken by this rapid acquisition of a wife. The girl, whose given name was Teha'amana (rechristened "Tehura" by Gauguin in *Noa-Noa*), appeared to take her new status in life with great equanimity; she had entered the room for their first meeting already carrying the small bundle of her possessions. To be the vahine of a Frenchman was no small matter, for Europeans were automatically considered to be wealthy, prestigious, and, no doubt, indulgent to their women. Tehura had no fear of Gauguin, but her impenetrable serenity was already beginning to react on him: "The mocking line about her otherwise pretty, sensual, and tender mouth warned me that the real dangers would be for me, not for her" (figures 97 and 98).

When he left the hut he took with him not only his new wife but also an assortment of relatives. The party proceeded to Taravao, where they stopped at another hut and presented the newlyweds to a second set of in-laws—Tehura's foster parents. "Then in silence fresh water was poured into a goblet from which we drank each in turn, gravely, as if we were engaged in some intimate religious rite.

"After which the woman whom my bride had just designated as her mother said to me, with a deeply moved look and moist eyelashes, 'You are good?'

"I replied (not without difficulty) after having examined my conscience, 'Yes.'

" 'You will make my daughter happy?'

" 'Yes.'

" 'In eight days she must return. If she is not happy she will leave you.' "

The responsibility for the girl's happiness and well-being had been laid upon Gauguin, but the burden sat well with him; in his mind Tehura had already been established as the Good. Characteristically, he lost no time in establishing her just polarity. When he returned the horse to the French gendarme he was confronted by the wife of the official, who turned a hawk's eye upon Tehura:

" 'What! You bring back with you a hussy?'

"Her eyes, full of hate, undressed the young girl, who met this insulting examination with complete indifference. I looked for a moment at the symbolic spectacle which these two women offered: it was decrepitude versus a fresh blossoming, law versus faith, artifice versus nature— and the latter breathed on the former a whisper foul with falsehood and spitefulness.

"It was also two races face to face, and I was ashamed of mine. It seemed that my race stained the beautiful sky with a cloud of dirty smoke. I turned quickly to redirect my gaze to the brightness of this living gold, which I already loved."

The tenure with Tehura was perhaps the happiest time in Gauguin's life—or rather, it took him back to the first happy time of his life, the early years in Peru. He described the first week with his golden girl as bringing him to a state of "childlikeness" which he had never experienced before; he was a child anew, not again. Tahiti did not take form in his mind as a return trip to Peru, but rather as a fresh venture upon a

well-beloved route; he knew instinctively that one could never relive
Eden, but only begin it over.

He loved her and confided the fact to her freely. "It made her laugh
—she knew it well." He loved her with a premature integrity which is
usually suspect—particularly in one of Gauguin's wary nature. How had
the fatal feelings reached his heart so rapidly! Most likely, he loved *be-
yond* her, and she, in her physical presence, did not distract him from his
vision as Titi had done. Tehura was quiet, yet forceful in her moods; she
appeared to understand Gauguin well but gave out little herself. This
quality of mystery fascinated Gauguin, and the girl became for him a
living symbol of the elusive Maori character which he tried so hard to
penetrate:

"The soul of a Maori does not reveal itself immediately. It
requires much patience and study to obtain a grasp of it. It escapes you at
first and foils you in a thousand ways, enveloped in laughter and variabil-
ity; and while you let yourself be taken in by its appearances, as if they
are manifestations of its intimate truth, without thinking of playing a
role, it examines you with a tranquil certitude." This passage might
serve as an explication of his own excursions into symbolism.

When the day came for Tehura to return to her people Gauguin
was filled with anxiety. He was unable to work—a striking symptom in a
man accustomed to take refuge from domestic problems in work. Fatal-
istically, he believed that she would not come back, that this foray into
Eden would prove, like all the others, abortive. Yet, after the prescribed
week, she did return, and with her the metaphor of Paradise, which
seemed now to find its daily equivalent in reality. In a very simple and
complete sense, Gauguin was now glad to get up in the morning, eager to
work, satisfied to love without question.

Life was all of a piece now, and it seemed that the main component
could do no wrong. He narrates an incident in which Tehura persuaded
him, through pouting and taunting, to purchase a pair of copper earrings
at a price far beyond their value: "What, would you not be ashamed to
see this jewel in the ears of some other woman? Someone over there is
already speaking of selling his horse so that he may offer these earrings
to his vahine." She would hear nothing of Gauguin's explanations about
the worthlessness of copper, and in the end he. gave in and bought the
coveted ornaments. A few days later, seeing her arrayed in her Sun-
day clothes, he suggested that she wear the earrings and was greeted

with an expression of contempt and a phrase thrown at him like an epithet: "They are of copper." Had the same incident been enacted by a French woman, Gauguin would have been quick to offer it as an example of gold-digging European decadence; in Tehura this perversity became enshrined, a priceless gem of the Maori character, a charming proof of the savage's unconquerable pride.

"And Tehura never disturbs me when I work or when I dream," he writes. Yet she was less a muse for him than a medium, a being through whom he might contact the spirits of another world. He claimed that she instructed him in the complex roll-call of gods and goddesses of Tahitian mythology. Although she was of a superstitious nature, it is not likely that a girl of her era would be knowledgeable about these legends—the missionaries had for too long claimed squatter's rights on native souls, and they had done their work efficiently and thoroughly. Although Gauguin castigates the "artificial veils" of Protestant teaching, he inadvertently shrouds the girl in the mantle of his own fantasies, his own need for her to be real, to be adequate, to embody his visions:

"Now that I can understand Tehura, in whom her ancestors sleep and sometimes dream, I strive to see and think through this child, and to find in her the traces of the faraway past which socially is dead indeed, but still persists in vague memories."

"To see and think *through* her," he says, and in his phrasing of this purpose, he reveals the specter of his own vulnerability in the face of reality, his own weakness—which becomes, in his work, his great strength: Tehura is the medium, more malleable than transparent, but the ghosts are all his, the "vague memories" are his; he sees through her to see himself through.

In his mind they became "the first man and the first woman . . . And the Eve of this Paradise became more and more docile, more loving." Crucially, his strong tendency to form polarities, to judge life as a complex system of weights and balances, disappears at this time— or else fixates at one end of the scale so heavily that the other end ceases to pull its weight: "I am no longer conscious of days and hours, of good and evil. The happiness is so strange at times that it suppresses the very conception of it. I only know that all is good, because all is beautiful."

⌘ XIV ⌘

The Tahitian Eve

"I T W A S T O Puvis de Chavannes that my thoughts turned last night, when to the southern sounds of the mandolin and guitar I studied the sun-drenched pictures on the walls of your studio, and the memory of them pursued me all night in my sleep. I saw trees no botanist would ever find, beasts Cuvier would never have dreamed of, and people you alone could have created. I saw a sea which appeared to flow out of a volcano, and a sky inhabitable by no God. 'Monsieur,' I said in my dream, 'you have created a new earth and a new heaven, but I do not feel easy in your new universe; for me, a lover of *chiaroscuro*, it is too ablaze with sunlight. And in your paradise dwells an Eve who is not my ideal; for I also have a feminine ideal—or two!" [1]

This passage was part of a letter written to Gauguin in January 1895 by the Swedish writer and antifeminist August Strindberg in which he explained his refusal to write a preface for the catalogue that was to accompany Gauguin's display of the fruits of his Tahitian labors of love, to be held at the Hôtel Drouet. These images of a new Eden appeared to Strindberg as nightmare visions of hell; he speaks of being "pursued" by them at night—and, in view of his noted hostility to women, it seems likely that the pursuer who chases him in his sleep is not the specter of unfamiliar vegetation, or the ghostlike retinue of strange beasts, or even the pagan sky, golden as an idol and barren of the mediat-

ing influence of the European God—but rather, the pursuer is
self, wanton, mysterious, and aggressive; guaranteed, in her
glory, to run a woman-hating European intellectual all the way

Gauguin was not daunted by Strindberg's refusal. He res
writer as a fellow artist, one with whom he could fence on ec
and above all he respected the frankness and admiration imp
refusal. Strindberg, even while claiming not to comprehend
art, understood it to the extent that he recognized Gauguin
savage, "a Titan, jealous of the Creator and wanting in his l
make his own little creation." With enemies as perceptive as this,
guin had no need to court friendly reviewers, and he decided to print
Strindberg's letter in lieu of a proper preface—to be followed by a brief
note of his own.

"Studying the Eve of my choice, whom I have painted in forms and
harmonies of a different world, she whom you elect to enthrone evokes
perhaps melancholy reflections. The Eve of your civilized imagination
makes nearly all of us misogynists: the Eve of primitive times who, in
my studio, startles you now, may one day smile on you less bitterly. This
world I am discovering, which may perhaps never find a Cuvier nor a
naturalist, is a Paradise the outlines of which I have summarily sketched
out. And between the sketch and the realization of the vision there is
a long way to go. What matter! If we have a glimpse of happiness, what
is it but a foretaste of Nirvana?" [2]

Gauguin acclaimed his Eve as a new creation, pre-Christian, re-
born in ancient form but heralding the new era to come—all of which
brought her above and beyond Strindberg's "civilized conception." He
had indeed made a new world, but Strindberg could not have known of
the means by which he attained Titanhood. Strindberg's image of Gau-
guin as "a child taking his toys to pieces to make new ones" pales before
the artist's own gutsy narration of the Eve saga—although it acciden-
tally hits upon Gauguin's referral to his own infancy and youth as a
source of substance for his re-created Eve: "Sometimes I have gone far
back, farther back than the horses of the Parthenon . . . as far back as
the Dada of my babyhood, the good rocking-horse."

The Tahitian Eve before the Fall is more earthy than her predeces-
sor, closer to an animal state (figures 99 and 100). She exudes the same
appeal as the wilderness of nature which is her home; in her virginity she
also embodies the primordial state of Paradise in which lush, perfumed

vegetation grows wild and unharvested, free from the ravages of man. Gauguin made several renderings of this exotic and idealized Eve under the title *Fragrant Earth*. Although the physiognomies differ from the Eves he painted in Europe, the pose of the body is derived from the same Javanese relief from which he evolved the figure of Eve with the head of his mother.[3] Eve is poised to pluck a flower; she is only a transplanted virgin maiden, set in the midst of a more ravenous natural setting, about to go to seed. Beside her head, at ear level, a red-winged lizard is suspended; he is the stand-in for the serpent, just as the flower is a ready replacement for the fruit. Mindful that neither snakes nor apples are native to Tahiti, Gauguin adjusts the essential stage props to reinforce the reality of the Tahitian Eden.

Lizards in Polynesia play a special character role in the ritualized byplay between sexes. The nocturnal scurryings of these little arboreal creatures register in the death-primed mentalities of Polynesian women as spirits of the dead rustling in the trees; the women hear these spirits as Eve heard the words of the deadly serpent. The fear is propagated in them as a societal confining device, limiting their nocturnal movements, immobilizing them in their huts at night.

The lizard, a four-footed beast, is the serpent before the Fall—not only ethnologically but symbolically indigenous to Eden. The shrewdest of all beasts, he is the Annunciator of Evil tidings, a bad angel whom Gauguin—outstepping Genesis—has endowed with wings. A winged lizard becomes a dragon, a frightful imaginary monster which is the male counterpart of the female chimera. In Eastern and Western tradition the dragon is a force of pure evil, an Anti-God who wreaks chaos in the midst of divine creation. It devours and ingests innocence: Saint George battled a classic dragon of the species which demands a certain quota of fair maidens from the village each month so that it may trap them in its fire-breathing maw and placate both its appetite and its temper. The ashes of virginity—for the victim must be a virgin—stick to its ribs. The force of good, if triumphant, is manifested in the form of the chivalrous armored knight who battles to save the girl's honor as well as her life.

In its literal meaning a dragon-chimera is a vain and foolish fancy, a whim of the night mind at play in open nature. Its legendary sexual aggressiveness then becomes less a tangible danger than a source of wish fulfillment in the dreamer's unconscious. For Gauguin the beast is two-faced and double-natured: the dragon's appetite grapples with the

chimera's back-breaking weight, even as Eve's appetite found its just match in back-breaking labor after the Fall. His own vain and foolish fancy—and his most potent and terrible dream—cast him in the role of the well-armored knight Saint Gauguin, the fatherless boy whose divine duty obliges him to assume the role of mother-protector, to fight (for his own life) to save the honor of Eve.

In his prose poem "To Everyone His Chimera" Baudelaire pursued the phenomenon of the chimera and its bearer: "I met several men who stooped as they walked. Each of them carried on his back an enormous chimera, as heavy as a sack of corn or coal. . . . But the monstrous Beast was not an inert weight; on the contrary, it enveloped and oppressed the men with its elastic and powerful muscles. . . . I questioned one of these men, and I asked him where they were going. He told me he did not know, nor did the others, but that evidently they were going somewhere, because they were driven onward by an invincible need of walking . . . none of these travelers seemed to be exasperated by the ferocious beast that clasped his neck and squatted on his back; they seemed to consider the Beast a part of themselves . . . they wandered on and on with the resigned aspect of those who are condemned to hope forever." [4]

The Baudelairean chimera, with its intimations of paradoxical vanity, would have appealed strongly to Gauguin. His Tahitian exodus had done little to eradicate his European sense of sin. Sexuality, even in a climate of relaxed morals, remained the beast which burdened and destroyed womanhood: each classic Eve posture, from the crouched anguish of decision to the moment of self-abandonment to the death dance of rhythmical submission and inevitable decline—each testified to the lot of "those who are condemned to hope forever," to bear the load without end. Eve's own fate (the very nature of a woman's life) was to be burdened by destiny, not only bent beneath the weight of the moment but also sifted and thinned by the passing of time. Sexuality, as embodied in the Chimera-Tempter—the weight of sin—was nothing more than a sweet lie by which life regenerated itself. "Do not listen to the liar," wrote Gauguin on one rendering of a Tahitian Eve theme—*do not listen to the spirit of death.*

The change from fruit to flower imagery was made not only to remain true to the local habitat but also to bring closer to Eve's legend the symbolism of loss of virginity and consequent death. Thus the flower

which Eve is about to pluck is not a natural Tahitian variety but rather a Baudelairean flower of evil, a Redonian flower-eye of death: it is a composite of symbolical equivalents which culminate in the form of the eye-like tail feather of a male peacock. The popular symbolic character attributed to the peacock associates it with vanity, and also with the hope of eternal life as generated by the fear of death. Gauguin underwrites this double symbolism to insure love against the depredations of vanity—paid for in seasonal premiums: the endurance of love was expressed in the eternal round of the life cycle, with its sessions of death and rebirth. With Baudelairean resignation he excoriates the illusory character of love even while acknowledging the necessity of maintaining the illusion. Beyond this, the intimations of eternal life allow him to carry his dream-Eve to the lower depths of earthly existence and then to summarily redeem her through motherhood. The peacock-flower is both the instrument of her downfall and the token of her salvation, just as in Christian tradition the same tail feather incorporates the symbol for the Church Triumphant in its definitive victory of life over death. The peacock often appears in nativity scenes as a reference to the durability of the flesh of Christ; an ancient belief, which transcended the tradition of the eternally open and farseeing eyes of the peacock's tail, held that peacock flesh did not rot. In a number of examples among Gauguin's religious themes, the peacock is present at the time of the Annunciation and at both the birth and death of the redeeming child.

The proud stance of the peacock, its opulent display of iridescent coloring, established it as a pet of *art-nouveau* painters who delighted in associating it with artificial, decadent beauty and indolent luxury. Whistler had popularized the peacock by constructing a perverse eulogy to it in the form of his Peacock Room at the Leyeland residence in London wherein he developed the bird's identification with vanity by depicting it as a greedy, quarrelsome creature. When Leyeland refused to pay the full price that the artist had demanded for the room, Whistler added a peacock in his client's likeness with some guineas clutched in its claws— a distant parallel to the motif of a bird clutching a lizard in its claws that Gauguin would use in later paintings of the Eve saga. In Oscar Wilde's drama *Salomé*, produced in Paris in 1896, the unfortunate Herod, seduced by the rhythmical serpent-writhings of Salomé into offering her anything she wished up to half his kingdom, pleads with her to accept fifty white peacocks in lieu of John the Baptist's head. Salomé danced a

Biblical striptease, removing before Herod's eyes one veil at a time until the king's desire was equal to his sexual domain—one-half his kingdom, the sexual half of himself.

(Gauguin in a letter to Émile Bernard:

"As they say, the prettiest girl in the world cannot give more than she has.

"This applies to me. And if you are unhappy, I cannot give you any other consolation than this.

"*The half of my cloak*. It is still the best kind of Christianity.")

Salomé deals Herod a castrating blow when she scorns the offer of the peacocks and delivers the head straightaway to her vengeful mother, who had been smitten by John's accusation that she had illegally married the brother of her rightful spouse.

Salomé had been used by her mother as bait for a base purpose, as an entrapping device. With the removal of the veils her open nature was revealed, and she became as naked and vulnerable as the girl in *Loss of Virginity*. Like Persephone, she was the virgin daughter sold into unholy union by an avaricious parent. The mother hovers in the background, wielding her watchful eye like a periscope, at once on guard lest the girl's prized virginity be threatened and on the alert for suitable takers. The mother-goddess Hera in ancient mythology gave the peacock its hundred eyes in honor of the great giant Argus who had been killed by Hermes while guarding the chastity of Hera's daughter Io. The eyes of the peacock tail multiply the watchful eyes of Argus, which had failed in the stand-in role of the mother's watchful eye: Io's virginity was taken by Hermes. Thus, in its original mythological symbolism, the peacock-tail eye is an emblem of the mother who keeps an eye on her daughter, and of the futility of the watch. The eye will be killed—or, in Gauguin's depiction of the Tahitian Eve, *plucked*, as both eyes and flowers are plucked—and the daughter's virginity will be taken. (Aubrey Beardsley's cover design for Wilde's *Salomé* is composed of peacock-tail eye-flowers of the exact kind that Gauguin's Tahitian Eve is poised to pick.)

Io's anticipation of sexual pleasure, like Salomé's anticipation of pleasure as a reward for pleasing Herod, resulted in the tragic death of a giant-man, a castration-death, as are all deaths of giants. The woman's death-dealing weapon is almost never a sword but more likely a loaded gesture—a mean shift of the hip, a pointed glance. The watchful eye of

Gauguin's own mother remained enshrined in his mind's eye: "How graceful and pretty my mother was when she put on her Lima costume, the silk mantilla covering her face and allowing a glimpse of only one eye, an eye so soft and so imperious, so pure and caressing." A charming vision—but also a perverse one. The eye of the mother invites what it offers: the soft eye evokes sweetness, the imperious eye invites obedience. Gauguin may have been immobilized by the two faces of his mother's glance, at once "pure and caressing," the veil of virtue repressing hidden delights. Aline's pristine façade may only have spiced her seductiveness: years later, Gauguin would experience a similar emotional paradox over the teen-aged Madeleine Bernard, whose affections he dared covet only in the guise of a "brother"—saved by an imposed incest taboo from acting out his lower instincts.

Gauguin experienced the full spectrum of his mother's glance; to what extent he experienced its fatality can only be surmised. Writing of the death of his father, he supplies a curious detail: "He had the bad luck to fall in with a certain captain, a terrible person who did him an atrocious injury when he already had a serious case of heart trouble." Gauguin could only have picked up this detail from his mother's narration, which might have implanted in him strange and unsavory suspicions and intuitions. Did he suspect that the terrible captain may have enjoyed an alliance with his mother, and that the "atrocious injury" had been dealt to his father in a conflict of honor? Suffering from a similar case of heart trouble, Gauguin would one day warn his wife against adultery with a "smart captain"—adultery being, in his stated judgment, the only true crime.

Gauguin's pictorial use of the eye habitually associates it with vanity, evil, and death. He shared this interpretation with many artists of the late nineteenth century who employed the peacock tail-feather eye as a vessel of vanity and an emblem of dangerous, fatalic women. Gauguin's siren (of the species whose beauty lures men to their deaths), gazing into a mirror with a peacock above her (figure 101), heralds Tiffany's hand mirror in which the head and neck of a peacock form its handle and peacock tail-feathers curl around its back and sides, enshrouding the image in the mirror just as the male peacock's tail spreads and covers the female's back and sides during copulation. In 1892, the year Gauguin first substituted the peacock tail-feather for the flower-fruit picked by

Eve, he painted a native couple copulating, surrounded by flowers, beneath a peacock in flight; the same couple also reappear in his manuscript *Noa Noa*, copulating in the corolla of a flower (figure 102).

Gauguin was familiar with Eastern mythology concerning both the peacock and the power of the eye; he once made a pot, shaped like a grotesque head, which bears a peacock in place of Buddha's Eye of Enlightenment. In parts of India, to make the earth fertile, victims were sacrificed on a post bearing the effigy of a peacock, and in other parts it was believed that one who treads on the peacock's tracks would come down with a horrible disease. Most often, Hindu beliefs associated the peacock with the moon. The eye of Buddha sees beyond earthly matters and can thus distinguish between good and evil, as can the eye of God or the eye of the watchful mother.[5]

The flower was a proper setting for the fatal eye; its sexual aspects had been recognized and utilized by Gauguin even before he came to Tahiti. Yet he might never have realized the full potentialities of the flower had he not been influenced by Odilon Redon, whose strange illustrations in *Origines* included a drawing of a flower with an eye at its center, poetically inscribed, "Perhaps nature first tried out eyes on flowers (figure 103)." In the context of Gauguin's themes, the eye within the flower would become an Evil Eye, the seat of death within the living organism. Just as the ear is the passive receptor of the words of the devil, so the eye takes an active role, becomes a weapon which penetrates as it glances. To see is to know, and to know, in its sexual connotation, is to kill. In Gauguin's journal one reads, "Do not attempt to read Edgar Poe except in some very reassuring spot . . . and especially do not try to go to sleep afterwards in sight of an Odilon Redon."

He goes on: "Let me tell you a true story.

" 'My wife and I were both of us reading by the fire . . . [Gauguin's wife was reading Poe's *The Black Cat*].

" 'The fire was going out and it was cold outside. Someone had to go after coal. My wife went down into the cellar . . .

" 'On the steps, a black cat gave a frightened jump. So did my wife. But after a little hesitation she continued on her way. She had taken two shovelfuls when a skull rolled out from the coal. Transfixed with terror, my wife . . . dashed back up the stairway and fainted in the room. I went down in my turn, and as I set about getting the coal I brought to light a whole skeleton.' "

It proved to be an old jointed skeleton which had been used by the painter Jobbé-Duval, from whom Gauguin was renting the house. "As you see, it was all extremely simple," Gauguin adds; "and yet the coincidence was strange . . ."

Strange, yes, but no stranger than the "coincidence" of Mette's superstitious fear of death symbols, so calmly related by Gauguin, and his later narration of Tehura's terror of the death spirits lurking in the dark. In each case Gauguin poses as the fearless Frenchman, cool, rational, and impeccably above-board in his dealings with the netherworld. Yet it is not the spirits that he controls but Eve herself, who dances willlessly a cosmic jig—love, childbirth, fear, death, all steps in time—to the tune of the Master Creator: in his realm, she dances in place.

Gauguin's Tahitian Eve appears alone, with no Adam to counsel her or share her fate. She is in a position of complete responsibility and complete vulnerability: the decision and the doom are hers alone. Adam is no fit adversary for her; if he exists at all it is as some vague, hovering spirit—a presence and a motivation but no participant. In Gauguin's mother-heavy world—the half of his cloak hopelessly weighted, an abberation of style—Eve's life drama is paramount. She shares the stage with her true adversary, the Spirit of the Dead, both archenemy and alter ego, and all the more potent for being an extension of her dream-nature. This spirit is as tangible as the skeleton in Gauguin's cellar: the temptations it offers are rooted in Eve's desires; the knowledge it disseminates has already flowered in Eve's thoughts; its darkness is all Eve's.

"When I opened the door, I saw that the lamp was extinguished, the room was in darkness. I felt a sudden pang of apprehension, of mistrust; surely the bird had flown. Quickly I struck a match and I saw:

"Immobile, naked, lying stomach downward on the bed, with her eyes inordinately large with fear, Tehura looked at me and seemed not to recognize me. I stood for some moments in a strange uncertainty. A contagion emanated from her terror. It seemed that a phosphorescent light was streaming from her staring eyes. Never had I seen her so beautiful . . . never with a beauty so moving. And then, in this half light, surely peopled for her with dangerous apparitions and uncertain suggestions, I was afraid to make a movement which might carry the child's fright to a state of paroxysm. Did I know at that moment what I was to her? Might she not, with my frightened face, take me for one of the

demons and specters, one of the *Tupapaüs*, of which the legends of her race fill sleepless nights? Did I even know who in truth she was? The intensity of the feeling which had dominated her under the physical and moral power of her superstitions had transformed her into a strange being, so different from anything I could have seen heretofore.

"Finally she came to herself, and I did all I could to reassure her, to restore her confidence.

"She listened sulkily to me, then with a voice in which sobs trembled, she said, 'Never leave me again so alone without light. . . .' "

As evidenced by this passage from *Noa Noa*, the intensity of the girl's belief, and the totality of her fear, made a deep impression on Gauguin. In a painting directly inspired by the incident (*The Spirit of the Dead Watches*, figure 104), he transformed the Spirit of the Dead into a sexual watchwoman haunting the night-dreams of a pubescent girl. A measure of his fascination with the theme is the extensive analysis he accorded it in the notebook dedicated to his daughter Aline:

"A young native woman lies flat on her face. Her terror-stricken features are only partially visible. She rests on a bed, which is draped with a blue *pareu* and a cloth of chrome yellow. The reddish-violet background is strewn with flowers resembling electric sparks, and a rather strange figure stands by the bed.

"I am attracted by a form, a movement, and paint them, with no other intention than to do a nude. In this particular state the study is a little indecent. But I want to do a chaste picture, and above all render the native mentality and traditional character.

"As the *pareu* plays such an important part in a native woman's life, I use it as the bottom sheet of the bed.

"The bark-cloth has to be yellow, both because this comes as a surprise to the viewer and because it creates an illusion of a scene lit by a lamp, thus rendering it unnecessary to simulate lamplight. The background must seem a little frightening, for which reason the perfect color is violet. Thus the musical part of the picture is completed.

"What can a nude Kanaka girl be doing on her bed in a rather risqué pose such as this? She can be preparing herself, of course, for lovemaking. This is an interpretation which answers well to her character, but is an indecent idea which I dislike. If, on the other hand, she is asleep, the inference is that she has had intercourse, which also suggests

something indecent. The only conceivable mood, therefore, is one of fear. But what sort of fear has possessed her? Certainly not the fear shown by Susanna when she was surprised in the bath by some old men. There is no such fear in the South Seas.

"No, it is, of course, fear of a *Tupapaü* (a spirit of the dead). The Kanakas are much afraid of them and always leave a lamp lit at night. Nobody will venture out on the road when the moon is down without a lamp—and even then nobody will ever go alone. As soon as this idea of a *Tupapaü* has occurred to me, I concentrate on it and make it the theme of my picture. The nude thus becomes subordinate.

"How does a native woman envisage a specter? She has never visited a theater or read novels. When she tries to imagine one, therefore, she has to think of some person she has seen. So my specter is just like an ordinary little woman stretching out her hand as if to seize the prey. My feeling for the decorative leads me to strew the background with flowers. These are *Tupapaü* flowers (i.e., phosphorescent lights) and show that the specters take an interest in us humans. That is the Tahitian belief. The title *Manao Tupapaü* (Thought or Belief of the Specter) can have two meanings: either she is thinking of the specter or the specter is thinking of her.

"Let me sum up. The musical composition: undulating lines, harmonies of orange and blue connected by the secondary colors to yellow and violet, and lit by greenish sparks. The literary theme: The soul of the living woman united with the spirit of the dead. The opposites of night and day."

The image of the old hooded woman, that unlikely specter, has a long history in Gauguin's work. *Vintage at Arles*, the painting of 1888, sets three older women, one hooded and the others coiffed, behind the seated figure of the young girl. As used (or harvested) women they stand as omens and archetypes of the fate which awaits the girl. The scene gives off an aura of preordained doom, as if the girl is not so much deciding her fate as contemplating the finality of it. She sees in the women the chart of her own future, the consequences of her own ruthlessly approaching maturity. (Gauguin gave this motif the alternate title *Human Misery*.)

At the stage when Gauguin painted *Vintage at Arles* the older women had homely, realistic origins; however ominous their role, they

remained simple peasants in substance. Not until Gauguin came to Tahiti did they become, patently, spirits, transcendent beings who existed as hyperextensions of the living. The lurking spirit behind the reclining Tehura was to set a pattern which Gauguin would return to again and again, sometimes featuring a single presence, at other times presenting the old women in pairs. In his *Self-portrait Nearing Golgotha* of 1896 (figure 108) Gauguin-as-Christ meditates upon his forthcoming confrontation with death; behind him, shrouded in darkness, two strange heads hover; one is hooded, with European physiognomy; the other, seen in profile, appears to be a savage death's-head, mummified or shrunken. They are the furthest extension of "figments of his imagination," classifiable rather as phantoms of his dual nature.

The paired spirits of old women appear again in 1897 in *Nevermore* (figure 105), the construction of which is similar to that of *The Spirit of the Dead Watches*. In another flowered room a nude girl reclines on her bed, far from sleep, her eyes slanted in concentration and mistrust, glancing backward. She appears to be listening to the conversation of two hooded women behind her, one seen from the back, the other presenting a death's-head profile. A strange bird perches on the window sill. "That bird," Gauguin wrote in a letter to Daniel de Monfried, "is not the raven of Edgar Poe but the bird of the Devil biding his time." The bird is the literal manifestation of the *spirit* of the dead, the unholy ghost, the winged messenger who delivers the word from Satan; like the old women, it watches and waits. One has the feeling that the two women are conspirators in a plot to do harm to the girl. They are in fact Infernal Gossips endowed with the eyes and ears of the devil.

On one level Gauguin's Spirits of the Dead are simply women who have been harvested—conspiracies of used women who have lost their youth and, in their barren and bitter age, taken on the character of witches. They are agents of the devil, fallen angels who must recruit young souls into their company. As experienced women they delight in recounting the details of brutal deflorations, of the agonies of childbirth, to younger women who have the ordeals ahead of them. As witches they possess this "secret" knowledge, for they have known, carnally experienced, the devil; they have heard his word and done his bidding. The classic charge for which witches were brought to trial was that of having intercourse with the devil (in the person of a fellow villager) and absorbing his secrets. Witches were also frequently accused of casting the Evil

Eye on a young mother and poisoning her milk. In them the act of succor, upon which the holiness of childbirth was founded, turned venomous, cannibalistic—antithesis of life instead of life-supporting. Gauguin may have been familiar with the legend of the Marquesan *vahini-hai*, female ogres who steal and devour small children. These spirits are manifestations of the oral mother who eats her children and ingests their substance—the old witch in *Hansel and Gretel* is one of their number. They inspire the primordial fears of being eaten and consumed by the very force which nurtures. The polarized functions of the Terrible Mother cancel each other out until at last only the paralysis of fear remains alive in the victim: impotency, immobilization by the Evil Eye, which sees and knows the truth and is nearly always censorious in its effect. Mothers "keep an eye on" their daughters to see that they stay out of trouble, exercising the spider's hospitality upon them to keep them in the chamber. The Spirit of the Dead hears evil and sees evil and imposes fatal knowledge upon innocent flesh.

In *Words of the Devil* Eve stands in a breaking wave, one hand to her face in a thoughtful gesture, the other holding a white cloth which hides the place of the devil's entry (figure 106). Notably, Gauguin's fallen Eve does not cover her breasts; the emphasis is not on newly discovered shame, with its consequent excess of modesty, but on newborn sin and its possible penalties. Behind her sits the Spirit of the Dead, portrayed full face and staring out at the viewer. Above Eve's head, to the right, an Evil Eye casts its mordant glow like a night-light in the dark sky. In the background an outcropping of earth undercut by the sea extends a great phallus toward Eve, who looks at it askance. The phallus is particularly frank in a woodcut executed after the painting (figure 107) in which all background detail is omitted to emphasize the phallic motif discovered in *Words of the Devil*. The outcropping is carefully fashioned into a semitumescent member with flames of pubic hair at it root. It is directed in line with Eve's concealed genitalia. The head of death, symmetrically placed on that line, stares at the same spot; the Evil Eye, the eye of the peacock tail, the eye of the sunflower, the mother's ambiguous eye—tempting, haunting, watchful—are fused in this image. In its original incarnation, the death's head was a serpent with a human head crowned by flowing hair—possibly a doorjamb sculpture from the church at Guimiliau, Brittany, which features this fair temptor confronting its Eve—who clutches a cloth to hide her shame.[6] Gauguin's per-

sonal reaction to serpentine temptation was more aggressive. On the phallus he placed a mongoose, killer of snakes; it is derived from a Javanese relief, the same relief that inspired the Eve whom Gauguin eulogized with the image of his mother. Directly above the outcropping Gauguin has placed his mysterious monogram P GO—in this case P over G, circled. Phonetically, in French, it reads Pego—the name he gave to the dog he kept in Tahiti. "Pego" is a seaman's term of that era, which he would have learned while in the Merchant Marine; bluntly translated, it means "prick," or, in its more active connotation, "pecker." The circle surrounding it, the O of P GO, is also the O which the fallen Eve hides beneath a white cloth; PG, or Gauguin himself, has penetrated into the secret recesses of Eve. The monogram is thus divested of its mystery.

Gauguin's monogram identifies the phallus as the signet of the crime, sharing the onus of the medieval serpent. In a self-portrait painting of 1890, the passive Gauguin is eyed by Delacroix's sketch of Eve being driven from the Paradisial garden—a subtle hint of Gauguin's culpability, as manifested in his very personal interpretation of the Eve saga. Another self-portrait of 1893 catches Gauguin with a shifty evasive expression, immobilized beneath the accusing glance of Tehura in *Words of the Devil*. This Tahitian Eve had transformed his obsessive fantasy into a new reality. Through her offices, Gauguin-Pego had at last been able to play out the role of Adam, to re-enact the crime and resolve the old conflict. As the great father-figure Adam, he could substitute himself for his own father, thereby working out his festering feelings about his mother-as-Eve. In the chronicles of Eve After the Fall, the phallus replaces the serpent, the climactic moment of temptation is subsumed in the annals of the cyclical screw, and Eve endures in shame, bounded on the one side by the rearing of sin's ugly head and on the other by the visage of death.

XV

The Green Hell

AMONG GAUGUIN'S paintings shown at the ill-fated exhibition at the Hôtel Drouot in 1895 was one that most perfectly exemplifies the creed of his newborn civilization. *We Greet Thee, Mary* (figure 109) is an evocation of a resurrected Eden, a world raised from its fallen state—not raised to the kneeling position of the penitent, as Catholic dogma would have it, but raised by *virtue* of grace to a *state* of grace. The Tahitian Mary, whose enigmatic smile seals her serenity and containment, seems to embody that Nirvana of which Gauguin's maligned Eve was the foretaste. She balances the child Jesus on her shoulder in primitive fashion, her halo uniting with him; two bare-breasted native girls greet her with hands folded in prayer, and behind them, amidst the foliage, a winged angel can barely be glimpsed; the lush vegetation which forms the backdrop is balanced by a foreground display of fruit, arranged in the manner of a still life upon a table.

Much later, in Pont-Aven, the writer Alfred Jarry wrote a poem about this painting. The description contained therein is unintentionally illuminating:

> And the savage virgin
> And also Jesus
> Look: in this place

The alba bat flies:
An angel whose green hell escapes
Toward the virgin.

How gilded the haloes
Which encircle their heads
We will worship
The newcomers with cymbals
And each bronze-limbed woman
How gilded the haloes
Which encircle their heads.

Under the slender trees,
Under our Pandanus
By the sea they came
Disdaining their wings
We will run toward them to kiss their bare feet
Under the slender trees
Under our Pandanus.

And the good Virgin
And also Jesus
With a softened eye
With an eye that pardons
Watch us as we extend our hands toward their haloes
And the good Virgin
And also Jesus.[1]

The Green Hell, so oddly named, is a metaphor for Gauguin's Earthly Paradise, in which the resurrected Eve-as-Mary walks in grace. It is a fruitful hell, as Eve's was a divine sin, redeemed by Mary through the act of childbirth. Its Nirvana-like serenity is no natural endowment, no eternal end point to which the world-weary aspire; rather it takes the form of a fusion of polarities, in which the transitory pleasures of the earth are no longer pitfalls to the depths but are preserved in greenness throughout time. Thus the prime attribute of this paradisal hell is a lushness from which the wantonness has been removed, a state of suspended "sin" (although the very term is now voided) from which all guilt has been exorcised. It is a Paradise all of one color, as the pre-Fall Eden must have been; within its boundaries all is fertile, all is good, morality is as constant and unitextured as a clear covering sky.

An Earthly Paradise is by its nature an estate of paradox. It oper-

ates by a process of vaccination-immunization which encourages nature to take its course, to proliferate itself in free and unchecked action: within the boundaries of the hospitable terrain the possibility of sin is canceled, the acts themselves are assimilated into the life process and become The Way. The antibody is no longer alien to the body proper. Sin is redefined as substance, becomes stable, loses its sting. The saving grace is no longer an external mediator but rather a system of internal *control* resulting from a divine balance of opposing natures. Long before he was to arrive in the playgrounds of the Green Hell Gauguin was subliminally aware of this balancing act, but he saw it at first with an autocrat's eye; the communion of polarities was seen as a play for power with Gauguin in the role of God, a holy juggler manipulating his dual natures through an exercise of will founded upon a gesture of skill. In the 1889 *Self-Portrait with Halo and Snake* (figure 8) Gauguin had chosen to focus upon those aspects of himself that are the stock of the magician's trade: his head and his hand. The disembodied visage is fixed in a sardonic leer, one eyebrow slightly raised, one moustachio arched, in the classic physiognomy of the practitioner of black arts; the head, wigged with a devil's cap, is surmounted by a halo which it wears, if such is possible, rakishly; a cluster of apples, another floating ornament, insinuates itself between halo and brow. The upper part of the head, with its attributes of halo and apples, is set against a dark background; at jaw level the dark is succeeded by a light mass against which the abrupt hand appears, jutting from the ground line, in the company of a strange sinuous stalk bearing white squarish lilies, and a small serpent. The snake is a *trompe-l'oeil* device: its forebody is clutched between the forefinger and index finger of the hand, and its small tail, seen in its natural progression wriggling behind a bowed flower on the stalk, appears to be an extension of the stalk. Gauguin's hand is quicker than the voyeur's eye—quicker also than the serpent's tongue. He holds the snake by the throat, immobilizing it, binding it at the seat of its power, maintaining a perfect control over it. As he directs his will upon it, he forces it to conform to the line of the stalk—for, as an extension of the plant, its nature is assimilated into the nature of the plant, its sinuosity, no longer sinister, is bent to the natural inclinations of sinew. And so long as he holds it in line, so also will the halo be suspended above his head, the apples dance inviolate on the branch—a sleight-of-soul trick worthy of the most celestial of sorcerers.

The *Self-Portrait with Halo and Snake* stands out as companion piece—and Christian counterpart—to the mystic Eastern intonations of *Nirvana* (figure 82) in which Gauguin's demonic visage is echoed in the concentrated malevolence of Meyer de Haan's. De Haan also wears a devil's cap, to which are added the usual diabolic haberdashery of pointed ears, pointed beard, and slanted Oriental eyes—empty except for pinpointed pupils, fixed in a Svengali-like gaze; the content of the glance seems to come from the inside, to be concentrated, glazed in place, like the glance of a hypnotist or an opium addict—or a practitioner of black arts. One hand is visible, curiously glovelike and disembodied as Gauguin's was; beneath the thumb writhes the ubiquitous slender vine, which metamorphoses into the head of a snake. Behind the head of the diabolist the familiar tableau is acted out—the anguished Eve against the black rocks, the woman throwing herself into the waves; across the beach is written "Nirvana."

The image of the magician comes readily to mind in both paintings of 1889. At this time of his life, with Eden as yet light-acres away, Gauguin could only *play* at his demonic role, could only perform parlor tricks with his magic halo, his lily-which-turns-into-a-real-live-snake, his waters which effect cures for moral decay—veritable Fountains of Redemption. Only in Tahiti did the consequences of the Fall strike him with seriousness, for only then did Eve's descent become relevant to the life process. The violence of his assault on the forest measures, among other things, his anger and self-disgust at falling short of the *reality* of savagery which was now within his physical grasp. The truth was now borne in upon him that on earth the devil can afford to be devilish, but in hell he dare not play at his profession.

We Greet Thee, Mary is a rendition not only of the seriousness of the Eve saga but of its ultimate sanctification. The European Eve, in her state of anguish, will now be replaced by the guiltless Tahitian Eve, no longer Adam's consort but a child of Mary, who absolves Eve's sin. "In order to conceive a child a woman must commit a little sin," wrote Gauguin, "but the sin is absolved by the most beautiful act, creation, a divine act in that it is the continuation of the work of the creator." His obsession with this exoneration was so great that a single act of childbearing was not sufficient to deliver Eve from her "little" sin: "A woman only becomes a good woman when she is a grandmother," he once wrote, perhaps not considering that Eve was said to be the mother of us all, not only eligible

for a berth in heaven but able to climb there on the heaped heads of her progeny. In his mind Eve was guilty until her Maryhood was proven; in her first manifestation her given fate in the world was to be threatened, to cower in anguish before the riddle tree; in her new birth she would be welcomed ⟩de the object of homage. Eve's journey was a passage from ual-object to woman-in-a-state-of-sexual-grace, wherein again a divine act, mustered in the service of the Creator

sympathy for Eve, his desire to see her "saved," struck o home. In his journals he wrote:

woman, if he has understood what a mother is.

woman, if he has understood what it is to love a child.

ighbor."

n a love that is both altruistic and androgynous, a love ties and extended to encompass all that is human—a d terrestrial affection. No wonder, then, that his shaled in the service of a better and brighter "hell," a ·e decency was a divine attribute and mutual tolerance

the gift of the g̲ȯ̲d̲ṣ̲—where men might live and let live and let live and let live into eternity.

The *Exotic Eve* of 1890 (figure 89), her head based on a photograph of his mother, her body modeled on an image of Buddha, emerges now as a metaphor for Gauguin's quest. Buddha is the path of life, and the path of life, in Gauguin's mind, led from Eve to Mary; the last step on the path is to renounce sexual pleasure. The body of Buddha is the body of an Androgyne in whose substance all conflicts have been resolved. The two welcoming figures in *We Greet Thee, Mary* were derived from the adorers of Buddha in the same Javanese frieze (figure 90); they are standing on a path, regarding Mary and Jesus on the green, and in their prayerful postures their message is enacted: the path to redemption issues from the womb of Mary. For Gauguin the path led across the ocean from Paris to Tahiti: the image of his mother in the paradisal garden about to pick fruit was his last vision of Eve before departing on his journey; in Tahiti he resumed the theme with the adoration of Mary: his mother reincarnated, himself reborn, the passage across the waters as profound—although not as threatening—as his first birth. The image of his mother as virgin, beyond harm or blame, had sailed before him like a figurehead, holding his ship to its course.

[handwritten margin note: Exotic Eve = Buddha metaphor of G. quest]

In her deified role, installed and insulated as Virgin Mother and Queen of the Green Hell, Aline took on the character of a fallen angel—with none of the stigma that usually applies to that state. Her divinity resided in her Fall: in capitulating to fleshly demands she had become pregnant, had assimilated sin into her nature and awaited its emergence as purified flesh. As Gauguin saw it, she had taken the one true path available to women, had traveled the road of calvary to its bitter end, achieved her cross and risen from it. The elected purity of the cloister, wherein desire is stanched along with risk, was no triumph—perhaps because it was no battle: "With sadness and disgust as well I see them passing, this procession of unclean, unhealthy virgins, the Good Sisters, forcibly driven, either by poverty or by the superstition of society, to enter the service of an invading power.

"*That* a mother? . . . *That* a daughter? . . . Never!

"And as an artist, a lover of beauty and beautiful harmonies, I exclaim, *That* a woman? Oh, no!" [4]

The "invading power" that Gauguin speaks of is, of course, the French missions, which had polluted the fertile Tahitian wilderness with doctrines as "unclean" and "unhealthy" as the arid virgins themselves. On the terrain of the Green Hell—which was nothing more than Gauguin's burning hallucination of Tahiti seen from a safe dream-distance, a mirage of a mirrored vision—the Good Sisters also walked. Lurking behind the two women who pay homage to Mary, almost obscured behind a flowering bush, is an angel with heavy wings, her face obliterated by a flower. She is the celestial nun, the agent from an invading power come to recruit the natives to her Master's cause. Her mentors are the do-gooders and Puritans who make up the army of the Catholic God—Gauguin's personal devil! The Green Hell was a refuge from these God-mongers, a haven where his creativity could flourish: he escaped to hell from the missionary's heaven. As in Jarry's poem, the angel's green hell "escapes toward the virgin"—out from under the repressive wing.

> Under the slender
> Under our Pandanus
> By the sea they came
> Disdaining their wings . . .

In the Green Hell the heavy wings of fruitless holiness, of unnatural elevation, are anachronisms. The virgin carries her child on her

shoulders in lieu of wings; his head rests upon hers in the manner of a crown, his halo surmounts hers and is united with it. He crowns her divinity, is her king. It is as if Gauguin gave literal form to this passage from Corinthians (11:3): "But I would have you know that the head of every man is Christ; and the head of the woman is the man; and the head of Christ is God."

Traditionally, an angel with a flaming sword is posted at the gates of Paradise to guard that holy place against the entrance of the damned. In the Green Hell of *We Greet Thee, Mary* she is the most obscure figure, a spirit by virtue of her ghostliness rather than her intangible presence, haunting and unreal as Mother Night. She is dual-natured; the sword she might have held is replaced by a palm in her left hand, betokening the visit of an angel bearing a palm branch to the elderly Mary, to inform her that within three days she would enter Paradise, where her son awaited her. Christ himself is often depicted with a palm branch held aloft like a scepter, or sword, in triumph over sin and death—but in the hands of Gauguin's angel it might have a less purely symbolic function: would this heavy-winged harbinger of The Expurgated Word flog hell out of the natives with her supple staff?

Gauguin made a drawing of an angel whose outspread wings seem to encompass and blend into the landscape (figure 110). Her body resembles that of the *Exotic Eve*, but her hand is stretched toward the contorted tree of *Agony in the Garden* (figure 6) whose branch turns back on itself as if recoiling from fruitful offering. He annotated the drawing "The wings are heavy—all is primitive." Yet the wings seem to be dissolving into the All, as if, once again, the foreign body is drawn into the presiding power, its own power bound by assimilation. The credo of this voracious Paradise is not to give of oneself and thereby receive, but to give oneself over, holding back nothing. The tyrannical greenness is all, and by its nature it will have its way, it will triumph, in the most primitive fashion, simply by proliferating, by spreading its fascistic fertility with the inexorability of a plague. Gauguin had captured the spirit in an earlier vision of hell—its heavens painted red—in which Jacob girded his patriarchal loins until they were rendered out of joint, and brought yet another angel down: "I will not let thee go, except thou bless me."

The fruit in the foreground of *We Greet Thee, Mary* is arranged in bowls upon a table, as in any proper still life; incongruously, the natural

abundance of the trees and bushes has been tamed into a formal offering, set upon an altar to honor the holy visitors. The composition of fruit preceding a scene of Eden is a visual spelling-out of Gauguin's portrait of Meyer de Haan at table, in which the fruit precedes the volume of *Paradise Lost*. In the same spirit, the lamp which spreads its artificial light over the reading area is paralleled in the haloes which crown Mary and Jesus: each is a vessel of light which derives its power from channeled energies rather than natural sources—not unlike the burning candle which van Gogh chose to place in Gauguin's chair as an attribute of his friend's virile creativity. Significantly, the angel has no halo; she is a noncreative being, anchored by the weight of her wings to the earth's face—thus earth-*bound* as the "natives" of the Green Hell are not—and incapable of flights of fancy.

The diminishment of the angel's role does not condemn her to insignificance. With the entrance of Christ, the angel is no longer a messenger of wrath in the service of an angry God but a bearer of glad tidings; upstaged in the celestial order, she waits in the wings, dwarfed by the magnitude of her message. The free-flowering bush which hides her— roses without thorns? iris, also known as "sword lilies"?—gives joyous form to the news of Eve-Mary's liberation into the Promised Land. The paternal deity of the Old Testament, who once delivered proscriptions and restrictions and punishments via wings of fire, is now transmuted into the God of love and charity, who greets his flock "with a softened eye/ with an eye that pardons."

In keeping with her dual nature, the angel takes on conflicting shapes and identities. As if assimilating the content of the messages she bears, she becomes the chameleon copy of salvation or damnation, good news or bad news. She enters earthly realms in the character of a saving grace—or of an unwelcome and intrusive visitor, a spy all too flesh-present in her gross show, in the tasteless opulence of her wings. She is the spirit of the syndrome and, starting from the top, travels the whole route of archetypes down into the ground. The Good Angel, proffering a palm before which men lay down their arms, is also Virgin Eve, Mother, Risen Saint, Defeater of Dragons. The Bad Angel, who lives by the sword, grows into a Dragon Personified, a Chimera, a withered and knowledgeable Gossip, and finally, Mother Night herself, a spitfire who flies by night, haunting the sleep of fair virgins.

"Angels for everyone" is the note Gauguin made on a strange draw-

ing which appears to be a deposition scene: an angel supports the body of a naked dead man against a backdrop of rocks; at first glance it appears that a drowned body has been lifted by angelic intervention from the sea, or from some undefined chaos of white space which swirls beneath the massed rocks (figure 111). Christ is frequently portrayed being placed in the tomb by angels, his earthly wounds displayed upon his inert form for all the world to see and sorrow over; in such scenes the angel takes on the role of the vendor of shame: "See what you have done to him," she seems to be saying. It is not known whether the limp figure in Gauguin's drawing was intended to be a self-portrait—certainly the beardless, hair-less image bears as little resemblance to Gauguin as it does to the classic Christ. Were it included in a catalogue of Gauguin's passive Christ-figures, it would surely rank as the most emasculated; in its very lack of definition it is beyond pity, lost in a sweet sleep and given over entirely to the ministrations of its Good Angel. . . . Given over to the *ministra-tions* of the Angel?—or to its clutches? Baudelaire's prose poem "To Everyone His Chimera" comes to mind like a sinister alter-echo. The chimera can be made to play the role of Mr. Hyde to the angel's Dr. Jekyll. The two vast claws by which it hooked itself to the breast of its mount are readily transformed into the hands of the angel gripping the dead man's chest; its fabulous head surmounts his forehead, emanating the power of a paragon, filling the observer with pity if not fear. In fact, the angel's power resides in the dead man's glory; she succors his wounds as a vampire bat might suck his lifeblood—to feed the *righteousness* which is her deepest repository of vanity. This bottomless casket contains her last ploy and ornament, after beauty fades and love fails: it is the chrysalis for her wings.

"*I have had much to do this winter, fortunately, and I am a little tired, but satisfied to be able still to carry the burden that Paul so wan-tonly laid on me.*" (Letter from Mette Gauguin to Émile Schuffe-necker)

"*Perhaps, Schuff, the worst is over, and one day I shall have a re-ward for my work other than the mere satisfaction of duty done, which, between ourselves, is not very satisfying. But can you understand a fa-ther who feels nothing, nothing, nothing! I believe he would see us all die without being unduly agitated.*" (Letter from Mette Gauguin to Émile Schuffenecker)

"I have borne heavy burdens. I have suffered all these distresses, all these worries alone." (Letter from Mette Gauguin to Émile Schuffenecker)

"You bewail your solitary lot (and don't let me forget it either). I do not see it at all; you have the children near you, your compatriots, your sisters and your brothers, your house. What about me who am alone in a tavern bedroom from morning to night in absolute solitude." (Letter from Paul to Mette Gauguin)

"You ask me to give you courage. . . . What you mean is that if you had dividends coming in you would be the happiest of women. Nobody to thwart your wishes, overwhelmed with attentions, spoilt, even courted." (Letter from Paul to Mette Gauguin)

"I hope that in France there may be silence, and above all that Z—— will not go around crying, 'That poor Madame Gauguin!'" (Letter from Gauguin to Daniel de Monfried)

Gauguin's rancor was reserved for the professional angel; for angelic women he had unlimited sympathy. He loved his mother as a sacrificed maiden; yet he sacrificed his own wife, perhaps partly because of her maternal qualities: "I have gone very calmly through all your letters which tell me quite coldly and reasonably enough that you have loved me, but that you are only a mother and not a wife, etc. . . . so you mustn't be surprised if one day, when my position has improved, I find a woman who will be something more to me than a mother. . . ." The hovering mother figure, fat with righteousness, could turn all too easily into the horrible mother who sucks the lifeblood from her offspring. Gauguin's chief anguish in his domestic situation was that he, as the providing male, would be forced to shoulder all, to pour his energies into the support of this chimera in order to placate the beast. In 1889 he had written to his wife, "What is it you want of me? Above all, what have you ever wanted of me? Whether in the Indies or elsewhere, I am, it appears, to be a beast of burden for a wife and children whom I must not see. By way of return for my homeless existence, I am to be loved if I love, I am to be written to if I write. . . ."

His evocations of women as beasts of burden were in part fantasies of revenge upon the burdensome beasts who burdened him. The guilt which Mette's recriminations stoked in him soon turned to gall; rather than cower he was roused to attack her for publicizing her valor in the

face of suffering, for playing the professional angel before an audience of their mutual friends. His assertion that the ideal family structure would function with the woman at its head was also a veiled judgment upon European matronhood: as a married male he had suffered for years in the grip of an imposed "duty," had been vilified for falling short, lacking love, caring little; now the time had arrived when Mette must take up his unshouldered load. So be it, and let her bear the weight of her wings! Early in their life apart he had brought this suit against her: "You sulk to gratify your self-esteem: what matters one pettiness more or less, and good God, if you think you are doing well, go on, it is a course that does you honor."

The sacrificed maiden and the professional angel were not simply two separate species of celestial beings living in segregated corners of the forest. As Gauguin conceived them, one was the natural victim of the other, as if, in the cyclic round of a woman's life, the different ages and stages fed upon each other, the power of light was served up in due course, like manna on the altar, to the power of darkness. Gauguin's compassion for the martyred virgin was more than gratuitous: in the image of her defilement he could see the stamp of his own threatened integrity; he could sleep once again in the flowered chamber of the pure young girl, shrinking from the lewd embrace of the Académie; he could rest once again like Red-Riding-Hood's wolf in that pure white bed, strange bedfellow of the saints—"a disreputable impressionist painter burdened forever with a chain for the world."

Perhaps Gauguin intended that a white bed in a Green Hell would be the last resting-place for his suffering Christ. In Tahiti the drama of the Cross is forfeited, and the figure of Christ appears as if cast in lead, a sculpture in the midst of a still life, curiously beyond pain. The image of Christ-in-Death merges with that of Lazarus: Jesus is both God the Father—the magician who performs death-defying feats—and Lazarus, the passive victim, awaiting the intervention of the divine hand. Lazarus becomes the metaphor for Jesus's earthly body, for the fate of a man on the earth. Thus in Gauguin's interpretation the holy trinity is composed of the Father, the Son, and the Son's earthly body: the Adam in Jesus anticipating a second birth.

In a later drawing the corpselike male figure of *Angels for Everyone* appears again, leaning back in the classic deposition pose, his left arm dangling loosely (figure 112). The angel no longer supports him

but observes him from behind, along with two other female figures in prayerful attitudes. In the foreground a native Mary holds the infant Christ, whose arm also hangs limp. The sweet placidity of Mary's expression is countered by the watchfulness of the woman directly behind her, just as the somnolence of the dead man is countered by the sentinel-like alertness of the native man directly behind his head. It would seem that the syndrome of Christ's life is being suggested: the holy child already limp, laid out in his mother's arms, his form presaging the form of the bald, naked corpse. Although the drawing has been titled (perhaps not by Gauguin) *Tahitian Nativity*, it is more redolent of the grave than the birth-chamber. The angel and the praying figures are as somber as friends of the deceased; the lurking observers seem curiously sinister: a midwife, who has delivered up her charge to death; a tomb guardian on the lookout for body thieves. Most ambiguous of all is the corpse. His very lack of definition accords to him the charisma of the antibody which dominates by mute presence—the blunt factor of death in the midst of life. None of the glory of Jesus's death is conveyed in this image; it conforms more logically to the legend of Lazarus, who, as a historical figure, attained his full identity in his death.

A revealing observation on the Lazarus theme is included in a document called "The Modern Spirit and Catholicism" written by Gauguin while in Tahiti as a diatribe against the Church, as well as a repository for his spiritual convictions. In the following passage he parallels the Egyptian god Ra with Jesus:

"Ra is also the God who makes the mummy come forth.

"Jesus brings forward the mummy under the form of Lazarus: and in the Roman catacombs Lazarus raised from the dead is not only represented by a mummy, but as an Egyptian mummy, which has been eviscerated and swathed for the eternal rest. Thus Lazarus is the typical representation of a mummy, which would be significant if the name were derived from Laz (or Egyptian Ras), a being raised from the dead, and Aru (Egyptian), the mummy figure, which with the Greek ending, Lazarus—the mummy raised from the dead.

"Ra called to the mummy to come forth. Jesus cried, 'Lazarus, come forth.' "

It is easy to see in the figure of the hairless and rigid corpse an image of the unbound mummy, eviscerated or emasculated, as if sex itself were a distinguishing mark on the side of life. The process of mum-

mification has reduced the man called Lazarus to clay and bones, to the most basic physical substance, and the most malleable; formless, he awaits the imposition of form: thus "Jesus brings forward the mummy *under the form of Lazarus.*"

The nativity of Lazarus took place in the tomb, wherein he was reborn of Christ. Gauguin lists one place of birth and three of rebirth which the Egyptian messiah and Christ share in common: "The fourth and last place, the worthy place of new birth, is the tomb, from which he is born anew. The Egyptians call it the worthy habitation." The typical place of new birth, however, is listed as "the waters of the Jordan," and this may account for Lazarus's drowned aspect, for the curious poise of his arms, which are spread as if he were being *lifted out* of a body of water; even as he appears in the *Tahitian Nativity* with no angel to hold him up, indentations have been shadowed in to mark the imprint of grasping hands.

In Gauguin's interpretation both Christ and Lazarus are manifestations of the greater father-spirit who inhabits all. At one point he refers to Lazarus as "the dead Osiris" and to Christ as "the live Osiris," as if each was but a different aspect of the same two-pronged cross. His preoccupation with this father-force was crucial. In attempting to explain Christ's origins he was also building a metaphysical structure to explain his own—a family tree in the form of another two-pronged cross: one for the spiritual father, one for the fatherless son.

"Ra is the supreme power, the sacred beetle, born like his own son. It is the God of the Gospel of Saint John who says, 'I and my son are one, and I am he who is the Father born of his own son'; for he says, in seeing and recognizing the Son: 'From this moment you have known him and have seen him, that is to say the Father. . . .'

"Ra like the God of the Earth, Tanen, makes his own limbs, is the only one who fashions his own body, is born on earth, and is himself incarnate. Jesus's own body is also without a human father."

Gauguin's search for the father lost at sea is a deep subliminal quest. In no way could he surface it, as he was able to surface his complex and highly colored relationship with his dead mother. She had a face for him, an image, a character, a realistic and an idealistic role. She had been sufficiently present for him in his life that now, after her death, he could abstract her at will. What he knew of his father was, save for a few scant facts, a great vacuum of abstraction; Clovis Gauguin was known

by his absence—surely the most terrifying tie with which to string along a son, for his total defection imposed no borders upon the fantasy that surrounded him. The great gap was as good as God, and for the rest of his life Gauguin accepted no other.

Because he, like Jesus, had no human father, he was both stronger and weaker than ordinary men. Responsibility—both burden and glory —had rested upon his head from the beginning, if not in the physical sense then in the weight of attention inevitably heaped upon him as the only son. His sense of self had gone unchallenged by competition: no repressive male hand ever pointed the way or held him down, except perhaps in boarding school—and by that time the distance between him and his masters was already too great. Thus it was both possible and necessary that he re-create his father's spirit from his own substance, struggle to give it birth, and, once successful, wear it draped over his shoulder like a holy image or a fox-tail—as an attribute of his own power.

"Ra is shown as a timid being, weeping; his face is that of one afflicted. And the Christ is the afflicted one, born to suffer. His (i.e., Ra's) emblem is the beetle, which produced itself, not being conceived by a female."

Gauguin's passive Christ-figure is an emanation of the woman in himself, forced to grow up with no defender, abandoned to make his own way in the world. To some extent he was born to suffer at the hands of fate, his own fate sealed at the moment of his father's death, unmanned as casually as if he had been the victim of a childhood disease. In his own eyes he was always more sensitive, more vulnerable than others: assailed by their hardness, he could only "harden" himself. When attacked, if tears failed and pleas for pity went unheard, he would apply his standard antiseptic solution of primordial instinct—a more productive tantrum of the spirit—which would wash away his finer feelings, his outraged sensibilities. The surefire remedy, pure kill-or-cure, would have been to convince himself that he had been conceived by no female creature, was therefore immune to that original sting. Like his mother he was an abandoned woman; to counteract this draught of congenital mortality he learned to counterfeit the divine process, to kill the worm at its root.

In his journal he had written, "It takes very little to bring about a woman's fall, but you have to lift a whole world in order to lift her."

Weak he was, afflicted he was, yet Gauguin was a creator-god of the first magnitude: in his scanty mortal lifetime he constructed a whole Hell-on-Earth to elevate Eve, and a whole Heaven to raise his father from the dead.

XVI

The Assault on the Tree

BEFORE GAUGUIN came to Tahiti he had set himself a lofty underground goal: he had expected, in spite of bitter experience, in spite of whole eras of disappointed hopes, to be reborn—and his factual rebirth followed docilely in the wake of his desire. . . .

Gauguin had a neighbor in Mataiea, a young man named Jotefa, who one day offered to accompany him on·an excursion into the mountains to find rosewood for carving. Walking behind Jotefa, he was struck by the young man's animal presence, which recalled to him "the graceful lightness of an androgyne." It seemed to him that the body of Jotefa was another aspect of the luxuriant plant life which surrounded them— "the Forest itself, the living Forest, without sex—and yet alluring. . . ." The presence of this abundant but undifferentiated vitality brought him to thoughts of the much-cursed civilization from whence he came, and of the unnatural conventions imposed upon a natural act. He was struck by the purity of the love relationships between the sexes in Tahiti, and by the physical likeness which women bore to men—so different from the cultivated fragility of European women: "Thus modeled on a bizarre ideal of slenderness to which, strangely enough, we continue to adhere, our women have nothing in common with us, and this, perhaps, may not be without grave moral and social disadvantages."

"*Our women have nothing in common with us*" . . . perhaps not such a strange lament to come from the pen of Flora Tristan's grandson. In Europe men and women were like two enemy camps, each seeking to subvert the other through guile, through the mechanics of possession; in Tahiti the camps had given way to a community in which all inhabitants were "comrades, friends rather than lovers, dwelling together almost without cease, in pain as in pleasure, and even the very idea of vice was unknown to them." Gauguin's ideal vision culminated in a classic Androgyne, a perfect being, who gave allegiance to neither sex but existed in a state which transcended sex—or whose whole existence, unmarred by false dictums and dialogues, was a sensual statement, an enacted state of nature. The shared item to be held in common with a woman would be nothing less than a complete nature—as if this coveted nature were a floating entity to which both parties might aspire. Gauguin's vision erupted from a nostalgia so intense that it was almost hallucinatory— this primordial nostalgia which longs for the Lost Paradise, wherein man and woman were created as one being, and united absolutely—as virgins. The Maoris, who existed side-by-side in harmony, appeared to Gauguin to have resolved the fatal polarity of differentiated sex. He chose to see no threat in their open and easy sex play but rather to treat them as children of nature, one golden acre closer to God.

But civilization was not through with Gauguin yet; arbitrarily the quality of his thought turned, as though to remind him of the sediment of decay which was upon him: "Why is it that this attenuation in differences between the two sexes of 'savages' which, in making men and women friends as well as lovers, rids them of the notion even of vice— why does it suddenly evoke in a person of the old civilization the formidable illusion of the new, the unknown?

"I came to myself, fever in my temples. And we were only two. I felt a foreboding of crime. . . ."

His companion, who walked in ambidextrous innocence before him unaware of the soulful longings he had evoked, had now become the object of a less savory desire. Gauguin was overtaken by a passion to possess this man-woman, to enjoy carnally the delights of its dual nature. He had fallen into a trap which was not uncommon to Frenchmen of his era, in whose hands androgynehood became a perilous and threatened state, a virgin bending to the will of an evil Svengali; the Androgyne no

longer represented a divine wholeness, achieved by a fusion of the sexes, but rather a free-for-all-in-one, a grab-bag of assorted erotic possibilities. Visions of divine fusion gave way to fantasies of depraved combinations and consummations. The Androgyne's status as a moral prodigy paled before its wealth of physical attributes.

Gauguin wrestled with his impulse and subdued it. In his mind he had vanquished an entire civilization, and the flush of victory dimmed his shame. Never one to cast over a ritual statement, he celebrated his self-conquest with a timely dip in the cold water of a brook, which cleansed his soul even as it cooled his ardor: "Nature understood me, heard me, and now, after the struggle and the victory, she raised in turn her loud voice to tell me that she received me as one of her children."

The pair forged deeper and deeper into the wilderness, into, as Gauguin referred to it, "the very heart of this Nature, powerful and maternal." He speaks of himself as blending "with her living elements" as if, in his state of relative purity, he has attained the power of a natural force. In overcoming his lower impulses he had chosen chastity—and this choice meant that his creative power would remain intact, would not be dissipated in futile emissions of energy. He implies that the male's fall comes about when his power is fractionalized to fit the functioning of differentiated sex mechanisms; thus a man in open nature is more fully in harmony with his total nature, more fully virgin in his self-integrity; a virgin girl in open nature is, quite simply, open season. It is as if she bears the stigma of the wayward consort who has left her master's rib and womb.

They approached the grove of trees, and Gauguin selected the finest to be "sacrificed." The carnage which followed deserves to be rendered in full as it appears in *Noa Noa:*

"I struck out, my hands stained with blood in my wild rage, the intense joy of satiating I know not what divine brutality within me. It is not at the tree that I was striking, it is not it which I sought to overcome. And yet gladly would I have heard my ax sing against other trunks when this one was lying on the ground.

"And here is what I heard my ax say to me, in the cadence of its sounding blows:

> Strike down to the root the forest entire!
> Destroy all the forest of evil,

Whose seeds were once sowed within thee
 by the breathings of death!
As in the autumn we cut with the hand the flower of the lotus.

"Wholly destroyed, truly dead, the old civilization. I was reborn; or rather another man, pure and strong, came to life within me.

"This cruel assault would be the supreme farewell of civilization, of evil. This last evidence of the depraved instincts, which sleep at the bottom of all decadent souls, by very contrast exalted the healthy simplicity of the life at which I had already made a beginning. By the trial within my soul mastery had been won. I was indeed a new man; a true savage, a Maori."

In enacting this literal cutting-off of his old European life Gauguin was attempting to unify his human nature with the vastness of the nature which surrounded him. On another level, perhaps more crucial and personal, he was striving to unify the two conflicting sides of his nature: no longer did he wish to kill the gentle man in him but to have it run apace with his resident savage. The forging of the two would make of him a spiritual Androgyne, embodying in his person two opposites-in-fusion. The *coincidentia oppositorum* (or mystery of the totality) is an established state in religious symbolism, and "its physical manifestation is often expressed in orgiastic rituals, aimed at the disorientation of the senses, which jar the participants into a state of mystic and surreal intensity. The metaphor for these sièges of madness is the symbolic restoration of the state of Chaos which preceded the creation of the world; with the same justification, ritual orgies were performed for the benefit of the crops to assure fertility in the fields." [1] Gauguin's act of brutality, his "sacrifice of the entire tree to obtain a branch suitable for his project," was just such an orgy of premeditated violence—an antiseptic bloodletting, a removal of a gangrenous limb—which would propel him into a new and fertile creative state. His instinct had always been to return to the primitive to renew himself; now this flood of molten instinct, more pure and more terrible than the compendium of animal spirits which had sustained him in Europe, found its true opposite in the bark of the tree; the violence met its equal in the object, which yielded, as its nature allowed, in accordance with the force expended upon it. The energy expended in the cutting was of an erotic nature, but it was asexual—all

undifferentiated force, all muscle and material, the primary act, abnegating the necessity for foreplay.

The product of this violence, a transfigured Gauguin, remained to be formed. "If . . . you want to *be someone* . . . you must consider yourself, like Androgyne, without sex," he had written to Madeleine Bernard. Now, like a golem newly formed of clay, he was required to assume a state of being to fit his new shape. In the benevolent environment of Tahiti he could at last relax and be Christ—but a Christ of a different color; the passive Christ of Pont-Aven must now give way to the muscular Androgyne who was, in truth, the perfect man. The reborn Christ was both savage and gentle, both man and woman, and, in his dual nature, the true image of the God who created him.

The nature of Christ's androgynehood originates in the circumstances of his creation: he was God-implanted in the second Eve (Adam's rib); thus he had a congenital share in the nature of the virgin female—a connection which tied him to earth and reiterated his humanhood. The earth itself, like the essential female nature, is a natural cosmic element, maternal in its nurturing and encompassing, virginal in its cyclic renewal. When Christ grew to manhood and shouldered the full burden of his divinity, with its concomitants of earthly death and rebirth as pure spirit, he was forced to reject his mother totally, to reject that part of his nature which was embodied in her. The very wording of his rejection vanquished her claim to him: "Woman," he addressed her, withholding from her the title of kinship, "what have we in common?" On earth he had required her substance to complete his "perfection"; now, in his risen incarnation, he put her apart from him by specifying her, by relating to her as an unknown factor, an otherness.

In order to instigate his own rebirth Gauguin was obliged to destroy his mother civilization—a formidable feat for any man but particularly for him because he was the product and victim of two maternal influences. France had formed and hardened him—hardened him against her until finally he had grown strong enough to leave her; but his natural mother was Peru, whose hold on his fantasy existence had bound him with a blood tie. His leave-taking from France would take on the nature of an expatriation, a decision to dissociate; after years of familial discord he might now at last ask of it, "What art thou to me?" He could never banish Peru so absolutely, never leave it completely for another realm; his departure from it would take the form of an expulsion—long felt but

now a fact—which echoed all the primal expulsions in one man's life, the ignominious oustings from Eden and the womb.

The act of chopping down the tree cast Gauguin in the role of the reaper-woodsman, wielding his fatal ax to destroy Paradise. He performed the brute act for a high purpose: he cut down his stale and static Paradise in order to turn on the life cycle. No longer would he be restrained by a vision of the past which, in its dream vitality, easily eclipsed the present; he had attained to a privilege both fearful and heady: that of cutting with his own hand the cord which bound him to his life source, his previous sole sustenance, thereby freeing himself for an independent life. His experience with the native boy infused him with the necessary psychic energy to accomplish this great feat; it was a catalytic experience which triggered him into a state of breakdown—of the pillar-polarities which had supported his existence for so long. The apparition of an Androgyne so close at hand had loosed the savage and the gentle man within him—both together, like two warriors fighting side by side, no longer dueling, no longer canceling each other out—and as a combined force both the savage and the gentle reached a supernatural intensity. Thus it was possible to juxtapose an act of overt destruction with a highly spiritual motivation, and to be propelled by the physical motions of chopping into a state of spiritual high: the destruction and the Paradise-rebirth forming an entity which is chemically different from its separate parts.

The forest was a perfect focus for Gauguin's holy rage. Lush and luxuriant as the most fecund of women, it also retained the traditional vulnerability and passivity of the feminine character; it was potent in its natural physical state, but eminently open to devastation. The trees which populated it were double-natured, maternal in the spreading and sheltering of their branches, masculine in their proved uprightness and their casual insemination of the earth floor. In their heaviest symbolic role they took on the character of Androgynes: the tree in Eden encompassed within it the knowledge of both good and evil, and the violation of its tainted fruit, the ambiguous apple, precipitated the separation of woman from man. It was this cruel division of what once had been held "in common" that Gauguin "struck out with joy" to overcome. "Destroy all the forest of evil," he rants, as if reciting an incantation to prevent another Fall, "Whose seeds were once sowed within thee by the breathings of death!" The fatal breathings had carried currents of change to

Eve, straight from the serpent's mouth; all unknowing, she had been inseminated with the knowledge of evil, cut down in the flower of her vanity.

Gauguin fantasized the destruction of the mother civilization in his attack upon the forest, the splendorous flesh of the earth, which in its luxuriance recalled the Garden of Eden. He was destroying by proxy the site of the Fall of the original mother, Eve, whose vulnerable flesh foisted upon men mortality and the striving for rebirth. Eve was the mother of man's flesh, and the figure which Gauguin sought to destroy was the mother of *his* flesh, in whose death lay the seeds of his spiritual life, dormant and waiting. Gauguin would later write in detail on these two births, basing his discussion on Jesus's rejection of his mother. Strikingly, in Gauguin's translation the question is rephrased: "Woman, what is there *in common* between you and me?" He quoted a dialogue between Jesus and Nicodemus in which the physician questions the method of rebirth and Jesus replies with a distinction between flesh and spirit. Gauguin continues to interpret the parable: "There are two births, that of the body born of the flesh, that of the moral, the intellectual, which is born of the spirit. That which is born of the flesh is that which is brought forth of the body with unalloyed animal instinct, and that which is born of the spirit is that which makes for the moral and spiritual birth of the Son of God. And it is this meaning which Christ had in mind when he says that his apostles were his mother and his brothers."

Quoting Saint Paul, Gauguin spoke of Christ as Adam given another chance: "The first Adam was created with a living soul, the second Adam has been filled with a quickening spirit. If you are the disciples of Christ, put off the old man, be renewed to the depths of your soul, put on the semblance of a new man who has been created according to God in justice and holiness based on truth."

To facilitate this new birth—and to allow it to "take"—the most extreme measures are called for. The mother of the first, fleshly birth must be so thoroughly obliterated that re-entry into her womb is impossible; the ultimate defense against incest must be established. To offer one's life up for cure, to enact the antidote to this taboo, becomes a holy quest, a regenerative mission which requires the cutting off of hereditary relationships; thus the apostles of Jesus, who accompanied him on his spiritual journey, were indeed the mother and brothers of his second birth.

In his attack upon the tree Gauguin cuts down in order to cut off. The final phase of his litany—"What I heard my ax say to me in the cadence of its sounding blows"—employs an ambiguous but potent image.

"Destroy all the forest of evil, as in the autumn we cut with the hand the flower of the lotus." The lotus is a symbol of regenerative forces, analogous to the phallus which arises from and is complementary to the water on which Buddha sits. As an attribute of Vishnu, according to Hindu tradition, "The lotus represents the universe, the flower that unfolds in all its glory from the formless endlessness of the causal waters. . . . The immaculate lotus rising from the depth of the shore is associated with the notion of purity. . . . As the representation of the unfolding of creation the lotus is a symbolic equivalent of the egg of nescience, seed of endless millions of universes." [2]

Gauguin's attraction to Eastern philosophy indicates that he knew and appreciated the Hindu vocabulary of symbols for rebirth. He made a painting of a young native wielding an ax which appeared to illustrate his moment of glory with Jotefa. The young man stands with ax poised on a barely visible finger of land, while behind him, upon a lively sea, a woman balances in a canoe in a bending posture; only two branches of the tree can be seen, extending curiously over the water and enclosing a small ship, which sails casually between them. Describing a similar scene, perhaps the same scene, Gauguin wrote, "With a harmonious gesture the man raises a heavy ax in his two hands. It leaves above a blue impression against the silvery sky, and below a rosy incision in the dead tree, where for an inflammatory moment the ardor stored up day by day throughout centuries will come to life again."

This painting (figure 113), in all its ingenuous genre trappings, takes on the momentary charisma of the scene of the crime: the man with the ax is linked with the causal waters; the act of chopping is expressed in terms of passion. All the elements are there, but the composition, in its simplicity, derides heavy analysis, assumes the stance of an illustration to an infinitely more complicated text. To run down the theme it becomes necessary to follow the descent of the ax—to a frank conundrum of a painting called *Arii Matamoe*, or *The End of Royalty* (figure 114). A decapitated head is set upon a cushion, which is in turn set upon a stool. The familiar figures of the Anguished Eve and the Woman in the Waves share the background tableau with two lotus flowers, one upright, one

drooping. Beneath the lotuses a seated woman holds an object which re-sembles a ceremonial double-headed ax.

The "royal end" represented harks back to the death of King Pomare, whose demise had evoked in Gauguin quantities of ingenue ro-manticism: "With him Maori history closed. It was at an end. Civiliza-tion, alas!—soldiers, trade, officialdom—triumphed." When, much later, Gauguin made a painting on the subject, the bulky shape of Pomare had all but disappeared; the head on the cushion memorialized no flesh-and-blood king but rather a mute scepter of savagery, unrooted but retaining its authority. Civilization had triumphed and had killed the king—unmanned him—as Gauguin had felt unmanned by the castrating forces of the European art world. He believed—it was to his benefit to believe—that the Europeans had attempted to kill the king in him, to under-mine the savage godliness of his creative power; he needed to believe so in order to work, and his head, emancipated from the body which bound it to earthly concerns, operated with intensified agility.

The two Eve figures are now cast as mourners for the dead king. The Woman in the Waves directs her grief toward the lotus flowers, literal sprouts of the causal waters, which in their attitudes seem to apos-trophize her and her sister sufferer; a similar coupling of bent and up-right flowers summarized the downhill cycle of the fallen women in *Be in Love, You Will Be Happy*. This time, however, the upward-turning lotus curves beneath the drooping flower, cupping it so that the arched line of the stem seems supportive and affirmative; only the head of the wilted flower appears, its petals poised curiously like a yearning mouth. Decapitation is the order of the theme, and unmoored heads appear to reiterate the condition of the king, like wives sacrificed upon the emper-or's funeral pyre; even the wooden idol in the corner shares in the halluci-nation, seeming to appropriate the attitude of a hanged man on a gal-lows. The writing on the wall—which functions as a backdrop for the king's head—says "Matamoe," which combines the Tahitian word for face (or eyes) with the word for sleep. In another incarnation, "Mata-moe" serves as the title for a painting which features the man with the ax cutting up a fallen tree—in the presence of two peacocks.

"Destroy all the forest of evil," wrote Gauguin, "as in the autumn we cut with the hand the flower of the lotus"—and also the flower of the grain, he might have added, or, in another season, simply—the flower. But the lotus is the flower of rebirth, harboring within it the seeds of

regeneration; if the Woman in the Waves is about to take a fatal dive toward it, she need not fear annihilation in the clutches of its phallicized petals. Its deadliness is ameliorated by its progenitive power.

The death of the king in *Arii Matamoe* is a long sleep. His head rests upon a pillow-like cushion—a sort of maternal lap—which in turn rests upon a stool, bringing to mind van Gogh's portrait of Gauguin's empty chair, decorated to evoke Gauguin's exotic origins. No doubt the pleasure-loving Tahitians preferred to think of death as a long sleep from which the deceased might one day awaken—to vistas as enchanting as those he had grudgingly departed. Gauguin shared the vernacular of the natives, but, lapsed Catholic and lapsed savage that he was, he wished not only to awake, but to awake reconstituted: a new Adam in a new Eden. This time around he would outwit the serpentine Salomé and, taking upon himself the roles of seductress, executioner-king, and victim-saint—"By the trial within my soul mastery had been won"—request his own head to be cut off by his own hand, to be placed comfortably on a pillow. With what relief and exultation he would then regard the new world—from the vantage point of his pariah's platter.

"I was, indeed, a new man; a true savage, a real Maori."

❈ XVII ❈

Hina and Tefatou

RESURRECTED AND refreshed, caught in the hallucination of his rebirth, Gauguin continued a plan to penetrate deep into the island, to cross the plateau of Tamanoü and explore the Orafena and Arorai mountains which form the island's center. He would go alone, for his Tahitian friends would not dare to accompany him:

"But what will you do in the night?"

"You will be tormented by the *Tupapaïs!*"

"You must be daring or mad, to go and disturb the spirits of the mountain. . . ."

Their wise counsel only piqued Gauguin's curiosity. He set out before dawn—as he describes his trip—through dense growth along a river. "But then I was repeatedly forced to cross the river. From every side the huge walls of the mountain rose straight up, projecting enormous blocks of rock out even to the middle of the water."

Later in the day he came upon a flat space of several acres covered with ferns and wild banana trees. There he prepared a dinner of roast bananas and made a bed of low tree boughs interlaced with banana leaves. He slept restlessly.

He described the night as "profound." "It was impossible to distinguish anything except a sort of phosphorescent powder right near my head which especially intrigued me. I smiled, thinking of the tales that

the Maori had told me regarding the *Tupapaü*, this evil spirit which awakens with the night to torment sleeping men. Their realm is in the heart of the mountain which the forest surrounds with shadows. There it swarms with them, and the souls of all the dead come to swell their legions.

"Woe to him who risks his life in these parts, infested with demons!

"And I was this audacious being.

"My dreams alone were disturbing enough.

"I knew later that this luminous powder emanates from small mushrooms of a particular species; they grow in humid spots on dead branches similar to those I had used in making my fire."

In the morning Gauguin resumed his journey, following the river along a tortuous route, continually losing the path, often advancing by swinging like Tarzan from branch to branch. The pure physicality of the experience, which allowed him to shed what vestiges of civilization remained in him and act the natural man, propelled him into an exhilarating high. He might well have swung from one branch into the sky and met his waiting vision:

"Suddenly, at an abrupt turn, I saw a young nude girl straightened against a rock that she caressed, rather than clung to, with both hands. She drank from a spring which gushed from very high in the rocks.

"When she had finished drinking, she took some water in her hands and let it run down between her breasts. Then, though I hadn't made a sound, she lowered her head like a timid antelope which instinctively scents danger, and peered into the thicket where I was hiding. My look did not meet hers. Hardly had she seen me when she plunged into the water, crying this word, '*Toëhoë*' (furious).

"Immediately I looked into the water: no one, nothing but an enormous eel which wound in and out among the small stones at the bottom."

After this event Gauguin proceeded on his difficult way and at last approached Arorai, "the dreaded sacred mountain which formed the summit of the island."

"It was evening, the moon was rising, and as I watched its soft light envelop the rugged brow of the mountain, I recalled this famous legend: '*Parau Hina Tefatou*' (Hina said to Tefatou). . . .

"It was an ancient legend which the young girls love to tell in the evening, and for amusement they say the event occurred on the very spot where I was.

) 213 (

"And I truly believed I saw:

"A powerful head of a god-man, the head of a hero upon whom Nature has bestowed the proud consciousness of his strength; a glorious face of a giant, shattering the ultimate lines of the horizon, as if at the threshold of the world. A soft clinging woman tenderly reaches for the hair of God and speaks to him: 'Make man rise up again after he dies. . . .'

"And the angry but not cruel lips of the god will open to reply: 'Man shall die.' "

The fruit of this journey materialized in two paintings, both literal renditions of the climactic incident-fantasies recounted by Gauguin and Morice in *Noa Noa*. In *The Moon and the Earth* (figure 116) the goddess Hina stands naked before the "powerful head of a god-man," whispering in his ear. From the narrative we assume that she, as the representative of earthly concerns, is pleading for a life after death for men, and that the god of the spirit is refusing her. "It was an ancient legend which the young girls love to tell in the evening," Gauguin had written. Perhaps so, but the concept behind it is native to Gauguin as well as to the local culture: his interpretations of Tahitian theology were derived from his own history, not Tahiti's, and it is not surprising that most of his dabblings in the Tahitian pantheon concerned the division of spirit and substance—male and female. The genesis of this myth may have its origin in a more likely still life: Gauguin passes his night hours observing groups of young girls, their chatterings (which he cannot understand) and their silences, and imposes upon their biding state this legend of mysterious authorship:

"The moon is often invoked in the traditional recitals of the Araois.

"But it would be difficult to decide if the role one attributes to Hina in the harmony of the world is positive or negative.

"It is above all the clearness which designates the two unique and universal elements of life that helps resolve them into a supreme unity. The one, soul and intelligence, Ta'aroa, is the male: the other is purely sensual and, being composed in some way of the body of the same god, is the female; that is, Hina. Hina is not only the name of the moon. There is Hina of the Air, Hina of the Sea, Hina of the Within. But this name pertains only to elements of the air and water, of the earth and moon; the sun and sky, light and its empire, are Ta'aroa. . . ."

Gauguin insists that this is "the fundamental doctrine of the Maori genesis." He uses it as proof that Ta'aroa and Hina are "twofold manifestations of a single and unique substance . . . the generative cause and matter which has become fecund, and the fruit, the motive cause, the object acted upon and the movement itself.

". . . in the fruit are united and mingled the generative cause and the matter which becomes fecund.

". . . in movement, the motive cause, the object acted upon . . .

". . . in life, spirit and matter. . . ."

The legend, no matter how ancient, floats up from Gauguin's unconscious like smoke. He had been given a theme, but his use of it seems almost involuntary, mysterious in the deepest sense of the word. From the trappings of the Tahitian night, Gauguin conjures his vision and renders it: "It was evening, the moon was rising, and as I watched its soft light envelop the rugged brow of the mountain, I recalled this famous legend: *Parau Hina Tefatou*."

The moon, which tenderly envelops the mountain, is the essential form of the "soft clinging woman who tenderly reaches for the hair of God. . . ." She also bears a suspicious resemblance to the young naked woman of Gauguin's narrative who, leaning toward a spring, caresses a projecting rock with both hands. This incident occurred just before Gauguin reached the final stage of his journey, following the river until he approached Arorai, "the dreaded sacred mountain." The girl at the stream—"which gushed from very high in the rocks"—may have been the first incarnation of Gauguin's phantom-goddess Hina, whose abode in the mountains paralleled the rocky nook. In Gauguin's painting of Hina and Tefatou a small stream seems to run from the flower-couched heart of the god, while Hina, her lips pursed as though drinking, inclines her head toward his ear, another source. The first girl at the stream also inclines toward *the source*, as represented in the painting of that name by Courbet—a striking example of Gauguin's mysterious chance encounters with traditional motifs. The painting *Mysterious Water* (figure 115), which preceded the narrative, and may have inspired it, was based on a photograph in circulation at the time.[1]

The stream of water issues from the heart of the rock, as it did from the heart of the godhead: it *is* the heart of the godhead, the substance of life released from the source of life. The girl whose hands caress the projecting rock is adoring it for its potency, for the benevolence of its

issue. She drinks of it to absorb its substance and assimilate it; having swallowed it she will be more alive, more female. "When she had finished drinking, she took some water in her hands and let it run down between her breasts"—just as the river that Gauguin was following ran through the valley of Punaru—"a huge fissure which divides Tahiti into two parts . . . from every side the huge walls of the mountain rose straight up."

As the journey progresses the apparition hardens into myth. The object no longer bears the shield of its natural form but realizes its true function: the rock-as-phallus becomes a singular being, a deity who assimilates the attributes of the rock and the phallus but who is more than the sum of its parts. The stone idol evolves into a living force, "a powerful head of a god-man, the head of a hero upon whom Nature has bestowed the proud consciousness of his strength, a glorious face of a giant"—embodying the hardness and immobility of the rock, the seducible nature of the phallus. The woman is "soft" to counteract the rock-hardness of the god; she is "clinging" to emphasize his "consciousness of his strength," but in her vulnerability she is more seductive than submissive. Her entreaty is a come-on, designed to arouse: "Make man rise up again after he dies. . . ." She knows that life is regenerated by the rise and fall of the phallus; Christ, as he appeared to the women after his resurrection, had been made erect again by grace of the godhead. Gauguin was aware of the phallic significance of the resurrection, of resurrection as a form of rebirth as opposed to renewal.

Gauguin's terminology is telling: he describes the "powerful head of a god-man," the godhead, the progenitive organ of the Creator-God from whom all subdeities, and all men, are created. The sheer force of the godhead fertilizes the receptive body of the earth—a feat of apocalyptic assimilation featured like a celestial sideshow in Gauguin's kingdom of heaven. Gauguin sees the same show wherever he goes, knows by heart its successive acts, its resolutions, depolarizations, assimilations, this grand spectacle of the *fitness of things*, of things within things, consumption, digestion, assimilation, *conclusion*—"and the angry but not cruel lips of the god will open to reply, 'man shall die.' " A hard act to follow, the cyclic follies, played out in this ravenous jungle where only the fat survive. Gauguin would like to devour his measure of flesh—"I have always wanted a mistress who was fat and I have never found one"

—but flesh always eats him first. "To make a fool of me they are always pregnant."

In a drawing (figure 117) from *Ancien Culte Mahorie*, Gauguin's notes for *Noa Noa*, Hina and Tefatou appear again in more equal partnership, two deities facing each other. Each is seen from a side view, but Hina's lower body is twisted around to display her genitalia. A plant set between the two figures bears eye-flower blossoms; one flower eyes the genitalia of Hina, the other eyes Tefatou's head. The fallen Eve in Gauguin's woodcut haunts this evocation like a frail ghost, her white cloth clutched to her shame, her tremulous gaze directed toward the rock-phallus before her; a hooded death's-head behind her casts its baleful eye toward the place of the devil's entry, counterbalancing the phallus across from it. Between the two evil forces Eve is immobilized.

Gauguin's own eye was on the godhead, and his spirits lifted when he saw that it was strong. Looking skyward, he saw mountains rising proudly "like ancient battlemented castles," sheathed to resist attack. "Is it any wonder," he asks, "that before this natural architecture feudalistic visions pursue me?" In his vision the phallus wielded its benevolent domination, while leagues of soft clinging women maintained its lofty estate like so many serfs. In a word portrait, Gauguin wrote, "Over there is the summit in the form of a gigantic helmet-crest. The billows around it, which make the noise of an immense crowd, will never reach it. Alone among these grandiose ruins stands the crest, neighbor of the heavens. From there a hidden look plunges into the deep waters, which had once engulfed the sinful race of the living for their having touched the tree of knowledge—guilty of mental sin—and the *crest*, also a head evoking some analogy to the sphinx, seems to suggest, in its vast fissure which would be the mouth, the irony or the compassion of a smile over the waters where the past sleeps."

The "hidden look" which passes from the mountain over the fissure is, like the gaze of the eye-flower, infinitely knowing: the rock-phallus recognizes the abyss for what it is, and as alternate forces they acknowledge one another. The hidden look passes between them like a salute, then *passes over* the fissure, leaving only a hovering smile of irony or pity which mocks the depths. The godhead can control his own fall, and thereby his own death; he knows that the receiving body is mortal, that it will receive what is given it, that it will not prevail. The past sleeps

below the waters, the waves continue to rise and fall, the wave of death *passes over* us all in irony or pity, but the mountain rises eternal from out of the depths.

That Gauguin furnished his terrain with monuments from his unconscious is in no way aberrative. Religious awe is universally generated by such natural phenomena, which resemble in huge, imposing scale the phallus, vagina, uterus, breasts. The mountainhead-phallus is countered by an earthful of female awesomeness—valleys, hillocks, clefts, mounds, flanks, tunnels: an autocracy of matter. The farthest extension of Gauguin's fear in the face of it led him to seek an antidote of pure spirit, which took form as the contemplation of death. These inclinations surface in his own interpretation of the dialogue between Hina and Tefatou: "The counsel of the moon, who is feminine, might be the dangerous advice of blind pity and sentimental weakness. The moon and women, expressions of the Maori conception for matter, need not know that death alone guards the secret of life. . . ." Perhaps Gauguin is implying that only blind pity and sentimental weakness could cajole a man to rise again for another round. The forces that would seduce him are the forces he must escape in death—for only when matter is annihilated, put down for all time, will the spirit be freed from the onerous body, from its fresh starts and false hopes, which flower like premature ejaculations of energy. The Spirit of the Dead who guards the young girl's bed is guarding the secret of life which resides *within* the girl, but she also guards the fatal knowledge of woman's fate *from* the girl. The crone is a death's-head made of bones, a remnant of life and a residue of flesh; her frozen stare is a badge of her female awesomeness, a replica of the abyss. She is uncanny.

Gauguin's interpretation of feminine counsel may have been an effort to reduce the awesomeness of female sexuality and fecundity. The woman's drive to maintain life is chastened and tamed, diluted into blind pity and sentimental weakness. Hina begged Tefatou to leave man alive —or to leave man to *her* so that she might succor and serve him; her entreaty was a veiled claim to man's tangibility, her share of the bequest. Tefatou, "angry but not cruel," refused to grant it, hardening himself, as Gauguin did, against his own incipient femininity.

"Tefatou's reply would be a national prophecy; a great spirit of ancient days had analyzed the vitality of Hina's race, presaged in her blood

the germs of death, without possible rebirth, without plausible salvation, and he said: 'Tahiti will die; she will die, never to be reborn.' "

The life which follows upon the death of the body is a risen life which rises out of the body, like a phoenix emerging from a bone-pile. As Gauguin envisionaged it, death was a cradle rather than a grave, the berth of the new birth. The supremest wisdom of Tefatou (in Gauguin's interpretation) is not so far from the anointed expressions of Christ, who cautioned Mary Magdalene, "Touch me not; for I am not yet ascended to my Father." Gauguin may have aspired to spiritual divinity, but his own ancestral seat in heaven was more humble: he would ascend from out of the stranglehold grasp of the woman in his life, whose soft and clinging maternality bound him still, to the arms of his own father, his refuge. It is possible that in *hardening* himself, way back, he was also unconsciously phallicizing himself—either to withstand, ward off, blind pity and sentimental weakness, or to *penetrate*, cut through, those dregs of the heart. The fantasy of the girl caressing the rock-hard phallus is Gauguin's own obeisance to the source of strength, father-god, godhead.

Gauguin's journey was in the nature of a puberty rite. He would undergo a series of strenuous physical gymnastics—alone and unaided by the natives, his playmates in Eden, whose fear of death consigned them to a lifetime of childishness. The object of the search was the male godhead, wherein resided his own manhood. His anxiety over the quest manifested itself in fantasy form in the image of the girl by the spring who usurps his identity and saves his pride—*she* is seen caressing the phallus, *she* drinks from the endless spring that flows from the mountain, *she* dives into the water and turns into an enormous eel, that is, a huge undulating phallus. The eel, like the snake, fuses the hard phallus with the yielding female body—rhythmical, undulating, winding "in and out among the small stones at the bottom"—a female-become-phallus cut loose to roam the waters.

At this point the crowning glories of the quests—Jotefa and the tree, the girl and the stream—begin to converge. The object of each journey is the same, and the patterns of pursuit narrow into a single path. Each journey is inaugurated in high idealism: Jotefa is the noble savage who instinctively appreciates and respects Gauguin's art and joins with him to search out the perfect piece of rosewood for carving; the girl by the spring is the beautiful maiden whose attractions equal the amount of

physical prowess required to win her. The fantasy of the phallicized woman gains impetus as the journey progresses, as the climb toward the summit gains momentum: Gauguin's thoughts about reaching and seeing "the dreaded sacred mountain which formed the summit of the island" may have been similar to the secret fears and desires he experienced when going up into the mountains behind Jotefa. Visions of the great unaltered ego, his externalized self, taunted him as he climbed.

When at last Gauguin encountered his fleshed vision, the girl at the stream, he could only regard her from a safe distance: "My look did not meet hers. Hardly had she seen me when she plunged into the water, crying this word, 'Toëhoë' (furious)." Her anger and her quick exit were engendered by fear and guilt—she had been caught in the act. There but for the grace of guilt went Gauguin himself; he would not meet her eyes for fear of seeing his own reflection there. Instead he directed his glance at the reflective waters, wherein he saw "no one, nothing—only an enormous eel which wound in and out among the small stones at the bottom."

This ritual plunge into the waters, an expiation and an escape, occurred in the incident with Jotefa. Gauguin's "horrible thought," which had grown in intensity as the climb progressed, was vanquished when Jotefa "turned and in this movement showed himself full-face." This time it was Gauguin who had been caught in the sexual act: as *Jotefa* looked at *him*, he fell into the glance of those "innocent eyes [which] had the limpid clearness of calm waters." When, a moment later, they plunged into an actual brook Gauguin's baptism had already been conducted, his original sin had been washed away, and he was open to "an infinite joy, as much spiritual as physical." The specter of the Androgyne had disappeared, the "actual young man" had returned, and Gauguin's own sexual identity remained intact. He had resolved his guilt, but the fury remained to be expended on the tree; the attack on the rosewood was a *furious* act which used up sex energy and guilt energy. Gauguin would see to it that the criminal phallus be cut down, punished, destroyed, unsexed. He would cut off the member that offended him and hope that the punishment would do glory to the crime. Self-castration was his fabulous and final feat—a martyrdom of love fit for a lady of celestial charm.

If the androgyne state had its perils, it also had its unqualifiable virtues, the foremost being that it separated him from his mother. Self-

castration resolved the anxieties of sexual differentiation, restored him to the bosom of his mother in the form of a nurturing, nonsexual creature. At last he would be toward her as he was meant to be—back in his proper place, dispossessed of all the unsavory fantasies of his adulthood. *Be in Love, You Will Be Happy* is a monstrous parody of the hand-holding infantile state of bliss, as overseen by images of doom, black nursemaids, spirits of the dead. The infant Gauguin sucks his thumb because the breast has been denied him; he wishes to ingest his mother, but she resists in terror. Underscoring frustration, a drowned man bites down upon the wood of the ship; the adult Gauguin nourishes himself on fantasies of fat women, tasty morsels.

In the course of both quests, the infantile and the adult, for the state of bliss, an interlude of homosexual fantasy is a stop along the route. The desire to re-establish his lost parentage was powerful in Gauguin: a union of male-female could reflect the loss of his father and the resultant failure to consolidate his own sexual identity. The primal dream of family unity is an androgynous state, blissful because it precedes the differentiation of the sexes—or the loss of a parent. So intense is Gauguin's longing that the separate quests take on the characteristics of genders: the paternal mountain inspires veneration, evokes a concern with physical and spiritual strength, demands virility of the searching son; the maternal forest inspires the urge to destroy, wipe out, cut down, demands that the son perform the ultimate sacrifice—to "destroy the love of one's self," or the fearsome sexuality of the mother, which has its outpost in the son.

One way to restore the sexual father, who has died and *cannot make himself erect again*, is to de-sex the mother—who must then become both parents in one. Destroy the mother's sex—vilify her as the embodiment of the original (and only) sin—shadow her with the specter of death—mummify her, bound like the Peruvian mummy, so she *cannot make herself erect again*—obliterate her sensuality, her flesh, her perfume, her soft and caressing eye—do all these things and you will then be permitted to rest in peace in the sanctuary of your own manhood, your headstone, your benevolent womb.

Gauguin's long journey to the mountain was a quest to reinforce his manhood. His narration of events in *Noa Noa* is riddled with statements which betray a state of impotence:

) 221 (

(After the Hina and Tefatou exposition): "It is true that I lacked many of the essential implements; it irritated me to be reduced to impotence in the face of artistic projects to which I had passionately given myself."

(After meeting Tehura): "But the mocking line about her otherwise pretty, sensual and tender mouth warned me that the danger was for me, not for her. . . ."

"I cannot deny that in crossing the threshold of the hut when leaving, my heart was weighed down with a strange anguish, a heavy apprehension of a very real fear."

"We did not cease studying each other, but she remained impenetrable to me, and I was soon vanquished in this struggle. In vain I promised to watch myself, to control myself so as to remain a keen observer; my nerves were not long in giving way to the most serious of resolutions. In a short time I was, for Tehura, an open book."

"I also experienced, in a way, at my own expense and in my own person, the profound gulf which distinguishes an Oceanian soul from a Latin soul, particularly a French soul."

Gauguin's paralysis may have been a form of cultural shock. He had been unable to re-enter the childlike state of the natives, unable to mine the gold of natural resources that Tahiti offered: in the depths of this abundance he sank like a stone, a heart in darkness, bearing his lack of agility like a Greek punishment. His new freedom had conferred upon him the dubious benefit of license; it had not increased his own natural resources. In theory he could now return to a state of primeval bliss, but the dictates of reality prevented him from going all the way back; mired in his sediment of years and fears, he could regress no further than his shaky adolescence. His Paradise was no all-accepting mother to him but rather a wanton tease, flaunting her sex but repelling his advances—an enticing and tormenting Green Hell of a girl who acts up but never puts out. She stood before him, always before him, in all her verdant promise.

"The great royal tiger is alone with me in his cage; nonchalantly he demands a caress, showing by movements of his beard and claws that he likes caresses. He loves me. I dare not strike him; I am afraid and he abuses my fear. In spite of myself I have to endure his disdain.

"At night my wife seeks my caresses. She knows I am afraid of her and she abuses my fear. Both of us, wild creatures ourselves, lead a life

full of fear and bravado, joy and grief, strength and weakness. At night, by the light of the oil lamps, half suffocated by the animal stenches, we watch the stupid, cowardly crowd, ever hungry for death and carnage, curious at the shameful spectacle of chains and slavery, of the whip and the prod, never satiated of the howls of the creatures that endure them."

The spectacle of the tigress-woman who controls, consumes, and "abuses" the fear of her cagemate is both fascinating and fearful to Gauguin. Her aggressiveness leaves him no option for seduction; in her claws he is a passive victim, consumed by caresses which he cannot counter, caught with his defenses down. The jeering and bloodthirsty crowd observes the "shameful spectacle" of his abjection. This fantasy is a dream-exaggeration of his relationship with the Tahitian girls, whose openness alarmed and immobilized him. They were *available*—frankly and un-self-consciously. Whether or not they beat a path to his door is unimportant: the specter of them was sufficient. Gauguin was nonplused by the absence of those machinations of courtship that he had always jeered at so strenuously; he could not win these women through guile, and as a consequence he did not dare to take them.

"Indeed, I saw in the district young women and young girls, tranquil of eye, pure Tahitians, some of whom would perhaps gladly have shared my life. However, I did not dare approach them. They actually made me timid with their sure look, their dignity of bearing, and their pride of gait.

"All, indeed, wish to be 'taken,' literally, brutally taken (*Maü*, to seize) without a single word. All have the secret desire for violence, because this act of authority on the part of the male leaves to the woman-will its full share of irresponsibility. For in this way she has not given her consent for the beginning of a permanent love. It is possible that there is a deeper meaning in this violence which at first sight seems so revolting. It is possible also that it has a savage sort of charm. I pondered the matter, indeed, but I did not dare."

The irresponsible Eve is *not responsible* for her seduction; the force, the blame, and the guilt all lie on Gauguin's head. Seduction at this price seems repulsive to Gauguin, wildly threatening, as if he were the one being forcibly taken. Yet the violation of the tree in the episode with Jotefa was impulsive, healthily regressive, a brisk and bracing backward march—and as totally exaggerated an act as his "did not dare" queasiness in response to a freely offered invitation.

"Then, too, some were said to be ill, ill with the malady which Europeans confer upon savages, doubtless as the first degree of their initiation into civilized life. . . .

"And when the older among them said to me, pointing to one of them, '*Maü téra*' (take that one), I had neither the necessary audacity nor confidence."

Isolated by his fear of infection, Gauguin broke his self-imposed quarantine to partake of a tried-and-true health measure: none other than the street girl Titi, whose exposures in the marketplace of Papeete had invested her with a diplomatic immunity to all forms of social disease. The dimensions of this gap in logic are as vast as Gauguin's insecurity. Titi was no "pure Tahitian"—he had once rejected her for her impure blood—nor was she tranquil in any deep way—her constant chattering eventually drove him to evict her. She was, purely and tranquilly, a whore—and Gauguin could handle a whore. With Titi he was able to maintain his precious emotional distance; she did not involve him, *she had nothing to do with him*. Embracing her, he was able to avoid the grip of the spirit of the dead, that well-beloved ghost, who threatened to violate and consume him in turn. To consort with a whore was the limit of his license and the metaphor for his guilt. The native girls who derived no sense of shame from sex, the native men who felt no shame in not working, appeared to him as apparitions of an abysmal freedom: he blanched at the thought of this moral vacuum, in which possibility gaped and mugged, egging him on. The presence of Titi restored his audacity and confidence, his potency—but her omnipresence obscured the teasing reality of his dream, which nourished his creative life even as it sapped his male strength. The relationship took on its familiar pattern, and once again Titi was sent packing to Papeete.

Gauguin's progress toward the beautiful savage life was littered with obstacles of his own constructing. He shared the classic obsession of men who lose their fathers when very young: lacking a model, a measuring rod, he consistently set himself trials of strength as if to prove, by his valor in the face of physical odds, the fact of his own existence. The history of his feats shows that his adversary was nearly always an expert—someone worthy of measuring up to—or, if not a professional, a complete incompetent: "a little shrimp whose sex and species would be hard to specify!" as Gauguin wrote of a prospective fencing partner. In con-

trast, his paean to his own swordsmanship is wielded with fine restraint:

"The various fencing matches that take place in Paris every year are the proof of what I have just been saying, for one sees fencing masters beaten by civilians who have had ten times less practice than they.

"The head, it is always the head. . . .

"Our excellent master at Pont-Aven was very much astonished when one fine autumn day there arrived at the fencing school a pair of swords, a present from an American pupil who had well-lined pockets.

"In a match with the professor I showed him that this again was quite a different game."

The American pupil with well-lined pockets might well have gotten away with a *gift* of swords; he had weapons to burn. For Gauguin, nothing but the bravest show of skill would do, for he was, in the deepest sense, a self-made man, equipped with natural gifts but no endowments: "They say, 'Like father, like son.' Children are not responsible for the faults of their fathers. I haven't a sou; that is my father's fault." His father had left him undefended, forcing upon him the vile necessity of fighting his own battles. All his life he would attempt to compensate for this omission by undertaking the rough and perilous upward climb toward the forbidden mountain, at the summit of which resided . . . his father. In this way he paid interest upon his estate of destitution.

Nationalistic pride in France, his *father*land, germinated in him like an alien growth. He had always belittled its claim on him, had consistently stepped over it in favor of Peru—yet, at the moment of challenge and imminent risk, he armored himself with the identity of a Frenchman and, as a Frenchman, accepted the homage due the conqueror. If his opponent happened to be American, victory became that much sweeter: his vision of Americans as flagrantly rich, overendowed, allowed him to assume the role of poor-boy-who-makes-good, a Horatio Alger hero whose native wiliness shames and shafts the synthetic booty of the fat capitalist. He even went so far as to record an unabashed Mittyesque fantasy in his journals:

"They say I am the champion billiards player, and I am French. The Americans are furious and propose that I should play a match in America. I accept. Enormous sums are wagered.

"I take the steamer for New York; there is a frightful storm, all the passengers are terrified. After a perfect dinner I yawn and go to sleep.

"In a great luxurious room (American luxury) the famous match takes place. My opponent plays first. He scores a hundred and fifty. America rejoices.

"I play, tock, tick, tock, just like that, slowly, evenly. America despairs. Suddenly a brisk fusillade of shots deafens the room. My heart does not leap; still slowly, evenly, the balls zig-zag, tock, tick, tock. Two hundred, three hundred.

"America is beaten.

"And I still yawn; slowly, evenly, the balls zig-zag, tock, tick, tock.

"They say I am happy. Perhaps.".

An invisible Gallic chorus absorbs the scenerio, observes the steadiness and fortitude with which Gauguin metes out his power, observes his calm in face of the hostile volley of shots, observes the cocksure rhythm, the élan which cools and sanctifies his reception of victory, observes, not without awe, that that was, indeed, one hell of a ball game.

Gauguin's feats were intended to aggrandize himself, but to a still greater degree they aggrandized the objects of his fearful desire. Physical daring was translated into physical awesomeness; the feat ceased to be remarkable because of its grandness—a large act in a small world— but was the touchstone for the enlargement of the world itself, which took on the dimensions of the feat. A drawing in *Ancien Culte Mahorie* (figure 118) exemplies this principle in its simplest terms: the trunk of a male figure tapers mermaid-like into a huge phallus, which the figure wields manually—an efficient and self-sufficient organism, uni-celled— against an enormous vagina resting against a pedestal, behind which a large profile looms. The drawing may have been a sketch for a sculpture, for the "figures" are set upon a large base, an island which unifies them in their mutual feat and solidifies their wholeness-in-isolation.

Like all good dream craftsmen, Gauguin never aggrandized what he could not aspire to. He was capable of extending the sculpture base into an amphitheater, a more spacious setting for his spectaculars. This particular performance occurred on a fine lazy morning, rich with potentiality, when Gauguin had a captive audience in tow. He had suggested that the "gay little company," consisting of himself, Tehura, three young girls, and a young boy, visit the mysterious grotto of Mara, which, like the sacred mountain, supported its own quota of dark legend: as Gauguin adds, in a self-appended footnote, "This word *mara* is found in the

language of the Buddhists, where it signifies *death*, and by extension *sin*." The grotto is well camouflaged, appearing at first to be only a deep fissure. "But when you bend back the branches and glide down a meter, the sun is no longer visible. You are in a sort of cavern whose farther end suggests a little stage with a bright red ceiling apparently about a hundred meters above." The stage has been set, the character of the quest has been established, and Gauguin bites hungrily at the cue:

" 'Shall we take a bath?'

"They reply that the water is too cold. Then there are long consultations aside and laughter which makes me curious."

Thus far it is a sad spectacle, a tragedy in motley. In the eyes of the gay young company, Gauguin is a clown, a performing seal, an aging and foolhardy antihero whose most outrageous tricks only increase his absurdity. The natives know that death is something to avoid, and the whole premise of Gauguin's daring is lost on them; they cannot see, nor would they appreciate, his drive to *conquer* the ravenous abyss, to subdue it once and for all so that it loses the power to terrify him. In the end they join him in the water, staying prudently close to shore, wondering more hopefully than fearfully what the crazy Frenchman will do next. He does not disappoint them.

" 'Will you come with me?' I asked Tehura, pointing to the end of the grotto.

" 'Are you mad? Down there, so far. And the eels? One never goes there.' "

Had she taunted him to perform the feat to prove his manhood, she could not have been surer of his follow-through. In fact, she *was* taunting him, but more subtly. "Undulant and graceful, she was disporting herself like one very proud of her skill in swimming. But I too am a skilled swimmer." He was off, shooting toward the unknown depths at the other end of the grotto.

Another audience, perhaps also "hungry for death and carnage, curious at the shameful spectacle of chains and slavery," was observing Gauguin's progress: "Here and there on the walls enormous serpents seem to extend slowly as if to drink from the surface of the interior lake. They are roots which have forced their way through the crevices in the rocks. . . .

"By what strange phenomenon of mirage was it that [the other

end] seemed to recede farther from me the more I struggled to attain it? I was continually advancing, and from each side the huge serpents viewed me ironically."

This corps of phalli mock him from the gallery, voting heads-down in judgment upon his feat of virility. He would not make it. He sees visions of a giant sea turtle whose head emerges from the water, whose brilliant eyes "fix suspiciously" on him. "Absurd, I thought, sea turtles do not live in sweet water. Nevertheless (have I become a Maori in truth?) doubts assail me, and it lacked little to make me tremble. What are those large silent undulations, there, ahead of me? Eels! Come, come! We must shake off this paralyzing impression of fear."

Gauguin is unable to swim further. He lets himself down but cannot touch bottom. Tehura calls to him to come back, but when he looks in her direction he can barely see her, she has become "a black point in a circle of light." With renewed vitality, a by-product of his anger at the odds against him, he swims for another half hour, coming no closer to his goal.

"A resting place on a little plateau, and then again a yawning orifice. Whither does it lead? A mystery whose fathoming I renounce!

"I confess that finally I was afraid."

Gauguin's choice of phrase is interesting. The mystery does not *elude* him; rather he *renounces* it. He has made the decision to escape, to look away, to emerge from this adventure in his original form, a big child instead of a man. His fear has bested him, but he can take pride in having battled it, and in the end this shell of pride will keep him afloat. He will remember that he swam for an hour, not that he feared to plumb the mystery.

In a letter to Daniel de Monfried he wrote, "*I stand at the edge of the abyss, yet I do not fall in—It has been that way my whole life.*"

On the shore Tehura awaited him alone. Her companions, bored by the slow show, had long departed. "I was still trembling a little from the cold, but in the open air I soon recovered, especially when Tehura asked with a smile which was not wholly free from malice, 'Were you afraid?' "

Now was the hour of the hero's reward, the kiss on the cheek, the gold trophy, the swooning maiden deposited in the lap of the victor.

"Frenchmen know no fear!" declaimed Gauguin, and the two proceeded homeward to eat an after-theater supper, serene in the postcoital calm.

❈ XVIII ❈

The Red Dog

"**M**Y FLIGHT MAY be a defeat, but my return will be a triumph," Charles Morice quotes Gauguin as saying.[1] The ardor of the Tahitian exodus, like the flush of first love, obscures the serious motivation which underlay it: that Gauguin always intended to return to France, triumphant, vindicated, reaping the repentance of the shamefaced world. In his hunger for this sweet conclusion to all hostilities he turned his "escape" to Paradise into a field trip, prowling the green pastures like a Darwinian taxonomist, collecting specimens of wildlife to be examined and dissected at home.

His arrival on home soil in August 1893 was less than auspicious. He had wished to present himself as the fearless Frenchman who, having assimilated the best of both worlds, had now come home to claim his proper place. Almost immediately, the familiar carping worries assaulted his bravado. His renegade nostalgia, which had heightened to a poignant pitch in his last months in Tahiti, tumbled as the reality of France confronted him like a dead end.

He was penniless, as usual; the faithful de Monfried had secured a loan from Paul Sérusier, which was on its way to him in Marseilles. Arriving in Paris, he discovered that the art dealer who had agreed to handle his paintings had left the gallery and that the current owners did not wish to invest in the indiscretions of their predecessors. Gauguin

dauntlessly forged on to Durand-Ruel's, where a better reception awaited him; the old man was away in America, and his sons, receptive to the recommendations of their eminent client Degas, agreed to put on a one-man show featuring Gauguin's Tahitian works. Gauguin would have to pay the framing, advertising, and poster costs himself, but the glow of unaccustomed success obscured this harsh fact. Now his show was on the road; he would write to Mette, "Now at last I shall know whether it was foolish to take myself off to Tahiti."

The home front was strangely silent. Gauguin's first letter to Mette after his return was ardent in its author's inimitable fashion, beginning with the standard account of money worries and expanding into a recitation of the sufferings of his journey: three passengers had suffocated from the heat and been cast into the sea, but he had avoided the abyss once more, was well and thankful for it, indeed, more than well—"You will find a husband to embrace you not too much like a skinned rabbit and by no means impotent."

Such expressions of open-hearted devotion, dealing with the tender subjects of finances and fertility, were not calculated to disarm Mette. She preferred to burrow in Copenhagen rather than risk the consequences of her husband's "dangerous" kisses; his unfortunate metaphor chilled whatever fugitive affection she might have hoarded. She had just written him a letter—which would reach him late after traveling a circuitous route—informing him that the Copenhagen exhibition of his paintings had brought in a poor return, all of which she had been forced to use to buy necessities for the children.

Gauguin fired off two letters, full of indignation at Mette's silence. In the meantime he had received a telegram from her with the curt message that his uncle in Orléans had died; they both knew that a legacy was in the offing, and that it would give focus to the contention between them, would, perversely, bring them together if only to alienate them for all time. Gauguin commended his uncle on the "good sense" of his fortuitous departure and was off to the funeral; he expected to reap ten thousand francs. When at least he received Mette's first letter, he wrote to invite her to come to Paris with one of the children to "discuss matters, for which there is much need (letters are very unsatisfactory)."

This casual invitation—"I should be happy to embrace you"—coupled with his offhand attitude toward the legacy, provided the fuse that Mette needed. She dared not vent her fury upon Gauguin, who now held

the purse strings, but she sought out her most faithful and sympathetic listener, Émile Schuffenecker: "And so he has returned! According to his letters, just as he was when he left, steeped in the most monstrously brutal egoism. . . . He will never think of anything but himself and his own well-being; he prostrates himself in contemplative admiration of his own magnificence! That his children are forced to take bread from the friends of his wife is a matter of complete indifference to him: he doesn't want to know it! . . . We know, you and I, that he left on his little excursion to Tahiti with *all* the profits of his sale, and I kept quiet; this time he doesn't even speak of giving me a part of the fifteen thousand francs, and I must be permitted to say something about that. He asks me, furthermore, to find some money for a little trip to Paris!!! I am more than ever obliged to stay; I can't leave alone five big creatures, for whom I *alone* am responsible. If he needs to see us, he knows where to find us! As for myself, I don't run around the world like a madwoman!

"Don't show this to a living soul, promise me!" [2]

Legal complications prevented Gauguin from drawing the legacy before the show. In desperation he turned to his old foe, the Académie des Beaux-Arts, hoping to wring a benevolence from the present director Roujon, just as he had managed to extract an official mission and a promise to purchase a picture from his predecessor two years before. The response was brutal beyond all utility, recalling the critical upheavings evoked by *Be in Love, You Will Be Happy.* Gauguin was a true savage to this extent, that he had natural enemies who reacted to his essential nature with horror and revulsion, turning from him in a sweat of disgust inspired by fear. When Gauguin demanded that the Académie purchase a painting in fulfillment of the promise made to him, Roujon coolly inquired whether he had retained the promise in writing. He had not.

This ugly incident was only a foreshadowing of disasters to come. Gauguin could harden himself to such setbacks—after all, what could one expect of the Académie?—but he could not rein the powerful hopes which now settled on the approaching show. His anger, with its byproduct of determination, made him vulnerable as a target, a sitting duck for fate. The weeks of preparation brought him an ally in the unlikely person of Charles Morice, whose abject plea for a reconciliation moved Gauguin to the extent that he chose to ignore the fact that Morice had pocketed rather than passed on the proceeds of Gauguin's 1891 Goupil show. This demonstration of compassion was not totally selfless; he

hoped that Morice would act out his repentance by handling the publicity for the show, just as he had done for the benefit exhibition in 1891. Morice's other great talent was to serve as a catalyst to Gauguin's fantasies; now the two planned to write a book about Gauguin's journey, which would have the practical effect of explaining his art to the public in colorful narrative form.

The business of publicizing was carried on in fine fashion. Art magazines carried announcements or articles trumpeting the event, and the leading figures in the world of art were mustered to appear. Gauguin included three Brittany paintings as a preface to his new work, and carefully selected forty-one out of his sixty-six Tahitian paintings (including *We Greet Thee, Mary* and *The Spirit of the Dead Watches*) and two wood carvings. The stage had been set with taste and discretion, the paintings radiated from the walls like strange fruit, delicious and forbidden, and Gauguin stood in the midst of his self-created glory and thought, perhaps, that he had done well.

Among the reviews of the critical press, stalwart guardians of the taste of the time, few spontaneous reactions have been preserved; ultimately, only the most carefully considered, indeed, exquisitely refined, considerations ever reached the printed page. One writer, however, thought to register for posterity the spectacle of the public encountering for the first time a Tahitian work by Paul Gauguin, and thanks to him we have this edifying vision: an Englishwoman, confronted with the image of the red dog in the *Hina* series, letting out a scream of horror.

Charles Morice has recorded Gauguin's reactions to this ignominy: "No one can doubt the fear which at that moment must have clutched at his heart. To use a metaphor of which he was naïvely fond and quoted frequently, he endured his torments like an Indian who smiles under torture. Yet, never once, confronted with the antipathy of everyone present, did he for a moment doubt that he was right. Of what importance were the incredible misjudgments of the moment, when the future would prove him right?

"Realizing that those present were judging him without troubling to study and discuss his art, he assumed and air of tranquillity, smiling without betraying the least bit of constraint, quietly asking his friends their impressions, and discussing their replies coolly and dispassionately without trace of bitterness.

"When, at the end of this ill-fated day, he accompanied Monsieur

Degas to the door, he remained unresponsive to the latter's praise. But as the famous old master was leaving, Gauguin took one of the exhibits, a stick he had carved, from the wall and handed it to him, saying:

" 'Monsieur Degas, you have forgotten your stick.' " [3]

It is interesting to note that at this moment, in the throes of his deepest and most humiliating defeat, Gauguin was thoroughly a hero, as full of grace as he had ever dreamed of being.

For pure viciousness, the critical reception of this exhibit may be unrivaled in the history of art. Once again the meanness seems to be another form of fear, a venom of pettiness thrown up defensively to ward off the magnitude of Gauguin's achievement. The reviewers were outraged at this blatant daring, at the gall of actually pursuing one's fantasy. Virtually all of them based their attacks on the *concept* of Tahiti, as if the idea of migrating to an exotic clime to renew one's art was insupportable to them. Perhaps it cut too close to the bone: Gauguin had lived out Everyman's wildest dream, and in response his critics attacked his art to puncture his arrogance. The kindest of these comments came from Gauguin's old teacher Camille Pissarro: "Only Degas admires, Monet and Renoir find all this simply bad. Gauguin is certainly not without talent, but how difficult it is for him to find his own way! He is always poaching on someone's ground; now he is pillaging the savages of Oceania." [4]

Another reviewer, one who held no sentimental memories of Gauguin, reacted in the same vein: "We now await the arrival in Paris of a Tahitian painter who will exhibit his works at Durand-Ruel's or somewhere, while living in the Botanical Gardens. In short, we await a real Maori." [5]

And on the lowest level, the gossip columnists had an Elysian field-day with the kindergarten forms and colors. This writer's four-year-old could no doubt have done better: "If you would like to entertain your children, send them to the Gauguin exhibition. The attractions include colored images of apelike female quadrumanes stretched out on green billiard tables." [6]

The positive reviews were few but fervent, and from familiar sources. Octave Mirbeau, the symbolist critic, wrote his usual prose poem, alternating between perceptive comments on Gauguin's art and flowery tributes to the glories of going native—no doubt distilled from Gauguin's own choice narratives. Yet his rhetoric revealed fully as much

as it disguised: "Through these tales, this music . . . the past of this marvelous land of laziness, grace, harmony, strength, naïveté, greatness, perversity, and love is gradually conjured up. The myths take shape, the monstrous divinities with bloodstained lips who kill women and devour children rise up again, inspiring the same powerful fear as in ancient times. . . . So intimately has Gauguin shared the life of the Maoris that their past has become for him his own." [7]

Gauguin would remain in France for another year and a half, biding his time, eking out the months until his inevitable return. He would vacillate, but his impulses were tantamount to flirtations with a corpse. Basically, the failure of his exhibition had demonstrated to him that he must settle, once and for all, in a primitive land.

He now experienced the liberation which arises out of living with an inevitability. His attempt to conciliate the Paris art world had failed; he knew where he stood with them, and he knew where it left him. His attempt to conciliate his wife had failed; her fury had grown when she learned that he had never intended to give her half his legacy, and eventually he would ask her to "desist" from writing him violent letters on the grounds that they endangered his health. Incredibly, he would not see his family on this trip—and perhaps never again; therefore he would live as if he had no family. A second round of license had been served up to him, and now, safely ensconced in hostile civilization, he would make use of it.

His choice of lodgings was fortunate. His neighbors, William and Ida Molard, were also artists, he a composer of unplayable music, she a warmhearted sculptress, and they soon adopted Gauguin as one of their number. Ida's daughter Judith, just thirteen, developed a more passionate attachment to this swarthy and mysterious newcomer, and she became a pleasant accent to Gauguin's daily ramblings. However, he soon rerouted his dangerous longings in the direction of a more available thirteen-year-old. By sheer chance—it appears that in minor matters Gauguin's luck was on the upswing—the art dealer Vollard had decided to win his favor by offering him a little half-caste Indian and Malay girl who had been requisitioned by an opera singer and then dismissed. Her name was Anna, and Gauguin could have her, signed, sealed, and delivered. It soon became apparent that Anna could perform modeling and other services, and she and Gauguin lived quite comfortably together, in company with a small monkey—and fond memories of another half-caste, Titi, whose character Anna eerily duplicated. She took over Ju-

dith's role as hostess at Gauguin's weekly salons, where she starred, even in that colorful company, as one of the more exotic attractions. It may be that for Gauguin the identities of the two young girls—the one untouchable, the other already marketable—were helplessly intermixed. On a portrait of Anna (figure 119), sprawled naked in a chair with her monkey at her feet, he inscribed the legend "The child-woman Judith is not yet breached". . . in pidgin Tahitian. The Molards would never know.

The momentum of his social life did not keep Gauguin from work. He engraved a self-portrait on a plaster plaque and called it *Oviri*—a shade of the savage he had been and would become again. His artist's vision was all rear-view at this time; he looked back to Tahiti for inspiration and stimulation, continuing what he had begun there. *Noa Noa*, his eulogy to Paradise, was progressing nicely; to illustrate it he made ten superb woodcuts, six of them copies of oil paintings shown at the fatal exhibit. Unfortunately, the manuscript did not fare so well, having been given over to the ministrations of Morice, whose "editing" consisted of plentiful insertions of baroque prose which cushioned Gaguin's simple phrases in a bosom of adjectives. It is known, however, that Gauguin appreciated Morice's expertise, and approved his changes.[8]

In May 1894, most of his Paris commitments fulfilled, Gauguin left for Brittany with Anna and the monkey in tow. It soon became apparent that the scene was one of revived desolation, with most of his old friends gone, his old haunts changed. He discovered that Marie Henry, his old landlady, had married and moved to another village, taking with her all the paintings and sculpture that he had left with her over three years before. When he attempted to retrieve these works she refused to hand them over; her husband, a prophet of sorts, had decided that they would be worth something in the future. Unmoved by this rare discernment, Gauguin decided to sue.

On May 25 a small party of Pont-Aven regulars, Séguin, O'Conor, Jordain, and Gauguin and their respective women, went on holiday to an obscure fishing village, Concarneau. The exotic assemblage attracted the attention of some of the local boys, who ran after them jeering, directing their most pointed jibes at Anna. Séguin turned on one of the rascals and attempted to pinch his ear, attracting the attention of the boy's father, who rushed to his son's defense. Gauguin's latent gallantry was aroused; he leaped into the fray, taking over for the frail Séguin,

who dived fully dressed into the ocean. The assailant's tavernmates, fishermen, now joined in, and before long Gauguin lay seriously injured on the ground, his right leg broken, his shinbone protruding above the ankle. The leg never completely healed, and it dogged him, a cruel reminder of his mortality, for the rest of his days. He started another lawsuit and was granted six hundred francs out of the ten thousand he had asked; his assailant received a sentence of eight days' imprisonment. His suit against Marie Henry would come to an even more outrageous end; his claims for damage would be rejected, and he would be ordered to pay the defendant's costs.

In mid-November he took a train to Paris, despondent and bitter and eager to leave the country. He returned to his apartment to find that Anna had preceded him there and had stolen all his valuables, leaving only his paintings and other worthless items: the final footnote to his triumphant homecoming. To bolster his escape funds he arranged another sale, to be held in February 1895. Strindberg's letter formed the preface to the accompanying catalogue. Nine out of forty-seven paintings were sold. (Sales from his first exhibit had totaled eleven out of forty-four.)

Spring brought with it, to add to his burdens, a sudden decline in health. Eruptions broke out over his whole body; he suspected syphilis. Unable to book passage, he settled once more into a state of waiting, dreaming an old man's dreams of Samoa, fantasizing another colony, this time with Séguin and O'Conor. He produced during this period a stoneware sculpture, also called *Oviri* (figure 122), which represented a nude female death-spirit standing above a wolf and with a whelp clutched to her side. It was rejected by the Salon.

A reporter for the *Écho de Paris* interviewed Gauguin for the issue of May 13, 1895:

" 'Why did you make your journey to Tahiti?'

" 'I had once been fascinated by this idyllic island and its primitive and simple people. That is why I returned and why I am now going back there again. In order to achieve something new, you have to go back to the sources, to man's childhood. My Eve is almost animal. That is why she is chaste for all her nakedness. But all the Venuses in the Salon are indecent and disgracefully lewd. . . .'

"Monsieur Gauguin fell silent, and with a rather ecstatic expression

on his face turned to regard a picture on the wall of some Tahitian women in the jungle. . . ." [9]

Judith Molard was present at Gauguin's last evening with his friends. She reports that he was "overwhelmed by his savage instincts, and anticipating the joy of soon being back once more in his right element he danced an *upaupa:*

> *"Upaupa Tahiti*
> *upaupa faaruru*
> e—e—e!"* [10]

Gauguin put on a good show, which continued at the station the next day, when he was forced to endure the unsolicited farewells of friends and admirers who insisted on accompanying him. His heroism remained intact even though the façade of romanticism was worn thin. In his final hour he experienced the loneliness of the star performer in the midst of an admiring audience. His friends saw only that he would go, that it was a pity, that they would miss him. They lost themselves in the emotions of the moment while he stood central and apart, isolated by his special knowledge. He knew now that he was no hero but only an old dog, injured beyond repair, going off to a quiet place to lick its wounds and die.

XIX

The Last Supper

G A U G U I N C A M E back to Tahiti to stay. He came back not as an explorer-artist but as a settler who has left the old life behind. Now his passion was exhausted, but his Passion had truly begun: he had dallied in the Garden, waiting for his cup to run over; now he waited for it to pass from him.

He arrived on September 8, 1895, come to reclaim what was left of his estate. No delegations greeted him this time, for his character was well known to the local government and to the elite European society of Papeete. As for that jewel-like city, it shone even more brightly for his second coming; the purveyors of progress had seen to it that a few of civilization's choicest refinements be brought to Papeete, and now there were electric lights, bicycles, a merry-go-round outside the royal palace, tennis on the lawn of the governor's mansion.[1] Gauguin absorbed the sight, and resolved to emigrate to the more savage Marquesas. Papeete was no longer acceptable even as a friendly monstrosity; its ludicrous parody of European life held no amusement for Gauguin, who may have been dismayed by the keener accuracy of its aping.

Nevertheless, he did not go to the Marquesas right away but fell once again into his old pattern of easing into the savage life. His health was shaky, and he was more alone than ever; in Papeete he had access to hospital facilities and a few friends. He chose to settle in the district of

Punaauia, eight miles from Papeete, where he was able to lease a site; a measure of his state of mind was his decision to build rather than rent a simple native hut made of bamboo canes and plaited palm leaves, situated, again, between Protestant and Catholic churches. Gauguin's first impulse after moving in was to send for Tehura, who would be able to transform the hut into a home. She had married in his absence, but he knew enough about native nuptial customs to feel no guilt about recalling her. Sure enough, she came, but she did not stay; her Frenchman had changed, was now afflicted with a strange plague of running sores, and she knew all too well what it signified. She avoided him with the superstitious dread usually reserved for spirits of the dead—and it may be that his ravaged façade was beginning to take on the aspect of those haunted night companions. Sadly, Gauguin was forced to consign her to the bulging file of his dead dreams and to take in another woman in her stead. Pahura, his new companion, was in no way the dream-girl that Tehura had been, but her mediocrity was no tragedy; at this stage of his life Gauguin no longer required starlets to act out his staged visions, for the visions had changed. He asked nothing more of Pahura than easy companionship—but even in this respect she fell short, preferring to spend her time with friends and relatives rather than with the taciturn painter.

No sooner had Gauguin settled than the process of erosion began again; he was like the character in the old tale who hopes to avoid death by staying on the move, only to find the grim specter awaiting him at each new destination. Money problems developed within the first few months—an inevitable and chronic indisposition. "When I have money in my pocket and hopes of getting more, I always spend it recklessly," he wrote to de Monfried, "believing that thanks to my talent all will be well in the future—with the result that I am soon at the end of my tether." In addition to his extravagances and regular expenses, he now had to pay for expensive drugs, mostly of the pain-killing variety; not only were his skin problems worse, but his unhealed leg had begun to hurt intensely, forcing him to abandon his work for his bed. In frustration he wrote a stream of anguished letters to friends, cursing fate and begging for financial help. His words to Morice were extreme enough to be brushed off as melodrama, yet desperate enough to be received finally with seriousness: "I would have you know that I am on the verge of suicide (a ridiculous act, no doubt, but inevitable). I shall make up my mind in the next few months, depending on what replies I get and whether they are

accompanied by money. . . . What matters the death of an artist!"

As was his custom, Gauguin rallied after having reached bottom. He entered the hospital and emerged miraculously in working order again. To earn money he took a job as drawing master to the daughter of a wealthy lawyer; if he had submitted to a new humiliation in stooping to accept such a position, his pugnacity got him out of it quickly enough. He also managed to alienate the local Catholic Church by erecting in his garden a statue of a nude woman, to the consternation of Father Michel, who threatened to destroy the iniquity with his own hands. Gauguin rejoiced that the Church could not trespass on his territory, and that the good Father's years of careful missionizing had been undermined by this single stroke from the world of art. Thereafter he was a marked man, the subject of bitter sermons and dark legends, a role which he bore with the poise and secret delight of a born Ismael.

In 1896 Pahura gave birth to a baby girl, who survived only a few days. Gauguin's attitude toward love-children, even his own, was nonchalant; therefore the painting inspired by this event may be taken as a dark omen, a portent of tragedy to come. A nativity scene, it depicts an infant cradled in the arms of a hooded death-spirit while the mother watches from the bed, mute witness to her own dying-in (figure 130). Some months later, in April 1897, Gauguin received the terse note from Mette informing him of the death of their daughter Aline of pneumonia contracted upon coming out of a ball. Lines from his last letter to her written more than three years earlier must have rung like a knell in his mind— another footnote of bitter irony: "Mademoiselle is off to the ball. Can you dance well? I hope the answer is a graceful YES, and the young gentlemen talk to you a lot about your father. It is a way of indirect courtship."

Gauguin's depression over his daughter's death was of the most dangerous kind. There was no catharsis in it, no relieving purge of tears. Instead it hit him as another hammer-blow in a long series of blows, a catalyst to numbness, a morsel for his mind to mortify and digest. In the end, perhaps, his memories of his daughter were lost in the darkness of his cosmic vision, which now bordered on paranoia; his green island had become a literal hell. "It really looks as if somewhere up there in the higher regions I have an enemy who never for a moment will leave me in peace," he wrote, and in the authority of his languishing godhead he charged God with "injustice and malice": his heaven, divided against himself, could not stand.

To add to his woes, the owner of the land on which his hut was built died suddenly, heavily in debt, and his heirs were forced to sell the property. Gauguin would have to move again, but this time he planned to buy his own land. He was able to obtain a bank loan of a thousand francs, and with this temporary fortune he purchased a plot of land nearby and hired builders to construct for him a house of great luxury. Built of expensive materials imported from North America, the dwelling was divided into a studio and a living area and was, by Tahitian standards, large to the point of profligacy. By the time it was finished Gauguin was satisfactorily in debt again—a state which had become so familiar as to make him feel truly at home.

This extravagance was in part a compensation for his latest round of misfortunes. It seemed that all things systematically fell away from him, were taken from him, and he had resorted in his destitution to a last worldly claim: that of possessing property of his own. His house, this strong structure made of imported materials, was also his fortress against further ravagement; it had been built to last—to stand up for him in the end. Ironically, he was more alone in it than he would have wished; because he now bandaged his ulcerous legs, the rumor sprung up that he had leprosy, and even his few close friends ceased to visit him.

Alone, ill, and persisting in life, Gauguin turned inward upon himself, not in voracity but in exhaustion. This period of his life passes in ominous tranquillity; he may have felt that he had reached the apex of his suffering, that nothing more could affect him now. Eye trouble made it impossible for him to paint, so he indulged in the elder stateman's occupation of setting down his *pensées* for posterity. Perhaps he had come to feel that his hope to achieve glory through his art was only a fantasy after all—a recurring fantasy which currently had no moral force behind it. His opinion of the world dipped and rose along with his hopes for himself; now both were at low ebb, and he could see, with great washes of hindsight, where all had gone wrong. During the periods when he had painted actively, his thoughts, criticisms, judgments were carried along in the tide of the working process; his own force had given them form. At this low moment he was bereft of force, and his belligerent pronouncements only delineated his passivity, his status as an observer of life. At the end of his journal, completed early in 1903, he was to write, "It was not my desire to make a book that should bear any

resemblance to a work of art (I should not be able to do so); but as a man who is well informed about many of the things he has seen, read, and heard all over the world, the civilized and the barbarous world, I have wished, nakedly, fearlessly, shamelessly, to write . . . all this.

"It is my right. And the critics cannot prevent it, infamous as it may be."

As usual, the critics not only did not prevent the diatribe, but also fanned it with their hostility. His first literary effort from this "retirement" period, begun in 1897, was inspired by his conflicts with the Catholic Church, personified by the ready buffoon Father Michel. The seriousness of the issues overrode the insignificance of his enemy: Gauguin's intention was to bypass crude parody for a lofty philosophical treatise entitled *The Modern Spirit and Catholicism*. Later, in his journals, he stated his aim:

"Remembering certain theological studies of my youth, and certain later reflections on these subjects, certain discussions also, I took it into my head to establish a sort of parallel between the Gospel and the modern scientific spirit, and upon this the confusion between the Gospel and the dogmatic and absurd interpretation of it in the Catholic Church, an interpretation that has made it the victim of hatred and skepticism."

The hundred-page manuscript, which Gauguin considered "the best expression I have ever given to my philosophical point of view," is in reality rambling and almost incomprehensible, concocted from a potluck of Eastern tomes and paraphrased portions of the New Testament. His primary source of information was a book by the British spiritualist Gerald Massey entitled *A Book of Beginnings, containing an attempt to recover and reconstitute the lost origins of the myths and mysteries, types and symbols, religions and languages, with Egypt for the mouthpiece and Africa as the birthplace.*[2] Gauguin's plagiarism, though extensive, serves to highlight certain preoccupations which appear as the themes of his later significant paintings, in which the tortuous imagery reaches its natural state of grace. The manuscript is like a museum in which themes of the past are gathered together to form a statement about an era:

"It is no less true that our complete regeneration, our resurrection from the dead, requires for its accomplishment an appreciation of Christ . . . our nature wants to follow the path thus recognized as regeneration, or progressive transformation, which has been revealed by

this individual type (Christ) historically realized and bright with perfection. . . .

"At this period we are undoubtedly undergoing the scientific evolution foretold in the Bible when it says, 'Nothing dissembled will remain hidden, and that which is spoken secretly in the ear today will one day be preached from the housetops.' Ev. St. Luke.

"Facing this problem [are the questions]:—Whence do we come? What are we? Where do we go? What is our perfect, natural and rational destiny? . . ." [3]

Gauguin defended the scientific pursuit of knowledge, applying it ideally to philosophical questions; he believed that the Church inhibited this seeking after truth, keeping the masses ignorant for its own gain.

Destiny overtook Gauguin even as he was pondering its origins. He was assaulted without warning by a series of violent heart attacks which left him more dead than alive; the probablity of his own approaching death became a reality to him, and he was able to speak of it calmly, even eagerly, in a letter to Charles Morice: "It is probable that I shall not see the book printed, my days being numbered. God has at last heard my beseeching voice, asking not for a change but for total deliverance: my heart, always beating too fast, buffeted by reiterated shocks, has become very diseased. And this disease makes me cough and spit blood every day. The body resists, but it is bound to collapse. And this would be better than my killing myself, to which I was being driven by the lack of food and of the means to procure it. . . ." [4]

As if in vengeance upon his God-playing, even this entreaty would be denied him; if he wished to die he would have to do it himself. Helplessly he hung on, too ill to work and too poor to stay at the hospital, waiting for the mail boat as for a sign from the sky. The idea of suicide had hold of him now, and small events took on cosmic importance; the mail boat was a test case, and its contents would determine where he was going. When it arrived, it brought him a copy of a literary magazine containing the first half of *Noa Noa*—visions of a golden land where fruit offers itself from the trees, where amorphous death-spirits convene on mountaintops to decide man's fate—but no money. [5]

Gauguin's decision to die was, like his greatest paintings and his greatest fantasies, annotated. It was his artist's license to make of his death what he wished, to make it a perfect thing. Taking the cue from

his essay on Catholicism, he decided to paint a "spiritual testament" for the world to puzzle over after he was gone: a thirteen-foot canvas, a frieze such as he had always longed to paint, to be called *Where Do We Come From? What Are We? Where Are We Going?* (figure 120). Its scope was heroic, and so was the effort it must have cost him to complete it. He painted with great fervor, all the more passionate for having been away from painting so long, reviving his remaining energies to meet this one last effort. By the time he finished it the next mail boat was due, and again he waited, prepared for a strange twist in another direction, a *positive* irony. Nothing.

Taking with him a box of powdered arsenic which he had used to treat his diseased legs, he made his way once more into the mountains, prepared to meet the spirits head on. No audience observed this last and greatest feat, this final gesture of vindictive suffering offered on the altar by the fatherless son. In the last moments no winged intruder came to stay his hand; he had the frugal comfort of knowing that his offering was accepted. He swallowed the entire contents of the box and lay back to die. Racked by terrible pains, he began to vomit, throwing up most of the powder: in his anxiety to do the job right, he had taken more than his stomach would accept. For many hours he lay in the same spot, in agony and unable to move, until finally he was able to rise and carry himself down the mountain.

Some say that it is impossible to swallow that amount of arsenic and survive; that the whole suicide incident is a fantasy, a reconstruction of his father's dream-death. For Gauguin's purposes, the suicide was enacted, and failed; he remained alive, not so much resurrected as thrown back.

Gauguin wrote to de Monfried a lengthy description of his spiritual testament: "It is a canvas four meters fifty in width by one meter seventy in height. The two upper corners are chrome yellow, with the inscription on the left and my signature on the right, like a fresco which is appliqued upon a golden wall and damaged at the corners. To the right at the lower end, a sleeping child and three crouching women. Two figures dressed in purple confide their thoughts to one another. An enormous crouching figure, out of all proportion, and intentionally so, raises its arm and stares in wonderment upon these two, who dare to think of their destiny. A figure in the center is picking fruit. Two cats near a child. A

white goat. An idol, with its arms mysteriously raised in a sort of rhythm, seems to indicate the Beyond. A crouching figure seems to listen to the idol. Then lastly, an old woman, nearing death, appears to accept everything, to resign herself to her thoughts. She completes the legend. At her feet a strange white bird, holding a lizard in its claws, represents the futility of vain words. All this is on the bank of a river in the woods. In the background the ocean, then the mountains of a neighboring island. Despite changes of tone, the coloring of landscape is constant, blue and veronese green. The naked figures stand out in bold orange. . . .

"So I have finished a philosophical work on a theme comparable to that of the Gospel. . . ." [6]

The writing of *The Modern Spirit and Catholicism* led to the painting of *Where Do We Come From?* which in turn led to the ingesting of arsenic on a mountaintop: Gauguin's pariah's progress toward death. "Our nature wants to follow the path thus recognized as regeneration, or *progressive transformation*, which has been revealed by this individual type (Christ) historically realized and bright with perfection. . . ." In the painting the progressive transformation is from infancy to old age and death. The central figure, like the ringmaster in Eden, plucks an apple from the fatal tree, thus animating all the other figures to take their places at each stage in the cycle. Gauguin's forthcoming ghost haunts the painting; now he is the spirit of death. Searching for a symbol of cyclical regeneration, he comes up with the figure of an old mummified woman bound like a fetus—the greatest affirmation that he can produce. His testament is a validation of his own destiny expressed in "scientific" terms: the young ripe woman on the left side offers an ear to the statue of the goddess Hina, who implores that man be allowed to live; the bracelet on her arm marks her as a domesticated animal, just as a collar marks the tame milk-giving goat at her feet; the old mummified woman in the corner knows better than to listen to these "vain words" and crouches with her hands over her ears, shutting out the expressions of hope; her attribute, the white bird, clutches the lizard in its claws, also *shutting out* its beguilements. A young girl sits beside the goat, biting an apple while two kittens behind her play in a milk bowl. Gauguin intends to prove, scientifically, aesthetically, conclusively, that life is a sweet lie that withers on the vine.

Where Do We Come From? is modeled on the Golden Age friezes of Puvis de Chavannes. In Gauguin's hands the Golden Age is a beauti-

ful frieze of golden life which meets its nemesis and its focus in the Tree. "I tried to translate my dream in an exotic decor without recourse to literary means, with all possible simplicity of the trade: difficult work," Gauguin wrote to André Fontainas. "Accuse me of having been powerless in this, but not of shying away from the attempt; advise me to change my goal, to linger on other ideas already admitted, consecrated. Puvis de Chavannes is the highest example of this." Gauguin had projected the Golden Age into its future tense, Eden, and his admiration for Puvis's concepts was nostalgic in nature, meditative—reflections upon a display of old gold. He had gone beyond the eternity of the flesh to bequeath an eternity of the spirit, however dark, however abysmal. "The moon and women, expressions in the Maori conception of matter, need not know that death alone guards the secrets of life."

The work was the fruit of his period of introspection and the product of his hard-won wisdom, gleaned from the long months of agony and anxiety. As he wrote to Fontainas, "Upon awakening, my work finished, I say to myself, I say: Where do we come from? What are we? Where are we going? Reflection which no longer belongs to the canvas, rather laid completely aside in spoken language on the high wall, which frames: not a title but a signature." He acknowledges the title as the *true author* of the painting, its inspiration and its masculine inseminating force. Yet he signs his own name on the right side, upper corner, above the reclining lamb—weak, passive, waiting to be sacrificed to the cycle. He associates himself with the female process: its gestational nature and its doom. The father of the painting is spiritual in nature; Gauguin was inseminated with this spirit and brought forth the form and flesh of the painting—"We see that in the fruit are united and mingled the generative cause and the matter which has become fecund, in movement, the motive force and the object acted upon, and in life, spirit and matter. . . ." Studiously resigning himself to life's end, Gauguin casts himself in the role of the cyclical woman . . . completes the painting . . . goes off to die with the satisfaction of duty done, function fulfilled.

His chosen means of suicide, the ingestion of arsenic, completes his submission to the female cycle: he has gone from breast milk, a nourishing substance, to a poisonous substance which devours in turn. The syndrome which began with the ultimate good of the mother's protective embrace has followed its course to the ultimate evil of complete ingestion and absorption—annihilation of the self in the clutches of the devouring

woman. In an earlier, more optimistic time, Gauguin had chosen to resist this second and final helping, this fearful *acceptance* within the grotto of sin and death: "A resting place on a little plateau, and then again a yawning orifice. Whither does it lead? A mystery whose fathoming I renounce."

Faced with the gaping mouth-womb, Gauguin was afraid and turned back. He feared being reabsorbed into female substance, returned to the womb of his first birth; in the final resting place of this second birth-of-the-flesh he would lose the manhood he had won in the world, lose his strenuously acquired spiritual self, and emerge for the next round as—a woman. When he stumbled down the mountain after his bungled suicide attempt he no longer had a deep sexual identity, for he had failed both parents, failed both spirit and matter, and was left with a broken body, dispossessed.

Gauguin's preoccupation with oral ingestion surfaced in his work as early as 1889, when he painted a still life of two ceramic vases facing each other, one a breastlike protuberance overflowing with an extravagant bouquet of exotic flowers, the other Gauguin's self-portrait vase bearing a sparse cluster of spindly wild flowers which waver on fragile stems (figure 126). Gauguin's Christ-image, seen in profile, the neckbase resting on the table like a decapitated head, seems to purse its lips toward the breast—the only aggressive gesture remaining to him. He is the man of sorrows, his deathlike grayish-green glaze streaked with oxblood red, wounds from the crown of thorns. He presents himself thus, in irony and humility, to the formidable female: Ecce Homo—Behold the Man. On the background wall a Japanese Noh dancer overlooks the scene, casting a threatening grimace at the alluring breast, proffering the sword that Gauguin no longer possesses to wield in defense. The Noh dancer plays savage to the gentle man, acting physically and violently as a counterforce to Gauguin's Christlike stance.

The breast as flower and fruit is an inherently lovely conception which runs the risk of satiating too quickly. Gauguin used it in Tahiti because the charm of it fit in with his surroundings, and with his favorite myths about the Promised Land. In *Tahitian Women with Flowers* (figure 125) a noble-featured Tahitian girl holds a tray of flowers beneath her bosom; the lushness of the presentation causes the breasts to appear as cornucopias from which all good things flow—a sweet memento of Gauguin's initial encounter with his mother's breasts, a sexual contact

permitted and encouraged at the nursing stage but forbidden at all other times. In its purity and classicism, this particular theme is landlocked in the Golden Age: the dark implications of Eden and the Fall do not enter in.

Gauguin uses an equally classical mold in other paintings to present a more personalized interpretation. The three women in *Maternity* (figure 131) represent the three graces of womanhood, one holding flowers in the bloom of her youth and attractiveness, another holding fruit, plucked from the tree and ready to be eaten, and a third holding a suckling infant—the fruit of her flower. The woman with flowers echoes a figure in a Puvis pastoral which features an array of draped virgins gamboling on the green while Death with his scythe emerges from the ground (figure 135). In *Three Tahitians in Conversation* (figure 132), the Puvis-type poses reappear, along with a male figure who stands between the two women in a strangely penitential and passive pose, a more direct issue from Puvis, from his *Sainte Geneviève at Her Prayers*, where the man appears as part of a family group (figure 134). Gauguin casts him as the manchild, immobilized between two larger females, the suckling infant grown up. He belongs to the same species as the Adam in Gauguin's last rendering of the archetypal Eden scene; pushed to the left of the painting, Adam walks off into death, his back turned from the central action between Eve and the snake, his hand dropped ineffectually to shield his genitalia (figure 129).

Monumental, threatening women have a long history in Gauguin's art—beginning with his formidable bust of Mette (figure 13). The sculptural form seemed amenable to this characterization, as if the terror of the woman's nature could thus be transfixed in all its tangibility: dimensional, vivid, concentrated in infused significance, like an idol which absorbs and emanates the fearful pleas of its supplicants. His portrait-vase of Madame Schuffenecker (figure 127) balances the head on two thrusting breasts like missiles; the snake coiled atop the head is both terrifying and dangerous—as was Madame Schuffenecker herself, who demonstrated to Gauguin her powers as a biting and strangling creature. She is the personification of the breast that bites back, paralyzing its victim with venom—the monster extension of the breast-vase which intimidated Gauguin's self-portrait head. Her ears are large, pointed, fawn-like; the tree of Eden is etched on the side of the vase. As a tempter-woman Madame Schuffenecker is subjected to Gauguin's bitter conceit:

the enlarged ear hears the urgings of the snake, and the brazen breasts tempt the mouth as Adam's mouth was tempted by Eve's offering.

The idol comes to its full deification in a small statuette, the *Black Venus* of 1889 (figure 128). The kneeling female figure is a Martiniquan half-breed or coolie, as her earrings indicate. A grotesque head at her knees, decapitated just below the chin, has Gauguin's features; the head seems to grow from a stem, from which lotus blossoms also grow—one beneath the head, supporting it, another arching up toward the woman's body. A frieze of exotic animals elaborates the base.

Black Venus may not be Gauguin's title. Baudelaire had a black mistress, Jeanne Duval, whom he called his Black Venus, and, indeed, his obsession to extract beauty from evil fit the common conception of black women at that time. Negresses were believed to be capable of sorcery, and were said to be possessed of demonic impulses which could control the passions of others. To consort with a Black Venus was to consort with death.

Gauguin's variation on this theme defines the Black Venus further as a Black Kali, whose attributes include severed male heads and whose scepter is surmounted by a lotus. The head at her knees resembles the head of Goliath beneath the foot of Donatello's *David*—a personification of virtue triumphant over vice, neatly reversing the polarities to assure the ultimate victory of the Black Venus-Kali over helpless males of his own image. Yet the victory is sweet for the vanquished; Gauguin would meet death in the woman's lap, but there he would also find regeneration in accord with the promise of the lotus. Resigning himself to his fate, he would drift off into death as into an infant's sleep, secure in his complete helplessness.

In real life, Gauguin's helplessness in the arms of threatening women takes the form of a contrived ignorance based on natural wit. He *knows*, and so he averts himself from a fatal act of knowing by assuming ignorance, just as the serpent assumed the speech of man; then, coy as Eve before the tree, dazzled by the pretty red fruit, he pretends not to understand either the invitation or the consequences. He is a Joseph, pure and unsullied by sinful thoughts, resisting the advances of a Potiphar's wife. In his journals he recounts a stock encounter of his early years: "A petulant lady (experienced, too experienced) said to my fiancée, 'Of course, my child, you're marrying an honest fellow, but how *stupid* he is, how *stupid* he is!' " Gauguin appends a footnote to the petulant lady: "A

woman who had frightened me and whom I, being a Joseph, had not dared to understand." He had not *dared* to understand her, had been frightened by her open invitation, her license freely offered. Rather than choose to take her—an admission of adult knowledge—he had preferred to withdraw into infantile ignorance; if she wanted him she would have to take him against his will and beyond his wit.

In Tahiti he made a copy of a Prud'hon drawing (figure 124), which had been in the collection of his guardian, Gustave Arosa; faithfully he reproduced the setting and the two main figures—Potiphar's passionate wife attacking the recoiling Joseph—but added his own contributions: a shorn Joseph and a savage mask, an Oviri, a head atop a bedpost,[7] observing the reversed rape even as the Japanese Noh figure had observed the drama of the vases. Joseph's male savagery is concentrated in the mask; without it he is only a travesty of himself, he dare not take what he truly desires.

The object of Gauguin's lust is the breast-fruit itself, delicious and taboo. In Martinique he had written his wife of his efforts "to keep his coat intact, for Potiphar's wives are not wanting." And then he recounted in fine detail the story of the young Negress who had crushed a fruit on her breast and offered it to him in order to entrap him. A "yellow lawyer," Gauguin's clear inferior, an educated savage, had taken the fruit from him and thrown it away, warning him of the hex attached to it. Gauguin had pretended to laugh at this "joke," implying that had he been left to himself he would have eaten to his heart's content. "Now that I am warned I will not fall," he promised Mette, "and you can sleep soundly, assured of my virtue." He had neglected to report to his wife that his own sleep would now be sounder, that his guilty conscience would be placated by this offering of manufactured virtue, that his Joseph's purity consisted in restricting himself to *dreams* about breasts.

Gauguin's migration to Tahiti was a return to a maternal body that would succor him freely. In his fantasies he would reach up for fruit as an infant reaches up for the breast; when the land failed to nurture him, his early feelings of mother rejection were revived on a cosmic scale. Tahiti remained tempting and alluring, even as his own mother had— and as ultimately inaccessible. He could observe the lushness from afar, coveting it, but he could not make it work for him.

After his suicide attempt Gauguin was more and more driven to seek a savage resolution to his appetites; he had been rejected by France

and by Tahiti, which, in its rebuff of his overtures, had come to take on the characteristics of France. Tahiti was not sufficiently savage, for it continued to repress him. His next dwelling place must represent the furthest polarity to the civilization which consistently *withheld* from him, held him back. He would have to travel so deep into the wilderness that residual guilt could not follow him or impede the fulfillment of his desires.

His last years in Tahiti were marked by physical and moral disintegration, as if his failure to die amounted to another form of death. Penniless once again, he was forced to beg for a job as a draftsman in the Public Works Department at six francs a day. Transportation difficulties forced him to leave his homestead for the suburbs of Papeete; Pahura would not accompany him, and when he heard that she had remained in his house, he sued her for housebreaking. (The case was dismissed.) At last de Monfried sent him money and he returned, to find her waiting for him as faithfully as ever. In 1899 they had a son.

He began to submit articles to a monthly paper, *Les Guêpes* (The Wasps)—mostly diatribes against public officials. His latent flair for rhetoric gained him a following, and before long he began his own four-page monthly, *Le Sourire* (The Smile). His career as a yellow journalist was launched, and with it his reinstatement as an active member of society. He became involved in local politics, joining, incredibly, the Catholic Party, a group dedicated in part to preserving the purity of the splendid race of French colonials settled in Papeete. On one occasion Gauguin was asked to make a speech before a gathering of his fellows, in which he tossed about such phrases as "the well-known Chinese problem" and "the Chinese invasion of our beautiful colony." He expressed fears for "the new generation, which will be more than half-Chinese and half-Tahitian," and he provided the climactic moment of the evening with the following statement, which lends itself well to requotation: "This yellow blot on our country's flag makes me blush with shame." [8] His red-dog days were behind him now, and the plight of the underdog held no glamour for him. He no longer possessed the strength or the inclination to fight, nor did he dare to set himself a new goal: he knew by now that *uphill* was the cruelest illusion, that the fatherland lay safely across the sea, static and dependable, to be imported in small patches and planted on the public common.

In 1901 he made the decision—it became possible for him—to go

to the Marquesas. Perhaps he was motivated by the germ of savagery still alive in him, this fealty to an old dream. He was still able to write to de Monfried, ". . . if I am hard up for a while I can live by hunting and on the few vegetables I shall trouble to raise." But the force of the fantasy was no longer there, and he thought only of getting along, of eking out a living. The focus of all his previous desires was now concentrated on his art, the only factor in his life which gave him an option to *continue*, his only remaining motivation: "I think that in the Marquesas, where it is easy to find models (a thing that is growing more and more difficult in Tahiti), and with new country to explore—with new and more savage subject matter, in brief—that I shall do beautiful things. Here my imagination has begun to cool, and then too the public has grown so used to Tahiti. The world is so stupid that if one shows it canvases containing new and terrible elements, Tahiti will become comprehensible and charming. My Brittany pictures are now rose water because of Tahiti; Tahiti will become eau de Cologne because of the Marquesas."

The character of the new and terrible elements is hinted at in Gauguin's choice of destination, Hivaoa, described by Pierre Loti in these terms: "Cannibalism, which still prevails in . . . Hivaoa, has for some years ceased in Nukuhiva. This happy mitigation of the national custom is due to the efforts of the missionaries; in every other respect the superficial Christianity of the natives has not had the slightest effect on their mode of life, and their debauchery and immorality defy imagination." [9] At the last moment, fearing another disillusionment, Gauguin decided to go to Fatuiva, which in a letter to Morice he described as still almost entirely in the cannibal stage: "I believe that there the savage atmosphere and complete solitude will give me a last burst of enthusiasm before dying—which will rejuvenate my imagination and bring my talent to its conclusion."

In 1898, after his suicide attempt but before his move to the Marquesas, Gauguin made a painting of the Last Supper (figure 133). The composition is diagonal: in the foreground a dog with suckling puppies; behind them two seated women, one peering fearfully with fist to mouth; a phallic female deity bearing two copulating figures in place of breasts; and in the very background, barely visible, a tableau of the Last Supper, illuminated by unnatural light; a dark robed woman pauses before the table, and to the right of the idol two servant girls stand with baskets poised on their heads. The progression is profound, and as inevi-

table as encroaching death: the puppies obtain nourishment from their mother; the two young women await the bartering of their bodies on the market; the copulating figures, interchangeable with the idol's breasts, are death-dealing objects, in keeping with Tefatou's decree that man shall die; and Christ, at his Last Supper, the scene of the betrayal which leads to his death, offers his body and blood to his disciples so that they shall be nurtured after his death. Like Gauguin's eternal feminine, he can only give what he has. The thematic structure is closely related to that of *Where Do We Come From?* in which a family grouping is juxtaposed with a scene of the Fall, the woman reaching up to the phallic idol-tree and plucking an apple, tempting and breastlike fruit, to ingest and offer Adam. The old mummified woman, at life's end, also has given her body and blood to be consumed by her children: *she has given all she has.* The resignation of Gauguin's Christ is cast in her image.

A woodcut called, like an earlier work, *Be in Love, You Will Be Happy* (figure 83) contains similar elements: suckling puppies, a baby, a mummified woman—and a young woman in an attitude of supplication, whose figure was modeled after that of Mary Magdalene in a fifteenth-century tapestry of the Passion, which Gauguin knew. The Magdalene too had given all she had, her body and blood; society had damned her for offering herself. She prays with a fearful over-the-shoulder glance, while the bird of the Devil peers down at her. Figures of personages lost at sea, from Delacroix's *The Wreck of Don Juan*, chorus her sad plea. "His Don Juan's boat is the breath of a powerful monster," Gauguin wrote to Schuffenecker. "All those finished people alone on the terrifying ocean, having only one dread—to be the next to draw the unlucky number in the hat. Everything shrinks in the face of hunger." Gauguin admired Delacroix because he had "the temperament of the wild beasts"—and because he painted them so well. Perhaps for this reason he drew upon Delacroix's *The Natchez Family*, a paean to dying savagery; the painting depicts a family grouping, remnants of a once-proud race, huddled forlornly on an abandoned shore. Gauguin used the head of the mother as a model for the exotic head-in-profile at left. The infant in the foreground has the same status as the infant in Delacroix's painting: it represents the child-in-death, the death-bound Jesus, the last savage, the last live shoot on the decaying tree. A hooded head in the upper left corner, whose features embody sublime resignation, is derived from Redon's lithograph *Death*. Gauguin implies that the culture can renew

itself only by nurturing new creatures—the single saving grace of used women.[10]

Gauguin's voyages, like his dreams, always fell short. He never reached the voracious paradise of Fatuiva, choosing to settle instead at Atuona on Hivaoa, where his boat had docked. He arrived on September 15, 1901, to be met by an unexpected and unofficial welcoming committee in the person of Ky Dong, a young Annamese prince who had been deported from Indochina and who spoke French fluently. The epic quality of Gauguin's arrival was not lost on Ky Dong, who produced a poem of fifteen hundred lines in commemoration of the event, much of it dealing with the first impression Gauguin made on the native women. Gleefully, the poet lyricized Gauguin's comic nearsightedness and assorted skin diseases which caused the women to withdraw from him in disgust.

From the landowners at the local mission Gauguin purchased a lot in the center of the village, convenient to the local stores yet surrounded by trees. He hired local carpenters to build a house for him, and within a month the dwelling was completed—". . . everything any modest artist could dream of. A large studio with a little corner to sleep in; everything handy and arranged on shelves raised about two meters from the ground, where one eats, does a little carpentering, and cooks. A hammock for taking a siesta sheltered from the sun, and refreshed by an ocean breeze that comes sifting through some coconut trees about three hundred meters away. . . ." Around the doorway he carved five wooden panels, with *Be Mysterious* to the left of the door and another version of *Be in Love, You Will Be Happy* to the right; above the door, between two female heads and a bird amidst foliage, was inscribed the legend "House of Pleasure"—the writing on the wall that would editorialize the sad estate of the master's affairs. The title might as well have been the literalization of the lizard in the bird's claw—vain words, futile as the lingering vanity which inscribed them.

Gauguin's hut soon became the scene of raucous all-night parties; he wanted to be sure that it would live up to its name. The public carousing aroused the ire of the Catholic mission, whose favor Gauguin had cultivated only long enough to effect the purchase of his land. Not content with setting a bad example, Gauguin felt impelled to undermine the system—which, in the Marquesas, made it difficult for him to obtain a vahine of his own. The missionaries had herded all the young girls into

convent schools where they were safely locked away from the likes of lusty painters; Gauguin played the devil's advocate, persuading a native couple to give him their fourteen-year-old daughter, Vaeoho, and rewarding their acquiescence with an abundance of gifts. He settled for a time into a relatively calm domestic state with his young vahine, a cook and a gardener, and a little house-dog who bore his monogram—Pego.[11]

Vaeoho soon became pregnant, and as her time approached she decided to return to her parents' home to have her baby. Gauguin was once again set loose—abandoned—and he reacted with a renewal of his earlier debauchery. The native girls were no longer magnificent golden Eves, but undifferentiated portions of yellow flesh: "Their skin, of course, is yellow, which is ugly in some of them; but is it as ugly as all that in the rest, especially when it is naked—and when it is to be had for almost nothing?" The romanticism of the Tehura era was dead, a relic of his ancient past. He continued to use animal metaphors when describing his women, but the magnificent animals which had peopled his early fantasies were now transformed into devouring beasts, whose sexuality was manifested in a listless and ruthless consuming: "They are nearly all wild. They want their dole without any caresses except glances. One female cat, the only one who is civilized enough for me to be unable to go out on the road without her following at my heels, is ferocious in every way, egotistical, jealous. The only one that growls while she eats. They are all afraid of her, even the males, unless she happens to take a fancy to all of them. But even then she bites and claws. The male submits to the blows, bowing before this female who plays the master's part so well."

He then muses upon another kind of animal, the tamed and submissive male: "All trained animals become stupid, hardly knowing how to find their own food for themselves, incapable of hunting for the medications that heal them. Dogs that end by having bad digestions are guilty of indecencies, knowing it but not suspecting that they smell badly."

Gauguin's appetites in the last months of his life seemed to retain no ardor. His disintegrating body clung to him like a shroud, measuring his mortality and stifling his male pride. He had no illusions about himself; he was an old dog, guilty of indecencies, an old wolf set upon by packs of whores, ravenous cats. The walls of his bedroom were decorated with obscene photographs, lures to pique the desires of his visitors as he no longer was able to do. It was as if the sins of the flesh had registered upon his flesh, so that, as he feverishly consumed young girls, his own

flesh was eaten up. As in the portrait of Dorian Grey, his gross appetites
—refractions of the gross appetites he imposed upon his sexual partners
—reflected his self-devouring.

The sediment of his passion was wiliness—an old dog's attribute,
or an old wolf's—and he rejoiced at the flocks who turned up at his door:
"A chicken had come along. . . . When I say a chicken I am modest,
for all the chickens arrived, and without any invitation." On his bed he
had carved an erotic scene, and he postured upon this final stage like a
dying king—artist, genius, savage, gentleman—unbothered by the con-
tempt of his subjects. In the extremity of his elevation he had used them
for what they were worth; they had served the diminishment of his pur-
poses.

"It is not always exactly spiritual, but it's a rest, after the labors of
art, to let one's mind play and one's body too. (The women are merce-
nary beyond a doubt.) Besides, it preserves you from the boring auster-
ity and the vile hypocrisy that make people so evil.

"An orange and a side-glance, nothing more is necessary. The
orange of which I speak varies from one to two francs; it is certainly not
worth the trouble of depriving oneself of it. You can easily be your own
little Sardanapalus without ruining yourself."

Nothing more was necessary than an offering of one or two francs,
but Gauguin had been left without a sou—his father's fault. ("They say,
'Like father, like son.' Children are not responsible for the faults of their
fathers.") Gauguin would stand up to the forceful advances of the
women himself, giving what he had, all that he had—but no longer
could he stand without support. To facilitate the desired state of upright-
ness he made use of two canes to carry his weight: on the handle of one
he carved two copulating figures, on the other a phallus; they served the
dual purpose of supporting him and keeping him erect.

Like Sardanapalus's, his drawn-out deathbed was an arena of sexual
energy, and from that dead king he borrowed another royal prerogative:
in his decline, like Sardanapalus, he destroyed all the beauty around him
to take it with him in his own death. He might have achieved in the
Marquesas the savagery that had always been beyond him, but he was
not up to it. He might have found an Eve worthy of reverence, but he no
longer possessed the grace to honor her. In front of his studio—outside
his working area but visible from the proper distance—he had placed a
clay idol, at whose feet he had carved the words *Te Atua* (The Gods).

The Last Supper

Here, like an offering, he left a sheet of copied verse which Charles Morice had written for *Noa Noa:*

> The gods are dead and Atuona dies of their death.
> The sky, which in former times set it ablaze, sends it to
> A sad sleep, with brief wakings of dream.
> Thus the tree, with regret, points into the eyes of Eve
> Who, pensive, smiles while looking at her breast;
> Sterile gold sealed by the divine scheme.

Oviri

IN AUGUST 1902 Gauguin wrote to Daniel de Monfried expressing a wish to return to France. De Monfried, his most faithful and levelheaded friend, wrote back to dissuade him: "It is to be feared that your return would only derange the growing and slowly conceived ideas with which public opinion has surrounded you. Now you are that legendary artist who, from out of the depths of Polynesia, sends forth his disconcerting and inimitable work—the definitive work of a man who has disappeared from the world. Your enemies (and you have many, as have all who trouble the mediocre) are now silent, do not dare to combat you, do not even think of it: for you are so far away! *You must not return! Now you are as are the great dead. You have passed into the history of art.*" [1]

Gauguin never again left the islands where, as he once swore, he would love, sing, and die. In his native land he was considered dead, and better so—his premature passing "into history" had enshrined him. The final phase of his life, an unwieldy appendage, was mottled by battles with the Catholic mission and with colonial officials. He would not die in peace but railed against authority to the last, as if his hard-won pariahhood were at stake. Often too ill to paint, he passed his days compiling his recollections and reflections in journal form and revising *The Modern Spirit and Catholicism*. The waspish and cynical tone of these works was

only a congealed form of the vitriol expended in his live encounters with priests and gendarmes who systematically "persecuted" him. Infirm though he was, he proved a formidable adversary. The local bishop had begun a campaign to keep the village girls out of Gauguin's clutches, but the artist had a ready revenge at hand. Taking inspiration from local gossip which linked the bishop with a young native girl who was his housekeeper, Gauguin immortalized the couple in wood and set them on his front step for all to see: on the base of the statue of the bishop Gauguin carved *Père Paillard* (Father Lechery). As if this were not enough, he took to patrolling the beaches to preach to the natives to keep their children out of the mission schools; he also exhorted them not to pay their taxes, inviting them to follow his example. Once again fueled by the hostility he engendered in official quarters, he set himself up as a one-man defense team for the natives. The colonial government was corrupt, impossibly corrupt, and he would devote his flagging energies to promoting justice for the simple savages, who had not been exposed to European legal codes; his own reputation could hardly be damaged. He believed himself to have a sort of fool's license in the colonies: the authorities would consider an artist and a fool the same thing; they would be pricked by his insight and outraged by his condemnations, but they would leave him alone. In the heat of indignation he dashed off a series of inflammatory letters to local officials, taking little care to bridle the full strength of his contempt. At one point he even acted as counsel for a group of twenty-nine natives accused of drunkenness, losing the case but establishing the reality of his presence in a manner uncomfortable to the authorities. He was soon made the subject of an inspector's report which detailed the activities of the "sick painter of the impressionist school" in the full glory of their infamy. The governor was out to get him now, and any further action on Gauguin's part would serve as bait. He was not long in supplying it: he wrote a letter to an administrator requesting an investigation of the conduct of a gendarme, Guichenay, who had been accused of smuggling and accepting bribes. As a result of this action a suit was brought against him for libeling the gendarme. He was tried on trumped-up charges, receiving a fine of five hundred francs and a sentence of three months' imprisonment. He resolved to travel to Tahiti to appeal the case.

"It will be said that all my life I have been fated to fall, only to pull myself up and fall again," he wrote to de Monfried. "Each day some of my old strength forsakes me." Perhaps he realized at the end the

logistics of his own cycle: the process of natural selection by which the savage fed off the gentle man and was devoured in turn. A month before he died he described himself to Morice as "a savage in spite of myself." All his life he had goaded the world into attacking him, suffered munificently in its clutches, and then risen fighting—to begin again. He had wept like a woman and battled like a man. He had suffered death because of himself, and enacted resurrection in spite of himself. So carefully constructed was his wildness that his last call to de Monfried, declaring his wish to return home, was refuted as a cry of wolf—not because de Monfried thought he lacked sincerity but because he had given up the right to cherish that wish. He was forced to live out the image he had imposed upon himself, to inhabit a carefree Golden Age when his psyche required the guilt of a lost Eden. His battle with the colonials was, in many ways, an effort to reinstate himself as victim and pariah, an effort to avoid the ultimatum of his fantasy. He could not live a savage life, achieved, realized, uninterrupted; he could, however, choose to die.

On May 8, 1903, that option was realized. Pastor Vernier, the Protestant missionary, arrived in the morning in answer to a summons from Gauguin. He found the painter ill and helpless, prostrate on his bed. Gauguin asked whether it was morning or evening, day or night; he seemed comforted by the presence of the missionary, who left him relatively calm "after a moment's talk." Later that morning the native servant appeared again to summon Pastor Vernier: "Come, come, the white man is dead." He arrived to find Gauguin dead, still warm, one foot hanging from the bed. No sooner was the news circulated than the bishop of the local church in company with his flunkies descended like vultures to claim the body. In spite of Pastor Vernier's protestations, Gauguin was buried in consecrated ground.

The cause of his death was listed as heart failure, but even in death he remained controversial. Some said that he had been assassinated by his enemies, the colonials; if so he would have fulfilled his revolutionary ambition to be a Marat. Others believed that he had committed suicide by taking an overdose of morphine. Majority opinion rested, and continues to rest, on the heart theory. The controversy is the just reward for the ambiguities of Gauguin's life; he deserved the right to select and annotate his death. As a savage Gauguin bared himself to the death-blows of civilization; as a pariah he was eligible for the ultimate alienation by suicide; as a Christ-figure he was foredoomed to give up his ghost. The

last alternative is the most probable and the most fitting in retrospect; at the end of a long decline, *his heart broke.*

Gauguin had already chosen the marker for his grave. In October 1900 he had written to de Monfried requesting "the large stoneware figure that did not find a purchaser. . . . I should like to have it here for the decoration of my garden and to put upon my tomb in Tahiti. This means that as soon as you can get the money . . . I should like you to send it to me. Then my little place here will be complete."

The coveted figure was *Oviri*, a large sculpture of a female deity clutching a whelp to her thigh; beneath her feet a full-grown wolf lies dead (figure 122). Oviri does not stand on the wolf, nor do her feet touch it; rather she half leans, half sits on a rock. The head and torso, full, fleshy, yielding, soft, rise up on short legs. The mouth is sensual and full-lipped, yet tightly closed; the eyes are round, large—probably based on a Marquesan mummified skull with mother-of-pearl eyes—and breastlike in their protuberance. A long sheaf of hair falls, flows, ripples, waves down the back of the idol, mingling with the blood at her feet.

In 1895 Gauguin had given a woodcut of Oviri to Stéphane Mallarmé; on the cardboard margin he wrote the inscription "To Stéphane Mallarmé: this strange figure . . . cruel enigma." Earlier that year Mallarmé had published "The Tomb of Charles Baudelaire," perhaps creating a connection between the Oviri and death in Gauguin's mind. The connection, however tenuous its first appearance, had grown to a conviction when, two years later, Gauguin referred to the figure in a letter to the art dealer Vollard as "la Tueuse" (The Killer).

The murderous nature of the Oviri goddess was duly noted by Pierre Loti, who called her "a savage cannibal." Gauguin's portrayal illuminates the method of her murderousness: his savage cannibal ingests the victim into the female cycle, draws it in to die a slow death in her flesh. Her devouring is doubly deadly for being maternal in nature: she is a savage mother, and cannibalism is her duty and her function. The strange, cruel enigma of her being is that she kills what she nurtures. Her human counterpart in *Be in Love, You Will Be Happy* grasps the hand of the infant-savage as Oviri clasps the body of the infant-wolf, held to the thigh over which the flower is bowed.

The savage mother has killed the wolf, cut down its manhood, so that she might possess the whelp, tame it, and make of it a creature formed in her image. She gives it harbor in her flesh; in return, when it

emerges grown into the world it carries her mark. Gauguin has added a neat twist to the most poignant of nineteenth-century tales: the human infant abandoned in the wilderness, adopted and suckled by a she-wolf. The power of ancient Rome was generated from just such a source— Romulus and Remus, suckled by a she-wolf who nourished them with strong milk, made them powerful, worthy to start a new civilization.

Gauguin's identification with the wolf was one of his proudest attributes. He wrote to de Monfried of Degas's explanation of him: "Degas recounted La Fontaine's fable: the dog and the wolf. Gauguin is the wolf, he said. . . . And the amusing thing about it is the fact that the sheep started to follow the wolf, though the fat dogs went on barking, never getting free from their collars."

The wolf had followers because he was lean, savage, powerful; success, the constraining collar of civilization, had not spoiled him. Gauguin's image of himself as powerful and potent was drawn from the mysterious abyss of his savage birth. He drew his strength from the savagery of his mother—an essential fantasy for a fatherless boy. His own father, early destroyed, early unmanned, left him to the ministrations of a mother-killer, killer-mother, who protected and nourished him. His manhood was forged in her image, his fatal womanhood also, and to her he owed his tainted savagery.

A drawing of Oviri, made in 1899, was accompanied by this inscription: "And the monster, clasping her creature, fecund with the seed of generous thighs for engendering Seraphitus-Seraphita." The reference was to Balzac's novel *Seraphita*, which eulogized the heavenly condition of androgynehood: "The Lord took the beauty and grace of man's life and infused them into woman. When man is disunited from this beauty and elegance of life, he is austere, sad, or savage; when he is reunited to them, he is happy, he is complete." In the androgyne state the father is united with the mother, and the mother with her son. Gauguin's dual sexual nature—this perfect union of languishing Christ with virile savage—was the product of generous maternal thighs: the son's perfection was born of the mother's fall. In *Delicious Waters* of 1898 (figure 138) the fallen Eve clasps a white cloth to her thigh, her new arena of shame; behind her an old woman grasps the arm of a young boy, dragging him along the path to divert him from the potent and perilous vision of Eve. The figures in the painting have all been transplanted from *Where Do*

We Come From?; perhaps the boy is being hurried away before he discovers the fatal answer to that question.

The *Oviri* would surmount Gauguin's grave, rising up from it to give birth to his death, sealing his savagery. He had chosen her to stand as his summation, his statement about himself. If he had his way his monument would read "Oviri—Savage." He would claim the promises of his mother's blood, which had tempted and taunted and ultimately eluded him in his life. Building upon the fragile substance of his Peruvian ancestry, he had created a new savage world, lush in images and dreams and ripe visions waiting to be divested of symbolic fruit. He had made a world over which he reigned as a creator-god; yet he never succeeded in remaking himself into a true savage. In seeking to live out his Peruvian birthright, he was pursuing a grail-like goal: if he were to find it, he would be saved, recovered, rediscovered. His tragedy was that he could not make a fresh start as a newborn creature, savage in innocence and by instinct, initiated at birth into the eternal verities in which reside the eternal mysteries. His mother's blood was his goal, but his patriarchal heritage was his daily burden: his true birthright. France, not Peru, was the fulcrum which propelled his grand rebellion. Ultimately, *he was a savage in relation to the life he left.*

Strolling on his property one evening Gauguin was assaulted by an apparition—an old woman, blind, naked, and mummy-like, a true dark spirit. She paused, and extended her hand, cold as a reptile, to touch him—his face, arms, body, and, underneath his loincloth, the source of his savagery, his private monogram . . . from which she withdrew in disgust. The natives were circumcised; Gauguin was not. In her blindness she had seen Gauguin for what he truly was. Long after she had gone her parting word hung in the air, a death sentence-turned-epitaph: feeling him, she uttered—*"European!"*

ILLUSTRATIONS

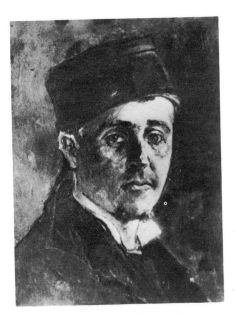

1. *Self-Portrait.* Ca. 1878. Collection unknown.

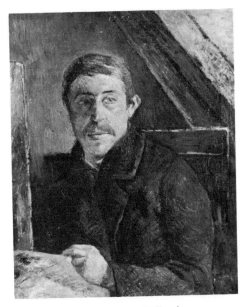

2. *Self-Portrait.* 1885. Collection Jacques Koerfer, Berne.

3. *Self-Portrait* dedicated to Charles Morice. 1894–1895. Collection Mr. and Mrs. Arthur Sachs, New York.

4. Photograph of Paul Gauguin. Ca. 1888.

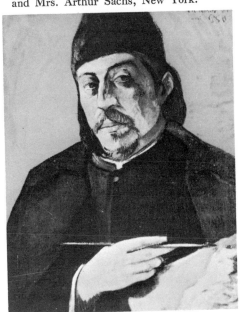

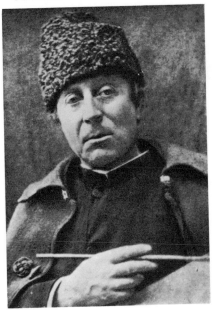

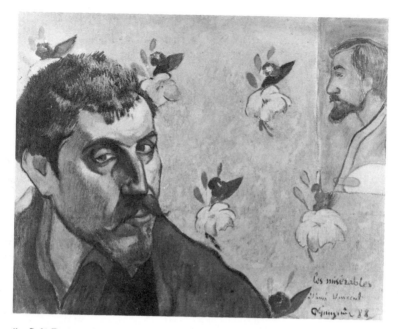

5. *Self-Portrait* inscribed "les Misérables" dedicated to Vincent van Gogh. 1888. Collection V. W. van Gogh, Laren.

6. *Agony in the Garden.* 1889. Norton Gallery and School of Art, West Palm Beach.

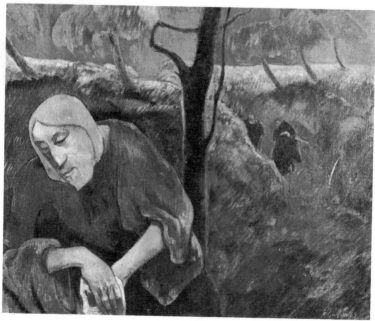

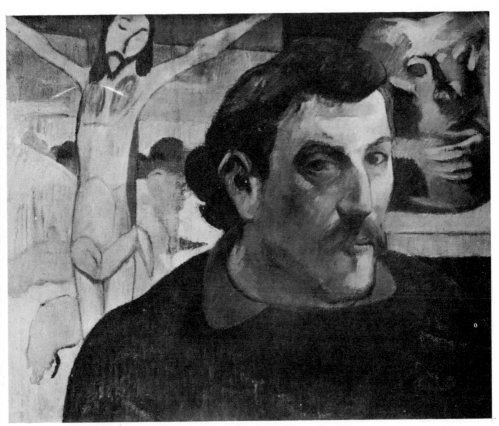

7. *Self-Portrait* with *Yellow Christ*. 1889–1890. Private collection.

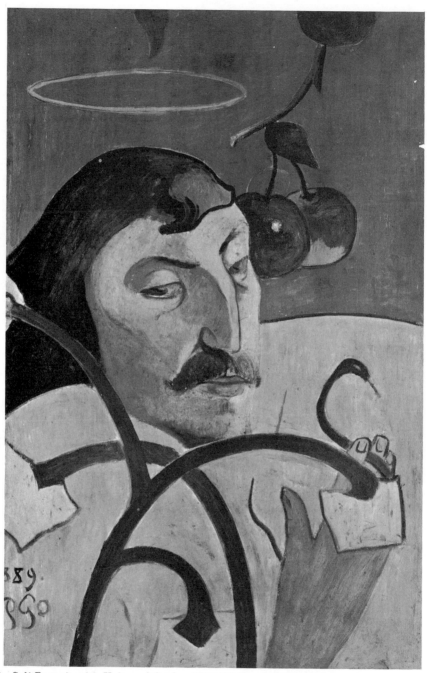

8. *Self-Portrait with Halo and Snake.* 1889. National Gallery of Art.
(Chester Dale Collection), Washington, D.C.

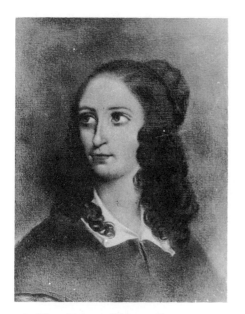

9. Flora Tristan. Lithograph.

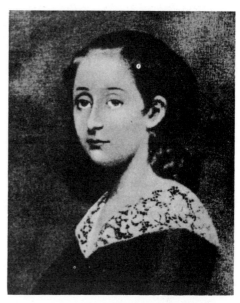

10. Photograph of Aline Chazal Gauguin.

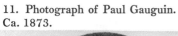
11. Photograph of Paul Gauguin. Ca. 1873.

12. Photograph of Paul and Mette Gauguin.

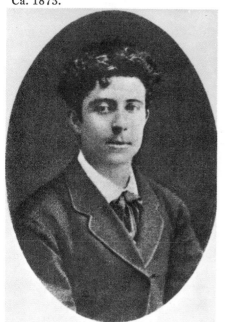

13. Marble bust of Mette Gauguin. 1877. Courtauld Institute, London.

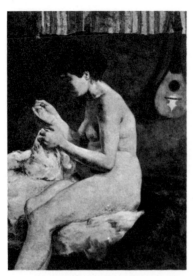

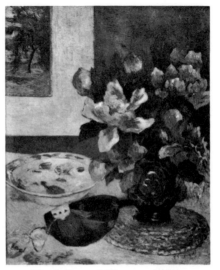

14. *Suzanne Sewing*. 1880. The Ny Carlsberg Glyptotek, Copenhagen.

15. *Mandolin and Flowers*. 1885. Louvre, Paris.

16. *Still Life with Onions and Birds*. 1885. Private collection, U.S.A.

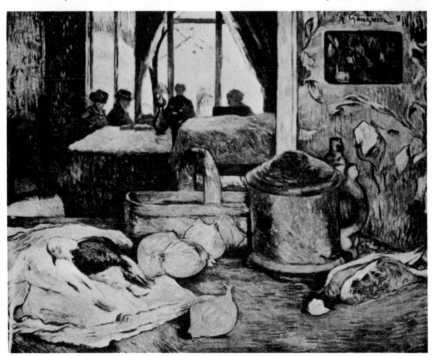

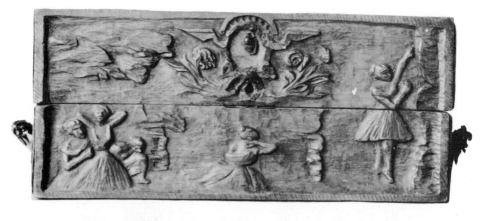

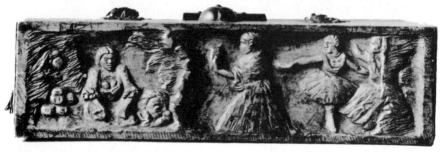

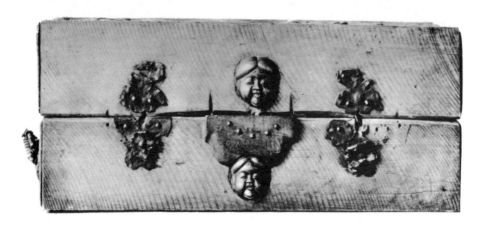

17. Carved jewel box, three views. 1884. Collection Halfdan Nobel
Roede, Oslo.

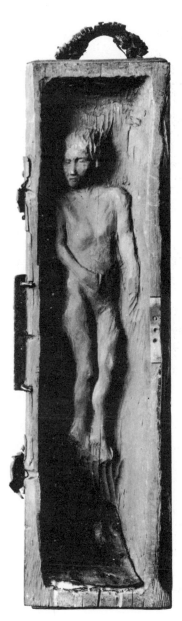

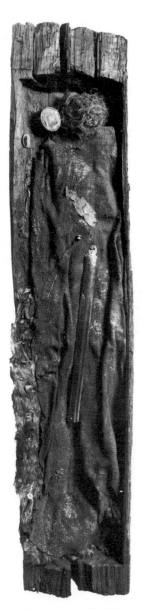

18. Interior view of figure 17.

19. Bronze Age Danish warrior's coffin. Photograph courtesy of Merete Bodelsen.

20. Photograph of the Pont-Aven, Brittany. Late nineteenth century.

21. Photograph of the Bois d'Amour near Pont-Aven. Late nineteenth century.

22. Photograph overlooking Pont-Aven. Late nineteenth century.

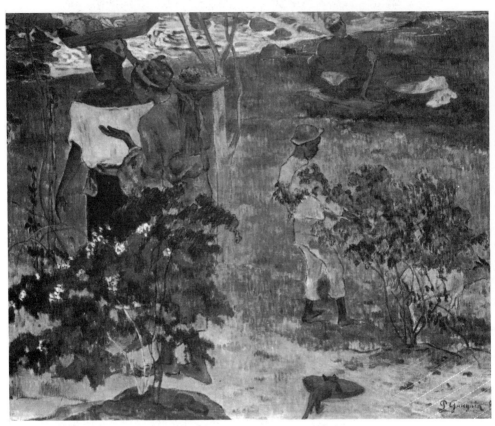

23. *Martiniquan Negresses.* 1887. Collection Mr. and Mrs. Robert E. Eisner, New York.

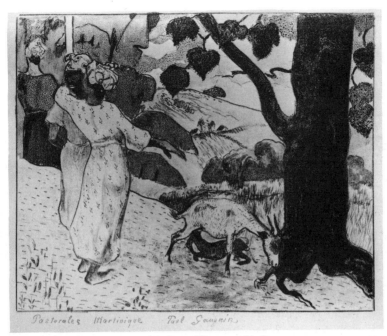

24. *Two Native Women with Goat*. Zincograph. Ca.
1889. Museum of Fine Arts, Reims.

25. *The Grasshoppers and the Ants*. Zincograph. 1889.
Art Institute of Chicago.

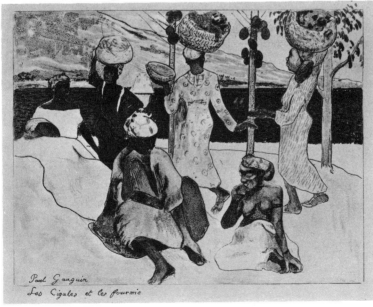

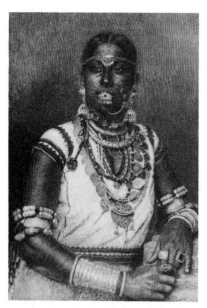

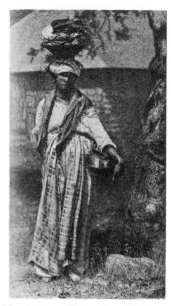

26. *Martiniquan Woman*. Engraving, after a photograph by William Lawless, 1890.

27. *Martiniquan Plantation Woman*. Engraving, after a photograph by William Lawless, 1890.

28. *Martiniquan Women*. Wood relief. 1888–1889. Present location unknown.

29. *Breton Boys Wrestling.* 1888. Private collection, Paris.

30. Puvis de Chavannes. *The Gentle Land.* 1882. Musée Bonnat, Bayonne.

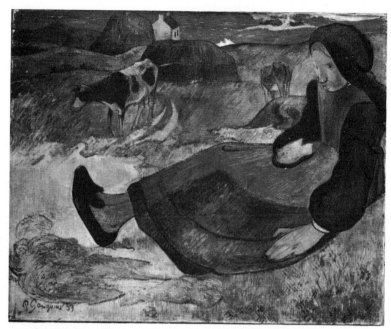

31. *Girl Tending Cows*. 1889. The Ny Carlsberg Glyptotek, Copenhagen.

32. Jean François Millet. *Bather with Geese*. Drawing. 1865.
Private collection.

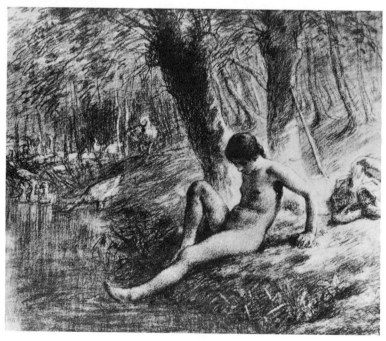

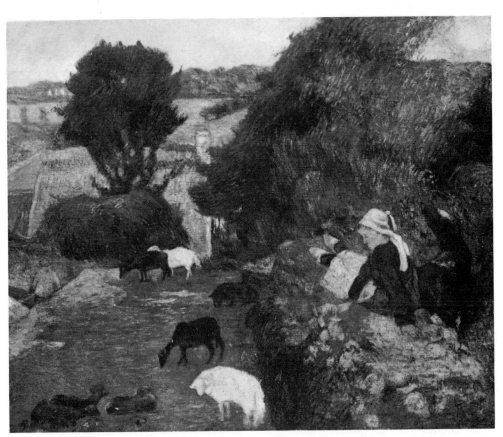

33. *Breton Shepherdess*. 1886. Laing Art Gallery, Newcastle-upon-Tyne.

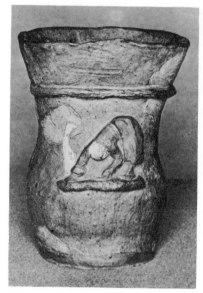

34. *Birds of a Feather Flock To-gether*, anonymous illustration from article "Au concours des animaux gras," *L'Illustration*, Paris. February 23, 1889, p. 158.

35. Stoneware vase. Ca. 1886. Collection Ari Redon, Paris.

36. *La Toilette* dedicated to Camille Pissarro. Wood relief. 1882. Private collection, Paris.

37. Stoneware jardinière. Two views. 1887. Collection Mlle Roseline Bacou, Paris.

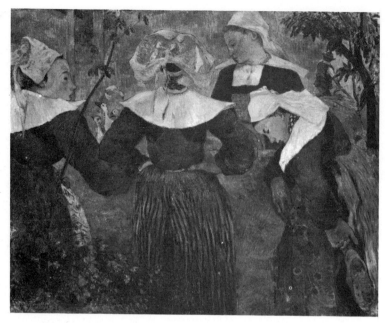

38. *Breton Girls Conversing*. 1886. Bayerische Staats-
gemäldesammlungen, Munich.

39. Edgar Degas. *Spartan Girls Provoking Boys*. 1860.
Courtesy of the Trustees, The National Gallery, London.

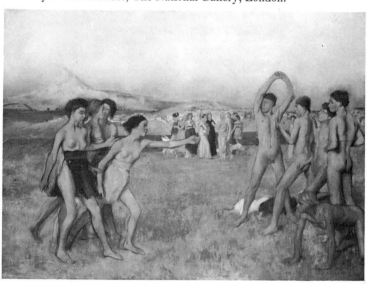

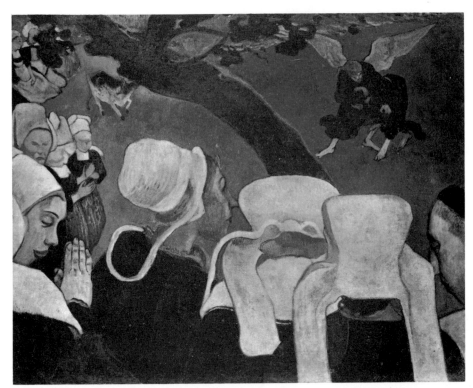

40. *Jacob Wrestling with the Angel.* 1888. National Gallery of Scotland, Edinburgh.

41. Piero di Cosimo. *Forest Fire.* 1485–1500. Ashmolean Museum, Oxford.

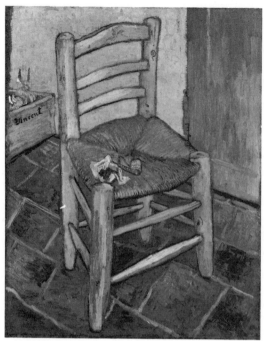

42. Vincent van Gogh. *The Day*. 1888. Tate Gallery, London.

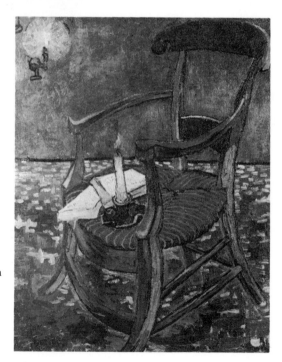

43. Vincent van Gogh. *Effect of Night*. 1888. Collection V. W. van Gogh, Laren.

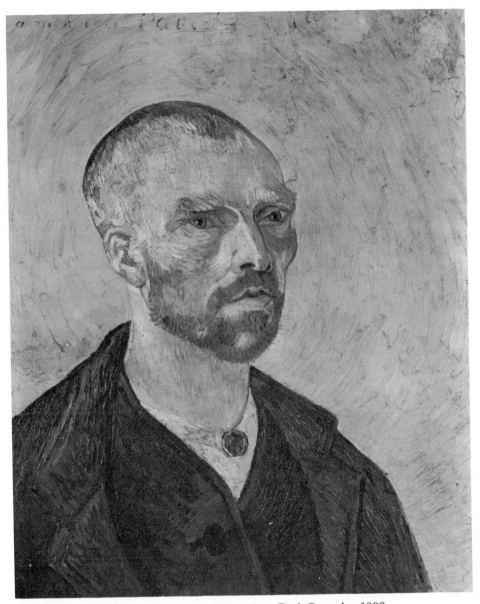

44. Vincent van Gogh. *Self-Portrait* dedicated to Paul Gauguin. 1888.
Courtesy of the Fogg Art Museum (Bequest—Collection of Maurice
Wertheim), Harvard University, Cambridge.

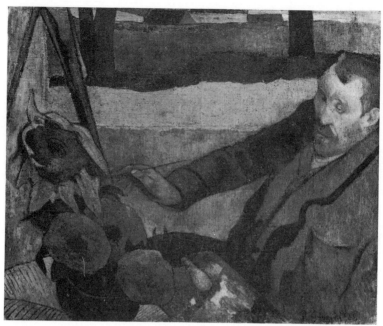

45. *Van Gogh Painting Sunflowers.* 1888. Collection V. W. van Gogh, Laren.

46. *Women of Arles.* 1888. Art Institute of Chicago (Mr. and Mrs. L. L. Coburn Memorial Collection).

47. Vincent van Gogh. *Souvenir of the Garden at Etten*. 1888. The Hermitage, Leningrad.

48. Vincent van Gogh. *The Red Vineyard*. 1888. Pushkin Museum of Fine Arts, Moscow.

49. *Vintage at Arles*. 1888. The Ordrupgaard Collection, Copenhagen.

50. *Woman against the Hay*. 1888. Collection Stavros Niarchos.

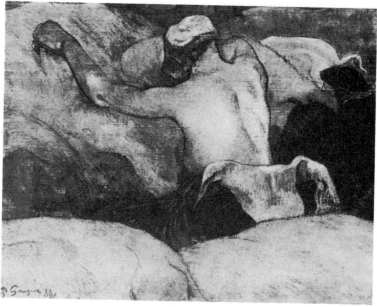

51. Jean Benner. *Girls in a Ravine near Caprile*. Salon of 1881.

52. Stoneware vase. 1887–1888. Private collection,
France.

53. *Still Life with Fruits.* 1888. Pushkin Museum of Fine Arts, Moscow.

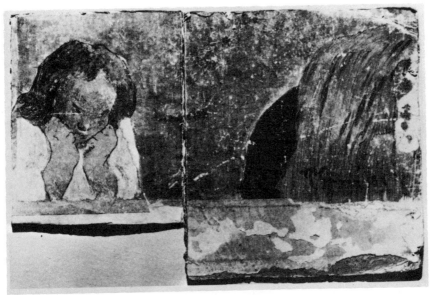

54. Study for *Vintage at Arles*. Watercolor. 1888.

55. Study for *Woman against the Hay*. Watercolor. 1888. Stedelijk-museum (Collection Théo van Gogh), Amsterdam.

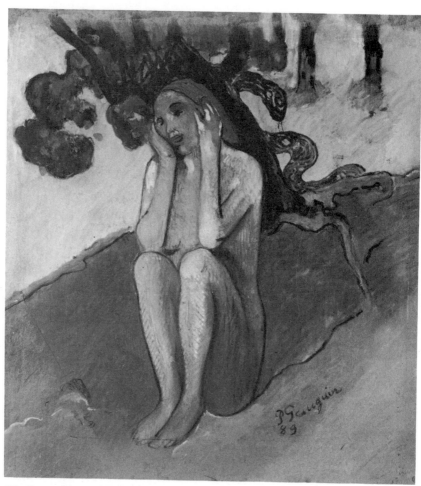

56. *Breton Eve*. Pastel and watercolor. 1889. Collection Marion Koogler McNay Art Institute, San Antonio.

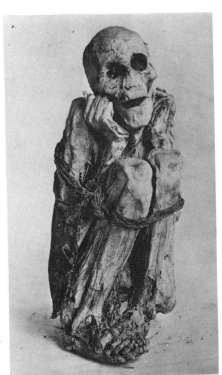

57. Peruvian mummy.
Musée de l'Homme, Paris.

58. *At the Black Rocks*. Woodcut. 1889. Art Institute of Chicago
(Clarence Buckingham Collection).

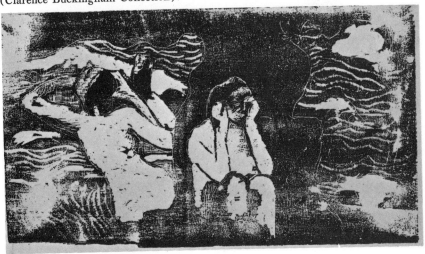

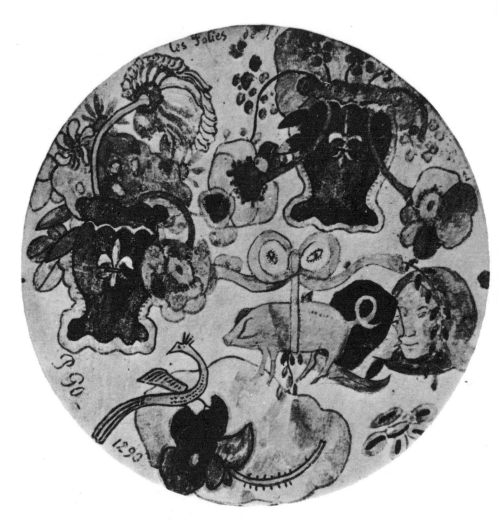

59. *The Follies of Love.* Watercolor. 1890. Collection J. K. Thannhauser, New York.

60. L. Deschamps. *La Songeuse.* Salon of 1880. (From an engraving.)

61. Émile Bernard. *Breton Women Feeding Pigs.* Zincograph. 1889. Kunsthalle Museum, Mannheim.

62. Photograph of crucifixion in the Trémalo chapel near Pont-Aven.

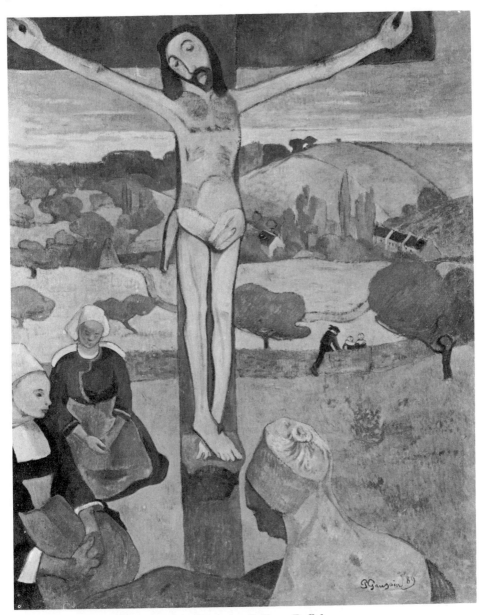

63. *Yellow Christ*. 1889. Albright-Knox Art Gallery, Buffalo.

64. Breton calvary at Nizon near Pont-Aven. Two views.

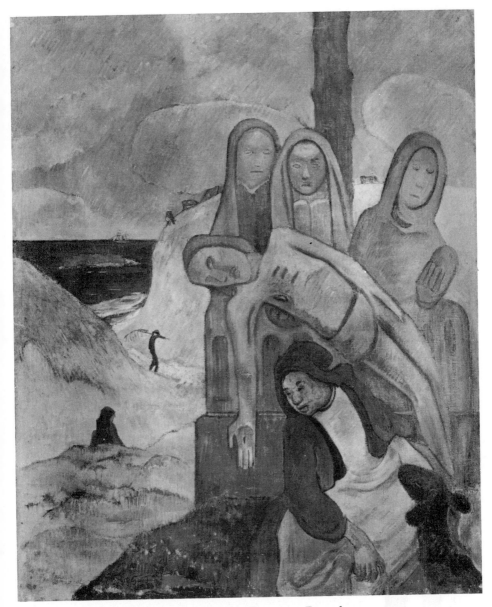

65. *Green Calvary.* 1889. Royal Museum of Fine Arts, Brussels.

66. Vincent van Gogh. Sketch of Émile Bernard's *Madeleine in the Bois d'Amour*. 1889. Courtesy V. W. van Gogh, Laren.

67. Sculpture of the Virgin Mary in the cathedral at Chartres.

68. Émile Bernard. *Madeleine in the Bois d'Amour*. 1888. Collection Clement Altarriba, Paris.

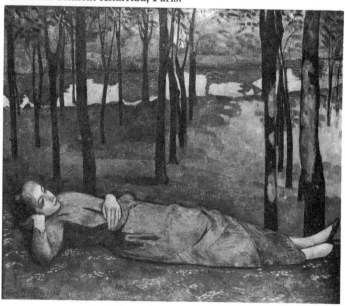

) 304 (

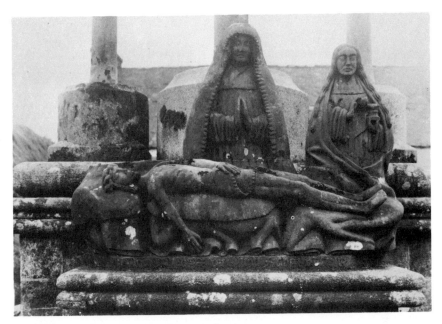

69. Typical sixteenth-century Breton calvary.

70. Émile Bernard. *Christ Taken from the Cross*. 1890. Collection
Clement Altarriba, Paris.

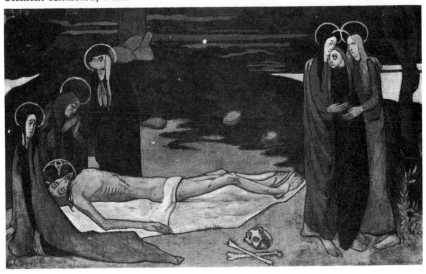

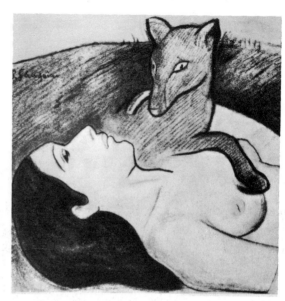

71. Sketch for *The Loss of Virginity*. 1890. Collection Mr. and Mrs. Leigh B. Block, Chicago.

72. Puvis de Chavannes. *Hope*. 1872. Louvre, Paris.

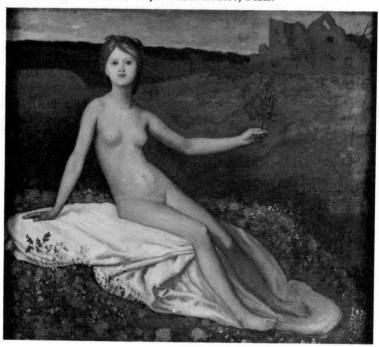

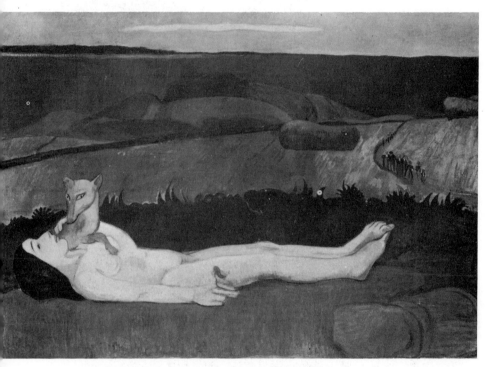

3. *The Loss of Virginity*. 1890. Collection Walter P. Chrysler, Jr.

74. Photograph of a cross in a Breton field.

75. Photograph of altar setting, St. Martin's at Boucherville.

76. Reynard the Fox preaching to geese. Capital from a church in Brittany. Sixteenth century.

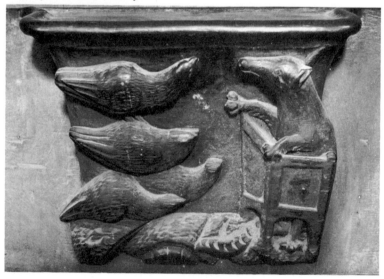

77. Breton family scene. Late-nine-teenth-century lithograph.

78. Charles Le Brun. *Fox Men.*

79. Jacob Meyer de Haan. *Self-Portrait.* 1889. Collection D. Denis, St. Germain-en-laye.

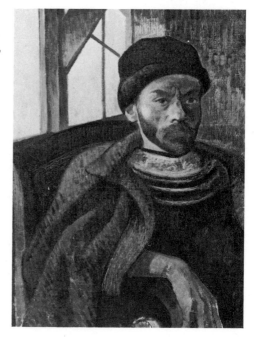

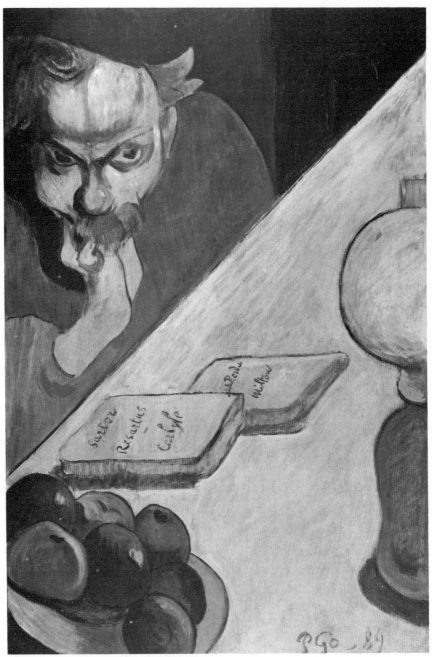

80. *Still Life: Portrait of Jacob Meyer de Haan.* 1889. Private collection, New York.

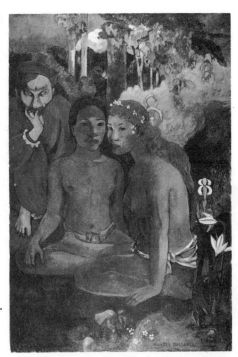

81. *Barbaric Tales.* 1902.
Folkwang Museum, Essen.

82. *Nirvana: Portrait of Jacob Meyer de Haan.* 1889. Gouache.
Wadsworth Atheneum (Ella Gallup Summer and Mary Catlin Summer
Collection), Hartford.

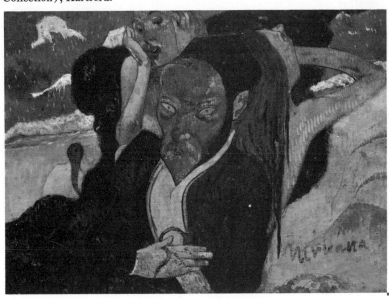

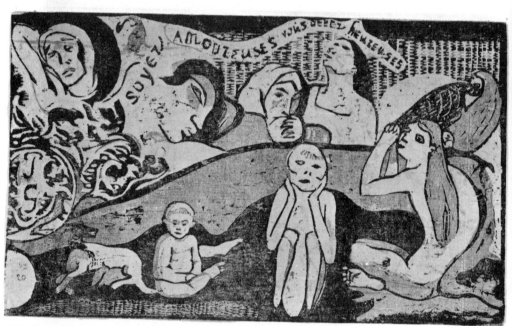

83. *Be in Love, You Will Be Happy.* Woodcut. 1897. Art Institute of Chicago.

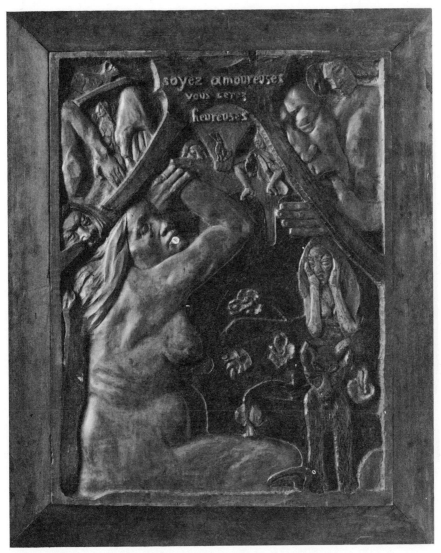

34. *Be in Love, You Will Be Happy.* Wood relief. 1889. Courtesy
Museum of Fine Arts, Boston (Arthur Tracy Cabot Fund).

85. Eugène Delacroix. *Barque of Dante*. 1822. Louvre, Paris.

86. Eugène Delacroix. *Wreck of Don Juan*. 1840. Louvre, Paris.

87. *Undine*. 1889. Collection Mr.
and Mrs. William Powell Jones,
Gates Mills, Ohio.

88. *Be Mysterious*. Wood relief. 1890. Collection M d'Andoque, Béziers.

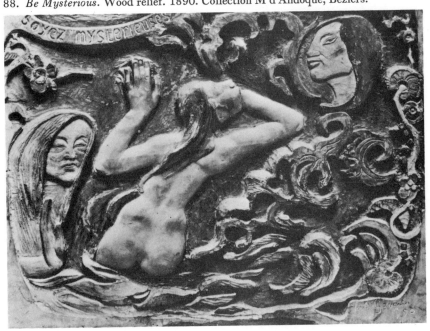

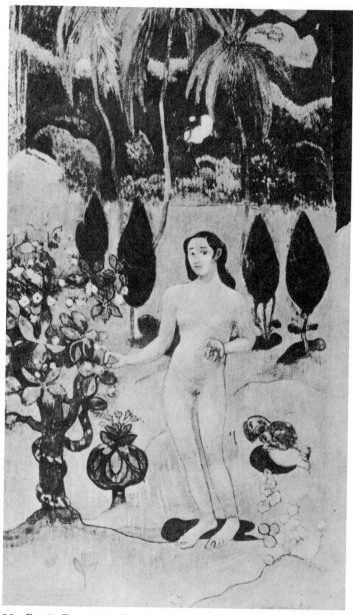

89. *Exotic Eve.* 1890. Private collection, Paris.

90. Relief from the Javanese temple at Barabudur.

91. Photograph of Aline Chazal Gauguin.

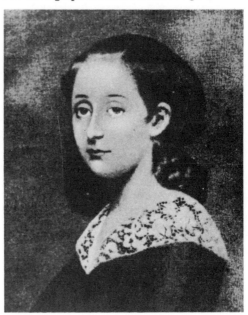

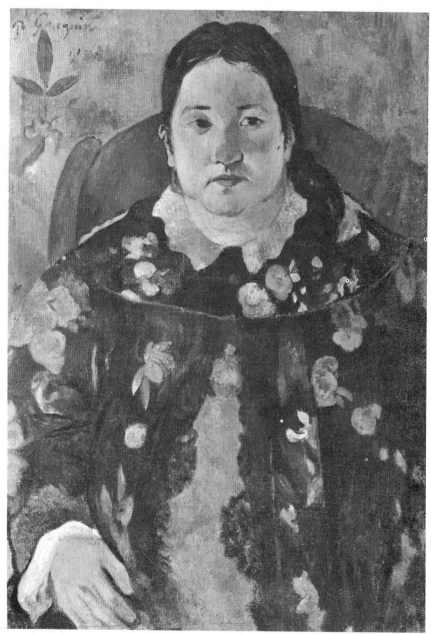

92. *Suzanne Bambridge*. 1891. Royal Museum of Fine Arts, Brussels.

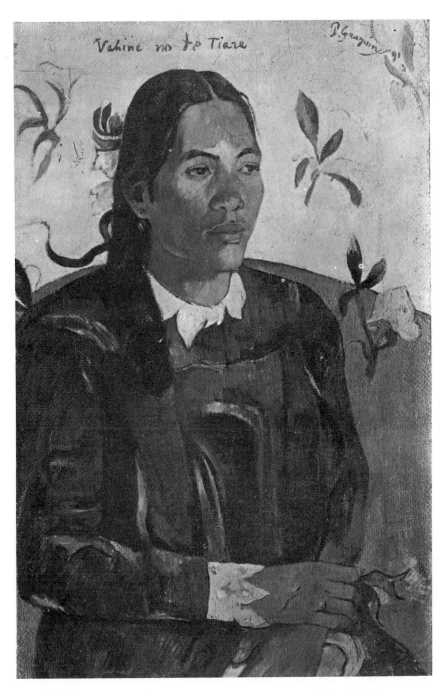

93. *The Woman with the Flower* inscribed "Vahine no te Tiare." 1891.
The Ny Carlsberg Glyptotek, Copenhagen.

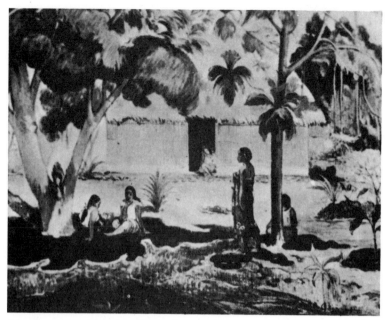

94. *The Great Tree* inscribed "Te raau rahi." 1891. Carnegie Institute, Pittsburgh.

95. *Who Will You Marry?* inscribed "Nafea faa ipoipo." 1892. Kunstmuseum (Collection Rudolph Staechllin), Basel.

96. *Tahitian Women Fishing.* 1891. Collection M. H. Harries, Berlin-Charlottenburg.

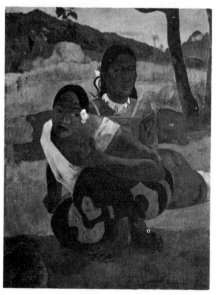

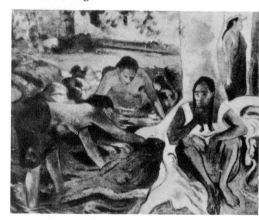

97. Photograph of Tehura(?).

98. *Portrait of Tehura* inscribed "Serahi metua no Tehamana." 1893. Collection Mrs. Chauncy McCormick, Chicago.

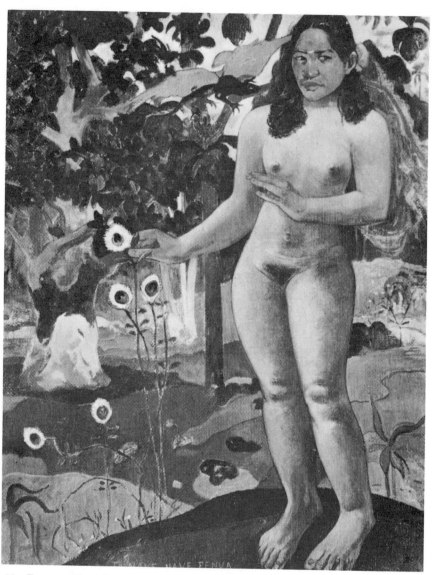

99. *Fragrant Earth* inscribed "Te Nave Nave Fenua." 1892. Ohara
Museum, Kurashike.

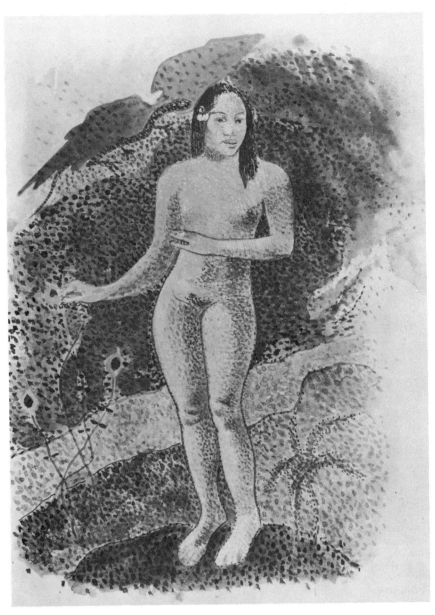

100. *Tahitian Eve*. Watercolor. 1892. Museum of Painting and Sculpture, Grenoble.

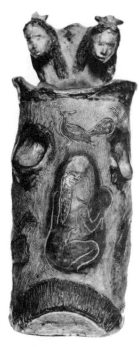

101. Stoneware jar. 1887–
1888. Musée de l'Arts Afri-
cains et Oceaniques, Paris.

103. Odilon Redon. Lithograph (illustration from
L'Origines). 1883.

102. Illustration from Noa Noa.

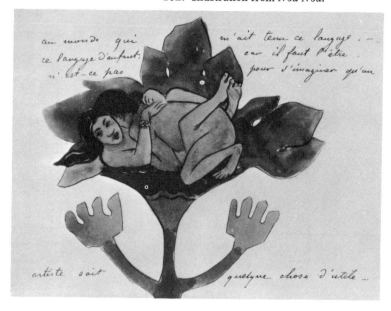

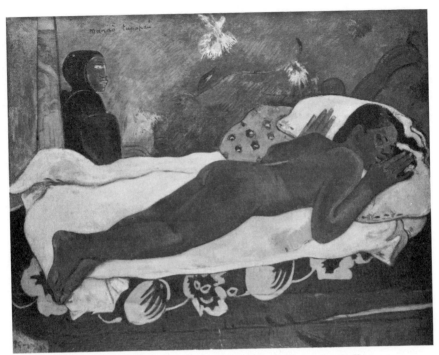

104. *The Spirit of the Dead Watches*. 1892. Albright-Knox Art Gallery
(A. Conger Goodyear Collection), Buffalo.

105. *Nevermore*. 1897. Courtauld Institute Galleries, London.

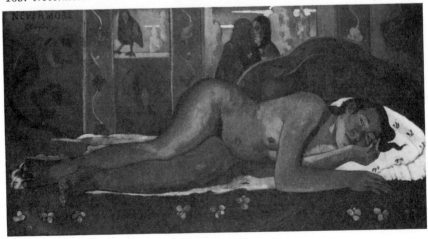

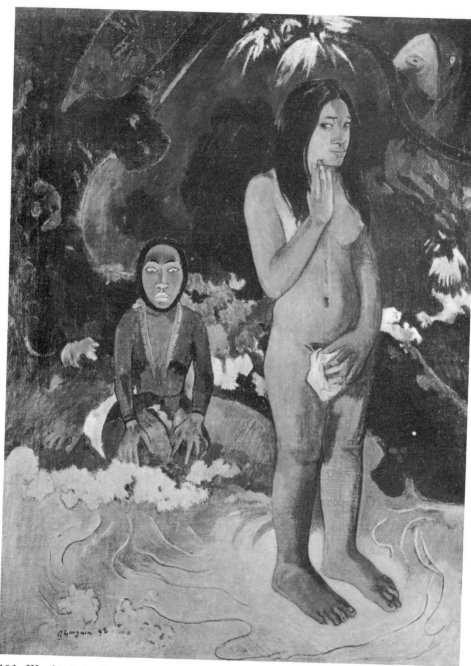

106. *Words of the Devil.* 1892. Collection Mr. and Mrs. Averell
Harriman, New York.

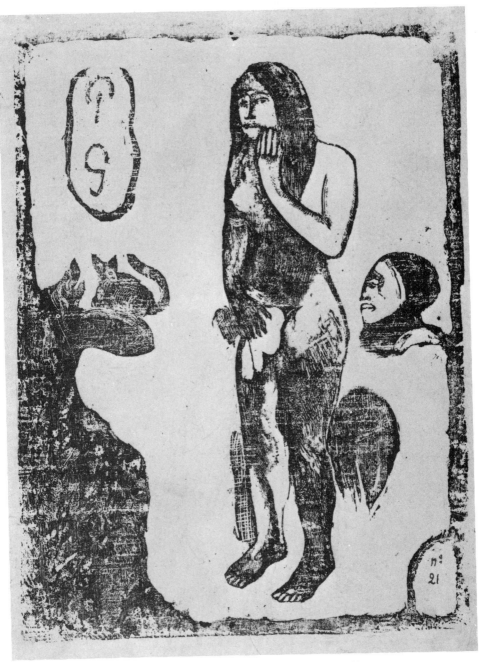

107. *Words of the Devil*. Woodcut. Ca. 1900. Art Institute of Chicago.

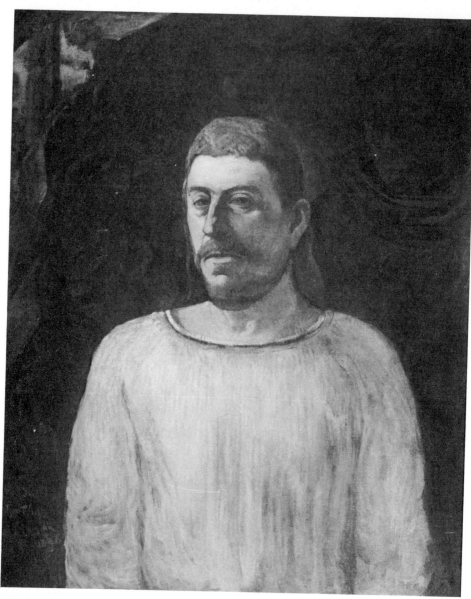

108. *Self-Portrait Nearing Golgotha.* 1896. Museum of Art, São Paulo.

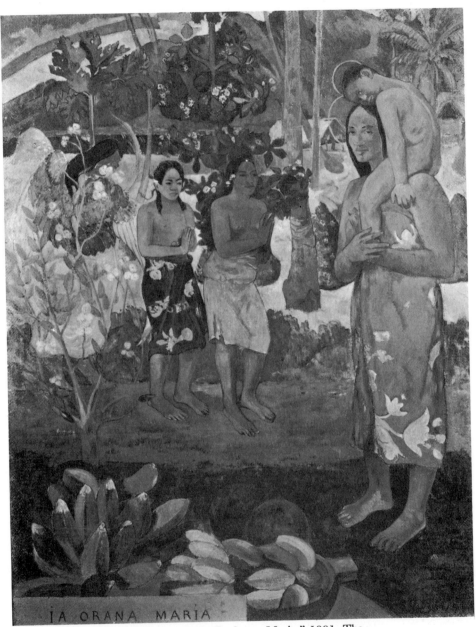

IA ORANA MARIA

109. *We Greet Thee, Mary* inscribed "Ia Orana Maria." 1891. The Metropolitan Museum of Art, New York.

110. *Tahitian Angel.* Drawing from *Avant et Après*.

112. *Tahitian Nativity.* Monotype. 1897–1898. The City Art Museum of St. Louis.

111. *Angels for Everyone.* From *Avant et Après*.

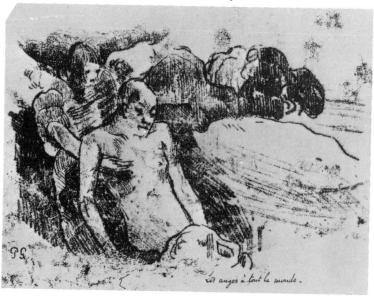

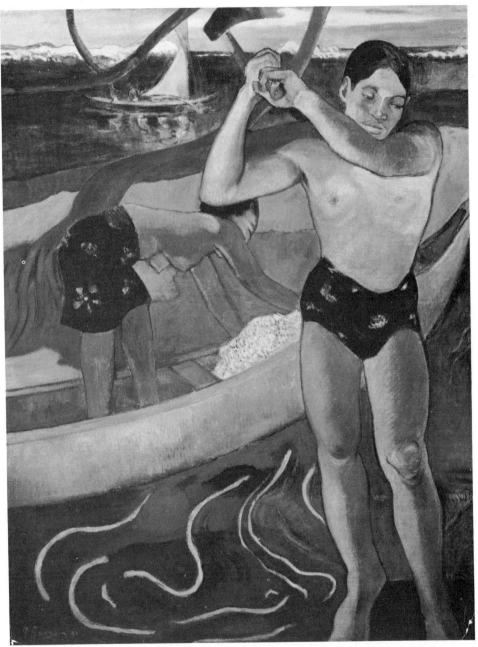

113. *Tahitian with Ax.* 1891. Collection Mr. and Mrs. Alexander Lewyt, New York.

114. *The End of Royalty* inscribed "Arii Matamoe." 1892. Private collection, Paris.

115. *Mysterious Water* inscribed "Pape Moe." 1893. Collection Mr. and Mrs. Géza Anda-Buhrle, Zurich.

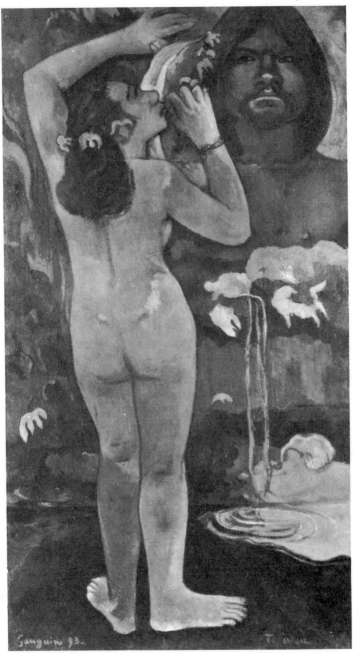

116. *The Moon and the Earth* inscribed "Hina Tefatou." 1893.
Museum of Modern Art, New York.

117. Hina and Tefatou. From *Ancien Culte Mahorie.*

118. Illustration from *Ancien Culte Mahorie.*

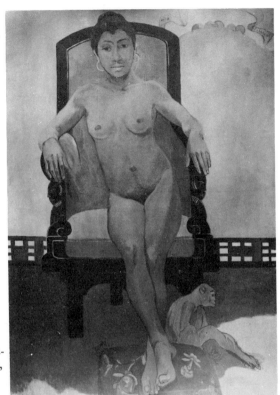

119. *Annah the Javanese* inscribed "Aita Tamari vahina Judith te Parari." 1893. Collection Professor Hans Hahnloser, Bern.

20. *Where Do We Come From? What Are We? Where Are We Going?* scribed "D'où venons-nous? Que sommes-nous? Où allons-nous?" 1897. ourtesy, Museum of Fine Arts (Arthur Gordon Tompkins Residuary und), Boston. Details, left, center, right, on following pages.

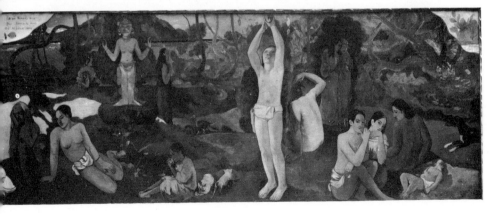

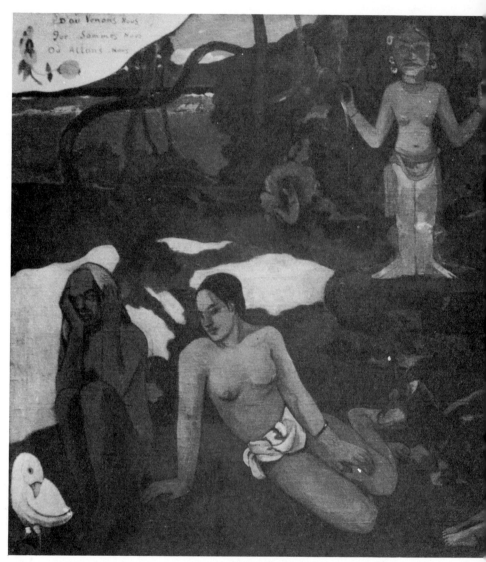

Left detail of *Where Do We Come From? What Are We? Where Are We Going?*

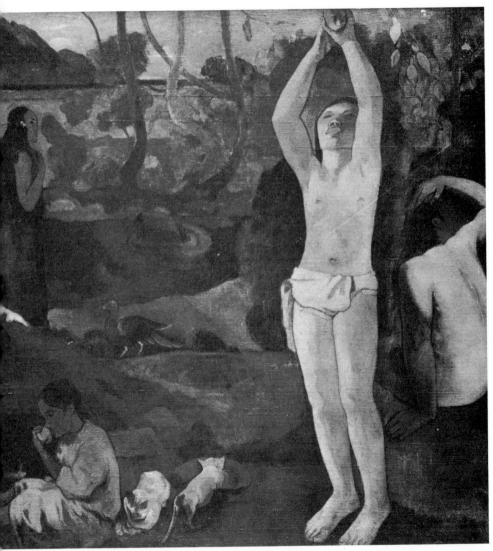

Center detail of *Where Do We Come From? What Are We? Where Are We Going?*

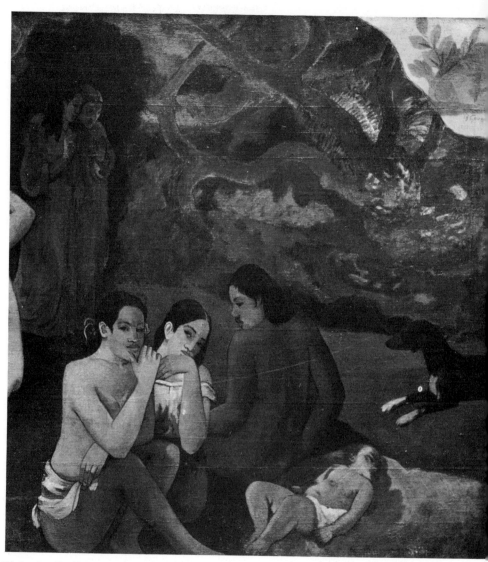

Right detail of *Where Do We Come From? What Are We? Where Are We Going?*

121. *Where Are You Going?* inscribed "Ea Haere ia oe." 1893. The Hermitage, Leningrad.

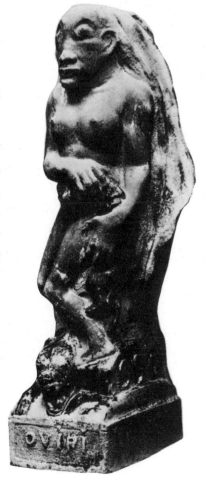

122. *Oviri.* Stoneware. Two views. 1894–1895. Private collection, Paris.

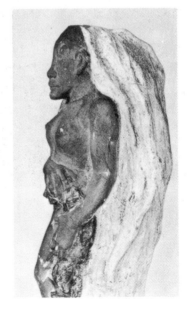

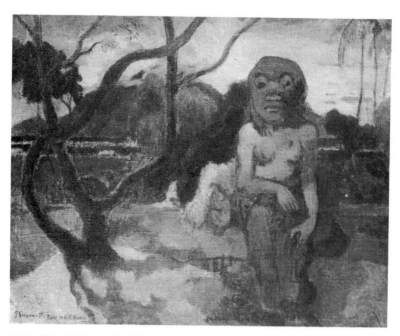

123. *The Idol* inscribed "Rave te hiti ramu." 1898. The Hermitage, Leningrad.

124. *Joseph and Potiphar's Wife*. 1896. Museum of Modern Art, São Paolo. (Photo courtesy Wildenstein & Co.)

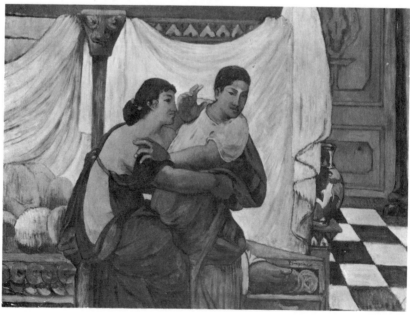

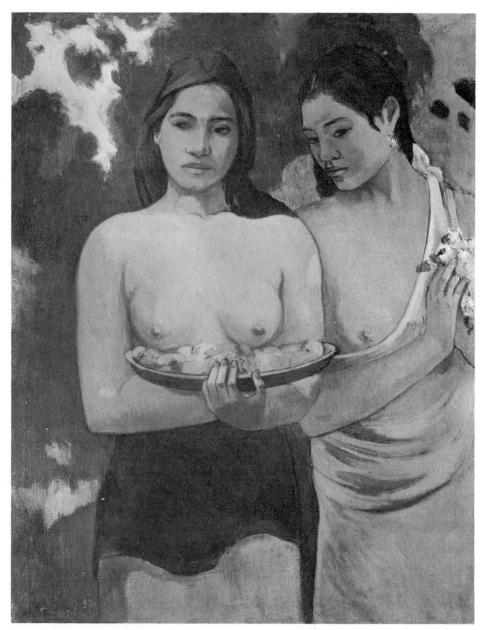

125. *Tahitian Women with Flowers.* 1899. The Metropolitan Museum of Art, New York.

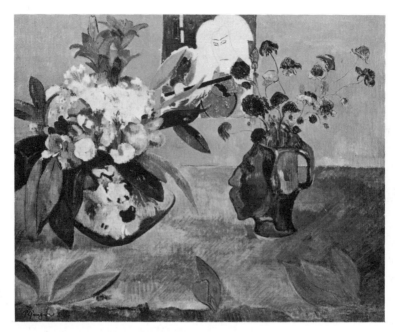

126. *Still Life with Self-Portrait Vase.* 1889. Ittleson Collection, New York.

127. *Portrait Vase of Madame Schuffenecker.* Two views. 1889. Collection Emery Reves.

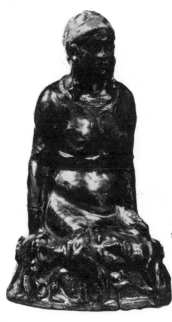

128. *Black Venus*. Stoneware. 1889. Collection Harry F. Guggenheim, New York.

129. *Adam and Eve*. 1902. The Ordrupgaard Collection, Copenhagen.

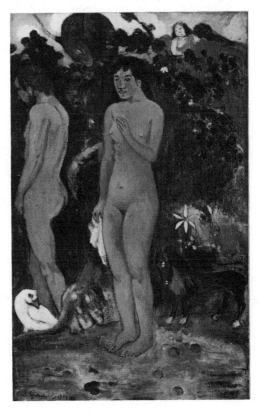

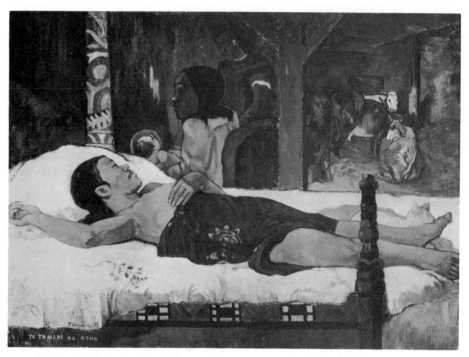

130. *Birth of Christ* inscribed "Te Tamari no atua." 1896. Bayerische Staatsgemäldesammlungen, Munich.

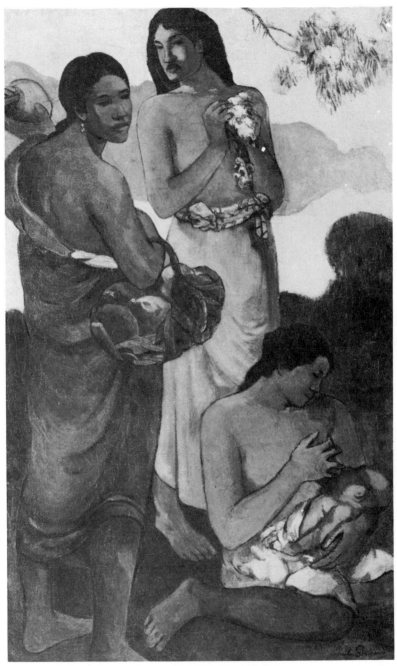

131. *Maternity.* 1899. Private collection, New York.

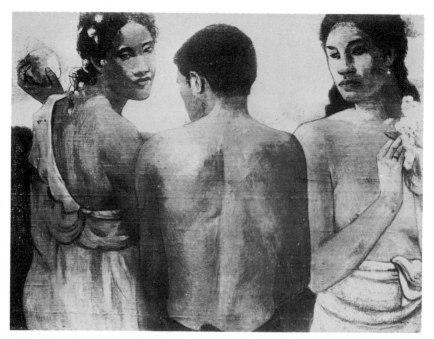

132. *Three Tahitians in Conversation.* 1897–1899. National Gallery of Scotland, Edinburgh.

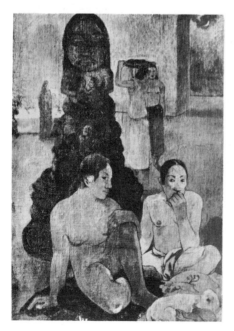

133. *The Great Buddha* (The Last Supper). Ca. 1899. Pushkin Museum of Fine Arts, Moscow.

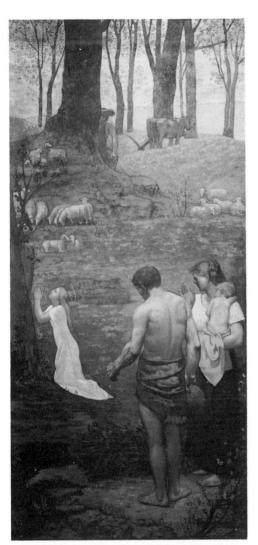

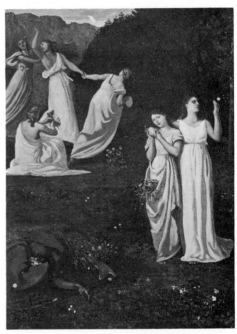

134. Puvis de Chavannes. *Sainte Geneviève at Her Prayers*. 1877. Panthéon, Paris.

135. Puvis de Chavannes. *Melancholy*. 1872.

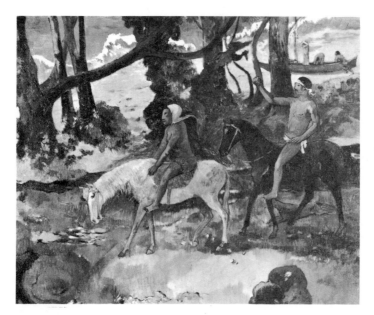

136. *Flight*. 1901. The Hermitage, Leningrad.

137. *Riders on the Beach*. 1902. Folkwang Museum, Essen.

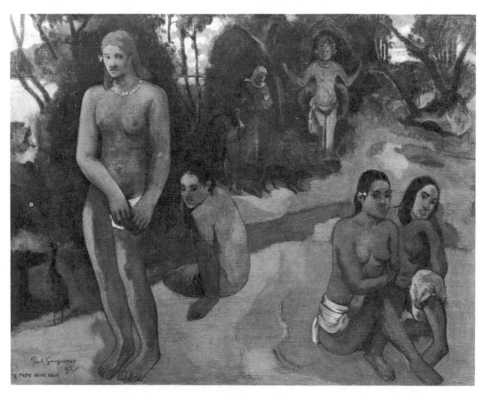

138. *Delicious Waters* inscribed "Te Pape Nave Nave." 1898. Collection Mr. and Mrs. Paul Mellon, on loan to the National Gallery of Art, Washington, D.C.

CHRONOLOGY

1848 June 7: born in Paris, of Clovis Gauguin and Aline Chazal.

1851 Family embarks for Peru; father dies en route. Spends four years in Lima with his mother and sister.

1855 Gauguin family returns to France, lives with Paul's uncle Isadore Gauguin in Orléans.

1865 Enters Maritime service; travels extensively.

1867 Death of Gauguin's mother, Aline.

1871 After discharge from navy, joins stock brokerage firm, where he meets Émile Schuffenecker.

1873 November 22: Marries Mette Sophie Gad.

1876 Landscape painting accepted in official Salon.

1879 Leaves stock brokerage firm; short period of connection with banking firm.

1880 Exhibits at the Fifth Impressionist Exhibition; joins insurance firm.

1881 April–May: Exhibits in the Sixth Impressionist Exhibition.

1883 January: Resigns from brokerage firm. June: Works with Pissarro in Osny; leaves insurance firm.

1884 January: Moves family to Rouen. November: With family, goes to Copenhagen.

1885 Acts as representative of a French tarpaulin firm in Copenhagen. May: Exhibits in Copenhagen. June: Returns to Paris with son Clovis. September: Goes to Dieppe; spends three weeks in England before returning to Paris.

1886 May: Exhibits in the Eighth Impressionist Exhibition. June: Goes to Pont-Aven, Brittany; stays at the Pension Gloanec, where in August he meets Émile Bernard. November: Returns to Paris; meets van Gogh in Montmartre.

1887 April 10: Sails for Panama with Charles Laval. June: With Laval, backtracks to Martinique. November: Returns to Paris; stays with Schuffenecker family.

1888 February: Returns to Pont-Aven; works with Bernard, Laval, and Meyer de Haan. Autumn: First one-man show at Boussod and Valadon, managed by Théo van Gogh. October 23: Joins Vincent van Gogh in Arles. December 24: Incident with van Gogh; Gauguin returns to Paris; stays with Schuffenecker family.

1889 April: Returns to Pont-Aven, works with Laval and Paul Sérusier. October: Moves to Le Pouldu, spends the winter with de Haan at Marie Henry's inn. Exhibits with *Les XX*, Brussels, and during the Paris World's Fair at the Café Volpini.

1890 January: Returns to Paris. June: Goes to Le Pouldu. November 7: Returns to Paris; stays with Schuffenecker; becomes friendly with Daniel de Monfried, and associates with the symbolist group at the Café Voltaire.

1891 February: Quarrels with Schuffenecker; moves to separate studio; exhibits at the Salon du Champ de Mars and with *Les XX*. February 22: Auction at Hôtel Drouot to raise money for Tahitian trip; breaks with Bernard. March: Visits family in Copenhagen; the symbolists give a banquet in his honor at the Café Voltaire. April 4: Embarks for Tahiti. June 8: Disembarks at Papeete.

1892 Takes native girl, Teha'amana (Tehura), as mistress. In Copenhagen, Mette gathers paintings for a show.

1893 Writes *Cahier pour Aline* and *Ancien Culte Mahorie*. June 14: Sails for France. August 30: Disembarks at Marseilles. Begins

writing *Noa Noa* with Charles Morice as collaborator. Novem-4: Exhibits Tahitian paintings at Durand-Ruel.

1894 January: Visits Bruges. May: Goes to Pont-Aven and Le Pouldu; at Concarneau breaks his leg in a brawl. December: Returns to Paris.

1895 February 18: Second auction of paintings at the Hôtel Drouot. July 3: Embarks for Tahiti. September 8: Arrives in Tahiti. Builds house in Punaauia.

1897 April: Learns of his daughter Aline's death. Begins writing *Esprit Moderne et Le Catholicisme*. August: Breaks off correspondence with his wife. October: First Publication of *Noa Noa* in *La Revue*.

1898 January: Attempts suicide. April: Takes drafting job in Papeete; moves to Paofai.

1899 August 21: Publishes first issue of monthly periodical *Le Sourire*.

1900 January: Made editor of monthly newspaper *Les Guêpes*.

1901 September 16: Sails to Atuona in the Marquesas Islands, where he builds a hut.

1902 Period of conflict with church and colonial authorities. Begins writing *Avant et Après* (Journals).

1903 March 31: Sentenced to three months' imprisonment for making libelous statements against public officials; plans an appeal. May 8: Dies in Atuona.

REFERENCE NOTES

I have not cited sources for all passages from Gauguin's well-known manuscripts and letters. Scholars will easily locate the quotations, and the general reader should be encouraged to read the source material in its entirety; most of Gauguin's writings are readily available in translation. Nor have I cited those historical or biographical facts and incidents which, having been told and retold, are now in the public domain.

I. HALO AND SNAKE

1. Charles Morice, *La littérature de tout à l'heure*, Paris, 1889, p 367. Cited by H. R. Rookmaaker, *Synthetist Art Theories*, Amsterdam, 1959, p. 225, in an important chapter on synthetist terms and concepts.
2. My discussion of Gauguin's self-portraits has benefited from Ruth Rothchild, *A Study in the Problems of Self-Portraiture: The Self-Portraits of Paul Gauguin.* Unpublished Ph.D. dissertation, Columbia University, New York, 1961.
3. Reported by Charles Morice, *Paul Gauguin*, Paris, 1919, p. 28.

II. EXOTIC ANTECEDENTS

1. Cited in Henri Perruchot, *Gauguin*, tr. Humphrey Hare, Cleveland, 1963, pp. 33f.
2. *Ibid.*, p. 35.

3. Ursula Marks-Vandenbroucke, "Gauguin, ses origines et sa formation artistique," *Gazette des Beaux-Arts*, 6, XLVII, January–April 1956, p. 34.
4. Perruchot, *op. cit.*, p. 50.
5. The claim has been made that Gauguin's ship *Chili* visited Tahiti in 1867, but this has been refuted by Bengt Danielsson, *Gauguin in the South Seas*, New York, 1966, p. 295, note 9. Cf. Perruchot, p. 54.
6. Emil Gauguin in the preface to *The Intimate Journals of Paul Gauguin*, London, 1923, p. vii.
7. As said by Octave Mirbeau in *Mirbeau, Duret, Werth, Jourdain, Cézanne*, Paris, 1914, p. 9.
8. Emil Gauguin, *op. cit.*, p. viii.

III. IMMUNIZATION

1. J.-K. Huysmans in *L'Art Moderne*, Paris, 1880, p.262. Cited in Georges Wildenstein, *Gauguin*, I, Paris, 1964, p. 19.
2. My thanks to Mark Roskill for opening my mind to this painting.
3. The association of Gauguin's carved box with a Bronze Age coffin was made by Merete Bodelsen, "Paul Gauguin som Kunsthandvaerker," *Kunst og Kultur*, 47, 1964, pp. 141–156. Mrs. Bodelsen believes, I think correctly, that Gauguin carved the box while in Copenhagen. (I am obliged to Mrs. Bodelsen for the photograph of the warrior coffin). For other information on this see Christopher Gray, *Sculpture and Ceramics of Paul Gauguin*, Baltimore, 1963, pp. 4–5 and Cat. No. 8.

IV. TERRESTRIAL IMPERATIVES

1. Neheamiah Whist, *Picturesque Brittany*, London, 1877, p. 186.
2. *Ibid.*, p. 221.
3. Alexander Nicolai, *En Bretagne*, 1893, p. 282. See also Paul Gruyer, *Les Calvaires Bretons*, Pardis, 1920, p. 61; Anatole le Berg, *Légende de la Mort*, Paris, 1892; *idem.*, *The Land of the Pardons*, tr. Frances Gostling, New York, 1927.
4. Henry Blackburn, *Breton Folks*, London, 1880, p. 132.
5. *Ibid.*, p. 122.
6. *Ibid.*, p. 59.
7. *Ibid.*, p. 147.
8. *Ibid.*, p. 140.
9. *Ibid.*, p. 128.
10. Dorothy Menpes, *Brittany*, London, 1905, p. 141.

11. *Ibid.*, pp. 138ff.
12. A. S. Hartrick, *A Painter's Pilgrimage through Fifty Years*, London, 1939, p. 30.
13. *Ibid.*, p. 42.
14. Letter of August 19, 1886, in *Paul Gauguin, Lettres de Gauguin à sa femme et ses amis*, ed. Maurice Malingue, Paris, 1946, p. 94, footnote.
15. Charles Mismer, *Souvenirs de la Martinique et du Mexique*, Paris, 1890. Later in *Noa Noa* Gauguin writes that his Tahitian mistress Tehura had learned this fable in the missionary school.
16. Charles Chassé, *Gauguin et la groupe de Pont-Aven*, Paris, 1921, p. 46. In my opinion a second relief carving based on the same lithograph (Christopher Gray, *Sculpture and Ceramics of Paul Gauguin*, Baltimore, 1963, Cat. No. 72) is not in Gauguin's hand.
17. Felix Fénéon, "Calendrier décembre," *La Revue indépendante*, VI, No. 15, January 1888, p. 170.

V. DECIDUOUS PARADISE

1. My thanks to Colles Baxter, participating in my seminar at Yale, for this reference.
2. Pierre Dupont, *Chants et Chansons*, Paris, 1852, Vol. 2, p. 1. I am grateful to Colles Baxter for this reference.
3. Jerry Leshko, a participant in my seminar at Columbia, made this discovery. I leave the problem of proving the accessibility of di Cosimo's painting to him, as he is currently expanding on this fascinating connection.

VI. VOLCANICS

1. All quotations from van Gogh's letters are from *The Complete Letters of Vincent van Gogh*, Greenwich, 1958.
 N.B. Mark Roskill's excellent book *Van Gogh, Gauguin and the Impressionist Circle*, New York, 1970, appeared too late for my use in this and the following chapter.

VIII. AT THE BLACK ROCKS

1. My account of these events follows John Rewald's in *Post-Impressionism*, New York, 1962, pp. 278–282.
2. Quoted by Danielsson, p. 161, from the unpublished memoirs of Judith Gérard.

3. See Wayne Andersen, "Gauguin and a Peruvian Mummy," *Burlington Magazine*, CIX, April 1970, pp. 238–242. Further on this see Richard Field, "Gauguin's Woodcuts," in *Gauguin and Exotic Art*, Philadelphia Museum of Art, 1970.

IX. THE CALVARY OF THE MAIDEN

1. In *Émile Bernard, 1868–1941*. Catalogue of the exhibition at Lille, Palais des Beaux-Arts, 1967, p. 8.
2. Stated in a letter from van Gogh to Bernard in *Vincent van Gogh: Letters to Émile Bernard*, ed., trans., Douglas Lord, New York, 1938, p. 96.
3. *Ibid.*
4. See Wayne Andersen, "Gauguin's Motifs at Le Pouldu," *The Burlington Magazine*, September 1970, pp. 615–620.
5. For the history of this motif see Mario Praz, *The Romantic Agony*, London, 1937, Ch. III.
6. Paul Sébillot, *Le Folk-lore de France*, Vol. III, Paris, 1906; Hans Bächtold-Staubli, *Handwörterbuch des deutschen Aberglaubens*, Berlin, 1930, col. 175–193; Kenneth Varty, *Reynard the Fox*, New York, 1967.
7. Bächtold-Staubli, *op. cit.*, col. 185; Sir James Frazer, *The Golden Bough*, Vol. I, New York, 1960, pp. 519, 537.
8. Édouard Shuré, *Les grands initiés*, Paris, 1889.
9. See H. R. Rookmaaker, *Synthetist Art Theories*, Amsterdam, 1959, pp. 39–42.
10. See Denys Sutton, "The Paul Gauguin Exhibition," *The Burlington Magazine*, 91 (October 1949), pp. 283–286; and additional comments in The Tate Gallery, *Gauguin and the Pont-Aven Group*, London, 1966, p. 12.
11. Thomas Carlyle, *Sartor Resartus: The Life and Opinions of Herr Teufelsdröckl*, 3rd ed., Chicago, 1905, p. 19. For this reference I am indebted to Barbara Landy, *Paul Gauguin: Symbols and Themes in His Pre-Tahitian Works*, unpublished Masters thesis, Columbia University, New York, 1968, p. 107, note 39.
12. Landy, *op. cit.*, p. 109.
13. Paul Sébillot, *Traditions et Superstitions*, I, p. 178.
14. Paul-Émile Colin in a letter to Charles Chassé quoted in *Gauguin et le groupe de Pont-Aven*, p. 52.

X . THE CALVARY OF EVE

1. For these observations I am partly indebted to two students in my seminars, Carl Chiarenza at Harvard and Bradford Collins at Yale. Delacroix's *Barque of Dante* was readily available in photographs and commercial lithographs. Concerning Gauguin's interest in Delacroix, see his letter to Schuffenecker of May 1885 requesting a photo of Delacroix's *Wreck of Don Juan.*
2. Excerpts quoted in *L'Art Moderne*, March 29, 1891; cited and translated by Rewald, *op. cit.*, p. 463.
3. *Ibid.*
4. Albert Aurier, "Le Symbolism en peinture: Paul Gauguin," *Mercure de France*, March 1891, p. 165.
5. J. E. Cirlot, *A Dictionary of Symbols*, New York, 1962, p. 345.
6. I am obliged to Carl Chiarenza for these references.
7. Heinrich Zimmer, *Myths and Symbols in Indian Art and Civilization*, ed. Joseph Campbell, New York, 1946, p. 34.
8. *Ibid.*, pp. 76, 202.
9. *Ibid.*, p. 204.
10. Henri Dorra, "The First Eves in Gauguin's Eden," *Gazette des Beaux-Arts*, 6, Vol. 41, March 1953, p. 196. Dorra associates the pose with a different Javanese frieze: compare his Fig. 7 with my Fig. 91.
11. Discovered by Dorra, p. 197.
12. See Perruchot, p. 214.
13. *Cahier pour Aline* (Facsimile edition of the manuscript now in the Bibliothèque d'Art et d'Archéologie, Paris), ed. Suzanne Damiron, Paris, 1963.

XI . LOGISTICS

1. Danielsson, *op. cit.*, p. 56.
2. Quoted by Denis in Paul Sérusier, *ABC de la Peinture*, Paris, 1942, pp. 42–44; Denis, "L'influence de Paul Gauguin," *Théories, 1890–1910*, Paris, 1913, p. 160.
3. Denis, *Théories, op. cit.*, p. 161. For a solid discussion of the symbolist movement in painting around 1890 see Anne Armstrong Wallis, "The Symbolist Painters of 1890," *Marsyas*, I, 1941, pp. 117–156.
4. Denis, *Théories*, p. 164.
5. Émile Bernard in a letter to Paul Gauguin, April–May 1890, un-

published document, collection Pola Gauguin. My translation is from Rewald, *op. cit.*, p. 446.

6. Pierre Loti, *Le Mariage de Loti*, Paris, 1880.

7. I am obliged to Bengt Danielsson for these quotations, which I have taken verbatim from his *Gauguin in the South Seas*, pp. 32–34.

8. Morice, *op. cit.*, pp. 21–22.

9. Albert Aurier, "Le Symbolisme dans la peinture: Paul Gauguin," *Mercure de France*, II, 1891, p. 162. (See Rookmaaker, *op. cit.*, p. 159).

10. *Ibid*. Translation from Wallis, *op. cit.*, p. 125.

11. Albert Aurier, "Symbolisme en peinture: Paul Gauguin," *Mercure de France*, March 1891, as cited by John Rewald, p. 482.

12. This article, translated for the first time and printed in full, forms Chapter XII of the present book.

13. Stated in a letter from J. F. Willumsen to John Rewald dated April 16, 1949, as cited in Rewald, *op. cit.*, p. 467.

14. Émile Bernard, *Souvenirs inédits sur l'artiste peintre Paul Gauguin*, Lorient, 1939, p. 12. Cited by John Rewald, *op. cit.*, p. 476.

15. Cited by Perruchot, *op. cit.*, p. 202.

16. Cited by Perruchot, *op. cit.*, p. 203.

17. See the account in Rewald, *op. cit.*, pp. 478ff.

18. Morice, *op. cit.*, p. 26.

19. The list of guests and the toasts are recorded in *Mercure de France*, May 1891, pp. 318–320. My translation is from Rewald, *op. cit.*, pp. 485–486.

XIII. PARIAH'S PROGRESS

1. Based on information in Danielsson, *op. cit.*, pp. 57ff.

2. Henry Adams, *Letters: 1858–1891*. Letter of February 23, 1891. Cited by Danielsson, *op. cit.*, p. 71.

3. See Bernard Smith, *European Vision and the South Pacific, 1768–1850*, Oxford, 1960, p. 26.

4. *Ibid.*, p. 25.

5. *Ibid.*, p. 26.

6. *Ibid.*, p. 25.

7. *Ibid.*, p. 27.

8. John Courtenay, *Epistle (Moral and Philosophical) from an Officer at Otaheite*, 1774. Cited by Smith, *op. cit.*, p. 30.

Reference Notes

XIV. THE TAHITIAN EVE

1. Translation from Danielsson, *op. cit.*, p. 177.
2. Gauguin replied to Strindberg in a letter of about February 5, 1895. For the complete letter see Paul Gauguin, *Letters to His Wife and Friends*, Cleveland, 1949, p. 197.
3. See note 11 for Chapter X.
4. Translation by Arthur Symons in *Baudelaire, Rimbaud, Verlaine*, ed. Joseph M. Bernstein, New York, 1962, pp. 98–99.
5. I am obliged to Judith Lifchez, a student in my seminar at Yale, for several of these references.
6. The association of Gauguin's Tahitian Eve with the sculpture was made by Richard Field, "Gauguin's Woodcuts," *op. cit.*

XV. THE GREEN HELL

1. Alfred Jarry wrote this poem in the *Livre d'or* of the Pension Gloanec at Pont-Aven. For the French text see Wildenstein, *op. cit.*, p. 167.

XVI. THE ASSAULT ON THE TREE

1. Mircea Eliade, *Mephistopheles and the Androgyne*, New York, 1965, p. 82.
2. Zimmer, *op. cit.*, p. 66.

XVII. HINA AND TEFATOU

1. Discovered by Richard Field, "Plagiaire ou Créateur?," in *Gauguin*, Paris, 1961, p. 165; also reproduced by Danielsson, *op. cit.*, Fig. 20.

XVIII. THE RED DOG

1. Morice, 1920, *op. cit.*, pp. 31–32.
2. Paul Gauguin, *Letters*, pp. 247f.
3. Morice, 1919, *op. cit.*, p. 27.
4. Stated in a letter of November 23, 1895. *Camille Pissarro, Letters to His Son Lucien*, ed. John Rewald, New York, 1943, p. 221.
5. As cited by Danielsson, *op. cit.*, p. 154.
6. *Ibid.*, p. 155.
7. *Ibid.*, p. 154.
8. One cannot discount the discussions that Gauguin and Morice had while planning and writing *Noa Noa*, discussions that no doubt grew out of Gauguin's relevant elaboratings of his own first draft.

) 361 (

Hence I have freely used quotations from the version they wrote jointly.

9. Danielsson, *op. cit.*, p. 184. See also Perruchot, *op. cit.*, p. 54. The complete interview is in *L'Écho de Paris*, May 13, 1895.

10. Danielsson, *op. cit.*, pp. 186–187.

XIX. THE LAST SUPPER

1. *Ibid.*, pp. 190–191.

2. *Ibid.*, pp. 210–211.

3. I am using Frank Lester Pleadwell's translation, kindly furnished me by the City Art Museum of St. Louis.

4. Gauguin's "eczema" was probably a symptom of a weakened heart, the circulation in his legs being insufficient to maintain healthy skin and subcutaneous tissue.

5. This portion of *Noa Noa* was published in *La Revue Blanche*, October 1897.

6. Translation by Ruth Pielkovo in *The Letters of Paul Gauguin to Georges Daniel de Monfried*, New York, 1922, pp. 94ff.

7. I am grateful to J. Silver for this observation. In Prud'hon's drawing the bedpost is surmounted by a ram's head.

8. Danielsson, *op. cit.*, p. 237. For the complete account of Gauguin's journalism see *Le Sourire de Paul Gauguin*, Paris, 1952; B. Danielsson and P. O'Reilly, *Gauguin, Journaliste à Tahiti*, Paris, 1966.

9. Loti, *op. cit.*, p. 95.

10. The association of the supplicating woman with the Passion tapestry figure, and the hooded head with Redon's *Death* was made by Richard Field, "Gauguin's Woodcuts," *op. cit.* For the source in Delacroix's *Natchez* I am indebted to Bradford Collins, a participant in my seminar at Yale.

11. Danielsson, *op. cit.*, p. 260.

XX. OVIRI

1. *The Letters of Paul Gauguin to Georges Daniel de Monfried*, *op. cit.*, p. 160.

PHOTO CREDITS

Annan: 41. Oliver Baker: 74. Lee Brian: 6. Bullaty-Lomeo: 23. Bulloz: 2, 7, 108, 119, 130, 131. Rudolph Burckhardt: 29. Giraudon: 15, 24, 80, 100, 136. Houvet: 68. Peter A. Juley: 116. O. Vaering: 17, 18. H. Roger Viollet: 9, 30, 98, 132, 134, 135. Ole Woldbye: 129.

INDEX